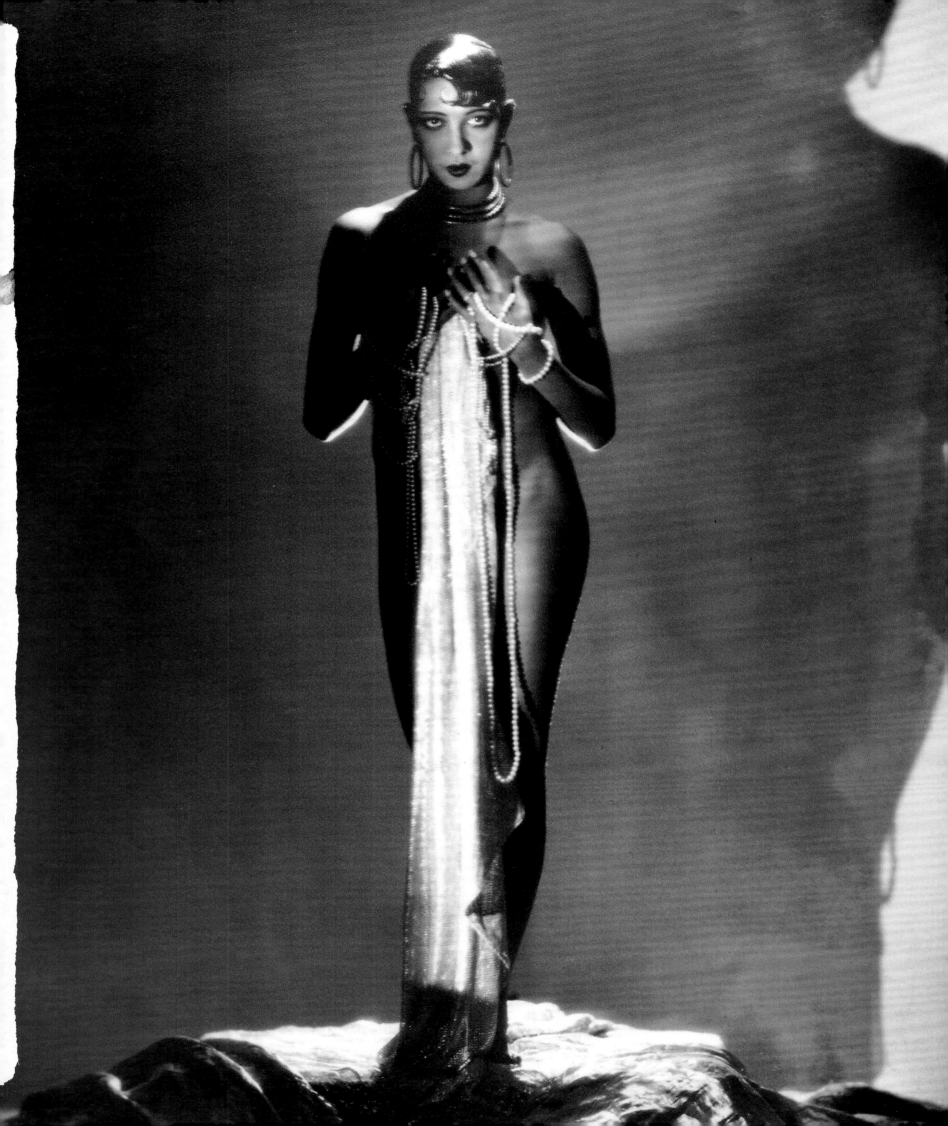

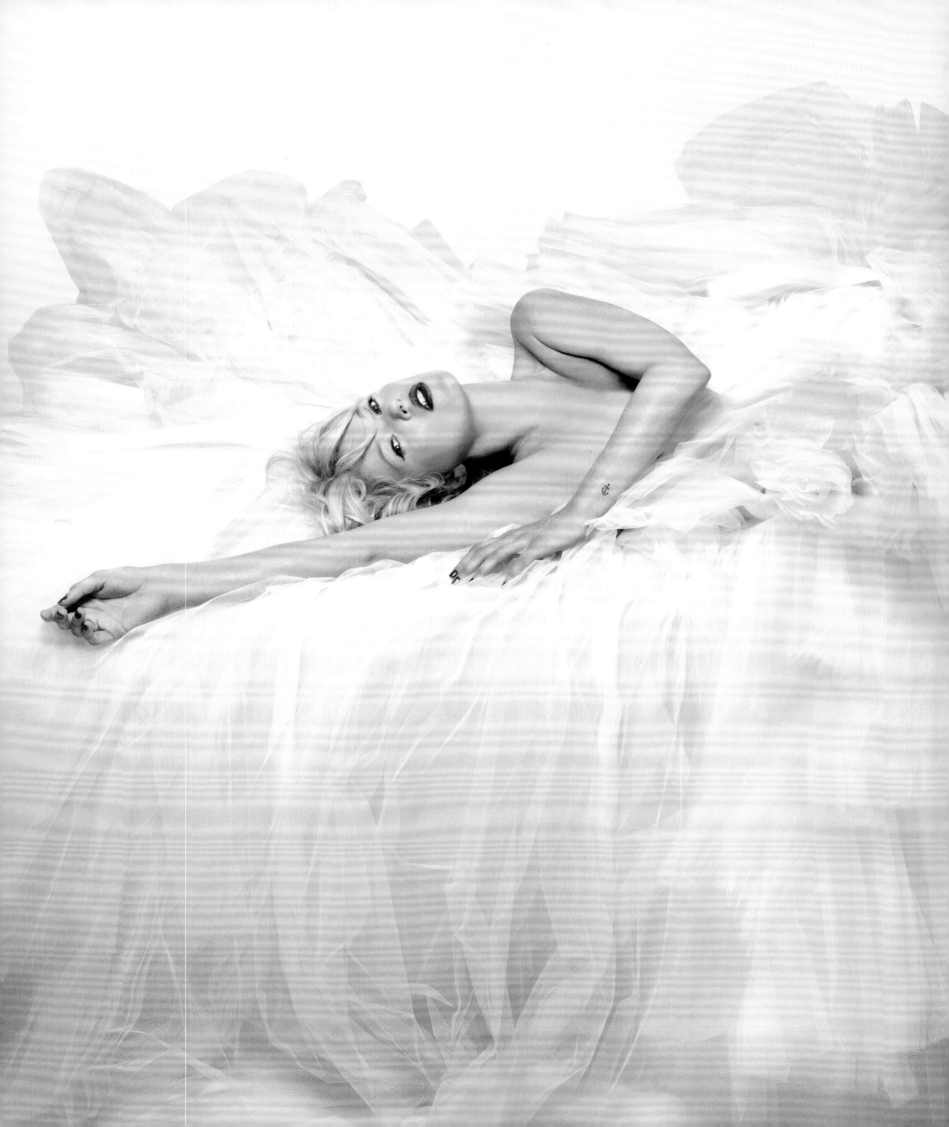

VOGUE100

A CENTURY OF STYLE

Robin Muir

National Portrait Gallery, London

CONTENTS

FOREWORD

Nicholas Cullinan

'FASHION changes, but style endures.' Coco Chanel's famous maxim seems particularly apt when considering the centenary of British *Vogue*. From its origins during the First World War to its present-day guise in the digital era, the personalities contained in its pages and the photographers who captured them – ranging from Marlene Dietrich by Cecil Beaton to Kate Moss by Mario Testino – are an extraordinary portrait of their age and comprise a panoramic view of the last century. *Vogue 100: A Century of Style* is a complex and ambitious undertaking that would not have been possible without the imagination and hard work of many individuals. I would first of all like to thank Robin Muir, the curator of the exhibition and author of the catalogue, for his brilliant work. At *Vogue* and Condé Nast Publications Ltd Alexandra Shulman, Editor of British *Vogue*, has been the most generous and inspiring of collaborators. Our sincere thanks also go to Harriet Wilson, Director of Editorial Administration and Rights, Condé Nast Publications Ltd; Jaime Perlman, Creative Director, *Vogue*; Brett Croft, Library and Archive Manager; Adam Boon, Curatorial Assistant for *Vogue 100*; and Stephen Patience, Sub-Editor, *Vogue*. The exhibition has been beautifully and intelligently designed by Patrick Kinmonth, Exhibition Designer and Artistic Director, and our sincere thanks are due to him too.

To my colleagues at the National Portrait Gallery, my thanks go first to Sarah Tinsley for leading the project, and the following for their characteristic flair and skill: Eloise Stewart, Exhibitions Manager, for overseeing such a challenging project; Rosie Wilson, Head of Exhibitions; and Jude Simmons, Head of Design. Many other colleagues across the Gallery have played a crucial role in the project, so my thanks also go to Michael Barrett, Pim Baxter, Nick Budden, Robert Carr-Archer, Naomi Conway, Joanna Down, Andrea Easey, Neil Evans, Sylvia Ross, Nicola Saunders, Fiona Smith, Liz Smith, Denise Vogelsang and Helen Whiteoak. I would also like to thank two people who were instrumental during the early planning for this exhibition – Sandy Nairne, my predecessor as Director, and Terence Pepper, Senior Special Adviser on Photographs (formerly Head of Photographs). My colleagues in the Publications Department have overseen this beautiful book, so my thanks go to Christopher Tinker, Managing Editor; Ruth Müller-Wirth, Production Manager; and Raymonde Watkins, Designer.

At the centre of this exhibition are the photographers who created these timeless images and the lenders who have allowed us to gather them together, so our gratitude goes to each of them.

The National Portrait Gallery is very grateful to Leon Max for sponsoring the exhibition. Such an ambitious project would not be possible without this vital support.

After the presentation in London, we are delighted that the exhibition will travel to Manchester Art Gallery, and we would like to thank the team there for a productive and enjoyable collaboration: Maria Balshaw, Director, and her colleagues Fiona Corridan, Miles Lambert and Amanda Wallace.

To all of these people, I offer my sincere thanks for creating a beautiful and fascinating survey of 100 years of both enduring style and substance.

Nicholas Cullinan is the Director of the National Portrait Gallery, London

p.1 Josephine Baker by George Hoyningen-Huene, 1929

pp.2–3 Kate Moss by Nick Knight, 2008

p.4 Marion Morehouse by Edward Steichen, 1927

p.6 Christy Turlington by Nick Knight, 1994

FOREWORD

Alexandra Shulman

BRITISH *Vogue* is 100 years old in 2016 and what a lot of living we've seen. Our first issue was published in the middle of the First World War, when Condé Nast, *Vogue*'s American proprietor, decided that despite the pall of bloodshed and tumult that hung over Europe, the British woman would nonetheless embrace a magazine dedicated to style and high-society life. He was right. That magazine has now thrived for over ten decades, chronicling the best of fashion and beauty, contemporary culture and intriguing personalities, in a vibrant, always modern, always exceptional manner.

The exhibition *Vogue 100: A Century of Style* provides an opportunity to experience the breadth and vision of a magazine that has as its cornerstone the best creative talents of each generation – mixing fashion with portraiture, film with art, beauty with social observation. On display is a remarkable collection of images, all of which have been commissioned by *Vogue* to feature in its pages. They were always designed to be a part of a magical mix: the work of the talented art directors, fashion stylists, features writers, fashion designers and editors who make *Vogue*. The images shown here might stand alone but they were conceived to be contained between two covers, juxtaposed with others, accompanied by type and edited as part of an overall vision.

The result is a riveting tour of a century: Nancy Cunard by Man Ray, Alfred Hitchcock by Irving Penn, wartime reportage by Lee Miller, and royal portraiture by Cecil Beaton. Then on to David Bailey's 'youthquake' fashion, the style of the 1970s by Sarah Moon and Helmut Newton, alongside graphic portraits by Snowdon and Terence Donovan. Mini-skirted supermodels of the late 1980s morph into the new waif models of the 1990s. And on to the present – always harder to distil without the filter of distance but still the same *Vogue* vision – via the work of Mario Testino and Tim Walker, Craig McDean and Glen Luchford, as the magazine expands its reach by means of the vast digital universe.

The exhibition *Vogue 100* takes you on that same journey. Robin Muir's curation (a passionate quest to encapsulate the essence of the magazine) has put at its heart the original photographic image, while Patrick Kinmonth's artistic direction allows the viewer an insight into the times and the process that gave birth to that image on the printed page.

We at *Vogue* feel honoured that this exhibition, thanks to Leon Max's generous sponsorship, is taking place in the prestigious and authentic environment of the National Portrait Gallery, where for generations visitors have come to view the people who have made history in their own time.

Alexandra Shulman is the Editor-in-Chief of British Vogue

SPONSOR'S FOREWORD

Leon Max

I HAVE always had an interest in art and fashion, in seventeenth- and eighteenth-century portraiture in particular. The National Portrait Gallery, under the exciting new direction of Dr Nicholas Cullinan, is a remarkable institution that gives visitors an excellent historical perspective, as well as showcasing the best contemporary works, in a variety of individual styles through its Collection, displays and exhibitions. It documents the way people have chosen to project themselves over centuries, through their clothes and the contexts in which they are portrayed; every detail speaks of their status and aspirations.

Vogue has been an important disseminator of taste, and in many cases a contributing force, from its inception in printed form in the early twentieth century to today's digital editions in an e-commerce marketplace, a world in which the word 'selfie' is part of daily parlance.

It is a natural fit for Leon Max, a company that produces clothing, shoes, eyewear and numerous other accessories that allow women to define their image, to support and celebrate both institutions.

Leon Max is the founder of Max Studio

VOGUE

This number a

Forecast

of

Autumn Fashions

L'Automne

September 15th CONDÉ NAST & CO. One Shilling Net. Fortnightly
 LONDON

'Yesterday, Today and Tomorrow'
THE CENTURY IN VOGUE
ROBIN MUIR

BRITISH *Vogue* was born in September 1916, near the mid-point of the Great War, when the threat posed by roving packs of German U-boats halted the import of American *Vogue* to British shores. In the same month, at the Battle of the Somme, General Haig launched a new instrument of war, the tank, to break the deadlock on the Western Front. It failed to do so. By November 1916, when the battle had officially ended, there were nearly half a million British casualties, the costliest campaign in British military history. This was an inauspicious moment to make a debut.

In 1914 the imported American *Vogue* had been selling at a rate of 4,000 copies per month. By 1916 its sales had quadrupled. Scarcely believably, American *Vogue*'s editor Edna Woolman Chase was able to say in her memoirs, *Always in Vogue* (1954), 'in the trenches our circulation was second only to the *Saturday Evening Post*, but I suppose it was natural. *Vogue* is about women and their frills and furbelows; it is a vastly different diet from mud and uniforms, boredom and death.'

Condé Montrose Nast, a publishing executive from St Louis, had acquired *Vogue* in 1909, when it was a New York weekly gazette in decline (it had been founded in 1892). He set about expanding it without alarming its core readership, Manhattan's social elite – 'the magnet that drew out the gold', as Nast put it. He made it a fortnightly publication; the society pages began to feature fashion as well as the 'fashionable life one leads'; he acquired the highest quality paper stock; he modernised its typography and layout; he replaced its over-decorated black-and-white front cover with designs in full colour. (Later *Vogue* would be the first to publish colour fashion photographs.)

As Caroline Seebohm observed in *The Man Who Was Vogue: The Life and Times of Condé Nast* (1982), 'at an exhilarating moment in history, Nast invented the superfluous in America. He showed Americans how to spend their money on the embellishment of life and carried his standards of taste to England and France in a triumphant reversal of form.' Nast understood the modern woman of taste and means because she lived life by his side. His parties, held in his thirty-room Park Avenue apartment, were extravagant – writers, actresses, dancers, socialites and fellow tycoons flocked there – and were later written up in *Vogue*'s pages. (*Vogue*'s Jazz Age photographers Lusha Nelson, Charles Sheeler, Edward Steichen and Cecil Beaton would use his sprawling penthouse as a backdrop in their work.)

Fashion and the fashionable life were the keys to the magazine's early success, replicated across the Atlantic at a shilling an issue. And *Vogue* foresaw early on the impact photography would make (the first photograph had appeared in 1893): 'Do not make the mistake of pretending that photographs are not photographs but something different,' cautioned the magazine in 1920. 'Nothing which has made *Vogue* what it is will be deleted,' Nast promised British readers. This was accurate: much of the same material – text and photographs – featured in both American and British *Vogue*. Cover artwork for the British edition was dispatched every two weeks from New York.

The tone was reassuring and non-parochial: 'You may turn with all assurance to British *Vogue*. It is quite the equal of American *Vogue* in its accuracy, smartness and its excellence of taste in all matters.' Yet a lack of stylishness set the tone for the magazine's first issues. The inaugural cover was a low-key affair drawn by the American illustrator Helen Thurlow.

First Vogue *cover by Helen Thurlow, 1916*

Vogue's first editor, appointed in early 1916, was Dorothy Todd. Unusually for the editor of a fashion magazine, Miss Todd, though modish, was mostly indifferent to fashion: 'A fat little woman, full of energy, full of genius,' recalled contributor Rebecca West in 1972. Todd's enthusiasm was instead for the avant-garde in literature and the arts. Although her tenure was brief – a matter of a few months – she was not cast aside, but sent to New York to learn magazine publishing the Condé Nast way.

Her replacement in 1917 was Elspeth Champcommunal, whose fashion credentials were impeccable. Close to the couturier Paul Poiret, she was also friendly with artists Roger Fry and Vanessa Bell, and had occupied a senior role at Maison Worth in Paris. She kept *Vogue* on a steady path into the 1920s, but a slump in circulation led to her departure. Ruth Anderson became caretaker editor, hiring as staff members the young novelist Aldous Huxley and Dorothy Wilde, Oscar's niece.

In 1922 Dorothy Todd returned. With a staff of fourteen, she moved into new offices in the Aldwych. Her second term was remarkable, for Todd was still defiantly literary. She attempted to turn *Vogue* from a fashion magazine with light coverage of the arts into a magazine *of* the arts, which hesitantly included fashion. Colette, Noël Coward, Vita Sackville-West and Evelyn Waugh all made their *Vogue* debuts under Todd. Between 1923 and 1927 more than 200 contributions were either made by or written about the Bloomsbury Group and their associated circle, including five essays by Virginia Woolf. Bloomsbury itself seemed to be on the verge of renouncing intellectualism for high fashion.

That they were in danger of being lionised also owed much to Todd's leading photographers, the team of Maurice Beck and Helen Macgregor. He provided elegant props and technical know-how, she the eye for composition. They joined *Vogue* in 1922 and made, according to Cecil Beaton in *The Magic Image* (1975), an incongruous pair: 'The quiet but determined little spinster and the full-blooded Beck ... but they worked together in great harmony.' Their portrait for *Vogue* of a bare-chested Rudolph Valentino, posing as Nijinsky in the Diaghilev ballet *L'Après-midi d'un Faune* (p.25), captivated Beaton and a copy found its way into his scrapbooks; so too a portrait of Virginia Woolf (p.35). Others who sat for them included Fred Astaire dancing with his sister Adele, the fledgling songwriter Ivor Novello, the less instantly alluring H.G. Wells and the economist John Maynard Keynes.

If the 'Bloomsberries' found it amusing to 'sweep guineas off the *Vogue* counter', as Woolf put it in her diary in 1925, others did not. Being talked about in narrow if elevated circles was not the Nast way. By 1926 Todd's modernist *Vogue* was losing £25,000 annually (the equivalent of around half a million pounds today) and she was fired. Out, too, went *Vogue*'s fashion editor, Madge Garland, with whom Todd had been living quite openly. Mrs Chase, now editor-in-chief of all the *Vogue*s (a French edition had arrived in 1920), was blunt: 'The atmosphere [Todd] created was lofty and she was browsing happily in rich pasture. Unfortunately, from our point of view, it was the wrong one.'

True, if one-sided. Outside influences also drove *Vogue* down, not least the General Strike of 1926, during which Condé Nast considered folding his British operation altogether. Inside, even a cursory glance at Todd's pages show that hers was not a case of overlooking fashion; instead she attempted to marry it to high art and serious journalism, and in so doing was too far ahead of her time. 'Together these women,' wrote West many years later of Todd and Chase, 'changed *Vogue* from just another paper to being the best

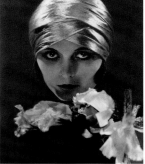

of fashion papers and a guide to the modern movement in the arts.' How a page looked was at least as important as how it read; this underpinned *Vogue* then and continued to do so throughout the century to come.

Mrs Chase came over to London to take charge with reassuring platitudes, as her memoirs record: 'The English woman of fashion should not be discounted in the matter of elegance; when she is right, she is very right ... There is no woman in the world who can wear a ball dress and a tiara with her distinction.'

Todd did make one significant discovery that would greatly influence the course *Vogue* would take. Cecil Beaton was a young Cambridge undergraduate and an aesthete *manqué* when, in 1924, *Vogue* first published one of his photographs (for 30 shillings). 'When Miss Todd wrote to me from her Mount Olympus home in Bloomsbury inviting me to photograph,' he recalled in *Photobiography* (1951), 'I felt I was on the road to fame.'

In the microcosmos of *Vogue*, few careers illustrate the magazine's capacity for benign indulgence better than Beaton's. For more than half a century until his death in 1980, he was a tireless contributor – not just as a fashion and portrait photographer, but also as an illustrator and caricaturist, writer and stylist, social commentator and arbiter of taste. Beaton replaced Beck and Macgregor, becoming *Vogue*'s chief photographer within eighteen months. His pictures were characterised by 'a recklessness of style' that allowed him to escape the restraints of a suburban middle-class upbringing. As his friend Peter Quennell wrote in *Time Exposure* (1941), '[Beaton] enjoyed treading the shadowy border-line between "good" and "bad" taste, less perhaps from that "aristocratic pleasure in displeasing" to which aesthetes attached a somewhat exaggerated and snobbish value than from an instinctive affection for the world of the theatre with its glitter and make-believe.'

Thanks to Miss Todd, *Vogue* could truly call Beaton – young, talented and increasingly well connected – its own discovery. For fashion coverage in its early years, the magazine had depended upon imported photographs from the American edition, most conspicuously the decorative, ethereal tableaux of Baron Adolph de Meyer, tempered by contributions from West End society portraitists such as Dorothy Wilding, Hugh Cecil, Howard Instead and Bertram Park, among others. Of these, Cecil was perhaps the most noticeable, retaining two pageboys at the door of his Grafton Street studio to welcome sitters. The naturalised Briton E.O. Hoppé was entrusted with *Vogue*'s first full-page frontispiece portrait – of Lady Eileen Wellesley. He had taken the lease on a thirty-three-room Kensington house, formerly the studio of the painter John Everett Millais. Setting a precedent for *Vogue* photographers to come, he staffed it with assistants, retouchers and printers, establishing a highly profitable production line.

To Beaton, who was much influenced by the Baron's extravagant style, de Meyer was 'the Debussy of the camera', the maker of 'Whistlerian impressions of sunlight on water, of dappled light through trees', as he wrote in *The Glass of Fashion* (1954). Recognised as the first professional fashion photographer, de Meyer had been put under contract to American *Vogue* in 1914 at $100 a week. His *raison d'être* was the creation of fictive worlds, where women of glamour stood in poses far removed from ordinary life. And if they fell short of an ideal, they were retouched ad absurdum. (Much of de Meyer's own life story was a fabrication, his title supposedly spurious. He later changed his name once more to 'Gayne de Meyer'.) His models were society women, showgirls and ingénues and he imbued each with an aura of romance and refinement, defining for *Vogue*'s infant years its image of feminine beauty. A celebrity in his own right, de Meyer was tempted from *Vogue* to *Harper's Bazaar* in 1922 for an even higher salary (and a Paris apartment). His genius declined thereafter. Edward Steichen replaced him.

Vogue had already trumpeted Steichen as 'The World's Greatest Living Photographer' for his success as a founder of the photo-secessionist movement. Putting any lingering impressionistic tendencies to one side, he propelled Condé Nast's magazines into the age of modernism as chief photographer for American *Vogue* (and *Vanity Fair*) from 1923. His dramatic lighting and high-key monochromatic style set the pace for those who immediately followed, among them George Hoyningen-Huene and his protégé Horst P. Horst.

In 1927 Mrs Chase appointed Alison Settle as editor of the British edition; she had a background on the women's pages of newspapers. She found *Vogue* very different: 'It was unbelievable how snobbish it was. I wasn't allowed to go on to a bus and the fact I lived in Hampstead and came down to the West End by Tube they thought was very lowering.'

Under Settle's editorship, with Madge Garland back as fashion editor (her association with the sacked Dorothy Todd ignored), *Vogue* reflected the new nature of the fashion business and began to feature ready-to-wear designs. The haute couture collections were vital, but so was the new breed of wholesale manufacturers – or 'copyists' – who, through the sheer number of garments then reaching provincial department stores, exercised considerable influence on the buying public. *Vogue* did not lose its interest in the arts, although highbrow literature gave way to profiles of screen stars, and *haute bohème* yielded to the Bright Young Things, who, according to *Vogue*'s Lesley Blanch, were 'cropped, plucked and pickled in cocktails and nicotine'. *Vogue* revelled in the new and the modern: 'There are probably still studios in St John's Wood where negro sculpture has not yet penetrated, but there can hardly be an ear left in England that has not responded to the quiver, the hesitation and the slide of jazz.' The magazine was *au courant*, being mentioned in Stella Gibbons's comic novel *Cold Comfort Farm* (1932), in Rodney Ackland's play *Strange Orchestra* (1931) and Rosamond Lehmann's *Invitation to the Waltz* (1932): '"You look like the girl on the cover of a Special Spring Number." Twisting to look at her cape, Kate said placidly: "I just took it straight from *Vogue*."'

Condé Nast had speculated wildly on the stock market – borrowing, it was believed, around $2 million to do so. Then, in 1929, came the Wall Street Crash; bankruptcy loomed. It was the prosperity of the British company under managing director Harry Yoxall that most likely saved Nast from ruin. If *Vogue* now appeared less aloof, then it wasn't solely down to Mrs Settle. British *Vogue* had boomed and Yoxall had introduced the *Vogue Pattern Book*, sales of which quickly overtook the main title. In 1931 the magazine expanded, moving to a larger, granite-domed office at 1 New Bond Street.

In 1934, after nine years, Settle left. In the same year, the British newspaper baron Lord Camrose (formerly William Berry) bailed out Nast, becoming British *Vogue*'s major shareholder, and the American Elizabeth Penrose became editor. A fully fledged Nast/Chase protégée, Penrose was cautious and reliable, according to her beauty editor Anne Scott-James in her autobiography *In the Mink* (1955), and found (with justification) *Vogue*'s house style to be 'excessively sprightly and riddled with clichés'. Penrose's standards were meticulous.

The prospect of a second world war threatened and by September 1939 it became a reality. The party was over. Penrose cabled Chase: 'We are digging in for a long hard winter', although she did not endure many more. In 1941 she returned to New York and the editorship of *Glamour*. Meanwhile, *Vogue* had outlined its immediate policy in 1939: 'To maintain the standards of civilisation. Once more we raise the "carry on" signal as proudly as a banner ...'

Lee Miller in dress by Patou
by George Hoyningen-Huene
Miller came to *Vogue* as a model, an association lasting twenty-five years. Before it ended, her words and photographs from D-Day to Dachau made *Vogue* an unexpected witness to the horrors of modern warfare
October 1931

Top Wartime *Vogue* cover by Porter Woodruff, 1918
Bottom Actress Pola Negri by Edward Steichen, 1925

Audrey Withers replaced Penrose. 'An intellectual who knew very little about it, she found fashion slight and ephemeral,' recalled her star photographer Norman Parkinson in *Lifework* (1983), his entrée to *Vogue* coinciding with the new editorship. Withers and her magazine had a good war, far exceeding expectations. She wrote to the American office in 1940: 'We try to look at each sentence and imagine how it will read in the face of all the disasters that may happen before it sees the light of day.' Condé Nast was roused – and amazed – to learn that, despite the vagaries of the times, British *Vogue*'s circulation was at its highest ever. 'Here is ample proof,' he wrote back to Withers, 'that civilised life goes on in Britain behind the blackout ... life with its graces stubbornly maintained. *Vogue*, with all that *Vogue* stands for, still matters to the women of England.'

Condé Nast died in 1942 before witnessing just how much further his British edition would go. From 1944 to 1945 the words and photographs of Lee Miller gave *Vogue* readers an unexpected front-row seat in the theatre of war. Accredited in 1944 to the US Army, she witnessed the siege of St Malo, endured the freezing hell of the Alsace campaign and the *Götterdämmerung* of the Third Reich in Bavaria, and was among the first into the Nazi concentration camps at Buchenwald and Dachau. On the home front, set against a rural background, the wartime fashion pictures of Norman Parkinson were reminders to *Vogue*'s readership of the fulfilment to be found in a simpler way of life, a theme he continued to explore in the post-war years.

With the end of the war, *Vogue* readjusted itself to a new mood. Victory heralded a slow domestic recovery. In 1946 *Vogue* moved to new offices in Golden Square, Soho, with a new photographic studio in Shaftesbury Avenue. Cecil Beaton, who had travelled the world as a war photographer, found it hard to adjust to the frivolity of fashion in the post-war years. He wrote in his diary that London had 'suddenly to me become lowering to the spirit. The air seems to be used up. One is conscious of the untidiness, the discarded bus tickets, the greasy pavements, the look of aimlessness on the faces of those with nothing to do.' *Vogue*, however, celebrated fashion's New Look, a response to the desire for a luxurious style after the restrictions of wartime. From a ringside seat at the 1947 collections, the magazine declared in its April issue: 'Christian Dior is the new name in Paris. His house was newly decorated, his ideas were fresh and put over with great authority, his clothes were beautifully made, essentially Parisian, deeply feminine ...'.

When paper rationing was lifted in 1951, *Vogue*'s monthly circulation stood at a record high of 100,000. Audrey Withers was a Fabian socialist with, by her own admission, little interest in clothes. She revitalised *Vogue*'s arts pages, her list of contributors a roll-call of mid-twentieth century literary achievement – and consciously left-leaning: Rebecca West, Dylan Thomas, Siegfried Sassoon, Kenneth Tynan, Jean-Paul Sartre and Simone de Beauvoir. Features editors Clarissa Churchill and Siriol Hugh-Jones introduced Albert Camus and existentialism to *Vogue*.

Tony Armstrong Jones, a former student of architecture who had turned to photography, became an immediate success with Withers and her team, not least for his charm. He was self-deprecating and refused to treat fashion with reverence, having a natural inclination to prick the bubble of what he saw as a supercilious world. This he achieved with unusual locations, extravagant props and a judicious use of nylon thread to stabilise a toppling champagne glass or a collapsing deckchair. 'The only thing that can be said,' recalled Armstrong Jones (who would later become the Earl of Snowdon) in *Personal View* (1978), 'is that the photographs didn't imitate

the elegant pictures by Irving Penn which I admired so much ...'.

Nurtured by American *Vogue*, Irving Penn was also prominent in the British edition from 1943 until the early 1960s (and occasionally thereafter until his death in 2009). A maker of inscrutable portraits, he was ambivalent about fashion photography, but his pictures of the Paris collections of 1950 proved a turning point. Sparse compositions against seamless grey paper, as taut and as concentrated as his portraits, they felt almost monumental in their simplicity and remain unsurpassed as documents of mid-century haute couture. Norman Parkinson's fashion assignment to India in 1956 also proved to be decisive: 'Some of the greatest fashion colour work that anyone has done,' said a cable from Alexander Liberman, the influential art director of American *Vogue*.

By selling Amalgamated Press to the Mirror Group of newspapers in 1958, the Berry family triggered a clause that disposed of their interest in Condé Nast Publications Ltd – for six months. Within that period a buyer came forward: S.I. Newhouse, of the American newspaper dynasty. In due course the Newhouse family became sole shareholder of the worldwide Condé Nast empire. British *Vogue*'s success generated several subsidiary publications and a need for larger premises. In 1956 Vogue House was built, a landmark, seven-floor building in the heart of the West End. The Vogue Studios were established on the topmost floor, and in 1958 the magazine moved into its new headquarters.

Withers retired in late 1959. Her successor was Ailsa Garland, formerly assistant editor of the *Daily Mirror* but with a Condé Nast training (on the British *Vogue Export Book*, an occasional magazine and subsidiary of *Vogue*, which promoted British fashion abroad). Her tenure was barely four years.

Until the early 1960s home-grown fashion photographers – with the exception of Parkinson, Snowdon and the now veteran Beaton – were scarce. Americans Clifford Coffin, Henry Clarke and John Rawlings had been posted to London to help out, as had a German émigré lately based in Melbourne: Helmut Newton, who was put on a one-year contract in 1957. In contrast to his later experience of the French edition, 1950s British *Vogue* denied him any opportunity to push the moral boundaries of fashion photography. 'The studios in Golden Square were depressing and dusty, with terrible old wooden floors,' he recalled in *Autobiography* (2003). 'I was told that under the grassy square were the bodies of people who had died during the black plague ... It was indicative of my whole feeling for the place, my feelings towards London.'

For decades *Vogue*'s fashion photography had remained impervious to social change, but it could no longer avoid a new breed of fashion photographer: Brian Duffy (in his mid-twenties) arrived at *Vogue* at the end of the 1950s, joined by David Bailey (aged twenty-two) in 1960 and Terence Donovan (aged twenty-five) in 1961. All were determined to invest their pictures – and the pages of *Vogue* – with the immediacy and exuberance of youth.

The seeds had been sown earlier. In 1956 the American photographer William Klein had discarded *Vogue*'s accepted standards in favour of a 'snapshot' aesthetic – a shifting pattern of techniques and devices that included distortion, split focus, graininess and unusual cropping. He made a virtue of the unplanned. He had 'eyes as sharp as knives', said Sophia Loren in 1958. 'He was unforgiving and extravagant.'

That Klein was allowed to bring this unpredictable sensibility to the pages of *Vogue* says much for its desire for novelty. From 1960, in a similar *verité* style, Paris-based Frank Horvat made documentary fashion photographs against the undulating vistas of the British landscape. What set Horvat apart was a *plein air* naturalism, a style new to *Vogue*. As *Photography* magazine explained in 1960, '[Horvat] is meticulous about the choice of model, because he looks for humanity, without the artificiality which seems to be a feature in the work of many other fashion photographers. The girl must have personality because people are as interested in her as the dress she is wearing.'

Ailsa Garland encouraged the revolution of the young, revitalising *Vogue*'s 'Young Idea' pages. These were not a novelty. In January 1953, as a

VOGUE
BRITANNICA
NUMBER
1951

'Summer Life'
by Tony Armstrong Jones
Armstrong Jones's first photographs for
Vogue appeared in 1956. He brought a sense
of fun to fashion, making his models 'run,
dance, kiss – anything but stand still'
June 1957

Top Pages at the Coronation by
Norman Parkinson, 1953
Bottom *Vogue* 'Britannica' cover, 1951

15

new Elizabethan Age unfolded, *Vogue* declared: 'The days when young ladies arranged flowers until – oh happy release – *he* came along are over, and we are glad of it ... We mean to photograph you wearing the clothes for the occasion – the *young* clothes for the *young* occasion.' Momentum was increasing and the young were rapidly becoming conspicuous consumers, forming their own tastes in fashion and entertainment. Garland's *Vogue* became mildly political, mourning the tragedy for the Western world of President Kennedy's assassination, warning against the arms race, and giving prominence to (and pictures of) the *Weltpolitik* of the mayor of Berlin, Willy Brandt, a thinly disguised opposition to Soviet repression.

Despite Garland's best efforts – she was able to trumpet that '*Vogue* has half a million more young readers than any other fashion magazine' – the barbs of the young satirist Jonathan Miller, writing in January 1962, were sure: 'The very name of the magazine, rare and glottal, stamps the publication as the brochure of stylish hedonism. The obsidian stare of the cover girls suggests an elegant corruption: a whiff of Beardsley, of voluptuous evil. With all these exciting trappings, the content comes almost as a let down. One is confronted instead by gentility ...' *Vogue* had fostered 'fashion for the older woman' since 1949 in the form of the determinedly upper-middle class 'Mrs Exeter', a make-believe reader of a certain age, around whose recommendations and partialities stories were skilfully woven. Her provincialism was her greatest asset. She lived life in town and country and carefully selected garments that met her demand for chicness and durability.

It was against this backdrop – from Ascot to Henley, from gloved hands to greyhounds – that Bailey, Duffy and Donovan's fashion and beauty photographs would be viewed. 'They – from Mars or wherever they are – said I wouldn't be a fashion photographer,' Bailey famously told *Vogue* in 1965, 'because I didn't have my head in a cloud of pink chiffon. They forgot about one thing. I loved to look at all women.' He added later: 'The place was run like a point-to-point. Don't forget being a cockney was no help in the beginning – only after '65.'

Their depiction of models, as manifested by stance and eye contact, suggested much more intimacy than was observed by Bailey's predecessors with their pink chiffon. The gaze back was not ambiguous: it was defiantly sexual. Labelling them the Black Trinity, Norman Parkinson airily dismissed Bailey, Donovan and Duffy as 'those fellows so passionate with the idea that they'd invented sex ...'. For *Vogue*, it is likely that they had. In a moment, as features editor Polly Devlin observed in 2003 of mid-1960s *Vogue*, 'everything is glossy and shiny and outlined, about illumination in every sense; there seem to be no murky corners at all. It's like suddenly accessing the future.'

In 1964, under pressure, Ailsa Garland quit. Beatrix Miller came to *Vogue* as the former editor of *Queen* magazine, which had rapidly established itself as a younger, brighter rival. Like Garland, the new editor had had a Condé Nast upbringing as a copywriter at American *Vogue*, where she had learned, she recalled in 1986, 'a curious dialect, all adjectival clauses and mincing dactyls. By the time I had mastered it, I was heading back to England.' For twenty-two years until 1986, Miller maintained her vision of *Vogue* as an unfailingly – and often idiosyncratically – British institution, celebrating the nation's triumphs in the arts and promoting its fashion designers, both young and established. Although it never neglected excitement overseas, it was British life as it was led – albeit looser, livelier and more unconventional as the years passed by – that typified her *Vogue*. 'Vogueland', as she explained it, was 'relatively superficial but in the broadest sense the mood of the moment translated visually'. The provocative punk movement, for example, did not pass her by; nor did other contemporary notions of street style hitherto unnoticed by the magazine. As designer Jean Muir observed in *Vogue*'s tribute to Miller in 1986: 'She took that particular American glamour and translated it into an English version of glossiness. This was a delightful contradiction when you think of the quieter, more restrained English qualities to which she was appealing.' Although she was never in thrall to the avant-garde – whatever appeared in her *Vogue* had first to pass her instinctive and unspoken standards – Miller's issues were distinguished by their visual impact and wit. One of her final issues in 1986 ran to a record 470 pages, by which point she had driven up circulation to 166,000.

Miller's fashion editors, chiefly Grace Coddington, Anna Harvey and Liz Tilberis, were dispatched to bring back not pictures but 'stories'. Most conspicuously, it was the American photographer Bruce Weber who provided the narrative framework. In her memoirs, *No Time to Die* (1998), Tilberis wrote that a shoot with Weber 'involves a cast of dozens, a journey, an emotional intensity that wraps us up for days'. She added that 'the best fashion photography springs from the heart. Bruce Weber's photographs were always about *something*, and they were always emotional.' Weber shifted the emphasis from the clothes to those about to wear them, avoiding model agencies in favour of 'real' people: actors, sportsmen, petrol-pump attendants, friends of friends. Out of this came one of his most recognisable motifs, namely, heroic beauty, which can be found in those who are aware they have it, but also in others who never dream that they might possess it.

Never in *Vogue* had the clothes seemed so peripheral. These stories – epic in scale, ambition and page allocation, shot against monumental American landscapes – betrayed Weber's extensive knowledge of photographic and art history from Alfred Stieglitz and Georgia O'Keeffe to Edward Weston and Tina Modotti. In the 1980s the climate at Miller's *Vogue* was benevolent enough for one commentator to remark that Weber's photographs were 'thank-you notes to people for simply being beautiful'.

At the time of her retirement in 1986, Beatrix Miller was *Vogue*'s longest-serving editor. In her place came its shortest-lived: Anna Wintour. Half-British, half-American and based in New York, Wintour rose to prominence at *New York* magazine. In 1983 she became creative director of American *Vogue*, a position created for her, and she then crossed the Atlantic to fill the vacant post in London. As an editor she would not fight shy of the radical overhaul: 'I want *Vogue* to be pacy, sharp and sexy ... I want our readers to be energetic and executive women with money of their own and a wide range of interests,' she said of her revamped magazine, which would in time serve as something of a template for her forthcoming editorship of American *Vogue*. As her fashion director, Grace Coddington, recalled in *Grace* (2012): 'Anna's mission, coming from the commanding heights of American *Vogue*, was to take its whimsical little cousin by the scruff of the neck and propel it forward into a brave new world.' Senior fashion editor Liz Tilberis was blunter, detecting a flintiness in Wintour that would wipe out the contrived, madcap, outré, weird, overdone and unconnected-to-reality – anything, in fact, that had marked Miller's *Vogue*. 'Anna wanted nothing of the rocks-and-rubber work I'd been doing. She wanted smiling, happy, athletic, professional pictures.'

In 1987, after barely a year – during which American sheen had varnished English eccentricity – Wintour was recalled to New York and the editorship of American *Vogue*. Tilberis had already resigned to take up a post in New York as consultant to designer Ralph Lauren when the call came to replace Wintour in London. Tilberis was the first editor of British *Vogue* to be drawn directly from its fashion department. Mark Boxer, the founding editor of *The Sunday Times Magazine*, later editor of *Tatler* and, by 1987, editorial director of Condé Nast in London, helped her with the transition. When he died unexpectedly in 1988, she took sole charge.

Top 'Young Ideas' cover by Norman Parkinson, 1959
Bottom Charles James dress and flowers by Bruce Weber, 1984

Cyrus and Joe Jr, Big Timber, Montana by Bruce Weber
Weber's most recognisable theme, heroic beauty, can be found in those who never thought they possessed it
January 1991

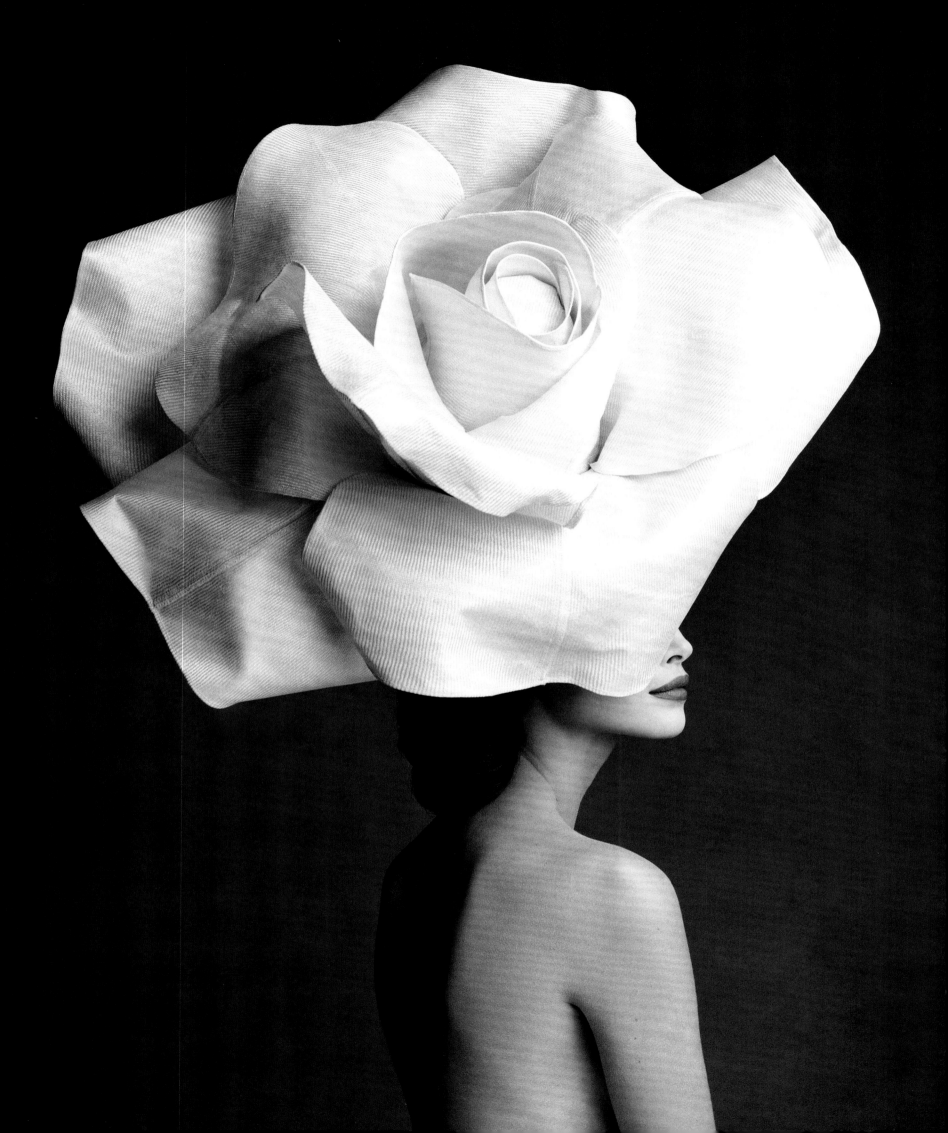

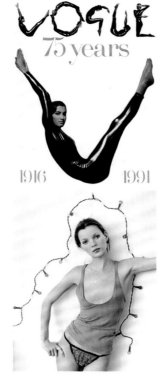

Tilberis took the reins at the exact moment, she recalled in *No Time to Die*, when fashion crossed over in the public perception from minority interest into full-blown, front-page fixation. 'Suddenly fashion mattered to a lot more people and we were witnesses, provocateurs and recorders of this seismic shift.'

On the features side of the magazine, which she admitted was not her speciality, Tilberis pushed particularly for articles on health and health awareness – in her own words, 'the aftermath of violent crime and Germaine Greer facing the menopause'. Neither topic would have excited her most recent predecessors. She also had the foresight to give her features editors licence to be highbrow when it mattered.

Under fashion director Sarajane Hoare and fashion editor Lucinda Chambers, Tilberis's *Vogue*, growing ever larger in extent, was crammed with pictures of eye-popping imagination. Hoare's showmanship was unbridled. If her pages owed little to real life as it was lived, then once again this seemed the point of the British magazine. Hoare's memory bank would incorporate, as she wrote in *Talking Fashion* (2002), 'the crimson velvet of a gown, evoking Ingres; a low-slung hip belt that makes you think of a cowboy's swagger; muslin smocks reminiscent of priests; draping suggestive of a Roman toga'. A rolling cast of pop-cultural figures willingly collaborated: Madonna, George Michael, Prince, Liza Minnelli. Photographer Herb Ritts factored in California sunshine, Bruce Weber the big sky of the western United States, while Peter Lindbergh plundered the tropes of European cinema.

A sense of removal from the real world continued. Supermodels (a neologism that became common currency) bestrode Manhattan in swimsuits, stilettos and holsters. Innovative covers – models with a horse or a head of Highland cattle, a mother and baby, a Jack Russell terrier and a tartan logo – emphasised that the qualities of a striking image alone were almost enough to sell the magazine. At their most minimal, the cover lines might run to just two words: 'Winter Dressing'. None came more conspicuous, however, than the Christmas cover for 1991. Its star, photographed by Patrick Demarchelier, was Diana, Princess of Wales, with whom Tilberis had forged a fruitful alliance, thanks to the behind-the-scenes authority of fashion editor Anna Harvey.

By September 1990 *Vogue*'s circulation was 179,000 and its readership was estimated at 1,800,000. The following year *Vogue* celebrated its seventy-fifth anniversary with a photographic show at London's Royal College of Art. For the commemorative supplement to the June issue, the cover featured an image by Tyen of model Yasmeen Ghauri, a reworking of a famous cover from 1940 of Lisa Fonssagrives by Horst.

At the end of the celebratory year, Tilberis was offered the editorship of *Harper's Bazaar* in New York, which put her head to head with Anna Wintour, now into her fourth year at American *Vogue*. She revived *Bazaar* (as it was known) to striking effect, taking with her from *Vogue* star photographers Demarchelier and Lindbergh.

Alexandra Shulman was appointed editor in 1992. She had been features editor under Tilberis and subsequently editor of British *GQ*. Twenty-four years later she is the longest-serving editor in *Vogue*'s history. In the magazine's second century she articulated its changing nature: 'I'm very aware that I've lived through a fantastic period of being a journalist – that ability to experience and gain information and then impart it to others is a great privilege. You might be reporting from a war zone or a fashion show, but what a luxury to be able to experience something and tell people about it.'

**Christy Turlington in 'Rose' hat
by Patrick Demarchelier**
Jasper Conran designed the costumes
for a revival of *My Fair Lady*, inspired in
part by Irving Penn's flower photographs
February 1992

Top Seventy-fifth anniversary *Vogue*
cover by Tyen, 1991
Bottom Kate Moss by Corinne Day, 1993

Shulman inherited a *Vogue* that had successfully traded on its idiosyncrasy and its unassailable status as the fashion authority *ne plus ultra*. But the climate had changed perceptibly: newspapers and their weekend colour supplements began to cover fashion confidently, in detail and with immediacy; new fashion magazines were launched and moribund titles revitalised. High-street fashion – affordable, well designed and of quality – became a major force. As a recession loomed, *Vogue* under Shulman changed from rarefied, as it had been under Beatrix Miller and Liz Tilberis, to something much more inclusive, all-embracing and authentic. In the years to come, as London renewed its status as a fashion capital, *Vogue* was in a position of authority to scrutinise the mass market as much as the high-end luxury sector.

Eighteen months into Shulman's editorship, *Vogue* published its first cover image of Kate Moss. This heralded a new photographic aesthetic. An informal School of London, dating from the early years of the decade, comprised a loose-knit group of stylists and photographers, many of them friends, including stylists Melanie Ward, Anna Cockburn and Cathy Kasterine, art director Phil Bicker and photographers Corinne Day, David Sims and Nigel Shafran. Emerging from youth and style magazines such as *i-D* and *The Face*, it wasn't a movement in any art-historical sense – each photographer had his or her own distinct visual style – but its participants appeared to have at least some common aims: a reaction against the glossy sheen of the upmarket fashion magazine and the logo-dominated corporatisation of fashion; a determination to bring their more casual sensibility into the mainstream; a desire to strip fashion photography of its traditional qualities of artifice and glamour in favour of something more pared-down and expressive of the individual.

As one commentator has put it, they wanted to 'drench their subjects in reality'. In this respect they had much in common with American photographers Bob Richardson, William Klein and Saul Leiter, whose 'snapshot' aesthetic at *Vogue* some three to four decades previously had paved the way for their 'anti-fashion' stance. Shulman and her team commissioned work from Juergen Teller, Craig McDean and Glen Luchford as well as Shafran and Sims, but it was Day's oeuvre that made the most immediate impact.

Drawing on the diaristic documentary photography of Americans Nan Goldin and Larry Clark, Day set her very personal images in an often-bleak urban milieu. She wanted real life to intrude into *Vogue*'s pages as never before. Her most famous set of photographs, from 1993, showed her friend the model Kate Moss in her underwear in an untidy west London flat. The pictures, like careworn snapshots, were raw and natural – completely without style, in the sense that there was nothing artificial in their conception. Moss's hair was ungroomed, her make-up minimal, the clothes almost incidental.

It was an unexpected departure for *Vogue* and Shulman faced howls of protest for its sensibility, which would be retroactively labelled 'heroin chic'. The term itself did not become common currency until two years later, when it chimed again with a campaign for Calvin Klein shot by Steven Meisel, his models scrawny and provocatively posed. It was based on a series Meisel had made for *L'Uomo Vogue*, where the pictures had run without comment. When he revisited the concept for mainstream consumption across the United States, it fed a debate that ultimately provoked a statement from the White House. Of 'heroin chic', President Clinton famously proclaimed in 1997: 'It's not creative. It's destructive. It's not beautiful. It is ugly. And this is not about art. It's about life and death. And glorifying death is not good for any society.'

Kate Moss's slight build ('waif-like' was a typical epithet) and her unapologetically hedonistic lifestyle had meanwhile made her the focus of press attention, little of it favourable. In 1994, when the dust had settled, contributor Lesley White wrote wryly in *Vogue*: 'In the minds of the tub-thumping leader writers, *The Sun*'s slimming editor and American feminist academe, she is a sinister influence: a Lolita nymphet, a paedophile fantasy,

the scourge of modern womanhood, promoting anorexia, self-loathing, the sexualisation of children ...'

As quickly as the quasi-movement arrived, it evaporated. Many of the leading players left London to establish careers in New York. There, Steven Meisel was the photographer of the moment. Responsible for launching the careers of supermodels – 'he can spot the girl of the moment well before the moment arrives', said *Vogue* in awe – he was a chameleon with an ever-shifting photographic style that allowed him to remain at the top for decades. He appeared to live in and for the present: 'I am always influenced by the philosophy of the particular couturier whose dress I happen to be photographing.'

At the height of his fame, in 1993, Meisel made the reverse journey to London for one of his few major fashion stories for British *Vogue*. 'Anglo-Saxon Attitude', which ran to fourteen pages, was *Vogue*'s most expensive shoot to date. Arranged by fashion editor Isabella Blow and Meisel's stylist Joe McKenna, it resonated beyond its time. It introduced the model Stella Tennant and her nose ring to readers, as well as giving a homespun sensibility a transatlantic gloss. 'We scouted endlessly trying to find girls who weren't models but were beautiful,' recalled Plum Sykes, who assisted on the shoot, in 2004. They also needed to be blue-blooded or come from an 'interesting family'. Tennant fulfilled both criteria, as granddaughter of the Duchess of Devonshire (formerly Deborah Mitford, whose five older sisters were a fixture of *Vogue*'s interwar years). So too did Sykes, who would herself become one of Meisel's models.

By contrast, there was always room for those who favoured a celebration of the artifice, the mystique and the pretence of fashion, the luxuriant fold of cloth, the flowers, the joy of it all and the sheer hauteur of *Vogue*'s traditionally rarefied world. For *Vogue* the photographer who kept it all alive was Mario Testino – perhaps the world's most famous fashion photographer and a personality in his own right, who would not shrink into the shadows. A latter-day Cecil Beaton, he was the link that connected *Vogue* to its distinguished heritage. Helping to make it come alive has been fashion editor (and from 1992 fashion director) Lucinda Chambers, who has driven *Vogue* stylistically for more than two decades. 'We started doing test shoots,' she wrote of her collaboration with Testino, 'and thirty years later we are doing the same, albeit with a bigger budget and more clothes and countries to play with.'

Testino's retrospective, *Portraits*, at London's National Portrait Gallery in 2002 was a defining moment for magazine photography. Attracting at its zenith well over 2,000 visitors a day, *Portraits* became the benchmark for blockbuster photography exhibitions to come. Testino stretched the parameters of portraiture to include fashion and beauty pictures, and they were not out of place. Other distinctions began to blur. Across the magazine's pages, the traditional division between art and commerce became increasingly arbitrary as photographers' advertising images began to resemble, intentionally, their editorial contributions. Modern fashion photography also began to find legitimate status as contemporary art, a presence in the salerooms of auction houses and on gallery walls.

Sharing the majority of *Vogue*'s lead shoots with Testino, Nick Knight took a more rigorously intellectual approach towards the medium. He would, for example, explore layers of meaning for what he termed 'the shoot as performance', one among many concepts that took fashion photography away from the printed page. Before the new millennium began, Knight was among the earliest to perceive what new technologies could bring to the depiction of fashion: 'I think the digital revolution in photography is leading us into a new medium,' he said, 'an exciting one, but one that we shouldn't be calling "photography" at all. It comes with its own distribution system, that of the internet and screens; it comes with the ability to communicate instantly on a global level, and, of course, with the addition of sound and moving image. It hasn't been named yet, because it hasn't been properly defined yet.'

Vogue had established its website, Vogue.co.uk, in 1996 and was well positioned for a digital future. The notion of internet-based fashion film, which Knight himself had foreseen over a decade earlier, is increasingly gaining currency (and widespread dissemination through social media) with the potential to enhance fashion photography's traditional repertoire. For some time *Vogue*'s strategy has been to expand into new areas, by means of tablets and smartphones. It is now at the forefront of new ways in which its readership expects to access the magazine, without losing faith in its historical qualities as a physical product. (It also commands more than 2.3 million followers on Twitter and 2.5 million on Facebook.)

As well as looking to the future, under Shulman *Vogue* has remained aware of its history; she has used *Vogue*'s past to cement its position of authority. Invariably this has been the starting point for occasional and sought-after thematic issues: an end-of-century millennial issue with a reflective cover; a gold issue; one devoted to royalty; another to parties. *Vogue*'s heritage has become increasingly vital as its parent company, Condé Nast Publications, has expanded into new territories from Russia and Japan to India and China. For those new to the *Vogue* aesthetic (there are currently twenty editions worldwide), photographs from its archive explain its historical position as the fashion bible, an authority with enduring qualities.

Other photographers have retained an insider's knowledge of *Vogue*'s history while leaving their own imprimatur upon it. Tim Walker, who was first exposed to fashion photography as an intern in *Vogue*'s library, acknowledges that the creation of fictive worlds is the stuff of fashion photography. 'What *Vogue* did made sense to me,' observed Walker in *Storyteller* (2012), 'because it dealt with fantasy and the magical. As I studied its archive I started to really understand photography.'

Aware of the attractions of digital photography as well as its pitfalls – mostly inauthenticity – Walker deliberately plans his shoots to include elements of the photographer's traditional modus operandi: prop-making and set construction, admittedly on a cinematic scale and with the clothes and styling invariably supplied to striking effect by fashion editor Kate Phelan. His earliest work revealed a romantic attachment to the English landscape, particularly the rural elegance of Norman Parkinson's wartime narratives. His painstaking preparation is fundamental: scrapbooks filled with aides-memoires, magazine cuttings, pictures from children's stories, photographs, illustrations and stills from films: 'I gather ingredients, then begin stitching them together.' These scrapbooks resonate with one of Walker's early areas of interest: Cecil Beaton's collections of paper ephemera, which he made throughout his life, for no reason other than the pleasure of the act.

Ingredients are gathered, stitched together and slowly, inexorably, the bigger picture takes shape for Walker – as it had some seventy years previously for Beaton, for Steichen, for Horst, and for many more who built up *Vogue*'s inventory of images, formed over the past 100 years in over 1,500 issues, mostly monthly, occasionally fortnightly. The magazine's archive remains a cultural barometer, testing the air outside, recording the social and cultural changes of the past century – the right, the wrong, the good, the bad, the adored, the misjudged, the overstated, the under-emphasised, the overlooked. Figures of fashion and style, masters of the arts, the forces of change. As *Vogue* put it in 1922: 'Let those who *were* modern look with leniency upon those who *are* modern and not make a grievance of it if the reflection in the mirror does not please them.'

Karen Elson in Texas
by Tom Craig
Fashion's most famous redhead admitted 'I've lived out of England so long, I don't sound like a Mancunian any more' – and that she was not a natural redhead
July 2012

Top Naomi Campbell by Mario Testino, 2001
Bottom Kirsty Hume at the Glastonbury Festival by Tim Walker, 1998

How One Lives

CONDÉ NAST, American *Vogue*'s owner, had long been convinced that the discerning Englishwoman of means would embrace her own *Vogue*. This would encompass the London Season, interior decoration, sport (fox-hunting in the winter, golf in the summer), travel (when possible), health and beauty issues, reports from the London stage and art galleries, vignettes from fashionable life – and last, but not least, fashion itself.

World events had overtaken Nast, but they did not deter him. Even in times of crisis, a British aspiration for the unaffordable and unobtainable made for an unstoppable force. And if these objects of desire were American, so much the better. When, in its inaugural issue of September 1916, *Vogue* reported on the uniting of 'all society and the dog' at the Southampton Kennel Club's dog show, you could be sure this was Southampton, Long Island. Equally *le style anglais* enthralled *Vogue*'s American readers. Everything British – from hunting coats to bespoke umbrellas, shoes from Northampton and rainwear by Burberry of London – was considered the *ne plus ultra* in both style and quality. It was a cultural exchange: glamour and showmanship for restraint and class.

Vogue's first London offices, just off Fleet Street, were so tiny that editorial conferences took place in the stairwell. 'A pioneer informality reigned among the staff', mainly because they totalled just fourteen in number, recalled *Vogue* in 1958. In its earliest issues, the First World War was treated with watchfulness. Covers in red, white and blue reinforced the magazine's patriotic stance, but there was little to suggest mud and death. True, the first issue ran C.R.W. Nevinson's war paintings in the Cubist style, but the immediate crisis for *Vogue* in September 1916 was 'a fashion crisis': 'You are about to embark on the perilous adventure of selecting your autumn and winter wardrobe. All sorts of pitfalls surround you.' When America entered the war in 1917, *Vogue* became less circumspect.

The magazine's impression-forming frontispiece portrait – the page readers were likely to start with – was, with only a few exceptions, drawn from the ranks of society beauties, young women of impeccable pedigree and undeniable chic. The first was Lady Eileen Wellesley, youngest daughter of the Duke of Wellington, taken by E.O. Hoppé, the most fashionable society photographer of his day. What marked Hoppé out from his rivals was a refusal to over-flatter his sitters or complicate matters with a battery of props and tricks. He sought a truthful likeness, and his greatest delight was to watch the thawing out of his sitters' resolve.

It was not *Vogue*'s place to discuss the contentious, but it found ways to alert the vigilant reader to her changing role. Lady Astor had become

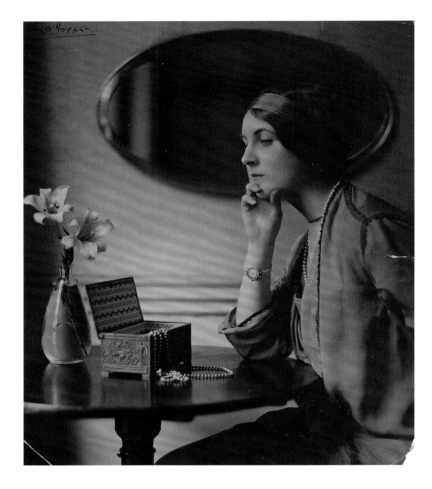

Previous pages, left
Helen Lyons
by Baron Adolph de Meyer
This back-lit diaphanous ensemble by Boué Soeurs, the first French haute couture house in New York, was – for *Vogue* – risqué
April 1922

Above Viscountess Maidstone contemplating her jewellery box by E.O. Hoppé, 1916 *Below (left to right)* Vogue covers by the magazine's early stars Pierre Mourgue, 1927, Eduardo Benito, 1929, and Guillermo Bolin, 1929; a page of sharply observed satirical drawings, 'Shining at a Private View', by 'Fish', 1920

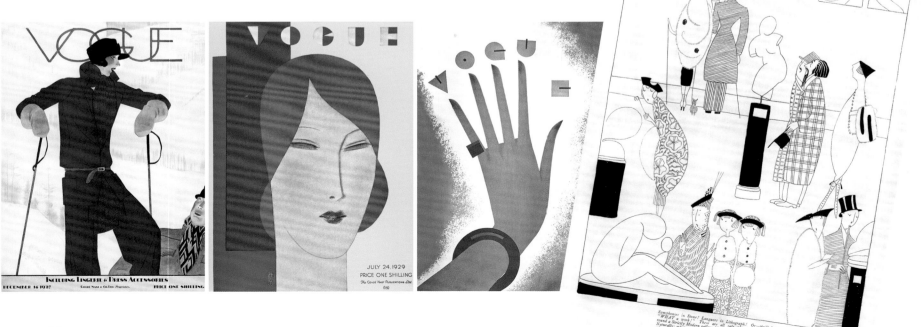

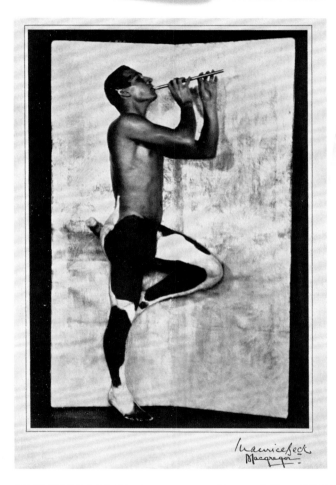

the first woman to take her seat in the House of Commons in 1919, and the same year saw women admitted to universities and called to the Bar. The emancipation of women was touched upon in 1918: 'Beauty will have its say, beauty will cast her vote.' The magazine's graphic artists – Eduardo Benito, Georges Lepape and Guillermo Bolin to name a few – gave *Vogue*'s covers idealised representations of the modern woman, ciphers alternately fluid and geometric.

On the fringes of the Bloomsbury Group, editor Dorothy Todd brought a wealth of talent to the magazine's pages. Virginia Woolf and Raymond Mortimer reviewed books; Clive Bell was art critic, a tireless promoter of the modern aesthetic; Aldous Huxley was promoted from sub-editor to features; Osbert Sitwell, a lifelong bachelor, wrote about successful marriages, while his younger brother Sacheverell submitted an essay on Spain. Todd was the first to publish the modernist poems of their sister, Edith Sitwell, and carried a review of Edith's joint entertainment with William Walton, *Façade* (1923). Todd was also the first to introduce to British readers the drawings of Jean Cocteau and the imagist verse of Gertrude Stein, while endorsing the 'rayographs' of Man Ray, the architecture of Le Corbusier and the art of Brancusi.

In 1926 *Vogue* published a group of drawings by 'Fish', entitled 'A Complete Set of Flappers', which portrayed types 'without which no party is complete'. Ann Fish was much in demand by *Vogue* and *Vanity Fair*. Edna Woolman Chase of American *Vogue* recalled her 'brilliant caricatures of English high life', which made the London season of 1924 'the gayest since the war'.

It was the magazine's only direct reference to the flapper phenomenon: 'After the fourth Bronx, Annabelle breaks into a Charleston which lasts with intermissions for refreshments until she is laid out on her side in a dark room.' Josephine Baker, the Dolly Sisters, Clare Luce and Mistinguett at the Folies Bergère kept up the pace. Socialite Elsa Maxwell wove her magic over surrealist extravaganzas, telling *Vogue* in 1929 that 'ruthlessness is the first attribute towards the achievement of a successful party', and there was an outbreak of fancy-dress parties and costume balls. But it could not last. When Wall Street crashed in 1929, the Jazz Age too came to a shuddering halt. In the last months of the decade, contributor G.B. Stern looked back to the notion of 'an old-fashioned Christmas', while *Vogue* extolled the virtues of staying in, and introduced a new feature: 'Chic means to economy'.

Top left Spread of early colour fashion plates by Eduardo Benito, 1923 *Top right* 'Age of Jazz' in all its vitality by Edward Steichen, 1925 *Above* Rudolph Valentino as Nijinsky in the ballet *L'Après-midi d'un Faune* by Maurice Beck and Helen Macgregor, 1924 *Right* Wartime *Vogue* cover by Georges Lepape, 1917 *Far right* Pair of portraits of Cecil Beaton, *Vogue*'s meteor, by Curtis Moffat and Olivia Wyndham, 1928

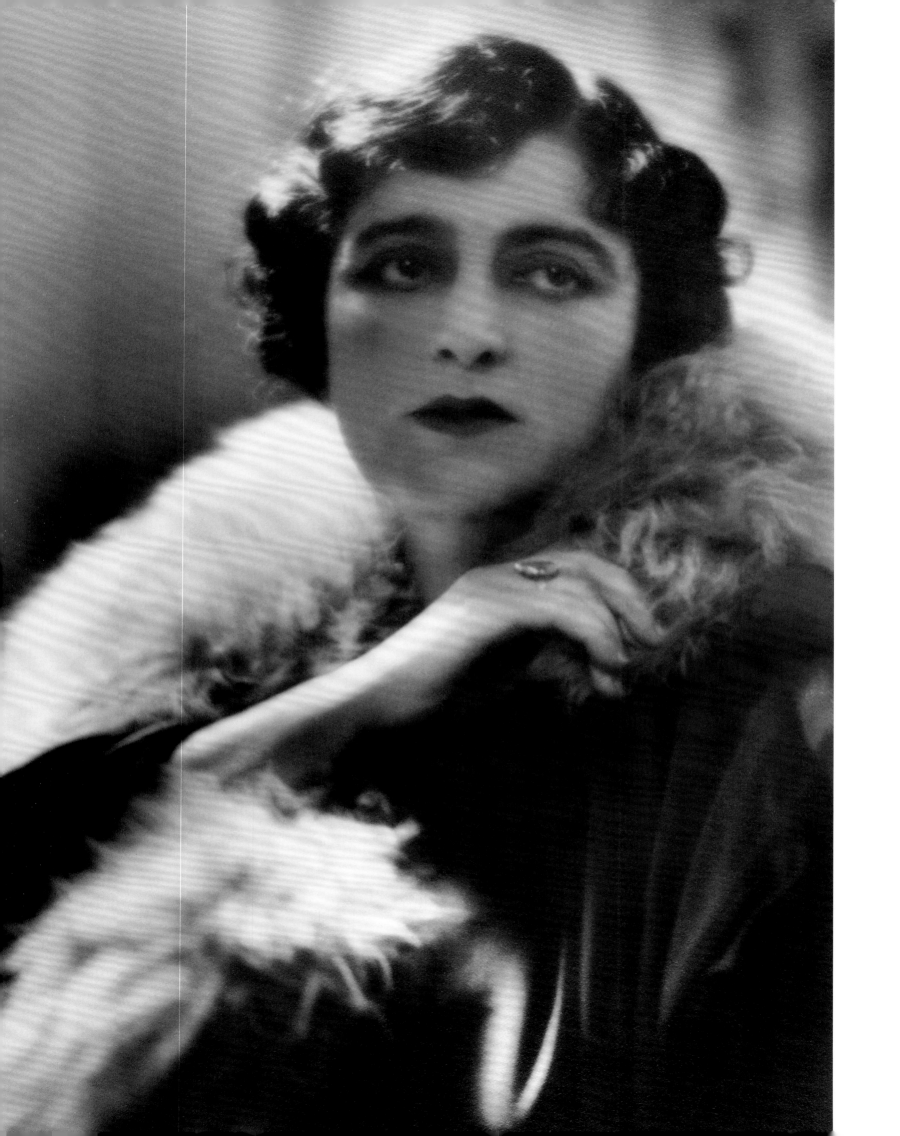

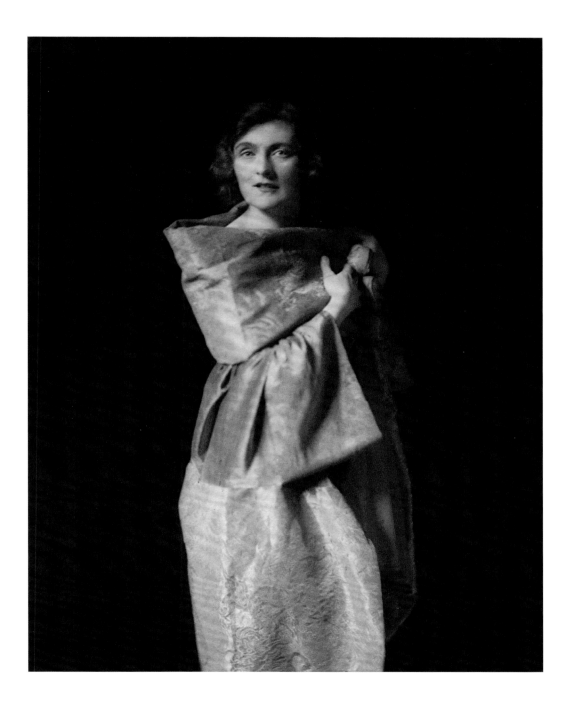

Maxine Elliott
by Arnold Genthe
The American actress, who opened her own
theatre off Broadway (the first woman to
do so), had just returned to the United States
from war-relief work in Belgium. She had also
just signed to Goldwyn Pictures
August 1917 (unpublished version)

Sybil Thorndike
by Howard Instead
Dame Sybil was hailed as the greatest stage
actress of her era. Her biggest success was
in the title role in George Bernard Shaw's
Saint Joan (1924). The playwright had her in
mind while writing it
May 1920

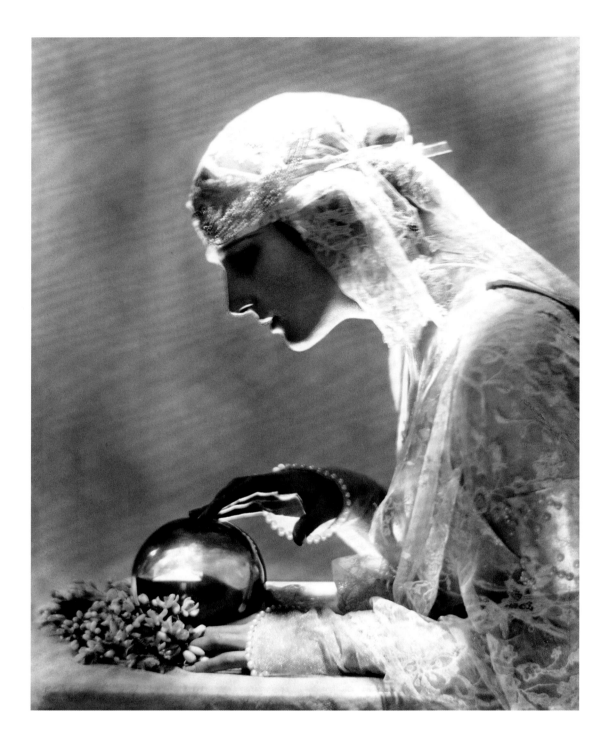

'Dolores and the crystal ball'
by Baron Adolph de Meyer
A Ziegfeld Follies showgirl, 'Dolores' (Kathleen
Rose) was the star of *Midnight Frolic* (1919).
In a bridal veil, fixed by a Cartier clip, she gazes
into the future to see if she would marry a
British millionaire (she did)
May 1919

'Summer brings the hat'
by Baron Adolph de Meyer
Vogue's first professional photographer,
de Meyer was put under contract on a
salary of $100 a week. This *mise-en-scène*,
impressionistic and graceful, is distinctive
of his high romantic style
June 1918

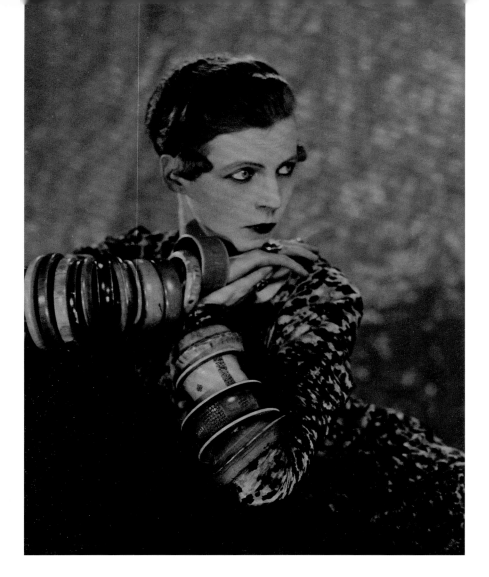

**Nancy Cunard
by Man Ray**
This scion of the Cunard shipping
family possessed a head 'carved in crystal
with green jade for eyes', said *Vogue*
October 1927

**Lady Diana Cooper
by Hugh Cecil**
A society ornament, the daughter of the
Duke of Rutland was barely out of *Vogue*
for the next half-century
April 1923

Oliver Messel
by George Hoyningen-Huene
A leading set designer for stage, opera
and film, Messel was for a time the most
highly paid of his profession in the world
April 1929

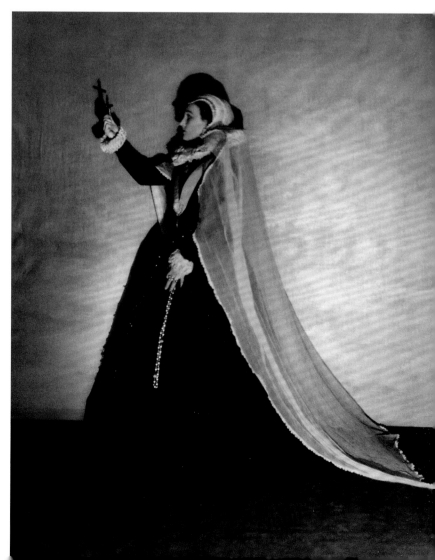

Fay Compton as Mary, Queen of Scots
by Maurice Beck and Helen Macgregor
The celebrated actress had just played the lead in
the silent biopic *The Loves of Mary, Queen of Scots*
(1923), but enjoyed more acclaim on the stage
October 1923

ALDOUS HUXLEY
from 'Beauty in 1929', *Vogue*, March 1929

'AUTOMOBILES, Movies and Bootlegging are the three biggest American industries. After these, I suspect, comes Beauty. Look through the advertisement pages of any popular American magazine; you will find that at least one page in every three or four is devoted to Beauty. Soaps, skin-foods, lotions, hair-preservers and hair-removers, powders, paints, pastes, pills that dissolve your fat from inside, bath salts that dissolve it from without, instruments for rubbing your fat away, foods that are guaranteed not to make you fat at all, machines that give you electric shocks, engines that give you massage and exercise your muscles for you, systems of physical training – how many millions are annually spent in advertising such commodities, how many more millions are spent on their purchase! And the beauty parlours, the beauty specialists, the masseurs and masseuses! Their name is legion, and the legion prospers.

If Beauty is less boomingly a great industry in Europe, that is due not to any reluctance on the part of European ladies to cultivate their faces and figures; it is due to the fact that Europe is relatively poor. Beauty is a luxury. A face can cost as much in upkeep as a Rolls-Royce. The most that the majority of European women have done is just to wash and hope for the best. Perhaps the soap will produce its much-advertised effects upon their skin. Perhaps it may transform them into the likeness of those ravishing creatures who smile so rosily from the billboards. Perhaps, on the other hand, it may not. In any case, the more costly experiments in beautification have been as much beyond the means of most of them as are high-powered motor cars and electric cigarette lighters.

But the March of Progress, if slow, is sure; and we may confidently expect that Beauty will take its legitimate place among the basic industries of the Old World as it has taken it already among those of the New. When they spend as much on their faces and their superfluous fat as they now spend on their alcohol and their motor cars, Europeans will be able to regard themselves as truly civilised.

But, joking apart, there is something genuinely significant about the recent growth of the cult of physical beauty. Enormously much more money is now spent on the attainment and preservation of good looks than was ever spent in the past – at any rate, the recent past. This is partly due, as I have already hinted, to the general increase in prosperity. The rich have always cultivated their appearance. The diffusion of wealth now permits those who would once have been ranked among "the Poor" (even "the Undeserving Poor") to do the same. But this is not the whole story. The modern cult of beauty is a function, in the mathematical sense of the word, of other things as well as wealth. It is symptomatic of the changed status of women, of the new attitude towards "the merely physical". Women are freer than they were in our fathers' day – freer not only to perform the generally unenviable social functions hitherto reserved to the male, but also freer to exercise a more pleasing and, I like to think, more naturally feminine privilege: the privilege of being attractive. They have the right, if not to be less virtuous than their grandmothers were, at any rate to look less virtuous. The British Matron, not long since a terrifying monument of jet and swelling bombazine, now does her best to achieve and perennially preserve the appearance of what her predecessor would have described as "a Lost Woman." She succeeds. But, in spite of her carefully preserved face, her slim figure, her well-shaped and much-exposed legs, we do not regard her as "lost". For we now admit much more freely than did our fathers that the body has its rights. And not only rights – duties. It has a duty to do the best it can for itself in the way of strength and beauty. Christian-ascetic ideas no longer trouble us. We demand justice for the body as well as for the soul. Hence the fortunes made by face-cream manufacturers and beauty specialists, by the vendors of rubber reducing-belts and massage machines, by the patentees of hair lotions and the authors of books on the culture of the abdomen.

What are the practical results of this modern cult of beauty? The exercises and the massage, the health-motors and the skin-foods – to what have they led? Are women more beautiful than they were? Do they get something for the enormous expenditure of energy, time and money demanded of them by the beauty-cult? These are questions which it is difficult to answer. For the facts seem to contradict themselves. The campaign for more physical beauty seems to be both a tremendous success and a lamentable failure. It depends, of course, upon how you look at the results.'

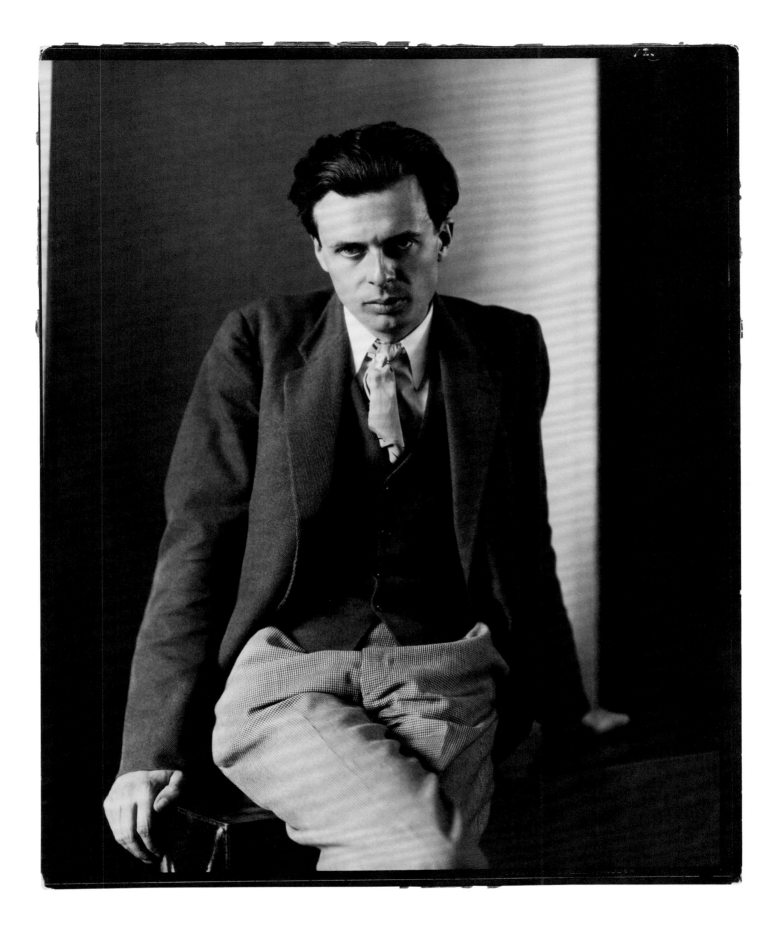

Aldous Huxley
by Charles Sheeler
On the fringes of Bloomsbury, the future author
of *Brave New World* (1932) was a sub-editor on
Vogue and later its chief book reviewer
1926 (published later)

Virginia Woolf
by Maurice Beck and Helen Macgregor
Like many in her Bloomsbury circle, Woolf
was a regular essayist for *Vogue*, and sat
for the magazine on several occasions
May 1926

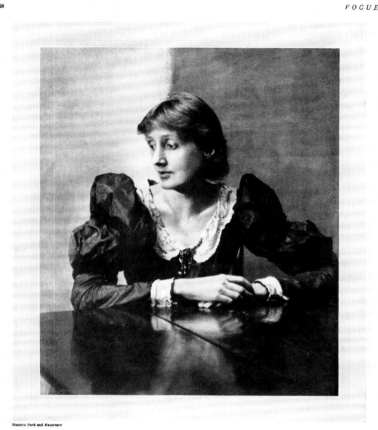

Maurice Beck and Macgregor

VIRGINIA WOOLF

Virginia Woolf is the most brilliant and enterprising of the writers of the younger generation. Her last two novels, "Jacob's Room" and "Mrs. Dalloway," are successful experiments in an original method: "The Common Reader," a volume of critical essays, is distinguished in style and thought, serious yet entertaining. Her earlier books are "The Voyage Out," "Night and Day," and "Monday or Tuesday." Mrs. Woolf is a daughter of the late Sir Leslie Stephen. She and her husband, Leonard Woolf, started the Hogarth Press, which has published several of her books

'The critic may be able to abstract
the essence and feast upon it
undisturbed, but for the rest of us
in every book there is something – sex,
character, temperament – which,
as in life, rouses affection or repulsion;
and, as in life, sways and prejudices;
and again, as in life, is hardly to be
analysed by the reason.'

Virginia Woolf, 'Indiscretions', *Vogue*, November 1924

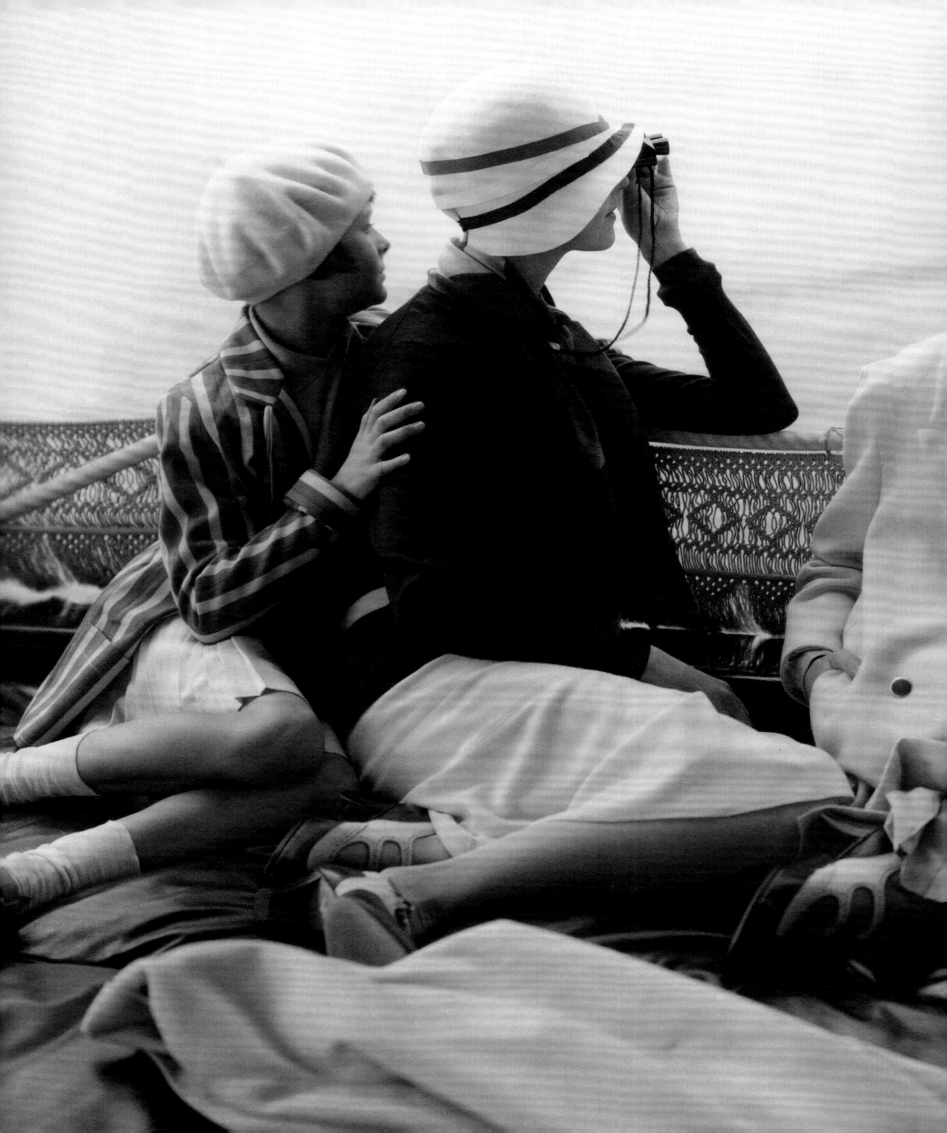

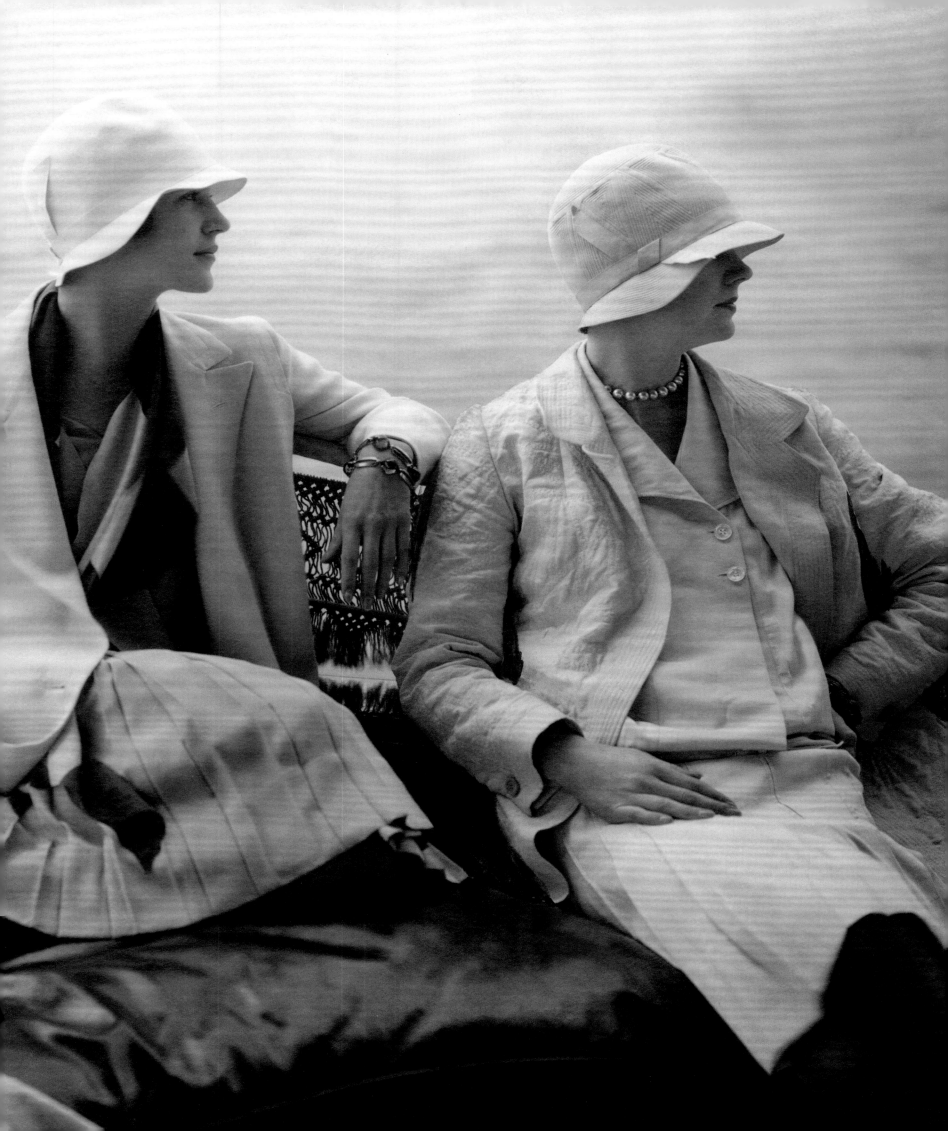

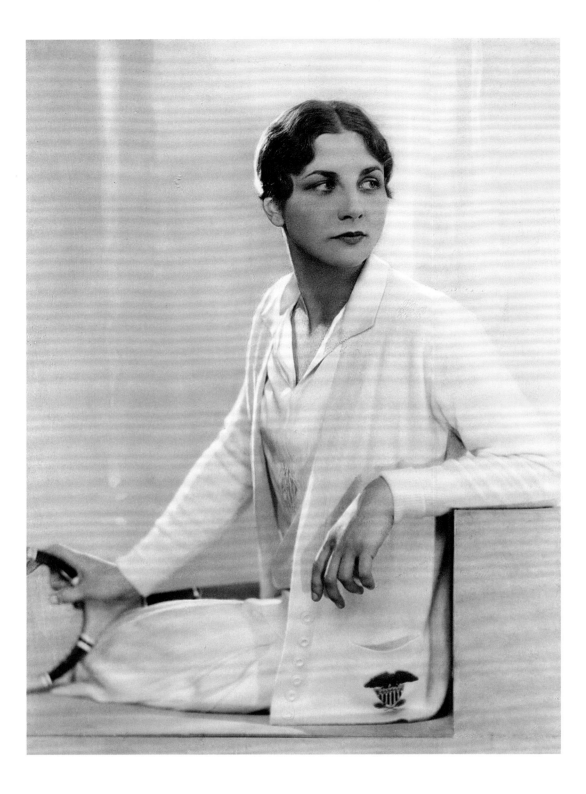

Helen Wills Moody
by Dorothy Wilding
From 1927 until 1938, the tennis player –
and epitome of sporting chic – did not
lose a single set at Wimbledon
June 1927 (unpublished version)

Previous pages
'Navy blue and white are good sailors'
by Edward Steichen
Future photographer Lee Miller takes centre
stage in a group of cloche-hatted models
arranged in the stern of one George Baher's
yacht, a picture of maritime fashion
July 1928

'Bare facts about fashion'
by George Hoyningen-Huene
Huene's sunlit arrangements, simp y
composed but with strong graphic elements,
promoted the benefits of healthy living and
of a less restrictive wardrobe
July 1929

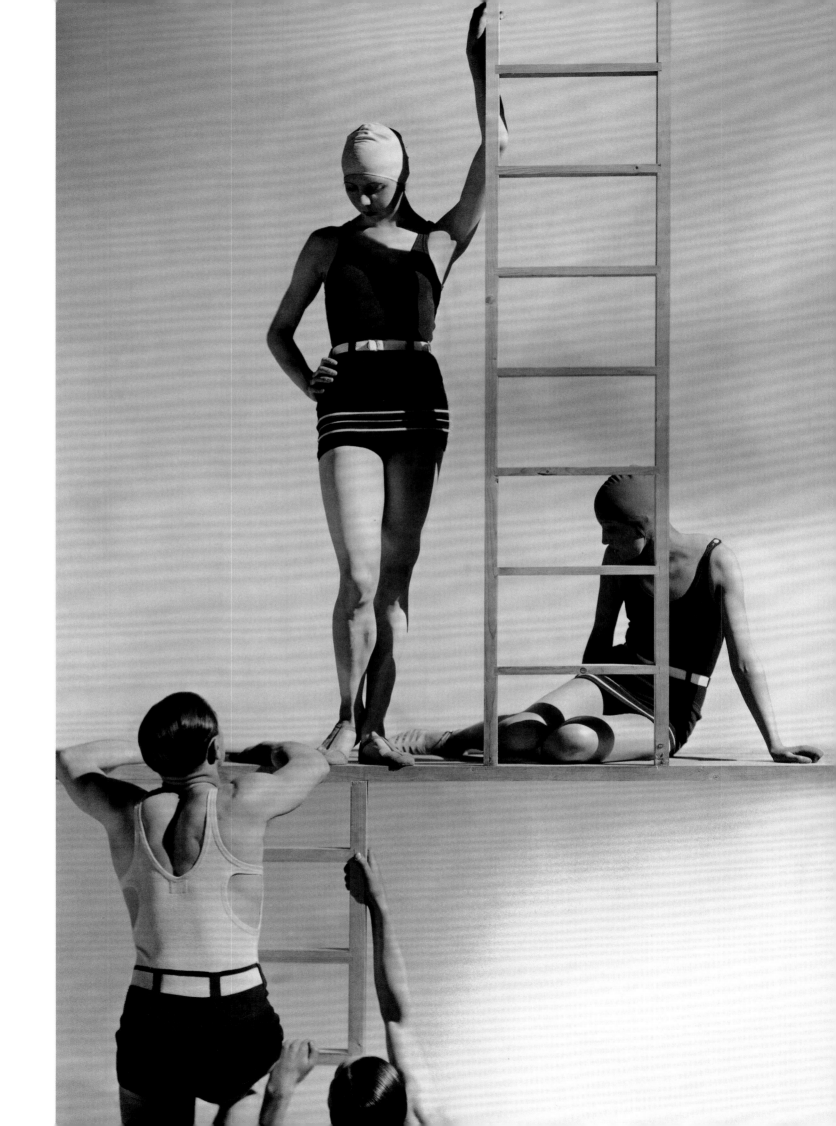

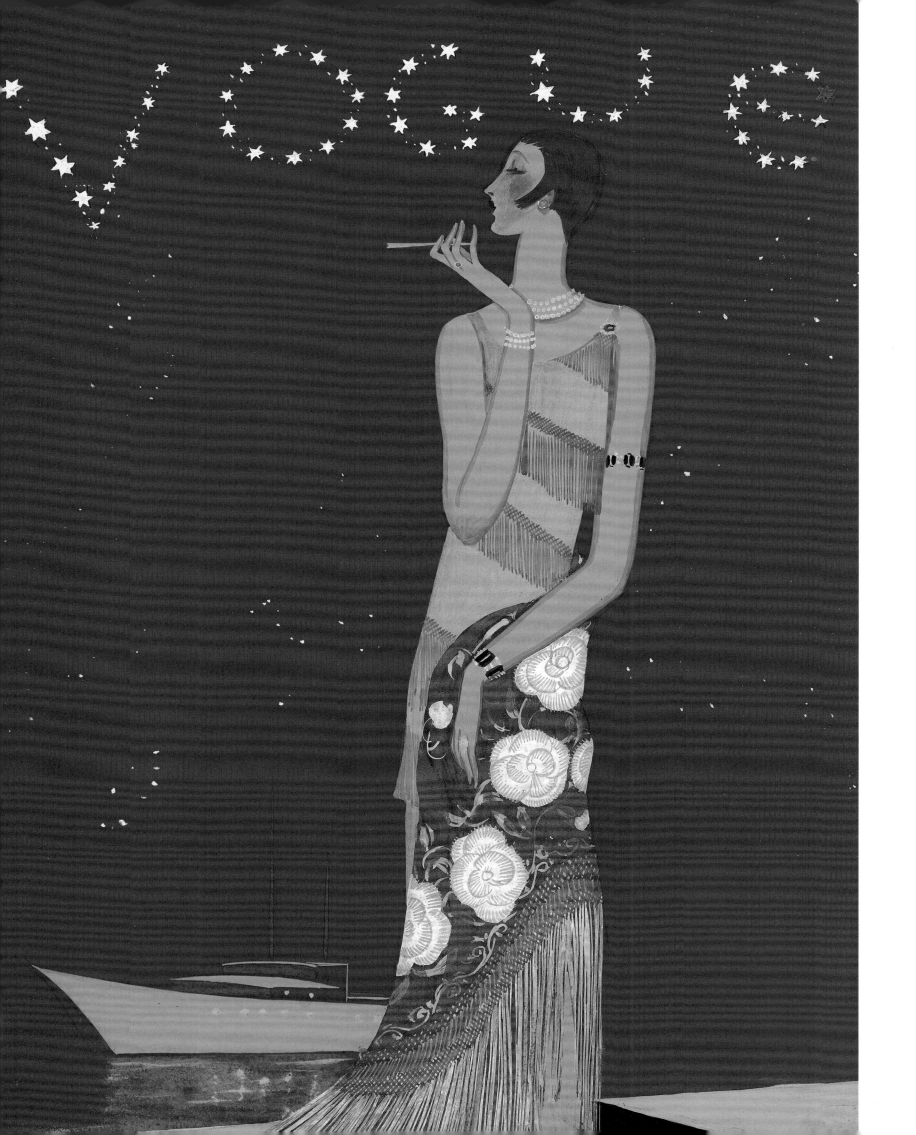

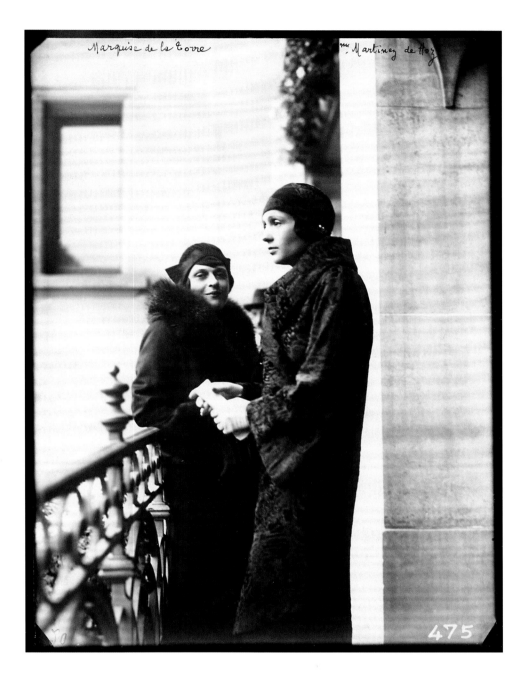

Vogue constellation
by Eduardo Benito
Benito's shingle-haired sophisticate in a
layered 'flapper' dress wears a fringed
shawl decorated with a peony design.
Such chinoiserie was very much in fashion
July 1926

The Marquise de la Torre and
Madame Martinez de Hoz
by Frères Séeberger
Two *femmes du monde* wear the smartest
of black coats. There were 'none more chic',
considered *Vogue*
January 1930 (taken 1929)

leave all in at sides

**Tallulah Bankhead as 'The Divine Sarah'
by Cecil Beaton**
A working print of the American actress, who
relished comparison to Eleanora Duse and Sarah
Bernhardt, to whom she pays homage here
April 1929

**Edith Sitwell at Renishaw Hall, Derbyshire,
by Cecil Beaton**
Beaton found natural sitters in her brothers,
Osbert and Sacheverell, but it was Edith's
unconventional looks that entranced him
1927 (published later)

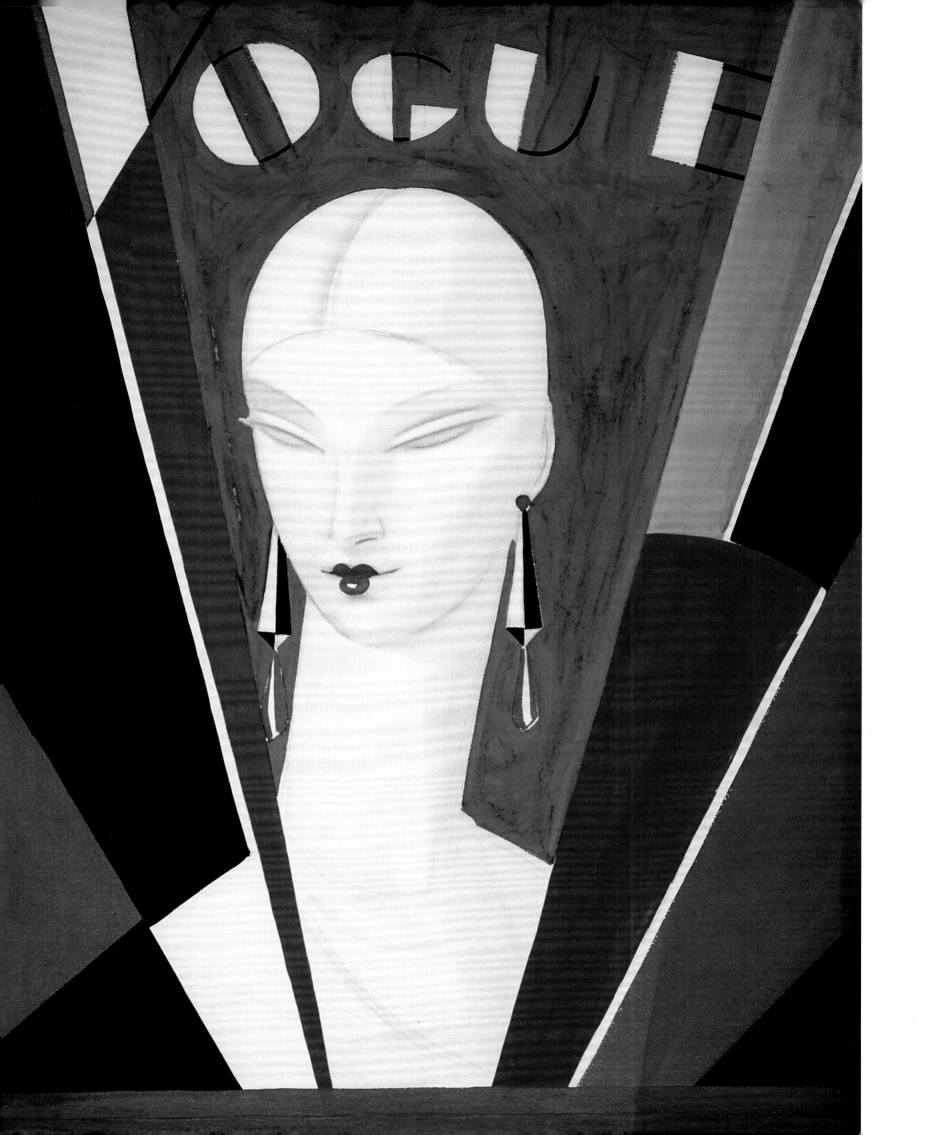

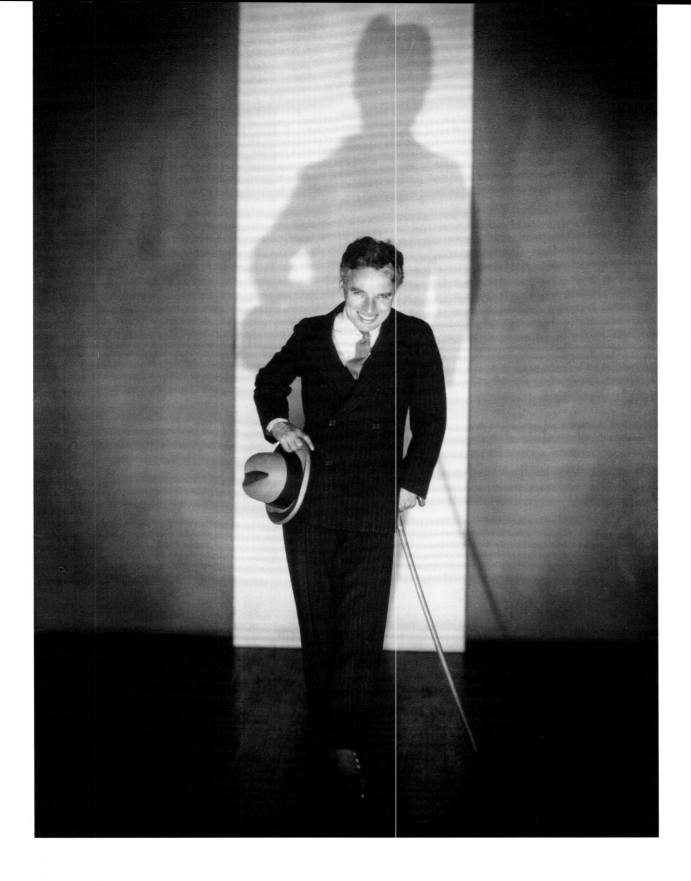

Vogue Deco
by Eduardo Benito
A sunburst of scarlet, black and gold rays
frames a sleek and streamlined modernist
head in the new Art Deco style
May 1926

Charlie Chaplin in New York
by Edward Steichen
The London-born actor and director's silent
comedy *The Gold Rush*, released the previous
year, was considered a masterpiece
November 1926

Following pages, right
'Soap Suds'
by Cecil Beaton
Three 'Bright Young Things' *en fête*:
Baba Beaton, Wanda Baillie-Hamilton and
Lady Bridget Poulett arranged as bubbles
1929 (published later)

'Snobs are curiously incapable
of gaiety, perhaps because gaiety comes from
the soul, and snobs only take their soul
"à la meunière". Also, snobs are too busy nicking
notches on each rung of the social ladder
as the gangster nicks each kill on his gun.
I have always thought that snobs are as cruel
as gangsters, anyway – certainly they hold up
a party the same way.'

Elsa Maxwell, 'The Art of the Party', *Vogue*, August 1929

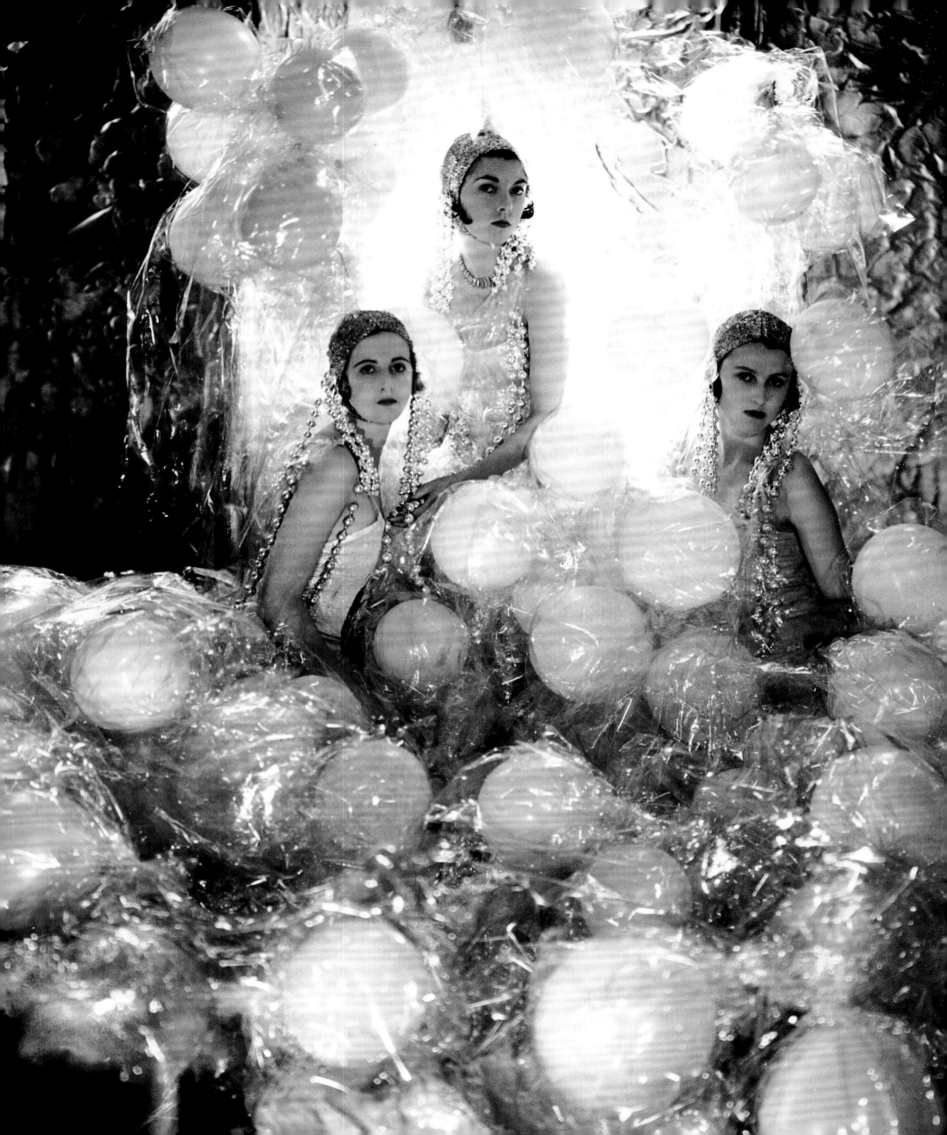

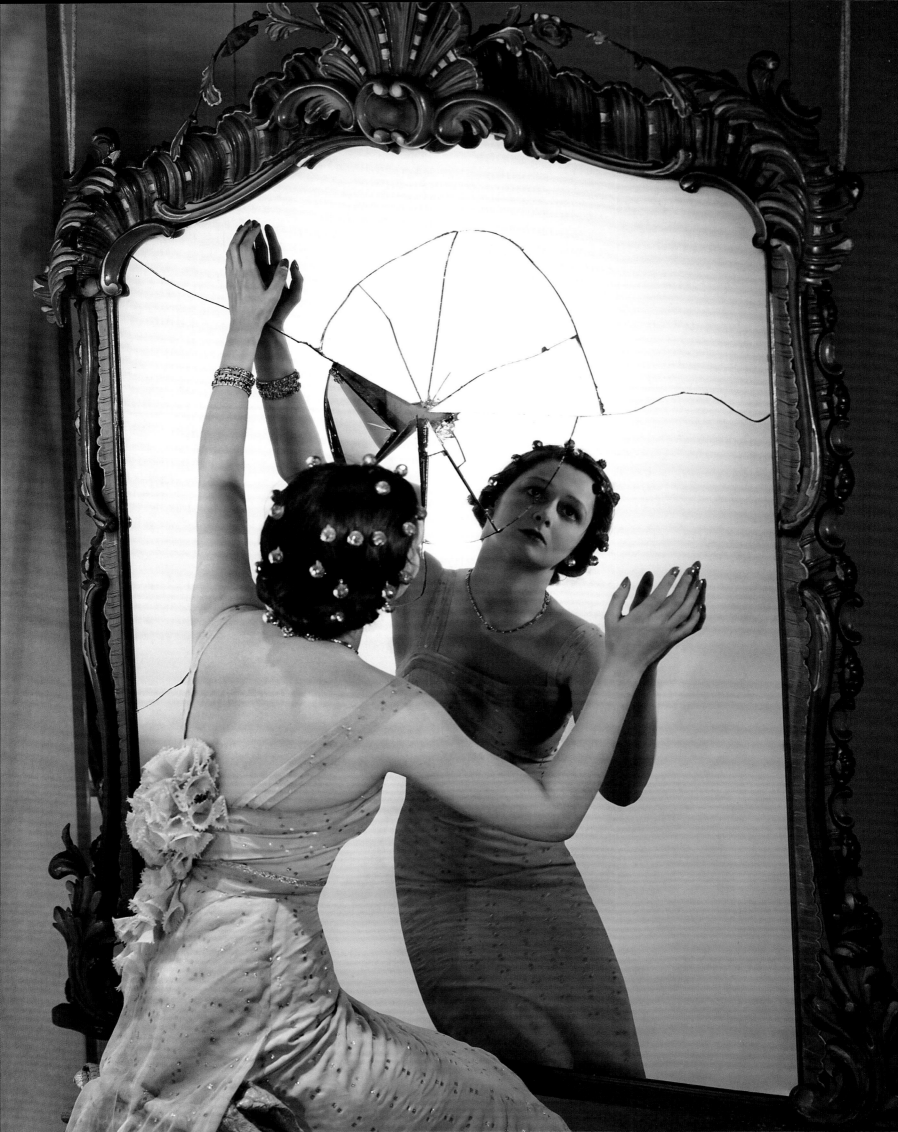

Glorious Twilight

1930–1939

THE 1930s held many omens of impending disaster, but none so symbolic as what happened during the funeral procession for George V in 1936: the gold and sapphire cross of the Imperial State Crown broke off and fell into the gutter. Within a year Edward VIII had abdicated to marry Wallis Simpson, an American divorcée. For *Vogue* the couple had been a glamorous antidote to the cheerless post-Depression years. The magazine found the burden of that period a heavy one: 'If you have not lost money, then pretend you have. Mayfair has gone native: no champagne and dinner cut to two courses.' The well-connected were forced to adapt or sink. For Lady Diana Cooper the novelty was a career in trade: in 1932 she opened a flower shop in Berkeley Square. 'Our fun is never so ingenious,' declared *Vogue* in the same year, 'as in those times when expensive entertainment is under a cloud.' Homespun pursuits apart, films and film stars dominated *Vogue*'s pages, the glamour by proxy, allowing readers to escape quotidian cares.

Coverage of Wallis Simpson's dresses (by Molyneux and Mainbocher), decoration tips and random aperçus – 'seeded white grapes with little cubes of Dutch cheese; she impales them on to sticks as she chats. It's quite charming' – receded as the abdication crisis loomed, in line with the discretion shown by the daily press. Yet, when it was over, *Vogue* was first in line for the couple's wedding photographs at the Chateau de Candé. As captured by Cecil Beaton, the newly minted Duke and Duchess of Windsor were as brittle and elegant as movie stars or fashion models – unsurprisingly, for their fascination increased with every calculated move.

Beaton walked a delicate tightrope. In the years to come he would be photographer to the new Queen and her immediate family. Almost single-handedly, *Vogue*'s chief photographer reinvigorated the image of the monarchy in the popular imagination, and the magazine reaped the benefit.

With his dazzling fashion pictures, Edward Steichen – termed *Vogue*'s 'Eye of Modernity' – pushed photography into an age of sparse and clutter-free innovation. His portraits glamorised culture: high, middle and low. While it took Steichen's particular genius to make an icon out of broken-nosed boxer Jack Dempsey, others with a natural allure required less effort: Greta Garbo, Charlie Chaplin (p.45), Joan Crawford.

Having observed Steichen's working methods, George Hoyningen-Huene became adept at studio lighting, a master of the cumbersome plate camera and slow-speed film. He sought to portray clothes as women might wear them; magazine photography had not yet captured 'the attitudes and gestures that women assumed. [My] models seemed to freeze in front of

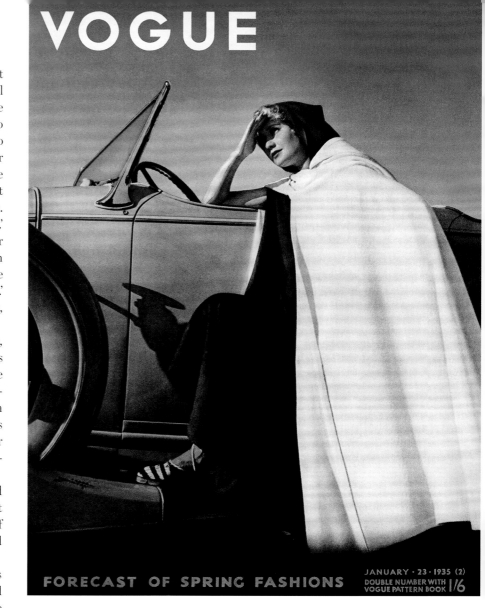

FORECAST OF SPRING FASHIONS
JANUARY · 23 · 1935 (2)
DOUBLE NUMBER WITH
VOGUE PATTERN BOOK 1/6

Previous pages, left
Lady Elizabeth Paget as 'The Lady of Shalott' by Cecil Beaton
'The mirror crack'd from side to side ...' Tennyson's verse of 1832 is echoed by Paget's jewelled hair decorations, medieval in style, and a mist-blue organdie dress by Eva Lutyens
July 1936

Above *Vogue* cover featuring actress Miriam Hopkins in a Travis Banton ensemble by Hoyningen-Huene, 1935
Below (left to right) *Vogue* covers by Eduardo Benito, 1932; Pierre Mourgue, 1932; Edward Steichen, 1932; with a cover in purple mourning the death of King George V, 1935; Spirit of *Nacktkultur* (naturism) by German photographer Dr Paul Wolff, 1936

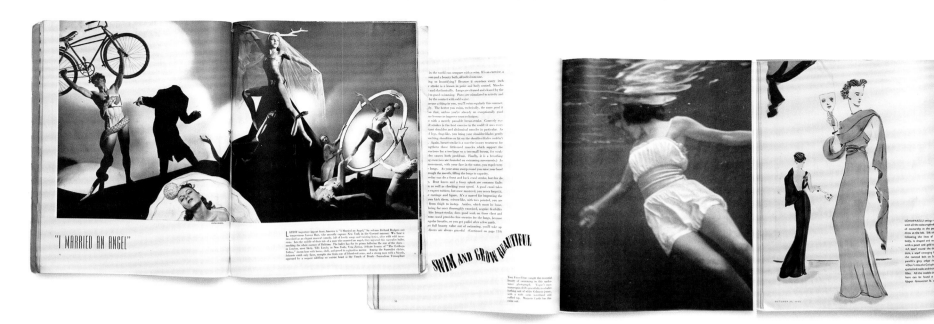

"I MARRIED AN ANGEL"

SWIM AND GROW BEAUTIFUL

Above George Balanchine's choreography for the musical comedy *I Married an Angel* by Bruehl, 1938 **Above right** Swimming costume by Brigance in the oceanarium at Marineland, Florida, by Toni Frissell, 1939 **Above far right** Fashion drawing by neo-romantic illustrator and painter Christian Bérard, 1935 **Below right** 'The Noël Coward Paper Doll' by Constantin Alajálov, 1938. The playwright was fêted by *Vogue* as the 'Wonder Boy of English Literature'

the lens ...' To offset this rigidity, Huene contrived to bring everyday life into the studio. He constructed simple but effective sets and introduced props that alluded to the outdoors: chairs, golf clubs, beach balls, skis. His skills in studio lighting enabled him to imitate convincingly daylight and the play of shadow.

Contrasting with these sunlit, sportive arrangements, *Vogue* flirted with another contemporary *mise-en-scène*. It could hardly have ignored fashion's playful plundering of surrealism. Couturier Elsa Schiaparelli's infatuation with the movement (and her shrewd understanding of its commercial applications) raised the craft of fashion design beyond mere style into a vital expression of contemporary culture. *Vogue* decided that perhaps surrealism, as evinced by its several contradictory manifestos, was best left unexplained, especially in the context of dresses and hats. Fashion captions were deadpan, making the surreality all the more pronounced: 'Miss Tilly Losch arranges herself on a butterfly divan to select a segmented "crustacean" dress by Charles James.'

For their part, magazine photographers embraced surrealism with enthusiasm, as though it might suddenly go out of fashion, which inevitably it did. In the meantime, for Erwin Blumenfeld the photographic possibilities ran out only when the budget did. Horst, a protégé of Huene, took a perverse pleasure in making off-kilter tableaux out of anything to hand. A fashion editor reached an *impasse* of etiquette when attempting to eat a devilled egg through the veil of her hat.

The perplexities of surrealism apart, *Vogue* declared that 'a lady of quality should be able to walk into any drawing room to look at the picture over the mantelpiece and exclaim, "Oh, what

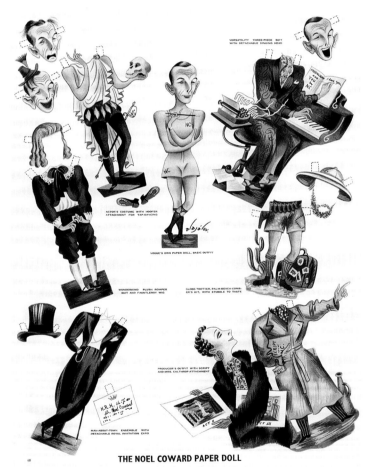

THE NOEL COWARD PAPER DOLL

a charming Picasso of the early Blue Period", or "I like your new Follower of Masaccio immensely"', and gave lessons accordingly. But in other drawing rooms, other voices raised concern about events unfolding in central Europe. *Vogue*'s society commentator Johnny McMullin had recently returned from Berlin: 'Why, I ask, is all this fuss about Hitler? No-one could be more commonplace ... I am told he represents an idea, but I can't find out what idea he represents.' Whatever the idea was, Lady Asquith firmly declared her own colours in the pages of the magazine in 1936: 'We do not believe in mock Mussolinis, silly shirts, self-advertising upstarts.'

When the Second World War finally broke out, *Vogue* showed a new purposefulness, as well as the new leather handbags – wide and deep enough to hold a gas mask.

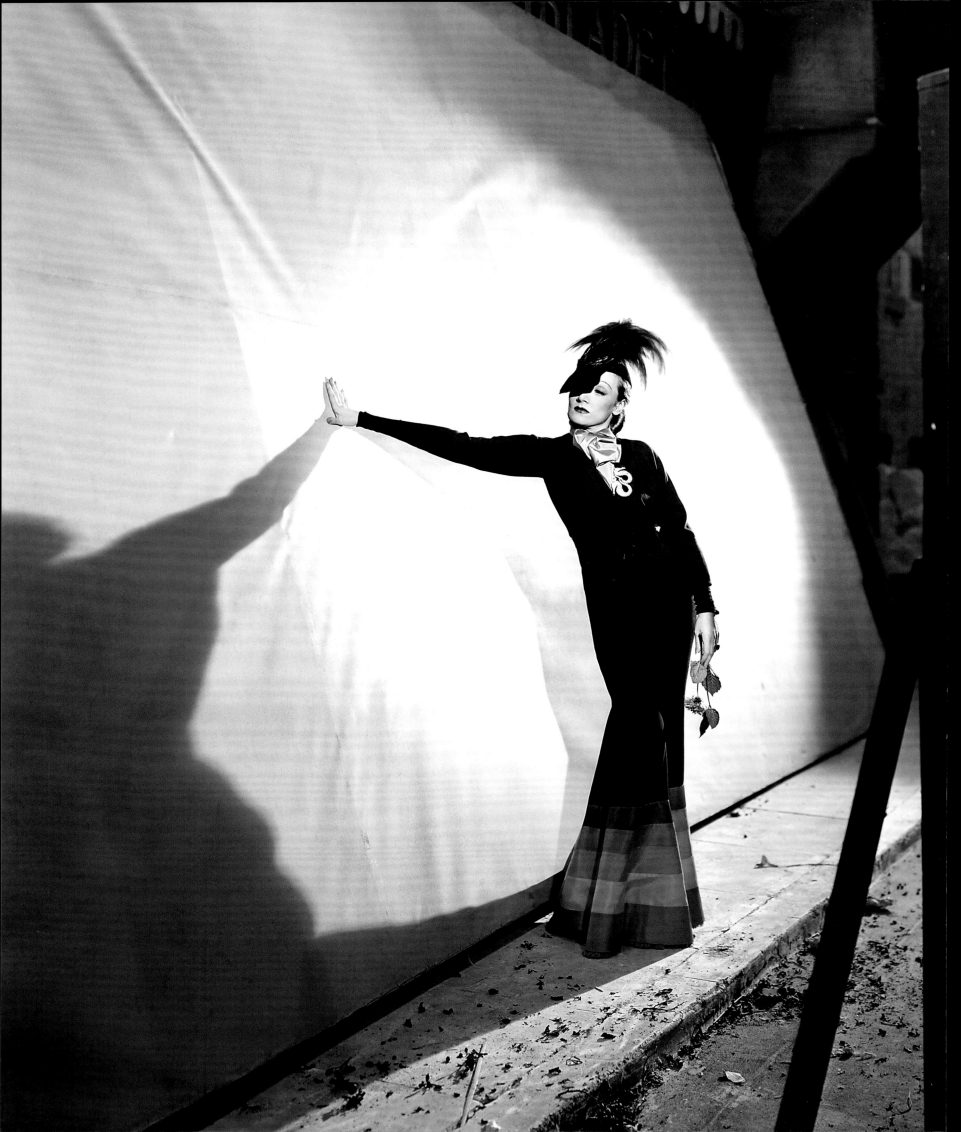

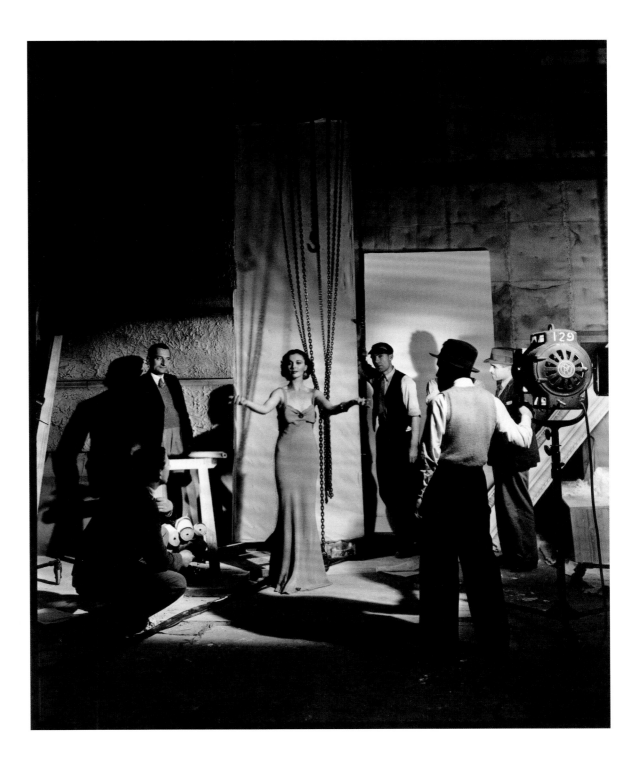

**Marlene Dietrich in London
by Cecil Beaton**
The actress often sat for Beaton. He had
photographed her in New York, in 1935,
for his series 'The Six Most Beautiful
Women in Motion Pictures'
October 1936

**Vivien Leigh in *Vogue*'s studio
by Cecil Beaton**
In her chartreuse evening dress by Victor
Stiebel, *Vogue* considered the actress to
be 'like a Persian gazelle in the dark studio
forest of chains and planks'
October 1936 (unpublished version)

'Fashion flashes'
by Edward Steichen
The compositional possibilities of the new modern architecture, with its sleek and uncluttered lines, gave Steichen's fashion photographs a pared-down, simple geometry
June 1935

'Variety in silhouette': Toto Koopman
by George Hoyningen-Huene
Vogue's 'dark star' of the 1930s had been a showroom model for Chanel. 'It really was another world,' said Koopman. 'One dressed not to please men, but to astound other women'
October 1934

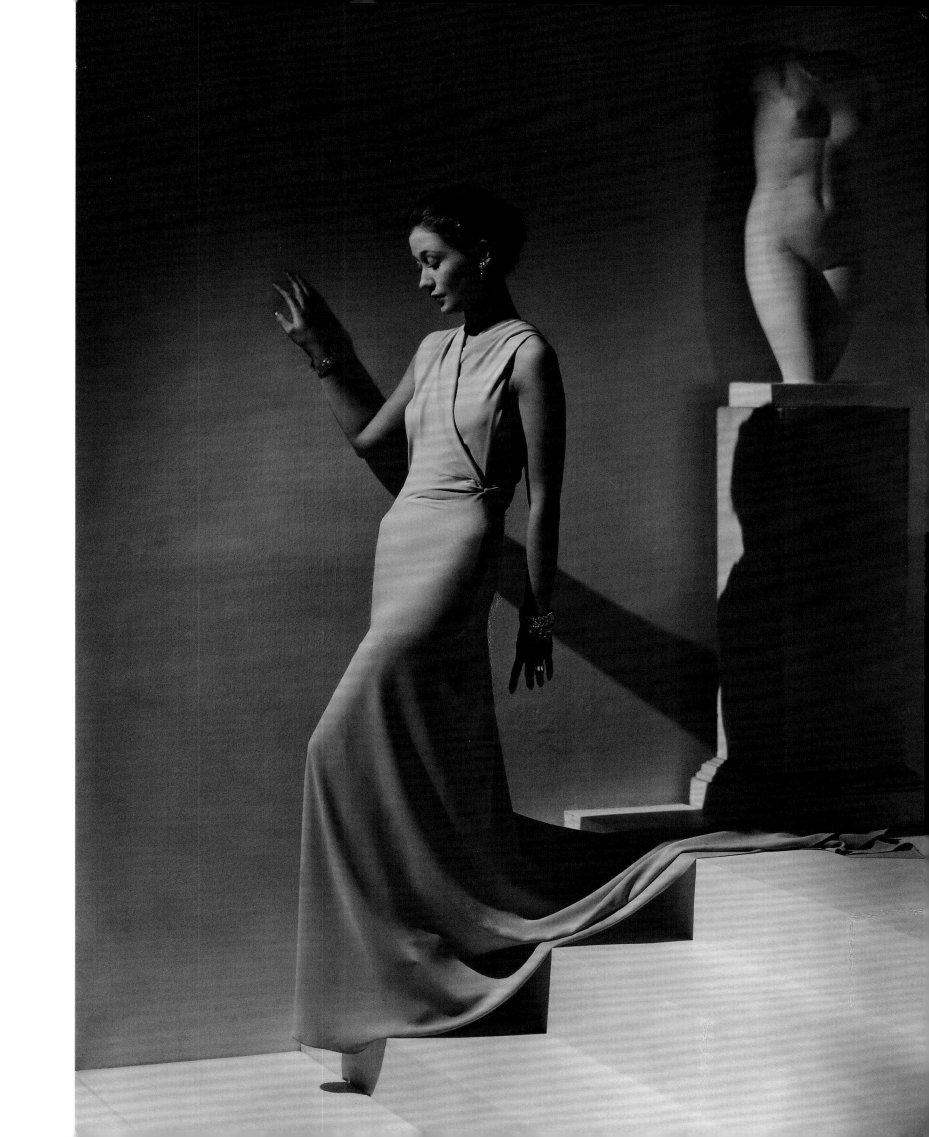

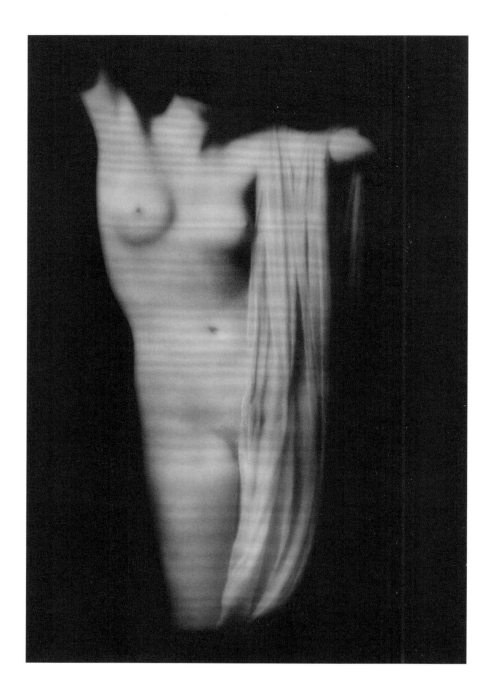

'Modern torso'
by Arnold Genthe
This nude study conformed to Hellenic ideals
of physical beauty that *Vogue* photographers
Hoyningen-Huene and Horst much admired
August 1938 (taken *c.*1910)

'Modern mariners put out to sea'
by George Hoyningen-Huene
Taken on the roof of *Vogue*'s Paris studio,
the two subjects of this fashion shot share
a sporty boyishness
July 1930

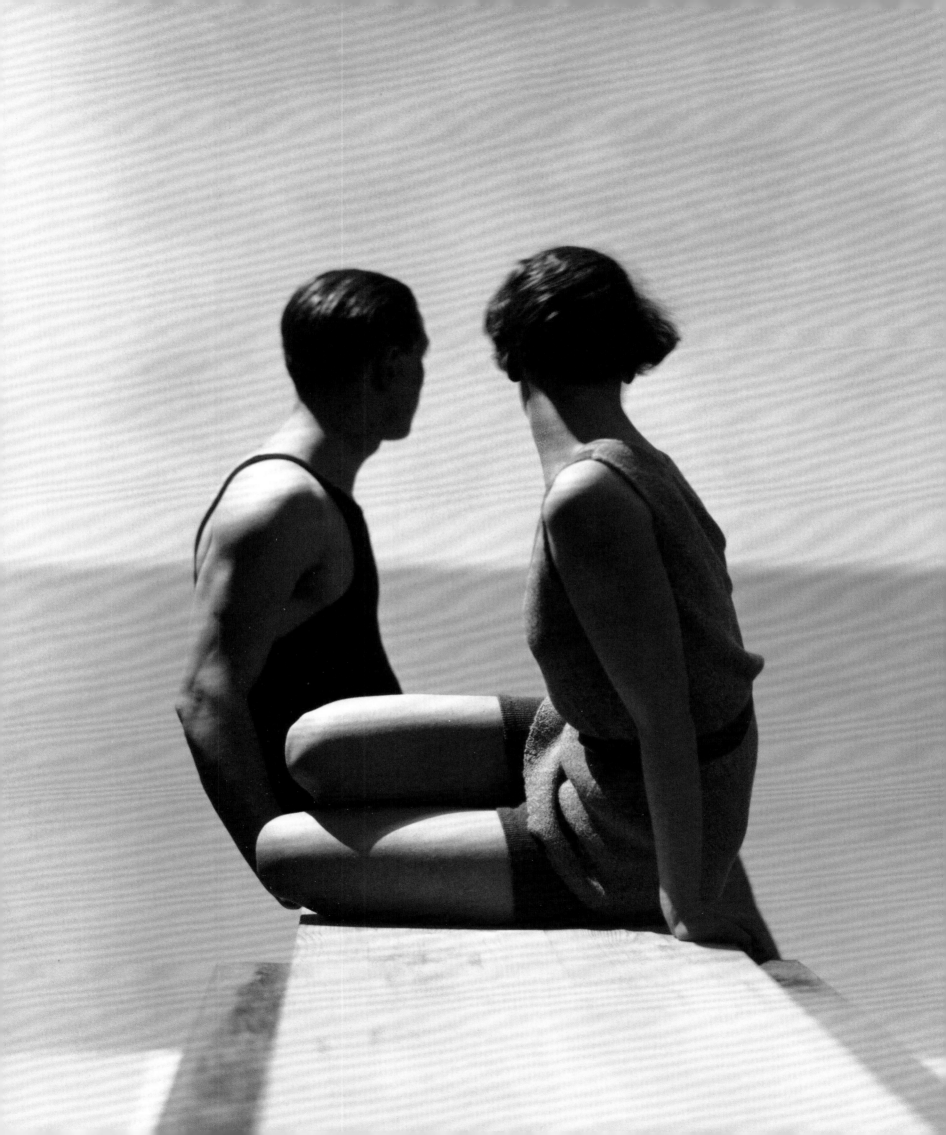

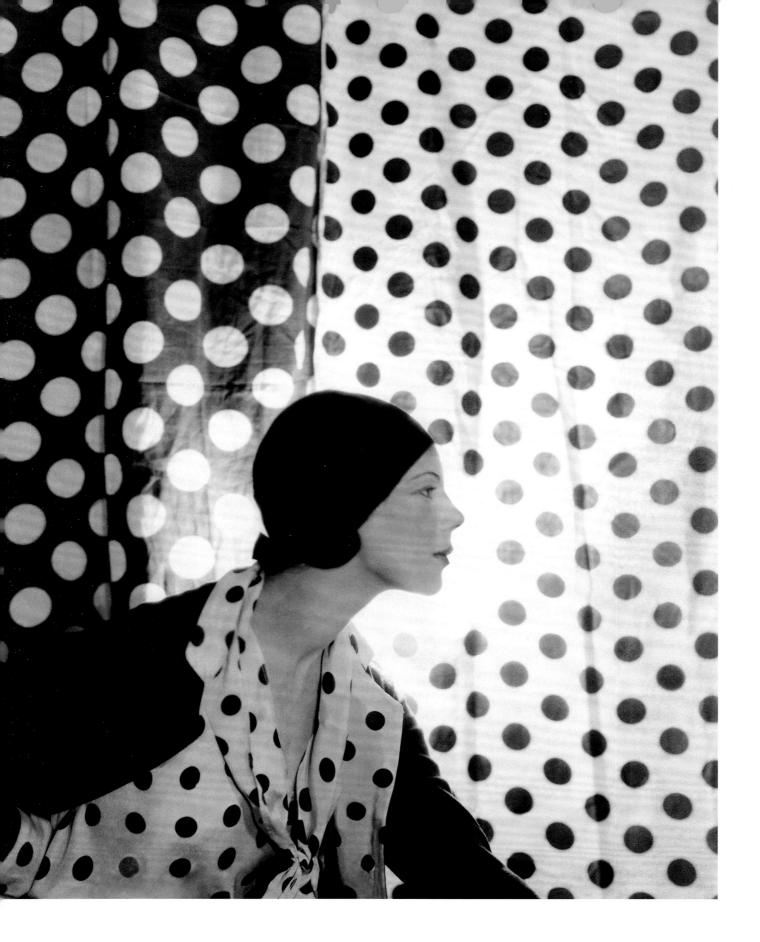

Tilly Losch
by Cecil Beaton
The Austrian dancer and actress, who would later marry the surrealist art patron Edward James, modelled 'polka dots that are so smart this season as to tempt superlatives'
May 1930

Mr and Mrs Harrison Williams in Palm Beach
by Cecil Beaton
Sketched by Beaton in one of their many homes, Harrison Williams was likely America's richest man; his wife, Mona, was a lifelong fixture of the best-dressed lists
February 1937

NANCY MITFORD
from 'Why is a Debutante?', *Vogue*, April 1931

'THIS year there are more important debutantes than ever before,' say the daily papers at the beginning of each London season in turn, and in this they are always right, because, of course, to themselves the debutantes are *much* more important than ever before, and to everybody else they are more than important – they are vital.

Who are these all-powerful beings? What is a debutante? Why is she?

A debutante is, of course, a young woman making her first appearance in society. But there is more to it than that, the word has other implications, and for some reason seems to carry us back to the agreeable atmosphere of the Edwardian days, when a girl was kept in the schoolroom until, round about her eighteenth birthday, a ball was given for her somewhere in the vicinity of Belgrave Square. Before this eagerly awaited occasion she met nobody outside her own family; after it she could meet those people selected by her papa and mama and in their presence. Tête-à tête conversations with young men were rigidly discouraged until they took the form of a proposal, in the conservatory.

From those days the notion has come to us, so strongly imbedded in our minds that it is almost impossible to remove, that a debutante is a young girl, an immensely shy girl, chaperoned with untiring vigilance, who is savouring the delights of society for the first time. We look around us and wonder sadly where she is to be found. The young girls of our acquaintance have generally savoured the delights of society from the cradle, and unchaperoned at that.

Nevertheless, debutantes in the proper sense of the word do exist even in 1930, although admittedly they soon escape from the restricting bonds of debutantehood. Dances are still given in Belgravia, the very chaperone is not entirely obsolete; she can yet be seen adorning the supper room with her seed-pearl dog collar and hen-with-duckling expression. No wonder the poor lady is bewildered; her charge before her very eyes is changing, so to speak, from a duckling to a swan, and at last her escapes to nightclubs, cocktail parties, midnight bathes at Eton and other forbidden delights become so constant and so flagrantly open that the chaperone with a sigh of something not unlike relief turns to more congenial occupations, such as bridge parties and the organisation of charity matinées.

In these days the debutante does as she pleases, with the result that everything she does she enjoys to the full. What in the world could be more exciting than dressing up for one's first Court? What more fantastic sensation than that of sitting hour after hour in the Mall with those three deliciously absurd feathers bobbing about in one's hair, and faced by a father in a uniform so tight that speech is difficult and laugher impossible?

So the modern debutante floats, important and beautiful, through her first season; her friends are lucky if she has not published a novel by the beginning of her second, and she enters upon her third with the finished aplomb which her mother took ten years of married life to acquire.

I personally incline to the belief that the London season is really kept going year after year by a large, secret and omnipotent syndicate, consisting of, among others, the dressmakers, the florists, the men who hire out gold chairs, the jewellers, and those people who stick quails' legs on to little lumps of chicken and turkey paste flavoured with Gentleman's Relish. They own those horses that run at Ascot, paint those pictures of unrestrained realism that hang in the Academy, and support Eton College entirely for the sake of the Fourth of June, Henley and Lord's.'

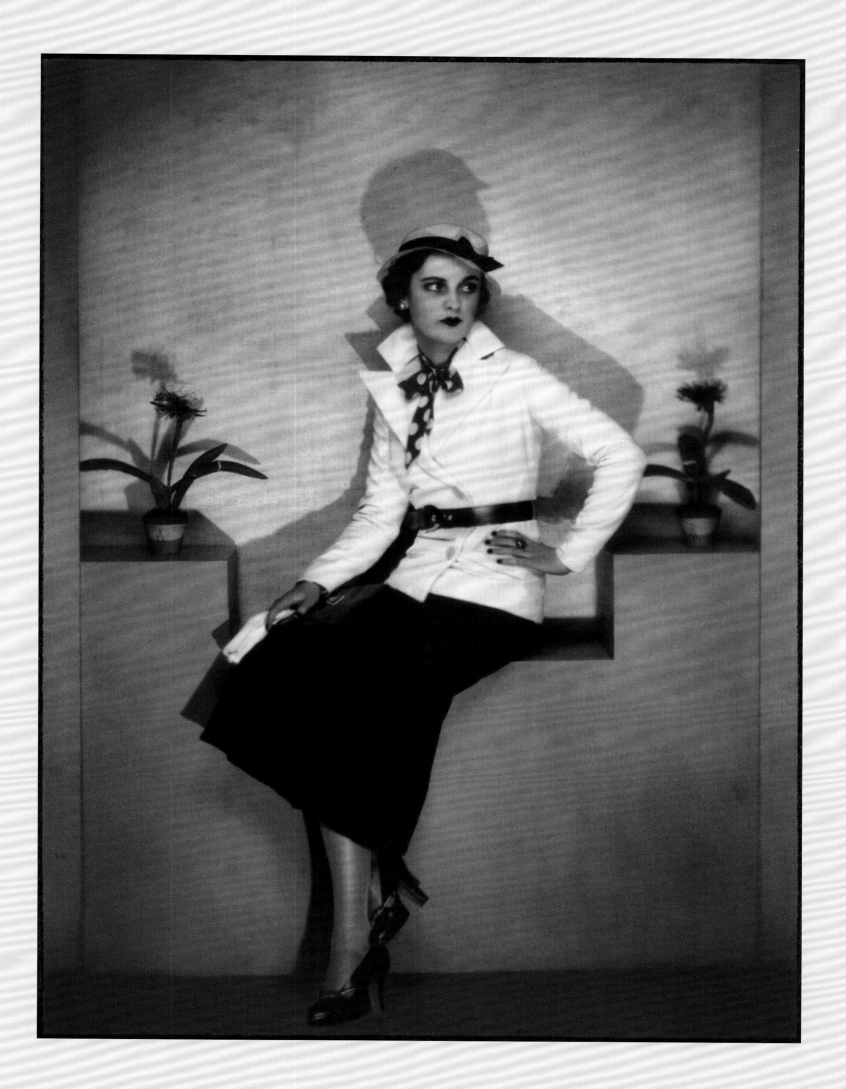

'Some people even say that there is no such thing as surrealism; that the whole movement died of paranoia long ago, and was disinterred only because the newspapers needed something to talk about. Beside being a movement of a considerable cultural importance (please do not laugh – I really mean it), surrealism has a great news value.'

M.F. Agha, 'Surrealism, or the Purple Cow', *Vogue*, January 1937

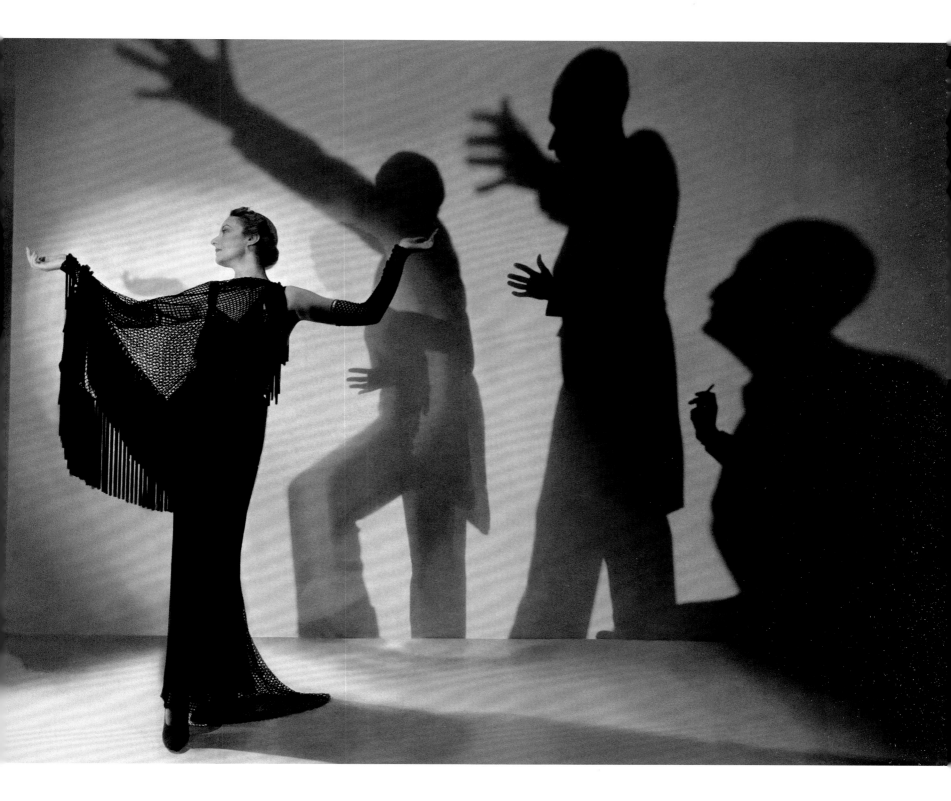

Advertisement for Victor Stiebel
by Peter Rose Pulham
Despite admirers such as Cecil Beaton, Francis Bacon
and Bill Brandt, Pulham's dark surrealist photographs
have been all but forgotten
September 1934

'Foreshadowing fringe': Louise Sheldon
by Cecil Beaton
A sense of foreboding hangs over *Vogue*'s model,
rooted to the spot in a Maggy Rouff gown of
crocheted chenille while visited by phantom suitors
December 1935

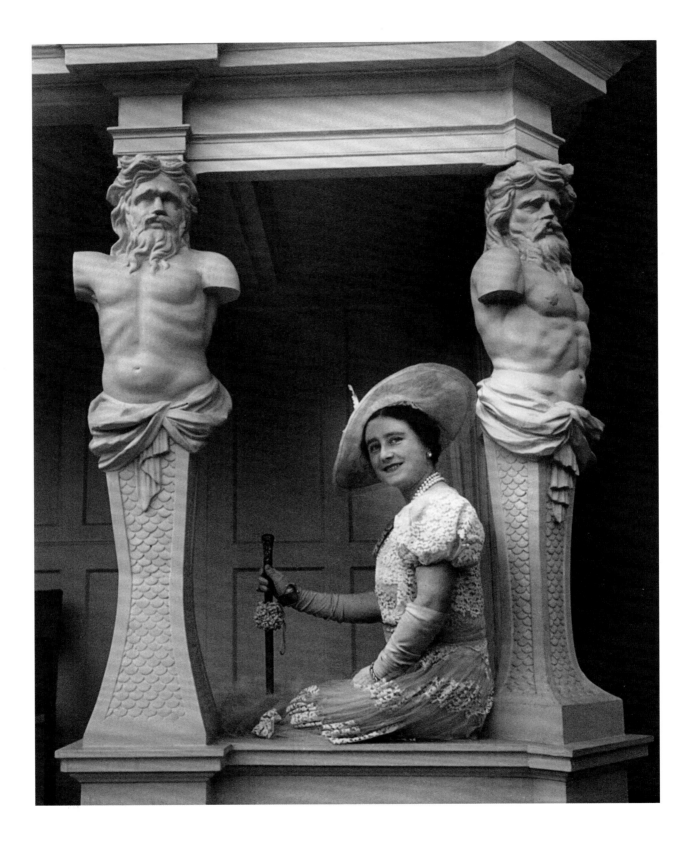

**Queen Elizabeth at Buckingham Palace
by Cecil Beaton**
'To my utter amazement and joy,' wrote Beaton
later, 'the Queen looked a dream – a porcelain doll
– with a flawless little face like luminous china in
front of a fire. Her smile as fresh as a dewdrop ...'
1939 (published later)

**Mrs Wallis Simpson in her Regent's Park apartment
by Cecil Beaton**
'She has the capacity to make afternoons amusing,'
said Beaton of his sitter. 'She reminds me of the
neatest, newest luggage and is as compact as a
Vuitton travelling case'
1936 (published later)

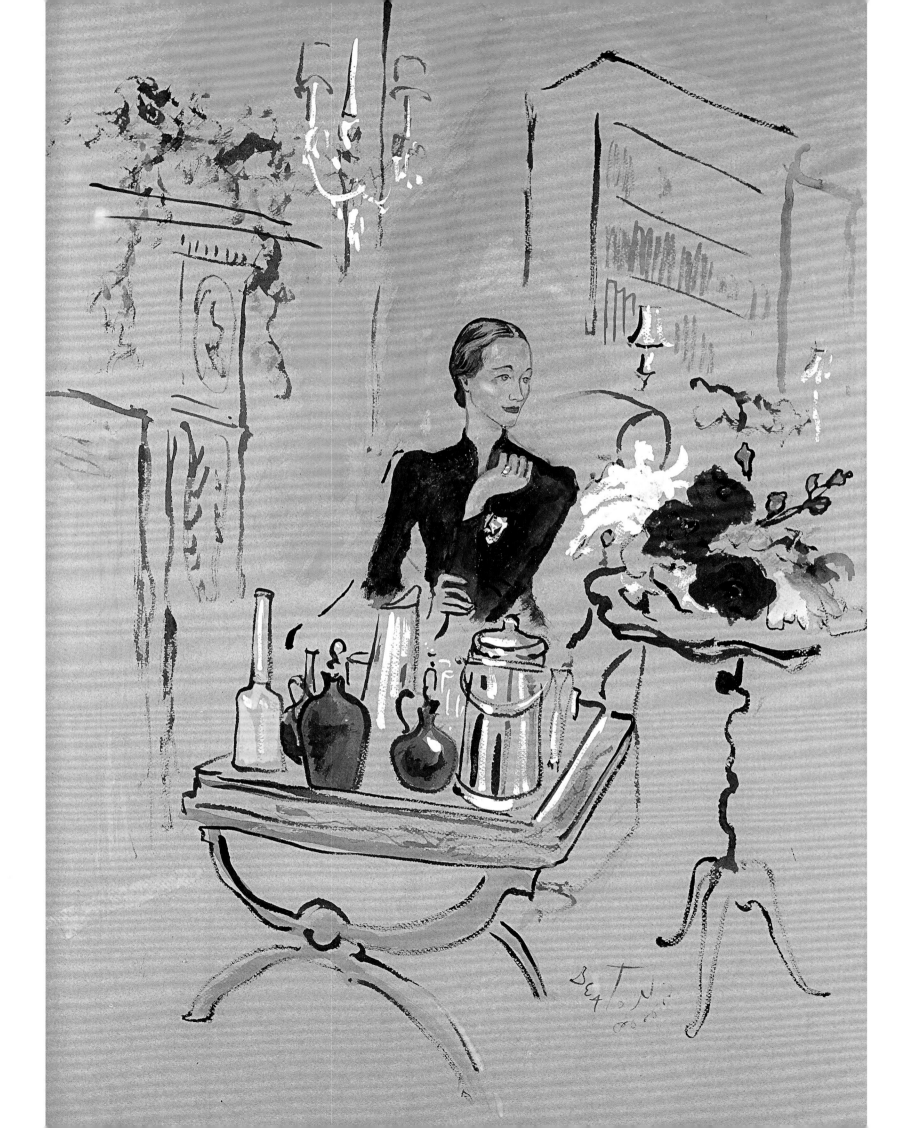

Fred Astaire
by André de Dienes
'The legend dances for us today, charmingly,
gallantly.' Performing a solo from his new film
The Story of Vernon and Irene Castle, the epitome
of pre-war male chic was seldom out of *Vogue*
May 1939

Baron Adolph de Meyer
by George Hoyningen-Huene
Vogue's first star photographer, whom
Cecil Beaton called 'the Debussy of the camera'
was also a figure of great style, despite his title
being questionable
February 1932

**'April comes to Paris: spring in town'
by Roger Schall**
Seeing clothes functioning in everyday situations was
still a novelty for *Vogue* readers. Schall, based in Paris,
was among the first to take fashion photography out
of the studio and into the street
March 1936

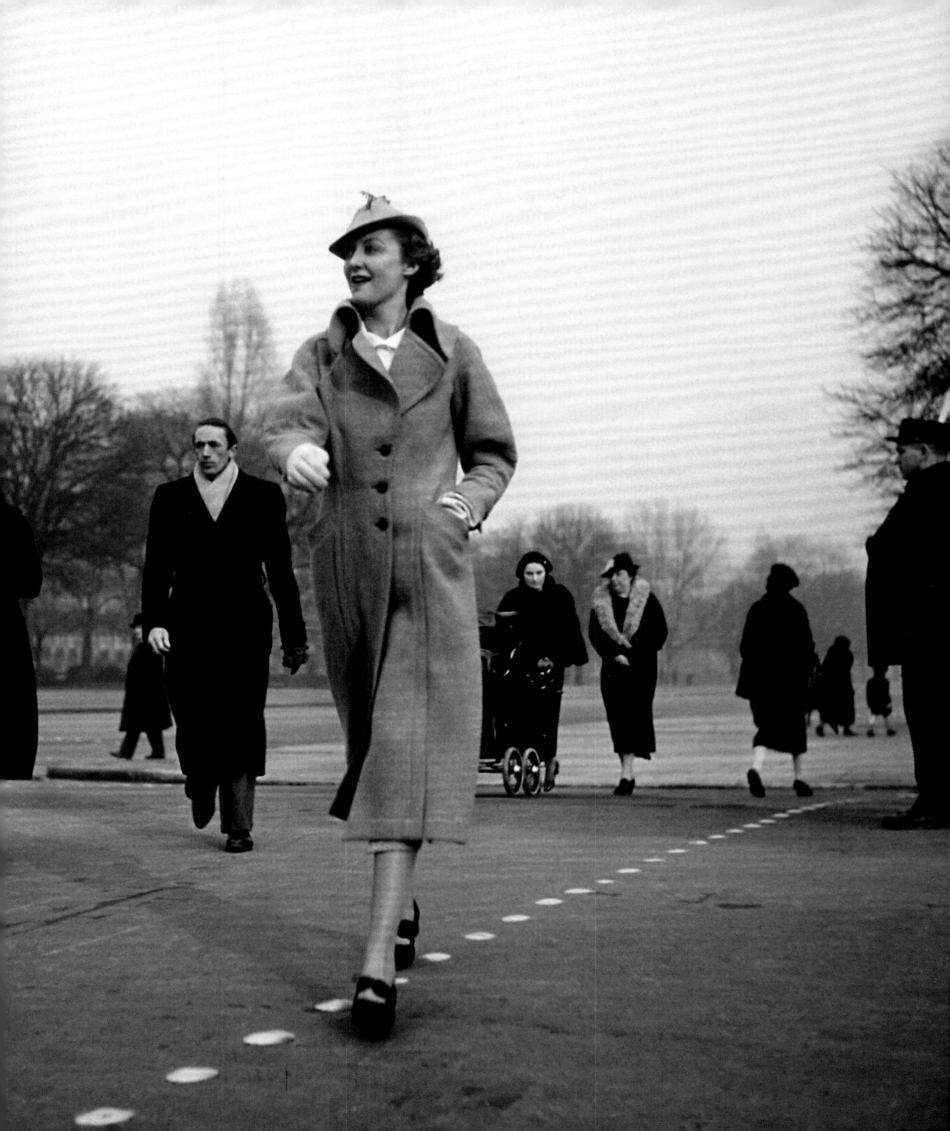

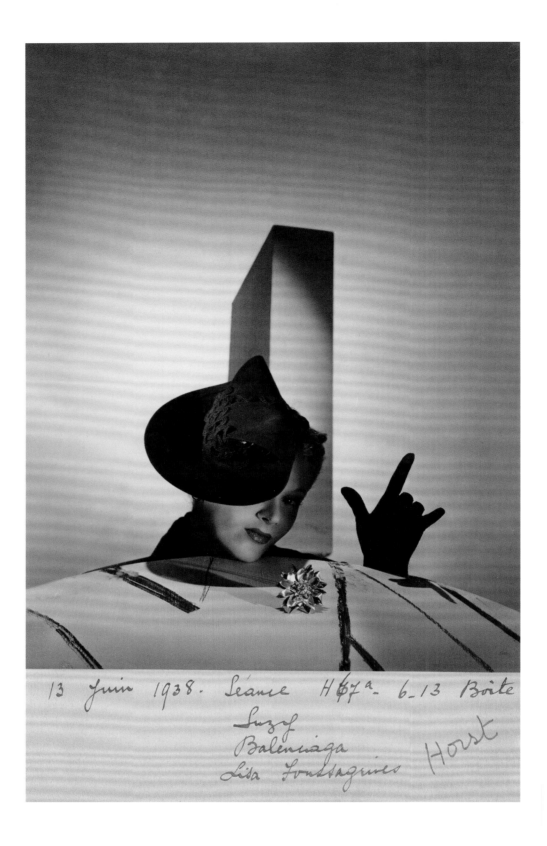

13 Juin 1938. Séance H67ª 6-13 Boîte
Suzy
Balenciaga
Lisa Fonssagrives Horst

'I love you': Lisa Fonssagrives
by Horst
The celebrated Swedish model signs 'I love you'
in a surrealist tableau. Her 'D'Artagnan' tricorn
hat, worn sideways, is by Paris milliner
Madame Suzy
August 1938 (taken in June)

'Where there's a will, there's a waist'
by Horst
One of *Vogue*'s best-known fashion photographs,
a Detolle corset for the designer Mainbocher.
It was taken shortly before Horst fled for America
as war loomed
September 1939

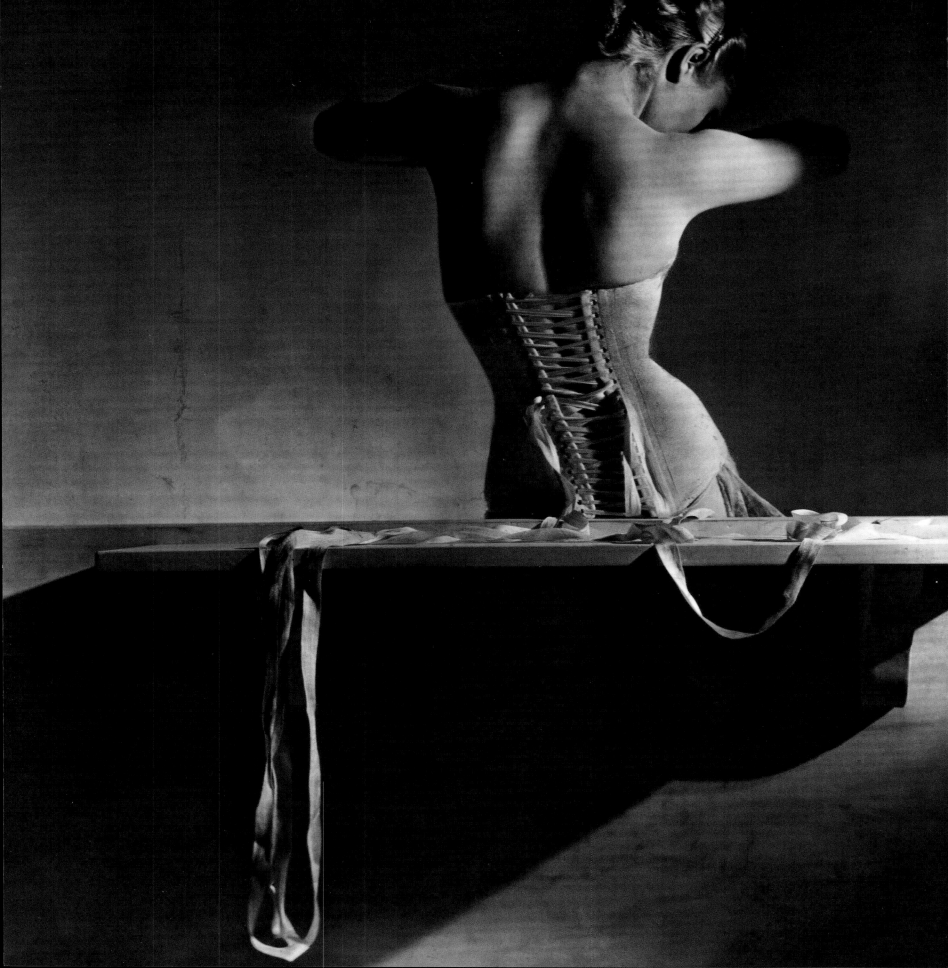

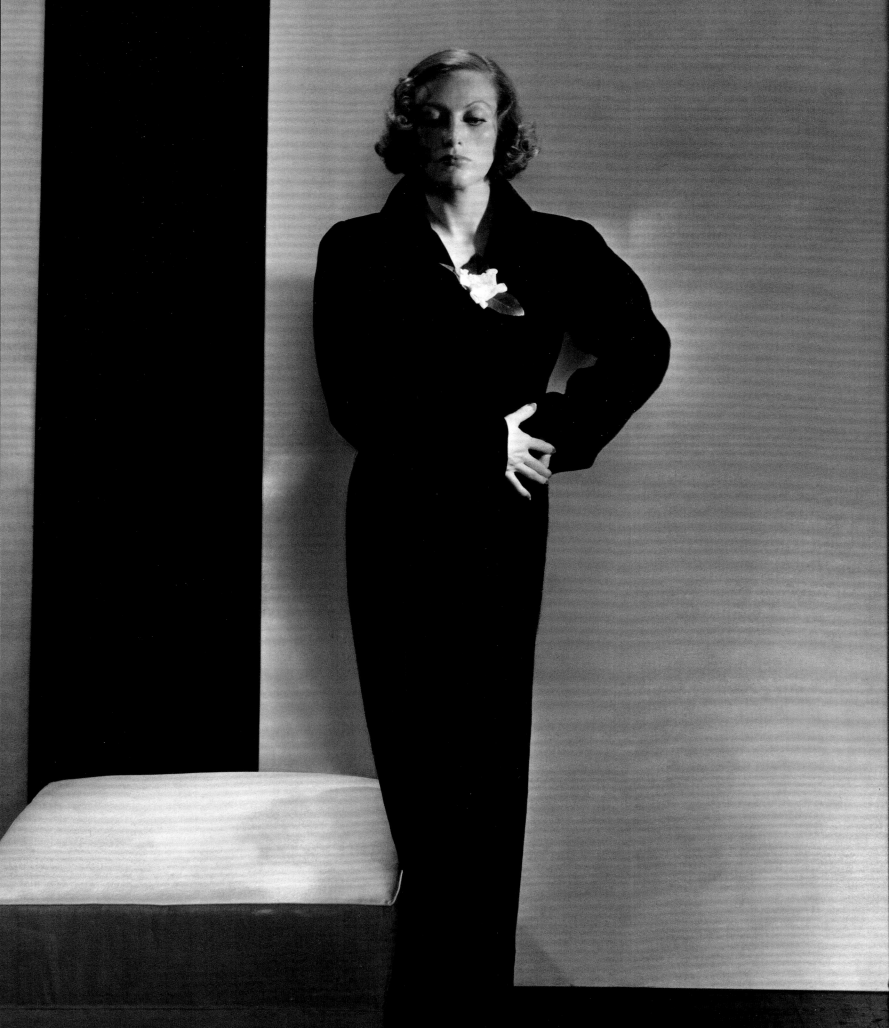

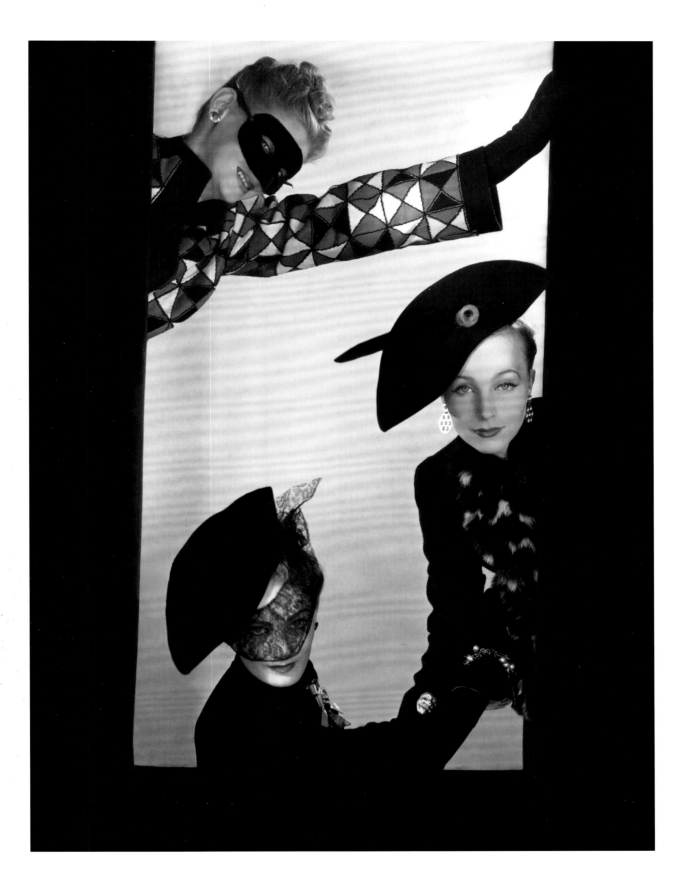

Joan Crawford
by Edward Steichen
'Joan Crawford and Schiaparelli's clothes are each sufficiently exciting alone,' consicered *Vogue*, 'but when combined the result is dramatic in the extreme'
December 1932

'Harlequin games'
by Erwin Blumenfeld
Blumenfeld enjoyed fame as a Dadaist, making collages of his passions: death, a hatred of Catholicism and a love of women. *Vogue* gave him unfettered access to the last of these
November 1938

Following pages, left
'A midsummer night's dream'
by André Durst
Chiffon dresses by Molyneux are modelled in a suitably Shakespearean sylvan setting, recreated in the *Vogue* studio – along with a sense of impending catastrophe
June 1936

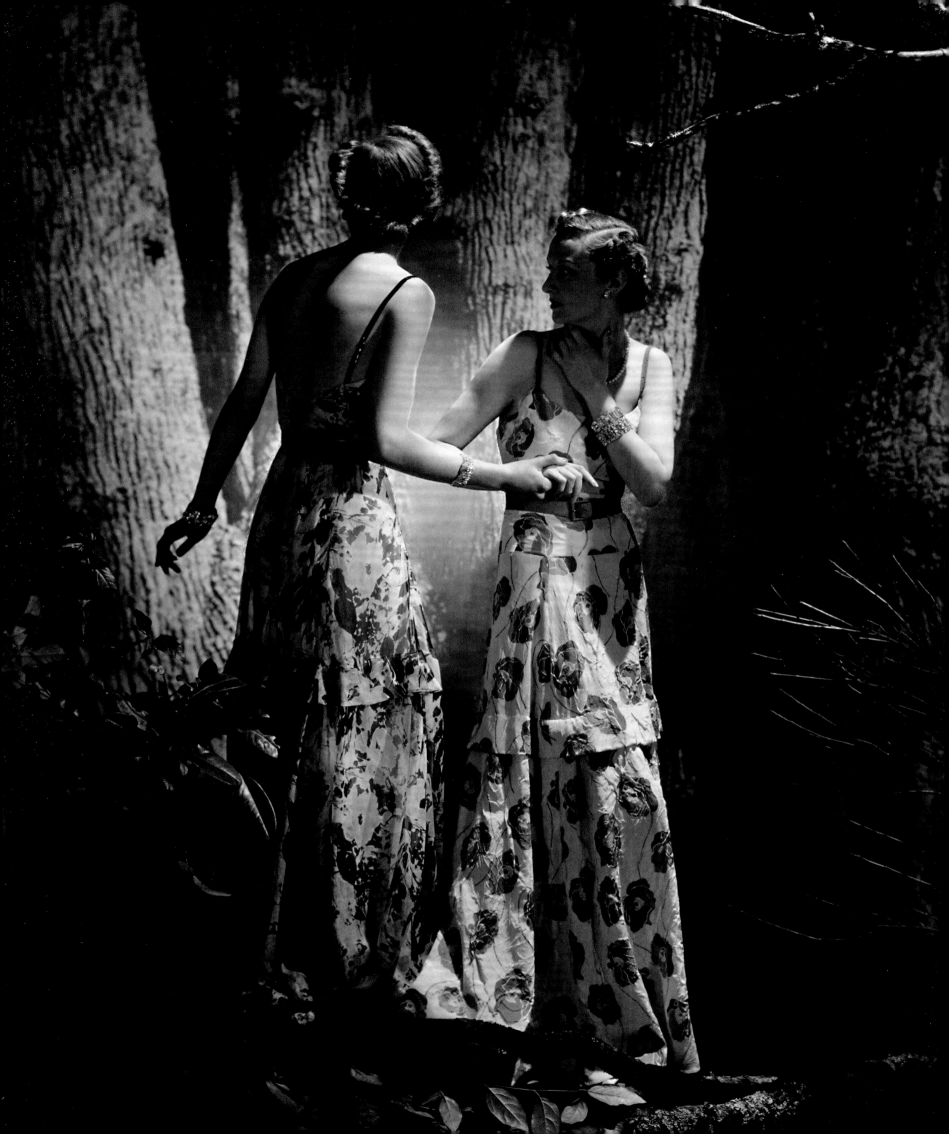

'Elsa Schiaparelli says
she knows there won't be a war
– just by instinct. Elsie Mendl
says there is going to be
a miracle. Diana Vreeland says
it's all chemical – that Hitler
is a madman during the
full moon and capable of any
extremities at that time.
Everyone thinks of the very
big full moon that will come up
in a few hours.'

Bettina Ballard, 'Letter from France',
Vogue, December, 1938

Preserving the
Art of Peace

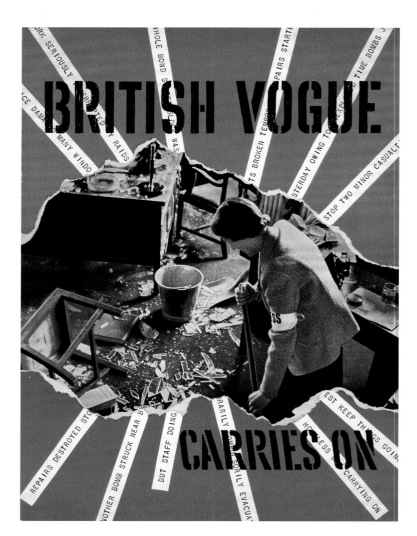

AS EARLY as 1933 *Vogue* had treated the emerging European dictatorships with derision. A report in *The Times*, touched upon in a *Vogue* editorial, ascribed to Mussolini these words of advice to the Nazi hierarchy: 'Any power whatsoever is destined to fail before fashion. If fashion says skirts are to be short, you will not succeed in lengthening them, even with the guillotine.' Scarcely credible, but nonetheless the notion of a higher power before which two mighty dictators were helpless was piquant to *Vogue*. By the time Britain went to war, however, the magazine had changed its tone.

Paper, as *Vogue* was quick to point out, was rationed more strictly than sugar and meat. For students of photographic history it came at a cost. Exhorting its readers to turn out their own 'squirrel hoards', *Vogue* pulped its archive of beauty and fashion pictures for the greater good. Cecil Beaton took the lead, photographed in 1941 sitting among hundreds of his luminous, skilfully retouched, labour-intensive prints that had been requisitioned for recycling.

In his petition to the Ministry of Information, the magazine's managing director, Harry Yoxall, had argued the magazine's cause as one that was vital to the morale of the home front and secured it extra supplies. As *Vogue* put it in 1939, 'we believe that women's place is *Vogue*'s place. And women's first duty, as we understand it, is to preserve the arts of peace by practising them ...' Distribution was drastically curtailed and fewer copies produced. From a fortnightly publication, *Vogue* became a monthly. A subscriber had to cancel (or die) before a new one could take his or her place. There was also a market in back issues – 7s. 6d, over and above a cover price of 1s. 6d, was the going rate for a piece of second-hand glamour. The magazine was late on the bookstalls only twice.

By 1941 *Vogue* was unshakeable: 'Owing to circumstances over which we have no control, there may be difficulties in supplying from our

headquarters the particular *Vogue* patterns you'll be wanting for your summer outfits ...' It neglected to say that the headquarters in the City of London no longer existed, having taken a direct hit in the last Luftwaffe raid over London. Nearly a million knitting patterns were destroyed. Yoxall, as phlegmatic as his magazine, was shown at his desk in New Bond Street, the office strewn with glass in the aftermath of a bomb blast. 'We are living real, robust life now,' wrote Lesley Blanch in 1940, 'the life of our ancestors comes nearer day by day – life and death seem so close.'

But the war years were the making of *Vogue*. In isolation, the duplication of photographs and features from the American edition all but ceased. At Britain's darkest hour, the quality of *Vogue*'s war coverage, both

Previous pages, left
Walter and Thérèse Sickert at home in Bath by Cecil Beaton
In his twilight years, the great painter Walter Sickert was living, according to Beaton, 'almost entirely in the past of youth, with only a few flashes of the war of today'
April 1941

Top When *Vogue*'s buildings suffered a direct hit, this supportive portfolio was produced, 1941 *Above (left to right)* A timely reminder from *Vogue* of the virtues of thrift, 1940; wartime covers by Horst, 1940, and Eduardo Benito, 1941; an exhortation for 'pulling in your belt', also 1941; and for the first peacetime cover, blues skies illustrated by James de Holden-Stone, 1945

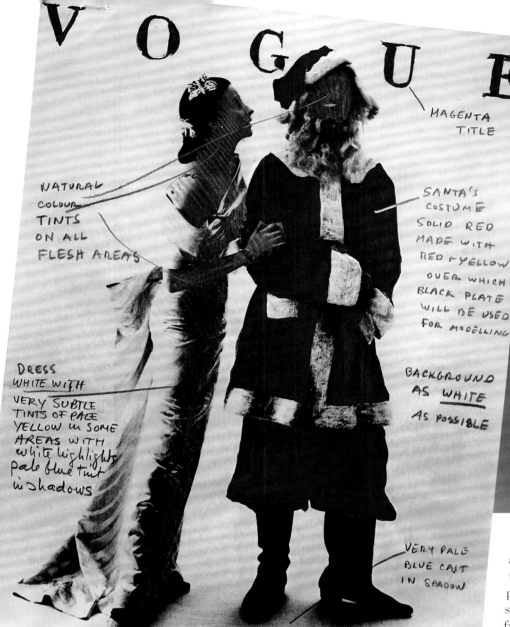

NATURAL
COLOUR
TINTS
ON ALL
FLESH AREAS

MAGENTA
TITLE

SANTA'S
COSTUME
SOLID RED
MADE WITH
RED + YELLOW
OVER WHICH
BLACK PLATE
WILL BE USED
FOR MODELLING

DRESS
WHITE WITH
VERY SUBTLE
TINTS OF PALE
YELLOW IN SOME
AREAS WITH
white highlights
pale blue tint
in Shadows

BACKGROUND
AS WHITE
AS POSSIBLE

VERY PALE
BLUE CAST
IN SHADOW

Above Design notes for a Christmas cover based on a photograph by Irving Penn, 1946 *Above right* Guipure corset to be worn under Dior's New Look dresses, by Clifford Coffin, 1947 *Below* Double-page spread showing a fashion drawing by René Bouché and fashion photograph of model Barbara Goalen by Horst, 1949

at home and further afield, set it apart from other publications. Tapping into a spirit of neo-romanticism that promoted the virtues of the countryside, its traditions and simpler ways of life, Norman Parkinson took 'documentary' fashion pictures. Cecil Beaton travelled the world tirelessly as a photographer for the Ministry of Information. Playing on his loyalty, editor Audrey Withers fought to secure the best of his photographs for *Vogue* ahead of the newspapers. But it was the unlikely figure of the American Lee Miller, a former *Vogue* model and pupil of Man Ray, who gave the magazine a dimension unimaginable at the outbreak of war. She became its very own war correspondent in words (which came to her with difficulty) and pictures, honed by an artist's eye.

The liberation of Paris allowed couture to flourish again; glimpses of its pre-war direction could be found in a fuller, more feminine silhouette. The opening of Balmain was greeted with excitement; none was more delighted than his first client, the modernist writer and poet Gertrude Stein. But it was the Paris opening of Maison Dior in 1947 that allowed, in fashion terms at least, the ghosts of war to settle. A reaction to the severity of the war years, Dior's New Look recalled the high artifice of the *belle époque* years. It was reported that 20 yards (some 18 metres) of fabric might constitute one outfit. Forty years later, the British couturier John Cavanagh gave his reaction: 'I was transfixed. In tears. The relief was overwhelming; the relief of seeing total beauty again, from the tips of the little shoes to the feathers on the hats – it was a total glorification of the female form.'

In Britain, peace had come at a price. The age of austerity was far from over and the job of the *Vogue* woman was not yet done: 'How long before a grateful nation (or anyhow the men of the nation) forgets what women accomplished when the country needed them? It is up to women to see to it that there is no regression ...'

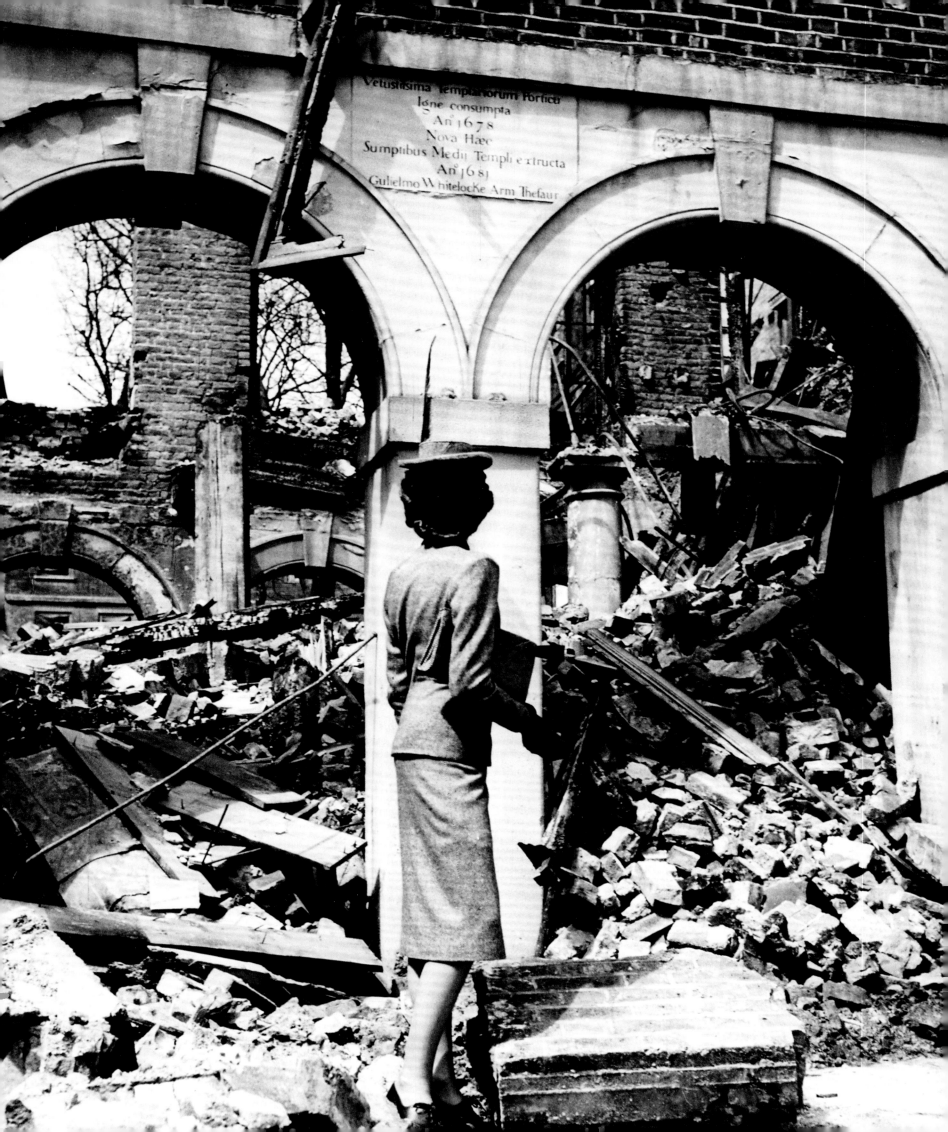

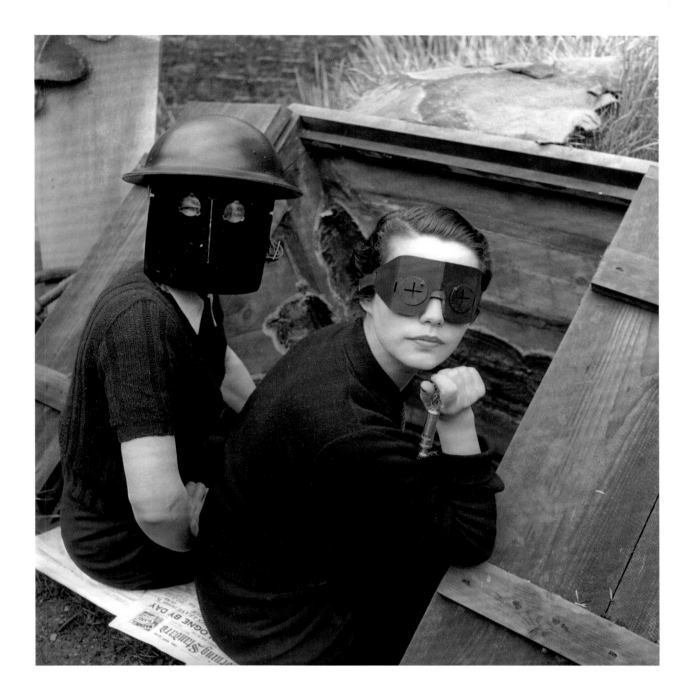

'Fashion is indestructible'
by Cecil Beaton
In spite of it all: a suit by Digby Morton is
framed by the ruins of London's Middle Temple,
the victim of a direct hit during the Blitz
September 1941

Home defence in Hampstead
by Lee Miller
With a finely tuned eye for a surrealist display,
Miller incorporates a fire mask and shield worn
for protection against incendiary bombs
1941 (unpublished version)

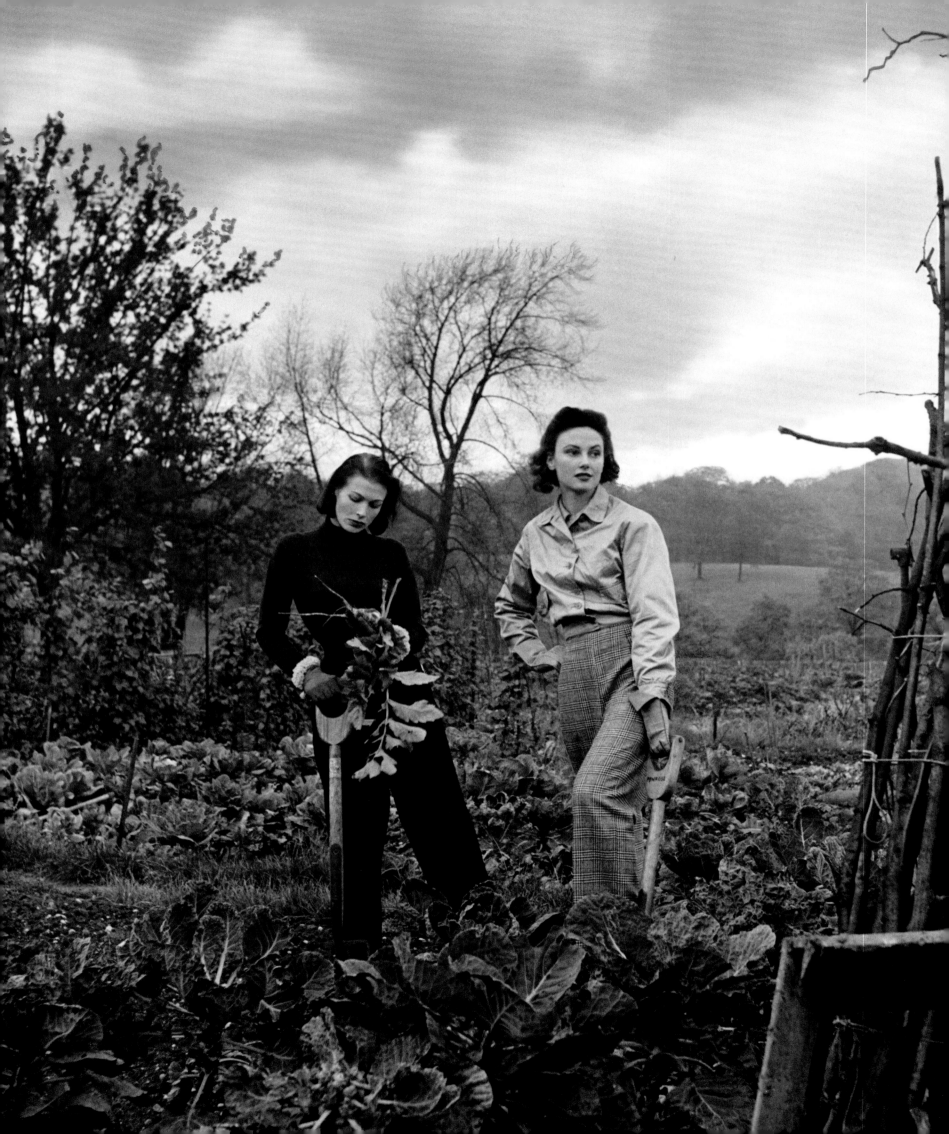

'Raising the vegetables'
by Lee Miller
Two market gardeners dressed for the job
in 'austerity trousers'. The corduroys are from
Harrods, the tweeds from Lillywhites. Both
cost eight coupons each
January 1943

'Bright fashion for dark days'
by 'Eric'
Looking brightly towards peace in the month
of the Normandy landings, flower hats
and 'stem' dresses illustrated by American
Carl Erickson added some optimistic colour
June 1944

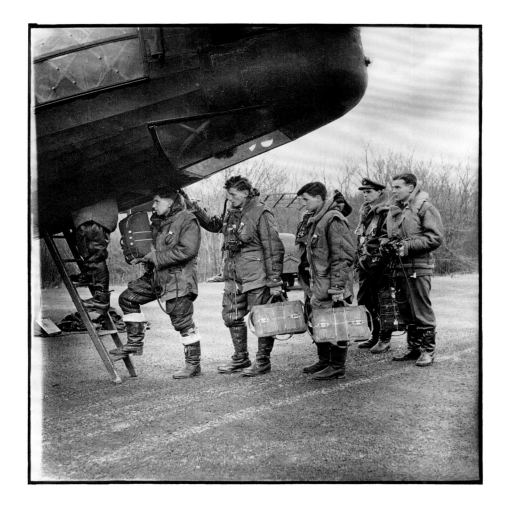

'Winged squadrons'
by Cecil Beaton
'For what bomber can enjoy finding himself flying through the enemy's searchlight belt while every piece of metal melted down from all the statues and railings is hurled up at him?'
July 1941

'Enemy skeletons'
by Cecil Beaton
The remains of German tanks at Sidi Rezegh, Libya. During the course of a month, the escarpment, south of Tobruk changed hands five times
November 1942

Opposite
In the aircraft recognition room
by Cecil Beaton
The walls are decorated with every type of warplane, friendly and hostile, 'bright and swooping as dragonflies'
July 1941

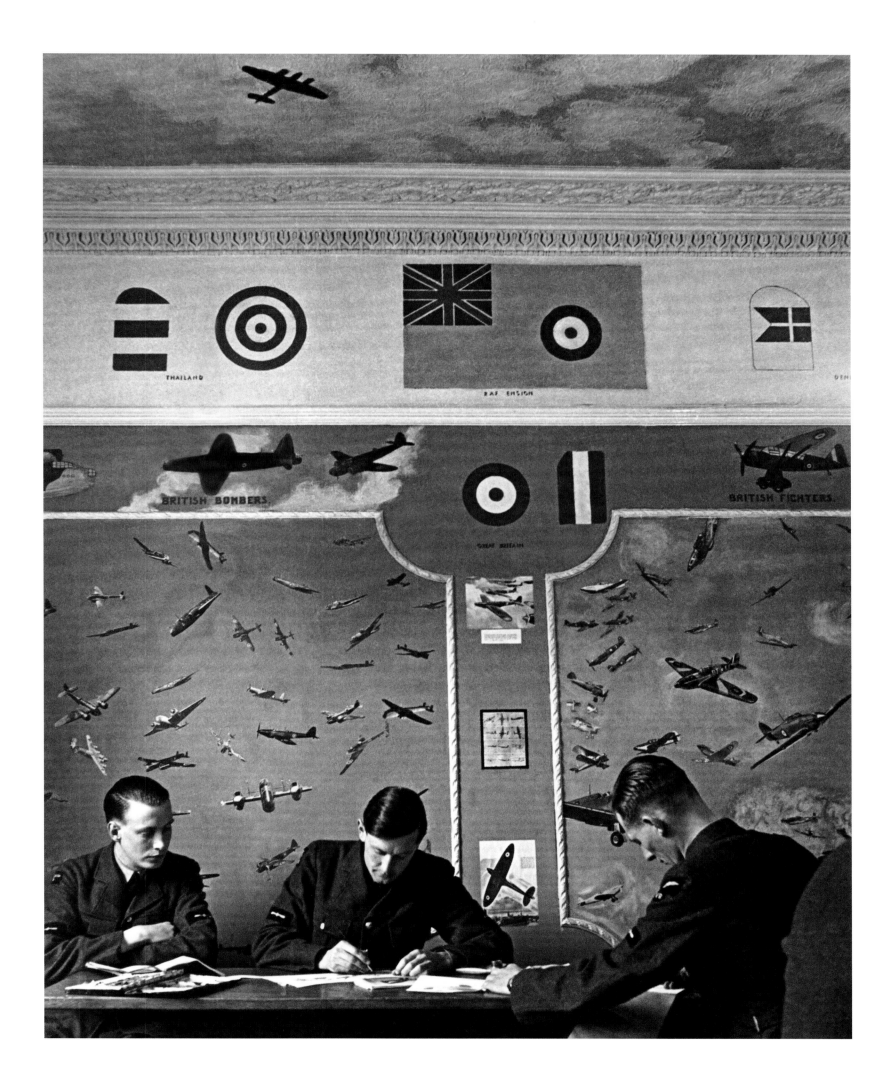

LEE MILLER
from 'Hitleriana', *Vogue*, July 1945

'I SAW the war end in a plume of smoke curling up from the remnants of Hitler's mountain retreat. Although the area had been blockbusted, houses crushed like hardboiled eggshells, and the mountainside was a mess of craters, Hitler's own house was still standing with the roof slightly askew and the fire which the SS troopers set as a final salute was lashing out the windows. I crawled up and down the bomb-made hills and the wreckage of Goering's house next door and looked at the empty flagpole which had carried the last Nazi banner to fly over the redoubt. The departing SS had ripped the swastika centre from it, but left the red cloth.

In the morning, the fire was nearly out and so were the looters, in force – legally, because this was Wehrmacht property. The French tanks had finally arrived, having missed their opportunity of making history in Berchtesgaden by mixing their traffic into snarls. Everybody hunted for souvenirs of Life with Hitler and explored the miles of underground living quarters cut into the rock under and behind the house. Considering that Hitler was a teetotaller and wouldn't allow a cigarette to be smoked in his presence, he was remarkably well supplied with the best wines and champagnes of Europe, the whisky of England and the finest cigars.

The whole house didn't burn, by any means, and there was a storage room of books and treasures above ground. But the main excitement was inside the mountain. Miles of library, dining rooms, cinema machinery, living rooms and kitchen space. Rustic Bavarian furniture and heavy art pottery were the style of decoration. Cases of silver and linen with the eagle and swastika above the initials A.H. found their way into the pockets of the souvenir-hunters and the books were tossed around if they didn't have a book plate or dedication or personal-looking binding. It was like a very wild party with champagne corks whizzing over the flagpole and the house falling down over our ears. Every once in a while a great cascade of masonry would slide off the roof, and from the bowels of the house an explosion (the French CIC trying to blow Hitler's safe) would shake the hillside and spout smoke and bricks out the passages. I don't imagine there were any valuable archives there, the SS elite would have seen to that, but if there were when the French took over, there aren't now. There isn't even a piece left for a museum on the great war criminal ... and scattered over the breadth of the world are forever going to be shown a napkin ring or a pickle fork, supposedly used by Hitler ...

I was living in Hitler's private apartment in Munich when his death was announced. It was an ordinary semi-corner old-fashioned building on a Platz. There were no signs that anyone more pretentious than merchants or retired clergy had lived there. Superficially, almost anyone with a medium income and no heirlooms could have been the proprietor of this flat. It lacked grace and charm, it lacked intimacy but it was not grand ... It wasn't empty enough to be "sub-let" as it stood, but a quarter of an hour's clearing cupboards (especially the medicine chests) would have made it ready for any new tenant who didn't mind linen and silver marked A.H.

To the left of the public rooms was a library – full of richly bound books and many presentation volumes of signatures and well wishes. The library was uninteresting in that everything of personal value had been evacuated; empty shelves were bleak spoors of flight. Several uniforms (probably being submitted for approval, because they don't appear in any catalogue of recognised heraldry as yet) were lying in a heap.

Directly adjoining these double doors was the nook in which all Hitler's Munich conferences were held. Chamberlain sat here ... and Franco ... Mussolini, Goebbels, Goering ... Laval ... the whole host of names for the reckoning which will never catch up with them. The bookcase which jutted out in the room had as savage an angle as the swastika itself. The artwork – sculpture still wearing, on a string, prize medals from exhibitions – was mediocre, as were the paintings on all the walls. I hoped to find one of the master's own works. There was also a plaster cast of Hitler's hands, and on the desk in the next section of the room, a globe of the world. The piano, a Bechstein, was out of tune ... but the radio was a masterpiece.

In the main entrance hall were cupboards holding crystal and china, linen and sliver, all initialled A.H. There was a rubber plant and a black plaster eagle with folded wings. His bedroom was hung with chintz and the bed was upholstered in the same material. The bed table had a push-button gadget, which had *Maid*, *Valet* and *Guard* marked, and there was a large cream-coloured safe in the corner. The adjoining bathroom could have been bought from a furnishing catalogue, and connected through to a small single bedroom where intimate friends of the Führer stayed when they were in town.

At the far end of the apartment was a separate little flat, not as grandly furnished, but more intimate, except for the super switchboard on the wall, which dialled directly to Berlin, Berchtesgaden, etc. Lt-Col William Grace tried phoning Berchtesgaden, and the Munich operator (in some part of the town, uncaptured as yet) rang them, but there was no answer. Anyway, Hitler wasn't there.'

Götterdämmerung of the Third Reich
by Lee Miller
The Berghof, Hitler's redoubt at Berchtesgaden, set ablaze by retreating SS troops. Miller 'liberated' a silver drinks tray with the monogram 'A.H.'
July 1945

THE CONDÉ NAST PUBLICATIONS LTD.

EDITORIAL AND ADVERTISING OFFICES, 1 NEW BOND STREET, LONDON W.I. TEL.: REGENT 4802

REC'D JAN 15 1945

1st January 1945.

Dear Edna,

Lee got back a couple of days before Christmas on ten days leave, looking very fit and most enthusiastic about her work.

Audrey and I gave a little lunch for her at the Savoy on Friday, inviting the members of the staff from the Editorial, Art and Studio departments who had had most to do with her work, and also the other department heads. I made a little speech along the lines of the enclosed notes, which Audrey thought you might like to see.

Is there not a Pulitzer prize for the best journalistic feat of the year? If so, don't you think Lee's name should be entered for it with a file of her contributions to American Vogue, beginning with the American tent hospital? I am sure there can be no other journalist who has been so good in both word and illustration.

All best wishes,

Affectionately yours,

Barry

H.W.Y.

See Cable
1/22/44

DIRECTORS: CONDÉ NAST (U.S.A.) H. W. YOXALL (BRITISH) EDNA WOOLMAN CHASE (U.S.A.) ELIZABETH PENROSE (U.S.A.)

**Letter to Edna Woolman Chase
from Harry Yoxall**
Lee Miller's contribution to *Vogue* as its war
correspondent, outlined in this letter, was
unanticipated before hostilities broke out
January 1945

**The daughter of the Bürgermeister of Leipzig
by Lee Miller**
The young woman in the German Red Cross
armband killed herself as the Allies closed in.
Miller noticed her 'exceptionally pretty teeth'
1945 (unpublished)

'Rococo rubble'
by the US Signal Corps
In the Pacific arena, at the University of
the Philippines, a statue pitted and broken
by shellfire makes a defiant last stand
September 1945

'War in the East': Chinese commandos
by Cecil Beaton
In the remoter reaches of Free China, Beaton
wrote, 'Although the average age of the troops
is said to be 20, most appeared to be boys'
September 1945

'The second age of beauty is glamour'
by Cecil Beaton
A youthful dress of checked wool and a bodice
with red leather buttons are worn with a hat
of red felt, all designed by Norman Hartnell
February 1946

Princess Troubetskoy in Paris
by Clifford Coffin
Married to a Russian aristocrat in exile,
the princess models the latest winter overcoat
from Balmain on the banks of the Seine
December 1946

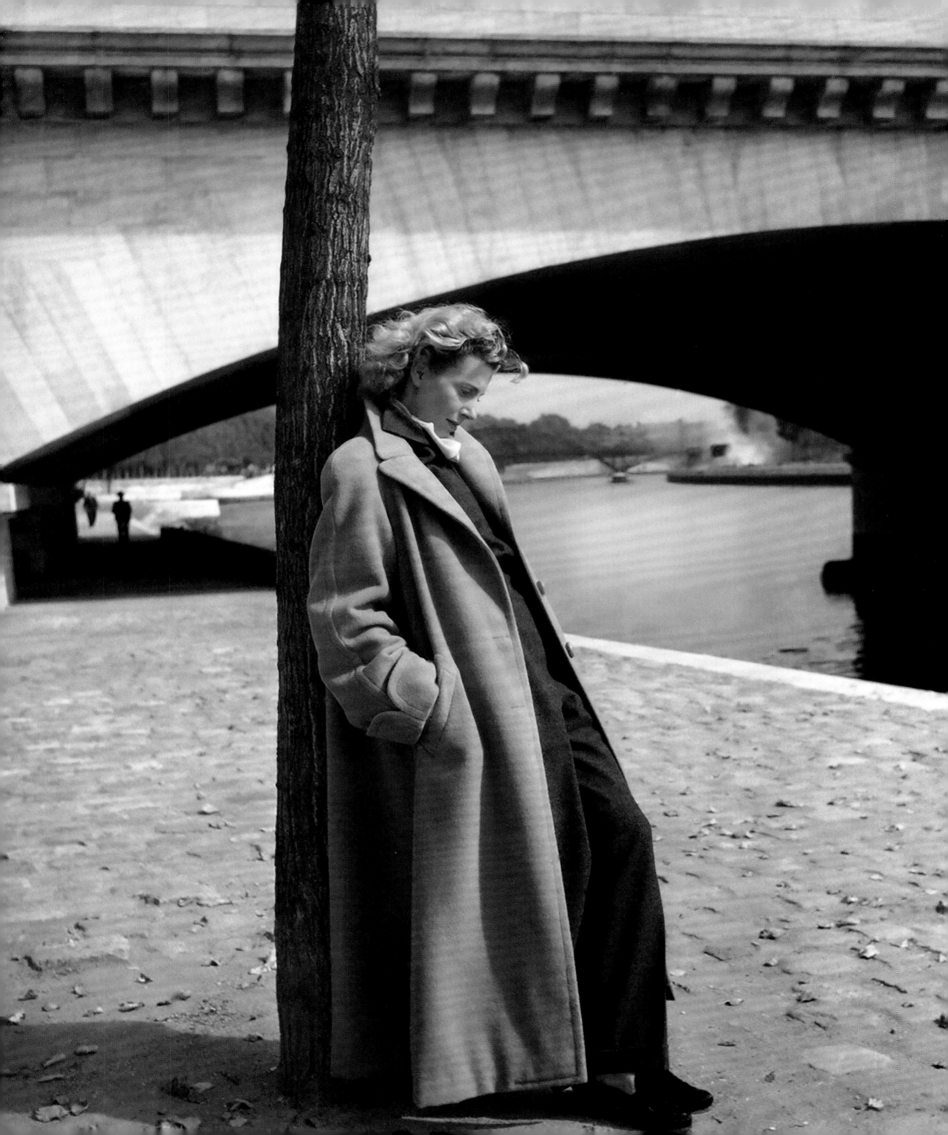

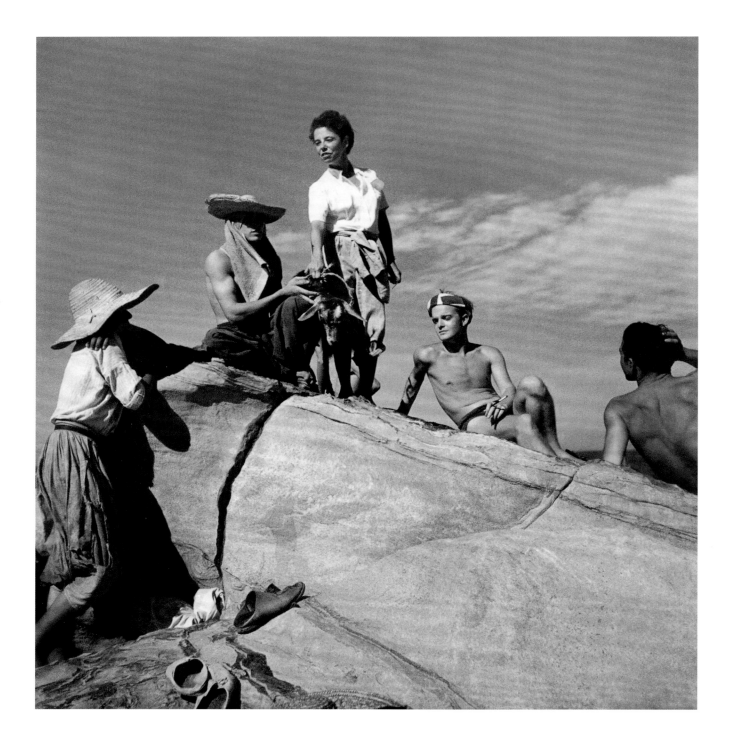

**Jane Bowles and Truman Capote
in Morocco
by Cecil Beaton**
The younger of two American writers
shows off for the camera, mimicked by
a young Moroccan to his left
January 1950 (taken 1949)

**Alfred Hitchcock in New York
by Irving Penn**
The British film director visited Penn's
studio during the production of *Under
Capricorn* (1949), a period melodrama that he
sandwiched between *Rope* and *Stage Fright*
October 1948

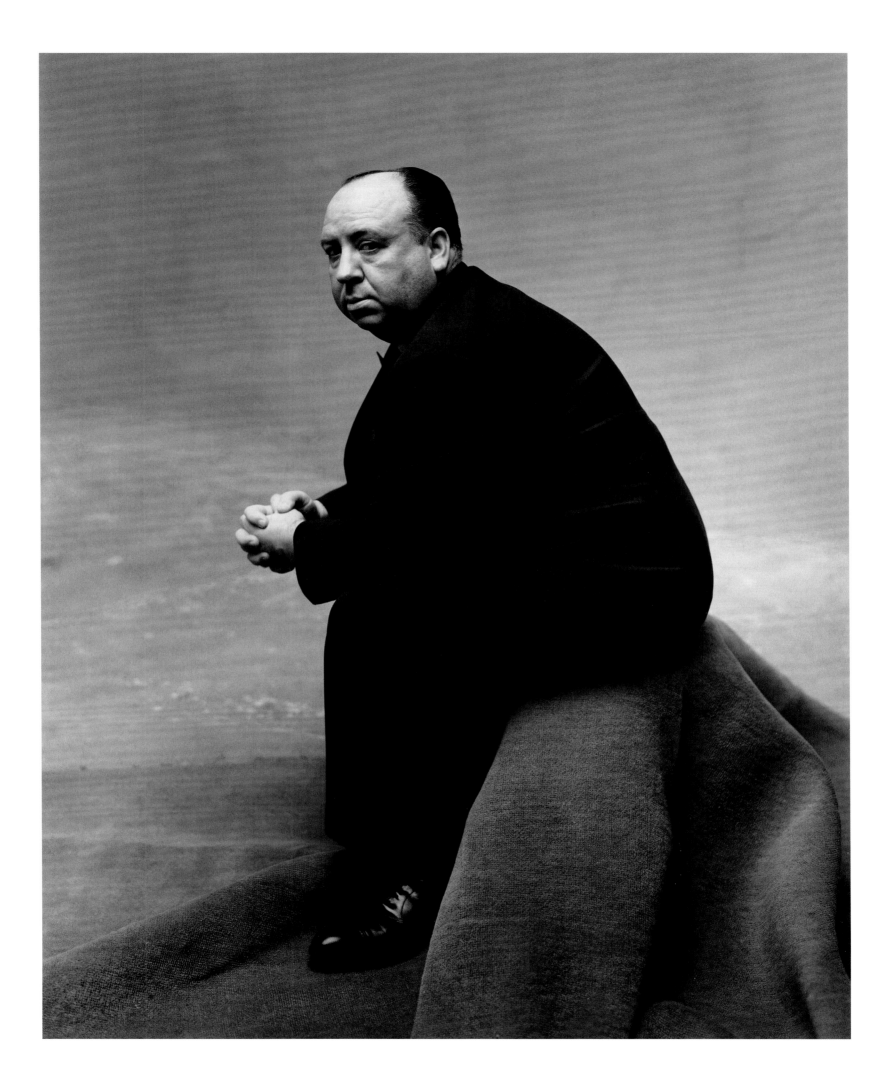

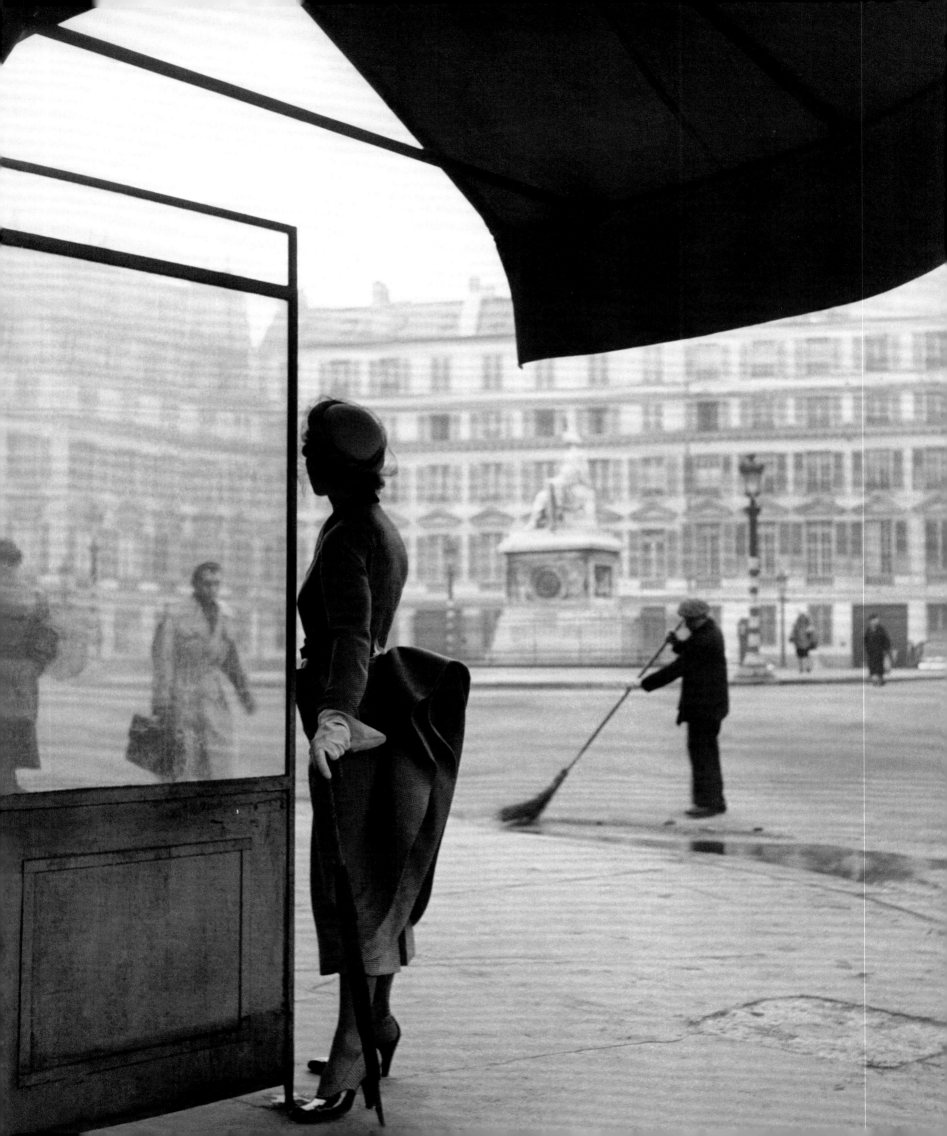

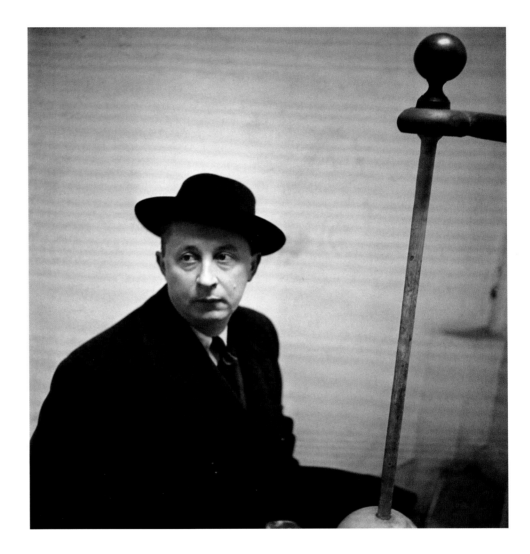

The New Look
by Clifford Coffin
An example of Dior's New Look: a
houndstooth wool dress with an *envol* (take-
off) back. A strong romantic feeling prevailed
throughout the spring collections, evoking
the Paris of Toulouse-Lautrec and Renoir
April 1948

Christian Dior at his first collection
by Clifford Coffin
'I was conscious of an electric tension,'
recalled *Vogue* fashion editor Bettina
Ballard. 'People who were not yet seated
waved their cards in a frenzy of fear that
someone might cheat them of their rights'
April 1947

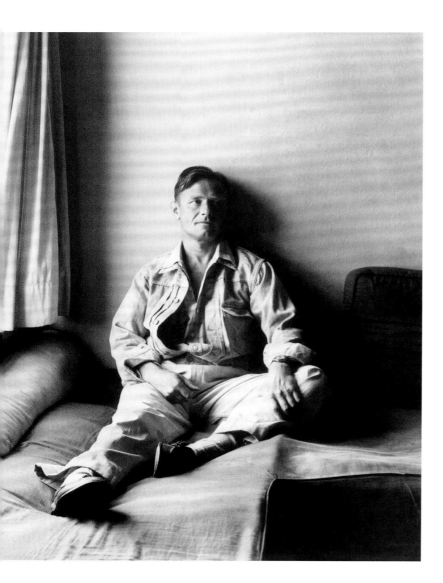

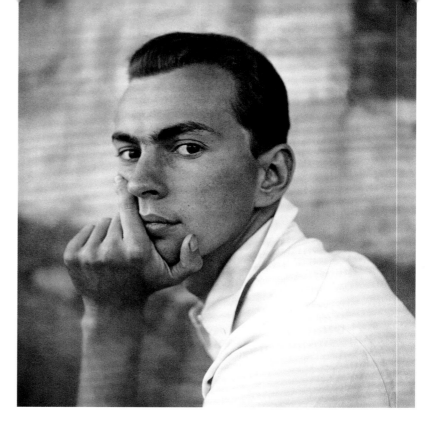

Above
**Gore Vidal on the Left Bank, Paris
by Clifford Coffin**
The young American writer of *The City and the Pillar* (1948) recalled, 'We spent a morning on the river, waiting for the right light to come off the river'
1949 (published later)

Left
**Christopher Isherwood at home in Santa Monica
by George Platt Lynes**
'Now and then he jumps from his chair,' wrote Lynes, 'stares out of his window at the Santa Monica beach, then sits down again, folding his legs under him like a yogi'
April 1947

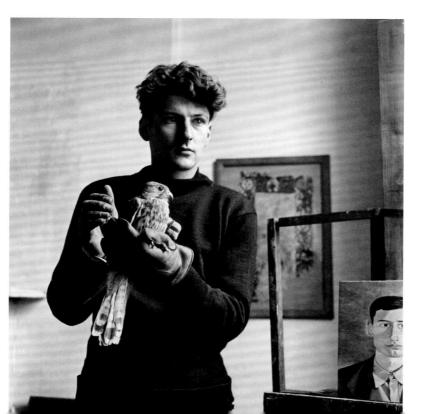

Left
**Lucian Freud and pet sparrowhawk
by Clifford Coffin**
Having traded a painting for a German Luger pistol, the artist shot rats for his birds alongside the canal near Regent's Park
December 1948

Opposite
**Henri Matisse at the Villa le Rêve, Vence
by Clifford Coffin**
In his eightieth year, the French artist was at work, from his bed, on designs for Sainte-Marie du Rosaire, a small chapel for Dominican nuns in Vence
June 1949

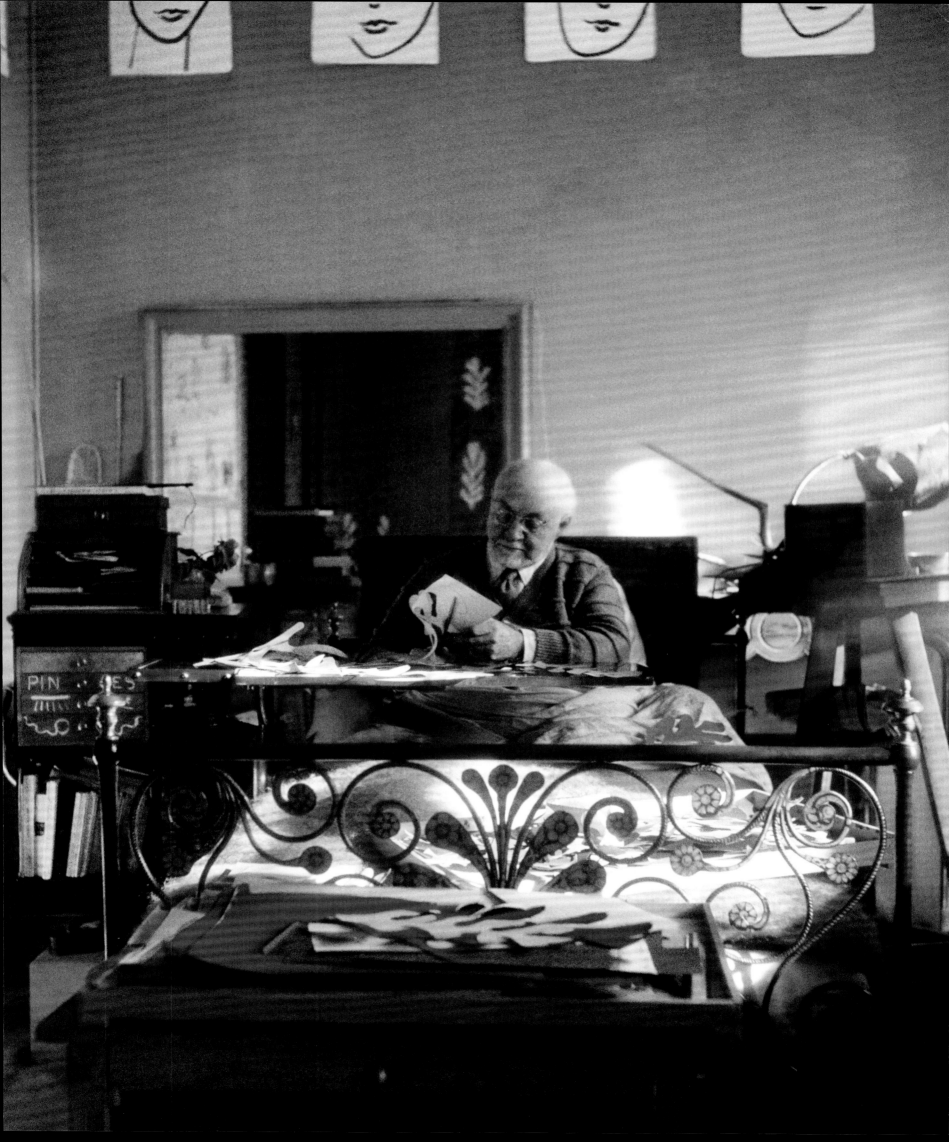

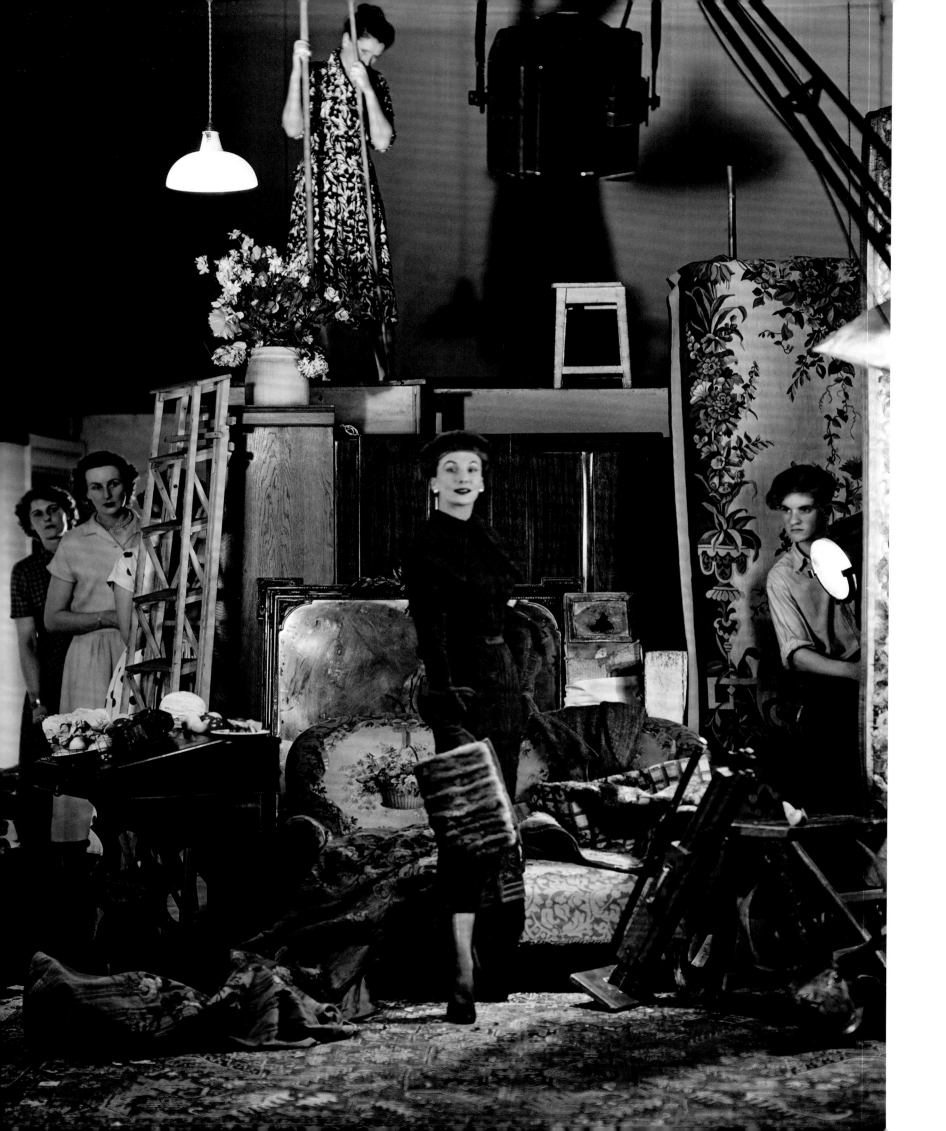

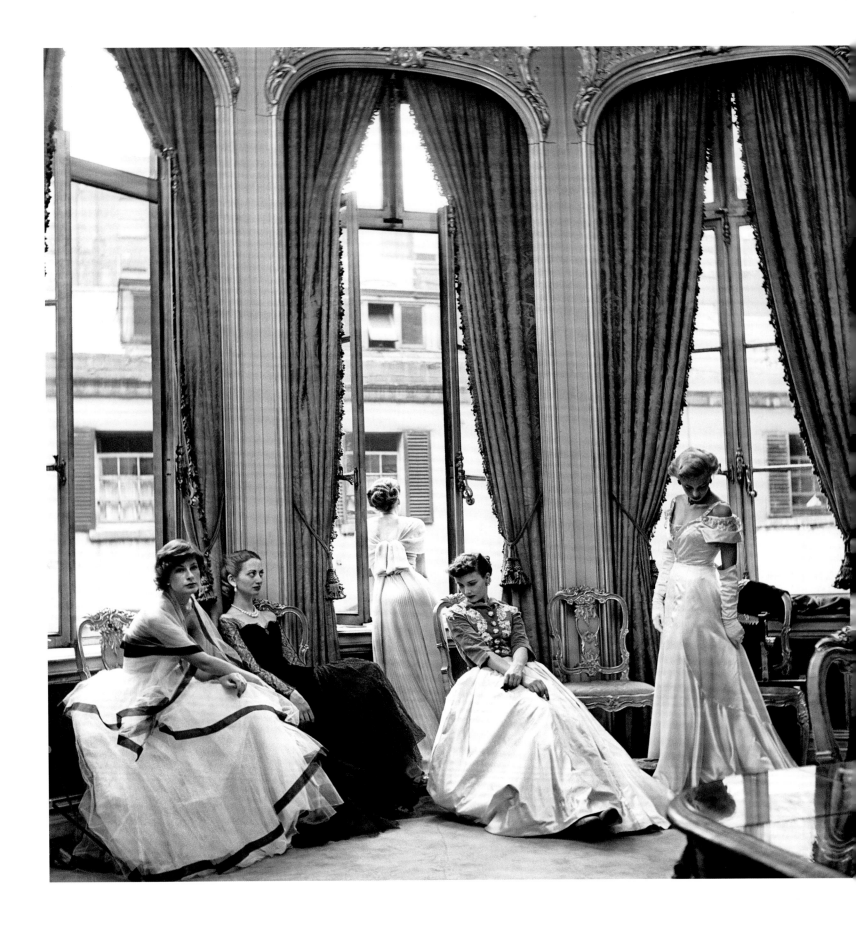

**Barbara Goalen in *Vogue*'s studio
by Cecil Beaton**
Breaking the fourth wall: Beaton
photographed the model behind the
scenes wearing a dress by Matilda Etches
October 1948

**A Conversation Piece
by Cecil Beaton**
The triumph of the New Look.
Romantic evening dresses from London's
eye-catching autumn collections
September 1948

Following pages
**Wenda Rogerson in Grosvenor Square
by Clifford Coffin**
Model Wenda Rogerson stands beside
the bomb-damaged staircase of a house
in London's West End
June 1947

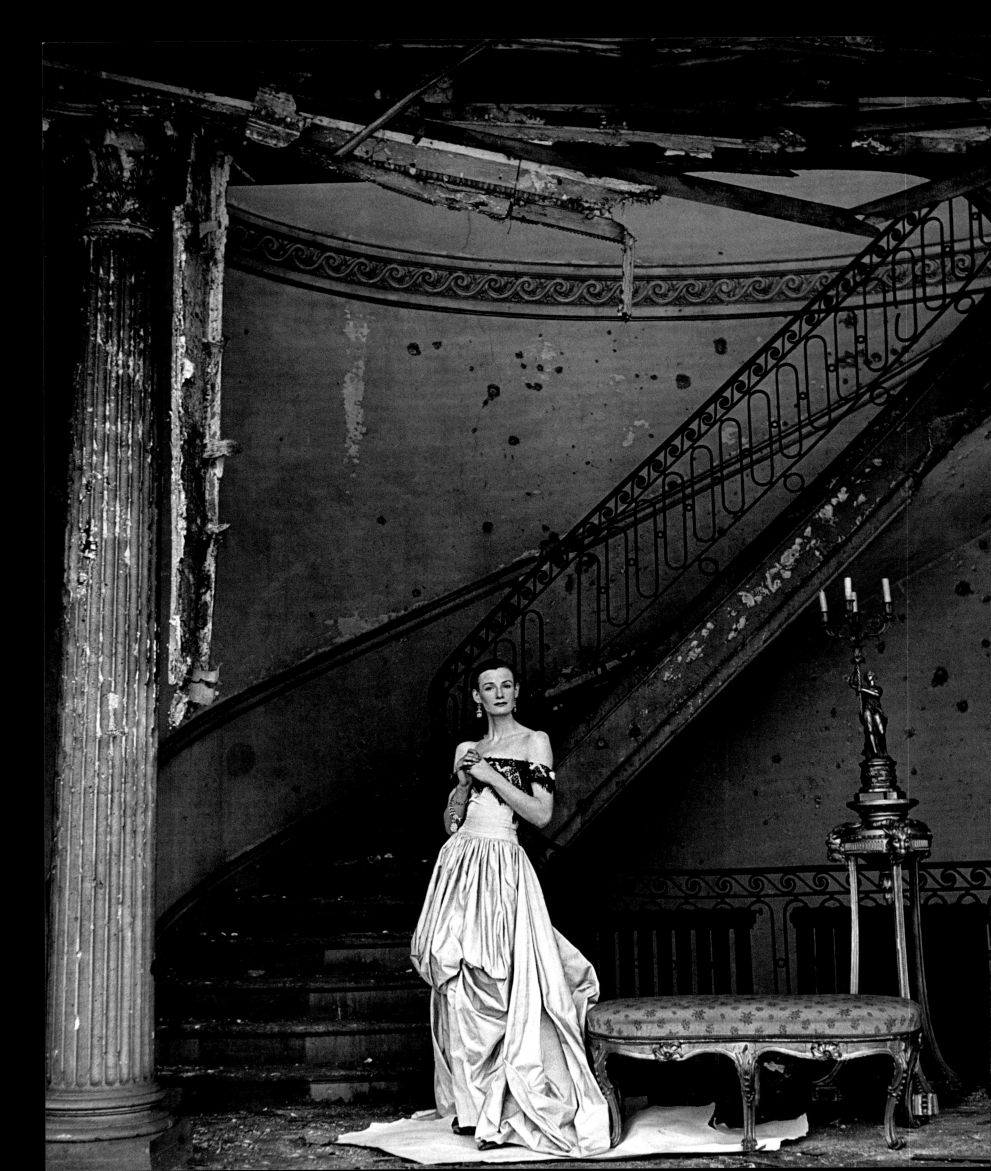

'New life – it spreads over the London scene like a dimly discerned haze. Ruins rise, and beauty has its second spring; the future holds equal hope and hazard, and the grace of a ball dress, bright against the rubble and brave in the encompassing dark, is a symbol of our gradual return to a certain serenity of life.'

'Renaissance', *Vogue*, June 1947

A Visionary Gleam

ogue had survived its second World War by reminding readers of their island nation's core strengths – resoluteness, pragmatism and an appetite for enduring crises with optimism. This was reinforced in words and pictures by neo-romantic notions of a simpler arcadian past, a theme that lasted into the 1950s and to which, most evocatively, the photographs of Norman Parkinson gave visual shape. Idyllic and inward-looking, in the years of peace Parkinson's photographs re-emphasised traditional and unshakeable values, daring the nation to think again of confidence and prosperity.

This was opportune, for Britain was bankrupt. Austerity measures – chiefly rationing – would remain in place until 1954. There were restrictions on travel and the Empire was decolonising. When George VI, the last British Emperor, who had guided his subjects through the greatest emergency of modern times, died in 1952, he was succeeded by his 25-year-old elder daughter, Elizabeth. As the prospect of a second Elizabethan age gained momentum, the spectacle of the Coronation – a pageant lent the full force of history and tradition – contrasted with the modernity that had distinguished 1951's Festival of Britain. *Vogue* gave extensive coverage to both. 'Suddenly, on the South Bank,' wrote Marghanita Laski of the festival, 'we discover that, no longer wealthy, we can be imaginative and experimental and ingenious, colourful, gaudy and gay.'

While the magazine was receptive to the new and the daring – and the science and technology of the festival promised a glittering future – it always found reassurance in the traditional and the familiar. The season's new colours may have been photographed next to a model of the double-helix molecular structure of DNA, but this was tempered with time-honoured staples: how to dress for a season that still embraced Henley, Ascot, shooting in Scotland and hunting in the shires. The cover of *Vogue*'s Coronation issue played to both, looking forwards and backwards. It showed simply a pub

Previous pages, left
**'The varnished truth': Jean Patchett
by Clifford Coffin**
In the California sunshine, Patchett wears a
Mexican *rebozo*, styled by the photographer. 'Coffin
was a perfectionist,' said *Vogue*. 'He could create
impeccable elegance from the simplest ingredients'
July 1951

Clockwise (from top left) Vogue covers: for the Coronation by
Norman Parkinson, 1953; a monochrome ensemble by Irving
Penn, 1950; a striking 'multiple' of a Dior dress by Clifford
Coffin, 1954; and a taxi cab sprayed fuchsia for Parkinson,
1957 *Left* 'Va-va-va voom' by Tony Armstrong Jones, 1959.
His carefree fashion photographs enlivened *Vogue*. 'Maybe
Vogue readers stopped to look, but I doubt if it helped to
sell clothes,' he remarked *Below* Audrey Hepburn and
pet donkey in Rome for *War and Peace* (1956) by Norman
Parkinson, 1955

window etched with the royal crown. An unexpected image, it marked a moment of egalitarianism for *Vogue* that presaged the 'classless' 1960s.

Another example of social equality had occurred earlier. In February 1951, for the magazine's 'Britannica Number', the American photographer Irving Penn made a series of portraits of the practitioners of the 'small trades', a high point of Audrey Withers's tenure at *Vogue*. Dustmen, coster-mongers, rag-and-bone men, brewers' draymen, chimney sweeps – all were invited to Penn's studio exactly as they were found. The butcher came in his stained aprons with knives drawn, navvies with their shovels, a hod-carrier with his bricks. Penn recorded each as a taxonomist might an undiscovered species or equally, as *Vogue* considered, one that might van-ish. 'We ask you to look with fresh eyes at some of your oldest friends before their different marks of office disappear into uniformity.'

The well-born photographer Tony Armstrong Jones made his own contribution to the new iconoclasm. At *Vogue* he found the perfect plat-form for deflating a world that he felt took itself too seriously. His meticulously contrived fashion shots were slapstick, irreverent and eye-catching. 'I was determined to have fun for myself and hopefully for the reader as well,' he recalled in 1983. 'The models were made to move and react, either by putting them in incongruous situations or by having them perform unlikely or irresponsible feats. Anything but stand still.' In 1960, when Armstrong Jones married the Queen's younger sister, Princess Margaret, his instinctive lack of stuffiness gave the Royal Family a different image for the decade to come.

Top left Jean Patchett in a Balenciaga dress by Norman Parkinson, 1950
Top centre Nena von Schlebrügge introduces *Vogue*'s model contest in a portrait by Claude Virgin, 1959 *Top right* Illustrated cover by René Bouché, 1954 *Above left* Spread for the colour of the season, photograph by Donald Silverstein and illustration by Eric Stemp, 1955
Above right Evening and day wear at the autumn collections as seen – in Paris – by fashion illustrator Bouché and photographer William Klein, 1957

With the new democracy came a new and untapped demographic: young people. In 1953 *Vogue* introduced its 'Young Idea' pages: 'We believe in an independent fashion for the young … a clean and uncluttered look, witty rather than frivolous, practical and yet not incapable of fantasy.' In 1955 Mary Quant and Alexander Plunket Greene opened their boutique (the term then a quaint neologism) on the King's Road, Chelsea. At Bazaar, as it was called, cheaper clothes were sold, aimed directly at the young. It would have a major influence on British fashion.

On the international stage, the 21-year-old designer Yves Saint Laurent, who had taken over Maison Dior on the death of its founder in 1957, launched his inaugural collection. The applause was deafening. 'Saint Laurent has saved France!' ran the hyperbolic headlines. Another key moment had not gone unnoticed by *Vogue*: the return to the fashion world of Coco Chanel in 1954, after a fifteen-year hiatus. Her words that year to *Vogue*'s Rosamond Bernier, unthinkable in 1939, were now entirely in tune with the new reality: 'I am no longer interested in dressing a few hundred women of privilege, private clients,' she pronounced. 'I shall dress thousands of women.'

**Dylan Thomas in the graveyard at
Laugharne, Carmarthenshire,
by John Deakin**
This print of the poet originally belonged to his friend
and fellow carouser, the painter Francis Bacon
March 1950

**Wenda Parkinson at Hyde Park Corner
by Norman Parkinson**
Rus in urbe. Mrs Norman Parkinson wears a
tweed suit by Hardy Amies and a black lamb
box coat from the London collections
February 1951

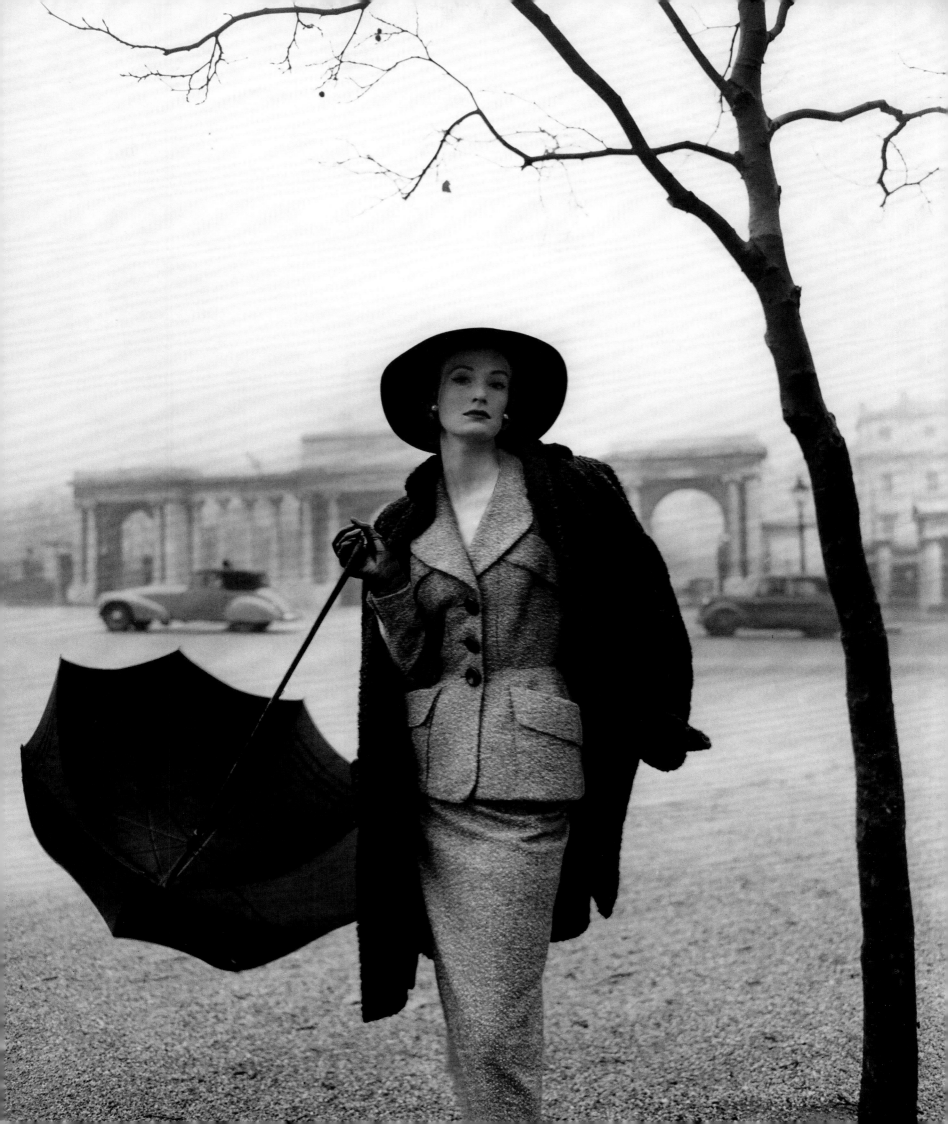

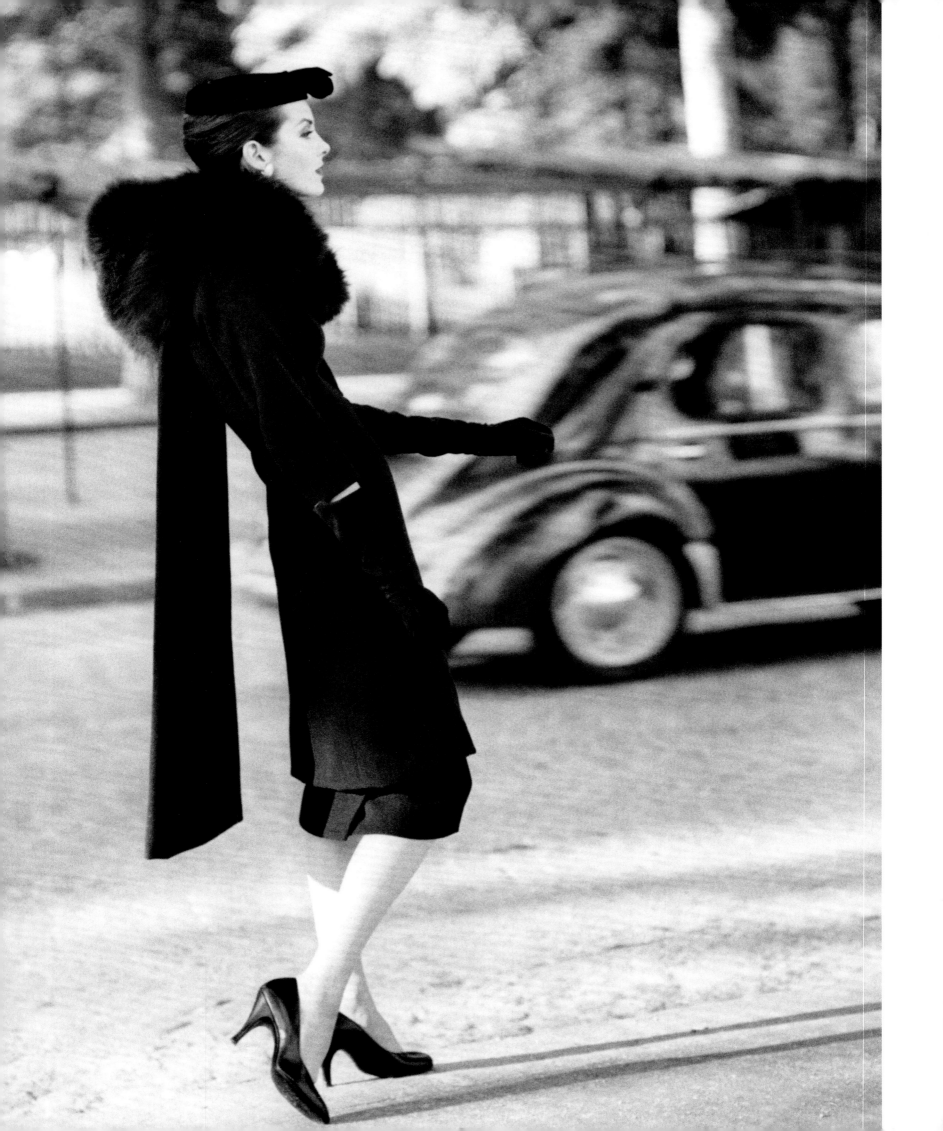

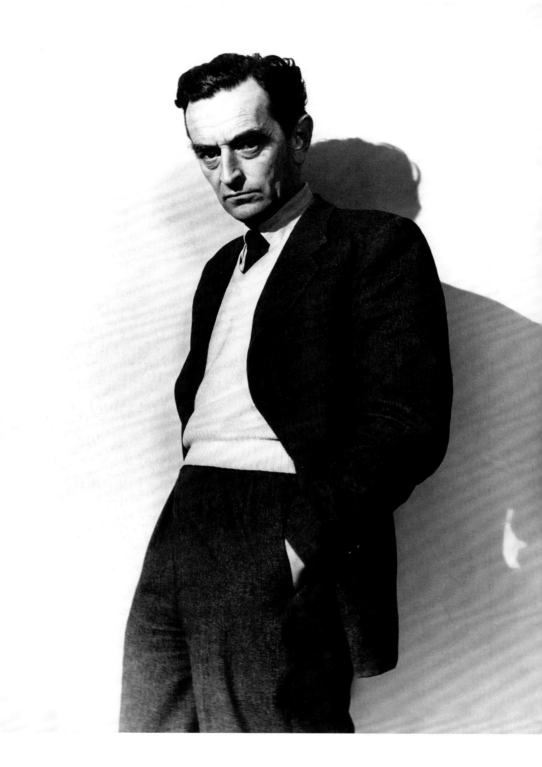

Previous pages, left and right
Anne Saint Marie in a Paris street
by Henry Clarke
'Rebirth of the panel, floating from collar
to hem,' reported *Vogue*. Such a sinuous
black dress with faux-fur collar marked
out Cristóbal Balenciaga as the couturier
of the moment
September 1955

'In the manner of Van Dongen':
Adèle Collins
by Norman Parkinson
Thrown out of focus to resemble a Kees
van Dongen painting, a deep glow of scarlet
suffuses a velvet toque by Otto Lucas
November 1959

Opposite
Francis Bacon
by John Deakin
'He's an odd one,' wrote Deakin, 'tender and
generous by nature, yet with curious streaks of
cruelty. I think I managed to capture something
of the fear, which must underlie these
contradictions'
1952 (published later)

Above
David Lean on the set of *The Sound Barrier*
by John Deakin
Lean was a consummate film-maker and director
of actors, one of the best of his generation. His
films would win twenty-eight Academy Awards
1951 (published later)

CECIL BEATON
from 'Royal Album', *Vogue*, June 1953

'WHEN I entered the gates of Buckingham Palace for the first time, on my way to photograph the Queen (now Queen Elizabeth the Queen Mother), I was determined that my photographs should give some hint of the incandescent complexion, the brilliant thrush-like eyes and radiant smile, which are such important contributions to the dazzling effect she creates in life. I wanted so much that these should be different from the formal, somewhat anonymous-looking photographs, or the rather hazardous candid camera shots that had, till then, been taken of the Royal Family.

To help me in my task I found I had every facility that the Palace could offer: the various state apartments, with their groups of marble columns, ornate ceilings with garlands of fruit and flowers, rows of crystal chandeliers illuminating the acres of Savonnerie carpet below, gave me wonderful opportunities for "conversation piece" backgrounds. Or, if I wished, my camera could utilise the felicitous glimpses of the long corridors with their tall windows hung with crimson silk, through which could be heard the click of bayonets and rasping voices during the changing of the guard. The gods were with me that day. Everything went well. There were no unforeseen difficulties. The sun even came out and poured down through the tall windows, giving an extra sparkle to the gilded carving and the glitter of diamonds. Wherever we went in the Palace, Blue Drawing Room, Yellow Drawing Room, Circular Music Room, Throne Room, the scene was dominated by the enchanting almost fairy-story figure in her sparkles and spangles.

Since that initial sitting, I have been fortunate enough to be asked to take pictures both at Buckingham Palace and at Windsor Castle on many historic occasions.

I have been honoured to photograph the present Queen at many stages of her adolescence. The first occasion was as a girl of sixteen, who wore a Kate Greenaway party dress of pink taffeta, and I tried to take the pictures "in the manner of Gainsborough". During the war I photographed her many times wearing schoolgirl blouses and skirts, Scottish tartan suits, or with the insignia of the Grenadier Guards in her cap: once, at a time when the Royal Family, like everyone else, had to conform to clothes rationing, in one of her mother's evening dresses altered to fit her.

During the bombing of London, we photographed in the ground-floor living rooms, when many of the possessions had been taken into hiding. After the war, pictures were taken with her sister on the ornate "Ministers'" staircase of the Palace and against a snow scene painted by the late Rex Whistler. I was always impressed by, and grateful for, the exceptionally charming manners that the young Princesses had in relation to the job of being photographed.

When Princess Elizabeth attained her majority, I was bidden to Windsor Castle to perpetuate the occasion. The youthful princess I photographed that day has now become a queen of remarkable qualities. Her unique legacy has made her a person apart, and the training to play the role of sovereign is today evident in the increasing authority of her personality. She is benevolent; her regard is unhurried and gentle, filled with human understanding and kindness; she is meek but not shy; assured and even proud – proud of her heritage. She has the strong and forthright virtues of Queen Victoria, and her reign may well become as famous.

Though I am not a child photographer, I was to take the first photographs of Prince Charles and, two years later, of his new-born sister. On this second occasion, after a number of pictures had been taken, Prince Charles, who had been watching the proceedings with great interest, kissed the baby on the cheek, and thus was achieved the best picture of the afternoon, an infant version of the Sleeping Beauty.

My most recent pictures of Princess Margaret were taken when she came of age. That day, we utilised the Chinese drawing room for our backgrounds, also a pretty, rose-coloured room whose walls were hung with Boucher tapestries representing the life of Don Quixote. She looked extremely small as she sat for my camera, while through the lens I could see her wonderful complexion, the ice-cream pink cheeks and the intensely blue cat-like eyes. She was wearing an evening dress by Dior of which she was very proud. The embroidery on this skirt intrigued her for she said it contained pieces of potato peel. It was not easy for her to get French dresses, as she must of course encourage British dressmakers, but this was a rare exception.

It is not always entertaining to sit still and pose by the hour while inarticulate people run around one in circles, but long after the novelty has worn off and saturation point has been reached the Royal Family are patient and obliging. Many members of the Royal Family are extremely interested in the technique of photography, and, taking their own private snapshots, know a good deal about the various small cameras in use. Like all of us, they are often curious or even impatient to see the results of these long sessions. When the proofs of the pictures have been submitted, I am sometimes summoned to discuss the results. There are perhaps thirty or forty prints laid out on the floor so that the housemaids have a shock in the mornings when they come to do the rooms. I have never suffered heartbreak that my favourites were not among those chosen, for, in general, the royal choice has coincided with mine.

Kings and Queens are not in the habit of visiting a photographer in his studio, and so he has to set up his paraphernalia and lights in one of the rooms in the Palace. I bring a number of extra props in case they are needed, but I try to avoid delays and to make the sitting as informal and relaxing as possible.

An equerry or lady-in-waiting appears to check that all is well, retires and soon the page announces the imminent arrival of the sitter. At the far end of a long corridor a very small figure, possibly wearing a crinoline, is approaching. As the swish of her dress material becomes louder, I go towards the advancing figure and make my bow. My assistants are presented. Bows left and right, smiles, some remarks about the background I have set up or the chair chosen to play an important part in the sitting. Then the feverish exciting work begins.'

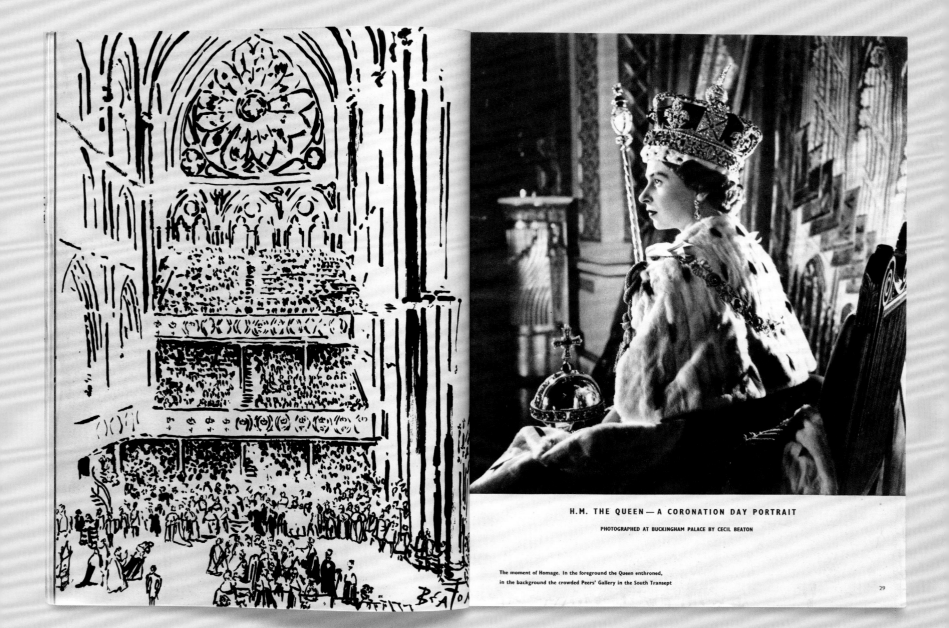

H.M. THE QUEEN — A CORONATION DAY PORTRAIT

PHOTOGRAPHED AT BUCKINGHAM PALACE BY CECIL BEATON

The moment of Homage. In the foreground the Queen enthroned,
in the background the crowded Peers' Gallery in the South Transept

29

**Queen Elizabeth II at her Coronation
by Cecil Beaton**
The new monarch poses in front of an ersatz
Abbey backcloth. Social historian Peter
Quennell noted how she appeared to glow:
'The strangely transfiguring radiance that
encircles those who occupy a throne'
July 1953

Evelyn Waugh
by Irving Penn
'Man of letters, man of wrath,' recorded *Vogue* on
the occasion of Waugh's new novel *Men at Arms*
(the first of his *Sword of Honour* trilogy), while the
historian James Lees-Milne called him 'the nastiest-
tempered man in England'
July 1952

Covent Garden market porter, London
by Irving Penn
'Mr Penn brought to his studio typical English
workers, taking them straight from their places
of work, and posed them in complete naturalness
to stand for the other countless members of
their trade', noted *Vogue* in admiration
February 1951

THE CONDÉ NAST PUBLICATIONS LTD.
INTER-OFFICE MEMORANDUM

To Miss Withers From Mr. Coats

Date 13th October, 1953.

I am sending you these photographs to see which were taken by Anthony Armstrong-Jones in the south of France at a villa belonging to Lady Kenmare, where I stayed this summer. You may remember we discussed Anthony Armstrong-Jones, who is Oliver Messell's nephew, in relation to photographs of personalities, house parties, etc. Since we saw his work then, I think he has come on a lot, and these photographs seem to me to be of high quality and would be the sort of thing we could use in House & Garden, & Vogue

PC:jjb

THE CONDÉ NAST PUBLICATIONS LTD.
INTER-OFFICE MEMORANDUM

To Mr. Coats From Miss Withers
c. Mr. Parsons Date 4.1.'54.

I am very sorry to have been so unresponsive with regard to the photographs of Anthony Armstrong Jones, which you sent me. I sent these on to John Parsons and I am afraid that, between us, they have got buried.

John feels, and I agree with him, that the photographs are not distinguished as such though they are adequate. We imagine that his value would mainly lie in his entre to people's houses, house-parties and so on. I suggest that you talk it over with Anthony Hunt and if he thinks well of the idea you might get Mr. Armstrong Jones to tell you of occasions whe he is planning to visit some interesting house so that you and Mr. Hunt could decided whether it would have a place in House and Garden. Certainly he is a photographer whose work I should be glad to see from time to time, but I feel that its value to us would lie in its subject matter, rather than its quality. By all means, however, let him know that we would always be glad to see his work and to be kept in touch with his plans.

Memoranda between Peter Coats and Audrey Withers
Having been a fixture on the 'deb circuit' for *Tatler* and *The Sketch*, Tony Armstrong Jones – the subject of this dialogue between *House & Garden*'s Peter Coats and *Vogue* editor Audrey Withers – took his first pictures for *Vogue* in 1956
October 1953 and January 1954

Opposite
'Mishap at Victoria'
by Tony Armstrong Jones
Armstrong Jones (later the Earl of Snowdon) liked to debunk high fashion in playful style. 'The only thing that can be said,' he observed, 'is that the photographs didn't imitate the elegant pictures by Irving Penn which I admired so much'
June 1959

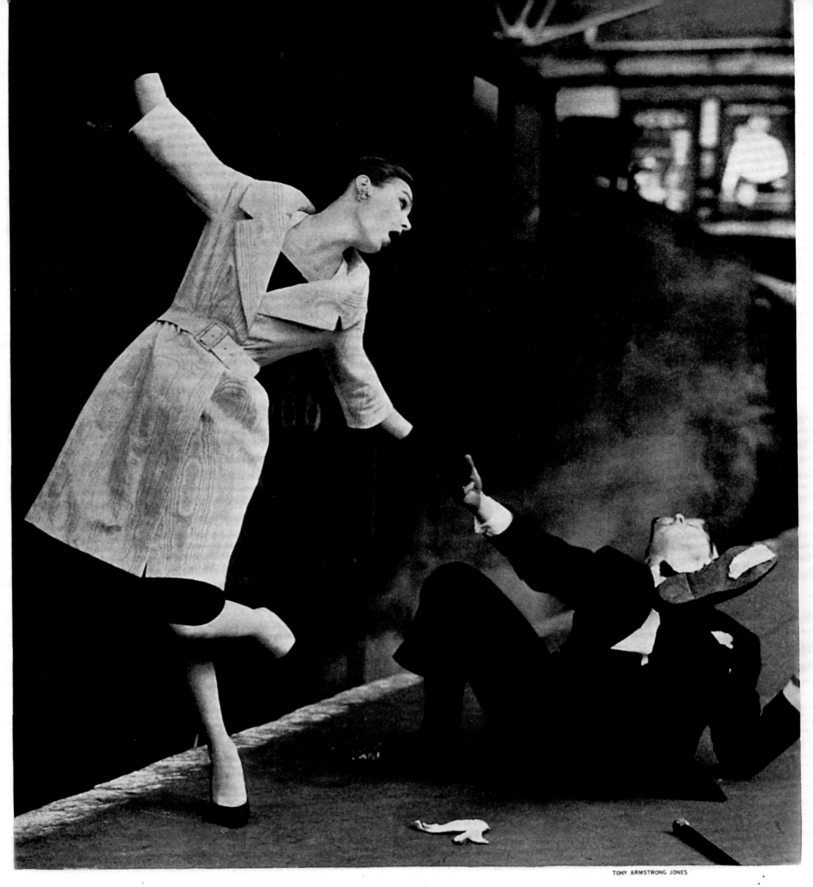

TONY ARMSTRONG JONES

Mishap at Victoria, where two elegant opera-goers were embarking for Glyndebourne till . . . a banana skin intervened . . . which leaves the cream moire trench coat still standing—serenely unmoved by a 3.45 p.m. platform appearance, and very much in charge of the evening dress beneath, a shaped and slender sheath of sleeveless black crèpe

**John Osborne
by Tony Armstrong Jones**
For *Vogue*, Osborne's play *Look Back in Anger*,
first performed in 1956, 'worked like an enema
of dynamite on the polite pretence that all
was fine in a world of stage drawing-rooms'
May 1957

**Alec Guinness in *Hotel Paradiso*
by Tony Armstrong Jones**
This dramatic close-up of actor Alec
Guinness rehearsing the Feydeau farce
marked Armstrong Jones's debut as a
Vogue photographer. He would become
the magazine's longest-serving contributor
May 1956

'She leans forward as she talks, the angular jaw thrust forward like a Toulouse-Lautrec lithograph of Yvette Guilbert. Without prelude the talk flows endlessly in rapid-fire, dry intense monotone. No full stops, no rhetorical effects, an uninterrupted long-playing record, no change of tempo or volume. A first-person-singular whirlpool, flinging off interpolations or questions, following its own course.'

Rosamond Bernier, 'The Return of Chanel', *Vogue*, February 1954

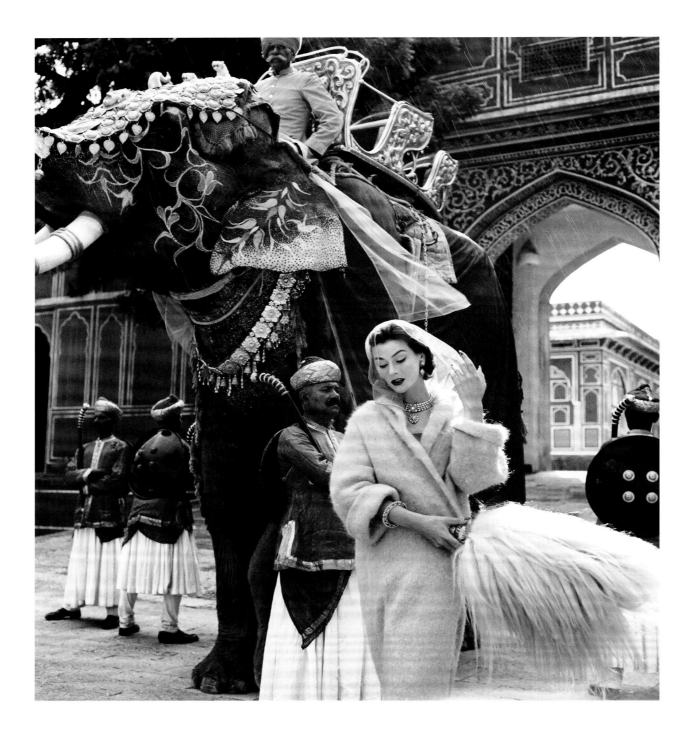

Previous pages, left
Anne Saint Marie at the Paris Collections
by Henry Clarke
A simple jersey suit marks the renaissance
of Chanel, 'the greatest individualist ever
to work with a bolt of cloth'. As always,
Vogue would be entranced
October 1955

Anne Gunning in Jaipur
by Norman Parkinson
'In India,' declared *Vogue*, 'one's urgent wish
is to be a photographer. The eye is stormed
a million times a day by colour of a full-
throated beauty'
November 1956

'Luminous brilliance'
by Herbert Matter
Vogue's graphic qualities meet its
photographic. The hand drawing a face
with a Charles of the Ritz lipstick belongs
to the fashion illustrator René Bouché
August 1955

**Yves Saint Laurent before his first collection
by Irving Penn**
'Yves Saint Laurent, on whom the Dior
mantle falls,' declared *Vogue*. 'How he will
wear it is the great fashion question mark
right now.'
February 1958 (unpublished version)

Following pages
**'Comet to New York': Mr and Mrs John Taylor
by Tony Armstrong Jones**
'If you imagine a silver lamé boa constrictor with
the curve of a quickly-gulped lunch inside it, this
is what the Comet looks like,' commented *Vogue*
on the novelty of jet flight
January 1959

'New York is a fantastic city. (I don't expect to be believed, but I saw a shooting, out of the windows of a large black car, on my first evening there.) But the trouble is that one's mind very quickly develops resistance to the fantastic.

So if one is in New York for a few days, one either develops a nasty headache and spends time drinking bourbon out of a tooth-mug in the hotel bedroom, or one gets into a so-what mood.'

Godfrey Hodgson, 'Small Towns and Long Journeys', *Vogue*, December 1959

The Pulse Is
Swinging London

'BRITAIN is the society that has done it all, and relinquished it all, only to lead the world again,' *Vogue* confidently proclaimed in 1969. By that time the world seemed to belong to the young, whose codes of behaviour, values and taste – and disposable income – influenced fashion as in no previous era. The Beatles stormed America (*Vogue* considered that the Rolling Stones, who followed them, required two further stages of evolution before reaching *Homo sapiens*). Vidal Sassoon revolutionised hairstyles geometrically. Mary Quant – or was it John Bates? – launched the miniskirt, emblem of the decade *nonpareil* (Courrèges introduced the couture miniskirt to Paris in 1964). Saucer-eyed model Twiggy sent *Newsweek* into overdrive, the magazine describing her in April 1967 as 'the phenomenon of the century'. (Twiggy herself said self-deprecatingly, 'I had to look that up in the dictionary before I could be sure it wasn't an insult.')

Others were less in thrall to the 'Swinging London' of popular imagination. Were these frenetic and glittering years at heart a myth, conjured up by 'the molten fraud of commerce, and copywriters, and journalists'? This view was suggested in *Goodbye Baby and Amen* (1969), David Bailey's photographic record of those whose vapour trails had soared high and, for a luckless few, had evaporated as the decade came to a close. His subjects – many shot for *Vogue* – included not only actors, writers and musicians, but also those with newly minted occupations: television hosts, creative directors and celebrity restaurateurs. At least six did not survive the 1960s.

Ironically, it was their recording angel himself, born in London's East End, who became perhaps the best-known signifier for the classless, meritocratic period he depicted. From 1962 to 1967 Bailey, still in his twenties, seemed to hijack every issue of *Vogue*. In November 1965 it gave over an entire issue to him and, in so doing, turned him into a concept as well as an adjective: 'Here they are,' it proclaimed in the new demotic, 'the most *Bailey* girls in the world ...'

Conventions were reversed; working-class photographers rubbed shoulders with hippy aristocrats who had dropped their titles. The Beatles received MBEs (though one was later returned) and a new 'popocracy' of models, photographers, musicians, the sons and daughters of peers, art directors and heads of advertising agencies was born. The abstruse, though of-its-moment, Michelangelo Antonioni film *Blow-up* (1966) explored aspects of this London elite, its unremitting self-absorption and its fascination with the new and immediate.

Against that backdrop and before London had begun to swing, the early 1960s were overcast for *Vogue*. The age of jet travel may have propelled fashion teams to new locations, but homespun fashion pictures were arranged against the rainswept, phosphorescent-lit streets of overspill new towns or barren Yorkshire moorland. Author Storm Jameson's tribute in *Vogue* in 1960 to the wool-producing northern towns was strikingly downbeat: 'Solid grimy streets, mills, warehouses, chapels, sluggish canals, factory chimneys vomiting smoke over hillsides scarred across and across by cramped houses.'

With the Iron Curtain drawn and the Berlin Wall erected, the Cold War nuclear threat seemed plausible. As *Vogue*'s features editor John Davenport put it: 'Somehow or other, even in 1960 it may be possible to straighten things out and back again. If you don't try, everything will be

Previous pages, left
Twiggy on a Raleigh motor bicycle, Battersea Park by Ronald Traeger
Twiggy was the most recognisable model in the world. 'Twiggy is called Twiggy,' explained *Vogue*, 'because she looks as if a strong gale would snap her in two and dash her to the ground'
July 1967

Above (left to right) Peggy Moffitt in Courrèges by David Bailey, 1966; Vidal Sassoon's angular bob by Terence Donovan, 1963 *Below (left to right)* 'Young Idea' spread featuring Kenneth Tynan and Jean Shrimpton by David Bailey, 1961; a graphic cover from 1961; a patriotic cover of Sandra Paul by Peter Rand, 1963

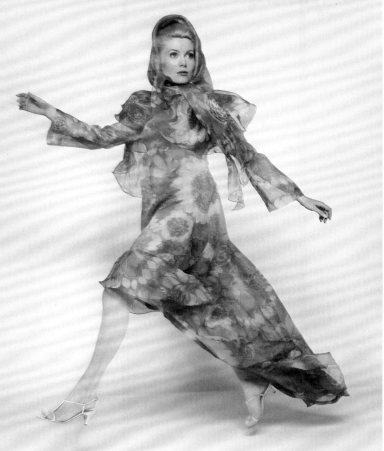

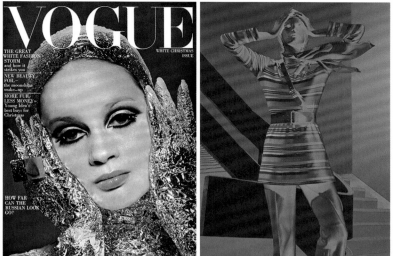

Above (left to right) Catherine Deneuve in orange and green chiffon by Bailey, 1967; Celia Hammond in silver, also by Bailey, 1966; a space-age tableau by Helmut Newton, 1969; two further examples of *Vogue*'s graphic design – a travel guide, 1962 and a recipe card from cookery writer Robert Carrier, 1963 *Below right* Jill Kennington by Bob Richardson, 1966

blown away by some cowardly, vulgar little push button …' Advances in technology were commended by *Vogue* but with an undertone of mistrust. In William Klein's photographs, Jodrell Bank looked hulking and sinister, pointing skywards and silently monitoring who knew what (p.135). Furthermore, in a series of low-angled fashion photographs by Helmut Newton, electricity hummed and spat behind chain-link fencing (p.146). No longer static and studio-based, the new fashion photography was hand-held and confrontational, and had its roots in the documentary photography of the streets. Suburbia never looked more derelict or its young inhabitants more anxious.

When the magazine embraced the exhilaration of the decade – around 1964 – it was revelatory. UFOs and Mick Jagger, the glory of synthetic materials, astrology, the horror of British food and Andy Warhol's 'Pop-ism' all found their place in editor-in-chief Beatrix Miller's *Vogue*. Art connoisseur Harold Acton wrote on reincarnation, satirist Jonathan Miller on spiritualism, feminist writer Germaine Greer on women's rights; *antiquaire* and leading light of the 'Peacock Revolution' Christopher Gibbs posed several imponderables in a modish 1968 piece, 'What's our Scene?': 'Are we an ailing generation of delinquent Gadarenes, high on acid and blighted hopes, participants in a shocking and godless *dégringolade*?' Set against student unrest in Paris, anti-war protest in Washington and in Britain economic decline, they went unanswered. And then the 1970s blew in: the chilly day of reckoning after a ten-year-long, occasionally lost, weekend.

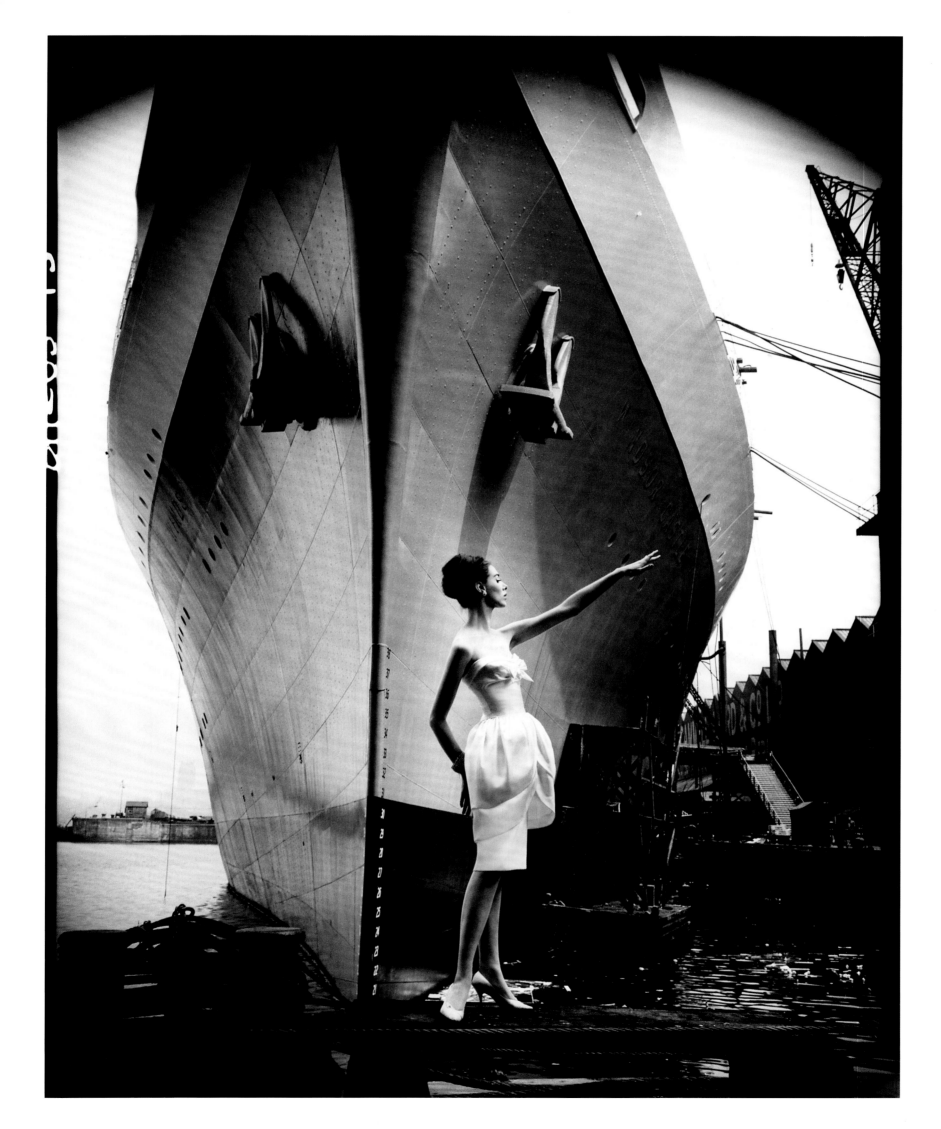

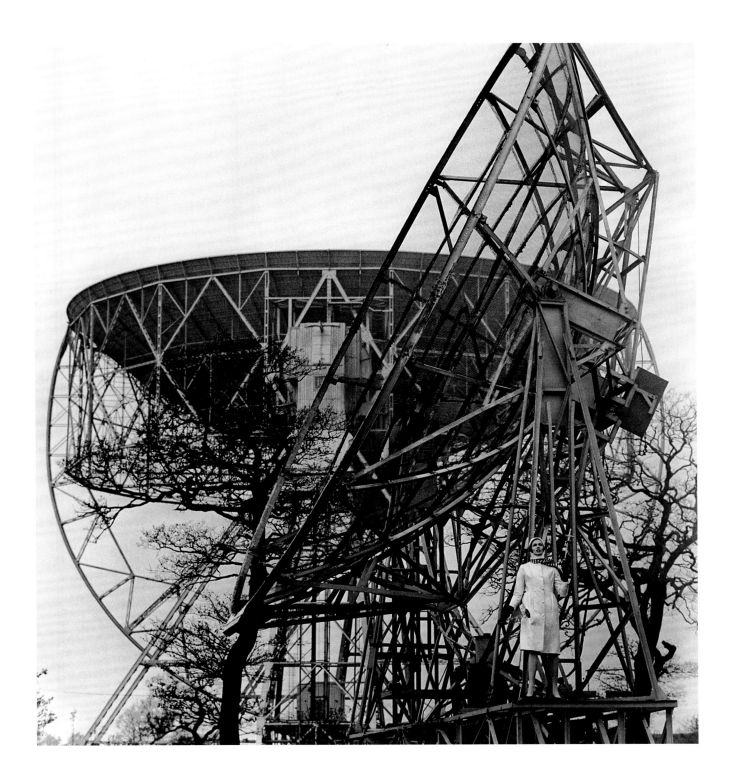

**'Ocean-going setting': Maggi Eckardt
at Birkenhead
by Don Honeyman**
The *dernier cri* of the ocean liner. Eckardt
poses alongside the RMS *Windsor Castle*,
briefly the largest liner to be built in Britain.
It was about to make its maiden voyage to
South Africa
July 1960

**'Space-age setting': Maggi Eckardt
at Jodrell Bank
by William Klein**
Eckardt models a white leather coat and
helmet at the Jodrell Bank radio telescope, set
in the Cheshire landscape. 'At set moments
through the day, the warning squawk of the
tracking hour breaks the silence'
July 1960

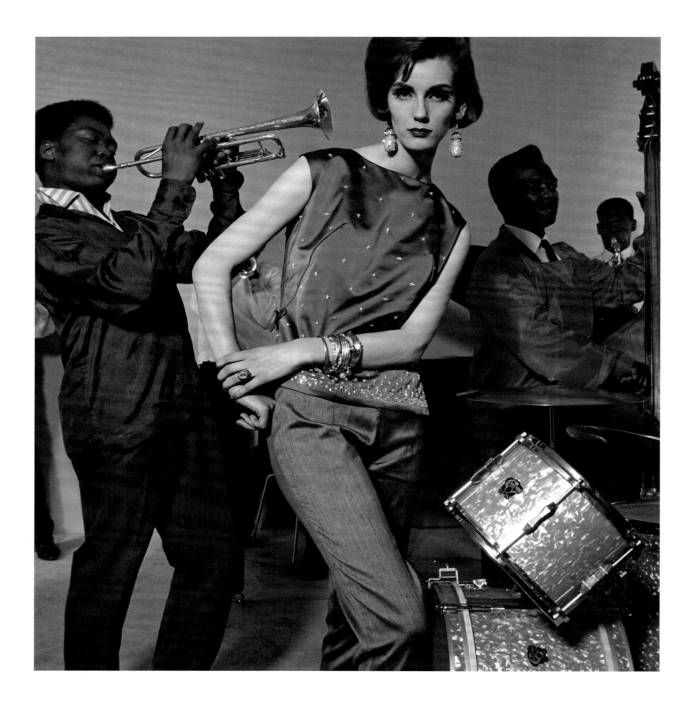

'Evening looks and all that jazz': Judy Dent
by Brian Duffy
Dent wears a Hardy Amies sleeveless top
embroidered with glass beads. Background
music was supplied by highlife quintet the
Koola Lobitos
October 1961

Ros Watkins in the streets of Bradford
by Frank Horvat
'With its cobbles, slate roofs, sturdy
stone-built houses, Bradford – with wool
as its staple trade – is still the centre of
the world market'
October 1960

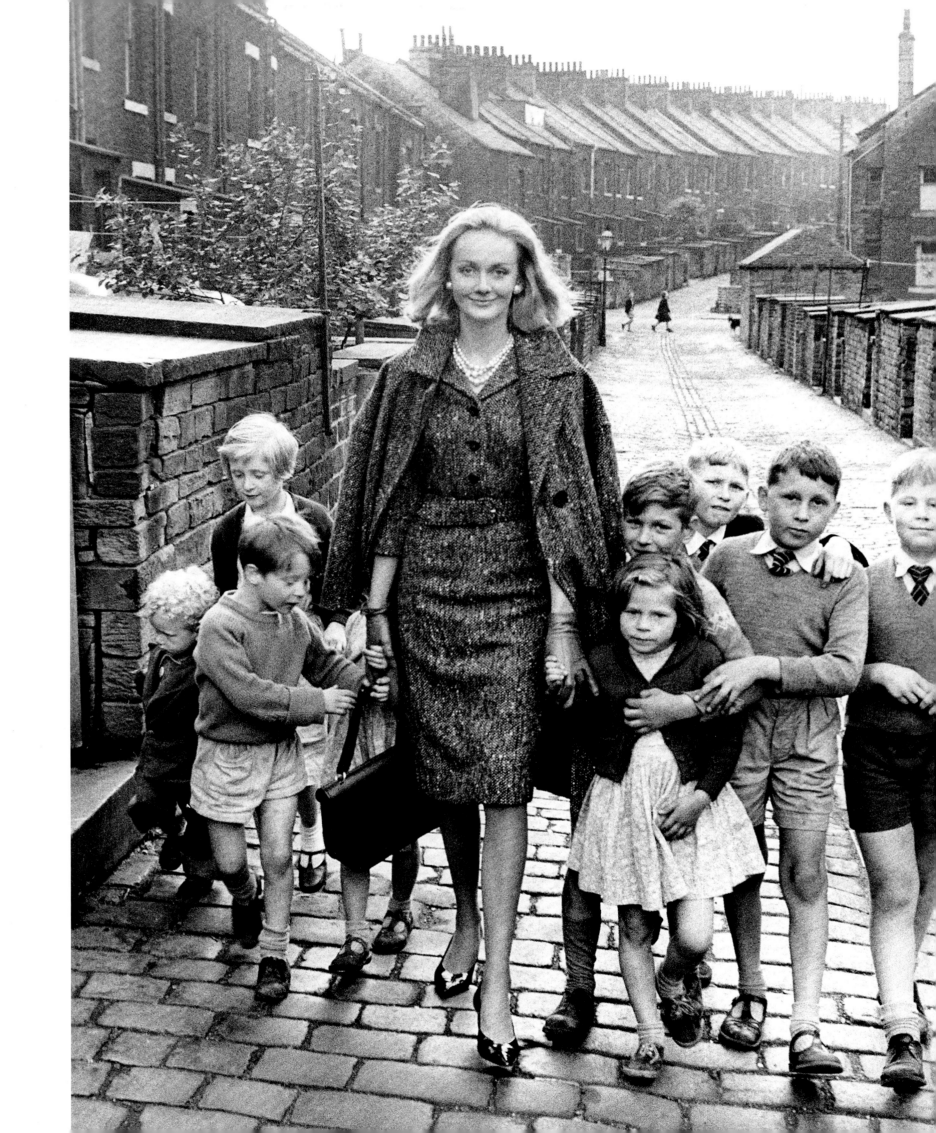

Crawley new town
by Terence Donovan
An advertorial image for Hoover set in rainswept Crawley, the site of one of the first new towns created to alleviate London's housing and employment problems
November 1962

'People who are just people'
by Peter Laurie
In the year the Berlin Wall was erected, the anxiety of this young commuter manifested itself in the symbol of disarmament chalked on to his jacket
December 1961

'*Somehow or other, even in 1960, it may be possible to straighten things out and back again. If you don't try, everything will be blown away by some cowardly, vulgar little push-button. Do you want this to happen? I don't. I want people to go on reproducing themselves in the only world we know. Nobody's going to enjoy the moon much. Poor old moon. But we've got to start now: there is literally no time to waste. That doesn't mean that you shouldn't be decently behaved and properly dressed in the meantime.*'

John Davenport, 'The Night Cometh',
Vogue, February 1960

**'Zest!': Tamara Nyman in Austria
by Ronald Traeger**
'The fashion word from Austria' – a heavy-
knit sweater and puffball hat of white
fox. The model became attached to central
Europe, marrying Prince Albrecht of
Liechtenstein a few years later
October 1963

ANTONIA FRASER
from 'Women and Cars – A Special Relationship', *Vogue*, October 1965

'ALTHOUGH chariots are temporarily out of fashion, women still drive their Minis swiftly onwards, as though drawn by horses rather than horsepower. Where cars are concerned, it is the spirit of Boadicea which animates the female breast, and it is not our fault, we feel, but the designer's that wheels no longer have knives flailing out of them. Of course, some latter-day Boadiceas are also inclined to reach for the poisoned chalice when things go wrong, for there is no historical evidence to show that the British queen knew how to change a wheel, any more than we do. But taken all in all, we are a company of enthusiasts, enjoying a series of special relationships with our cars, in an age when these may have gone out of the sphere of international politics but are still very much part of a woman's world.

In what does this special relationship consist? Undoubtedly it rises to its height in cases where the woman drives and the man does not, and husbands who are dependent upon their wives' driving speak with awe of The Car ("she's out with The Car...") as if some fearsome third party in their marriage. Perhaps English women have transferred to their cars those feelings which they traditionally feel for their horses: after all, it is in the teens that devotion to the pony and the riding school reaches its heights. Who knows if adolescent girls would not be just as happy grooming an E-type Jaguar, if the law of England permitted them to have a driving licence under the age of seventeen?

In the early days of motoring in this country it was often the pioneer spirit of the ladies, rather than of their husbands or fathers, which inspired the purchase of a car. The first woman to drive a car in this country, Mrs J.A. Koosen, was a person of such enterprise and initiative, that one is proud to "mote" (her own word) in her wheel tracks. Mr Koosen describes the importation of their Lutzman motor car in 1895 – one of the first three in England – in the following terms: "My wife said she liked the look of the thing, so I ordered one. I had then never seen a motor car, and was under the impression that you take your seats, press a button and the machine does the rest." He was soon undeceived, as reference to Mrs Koosen's diary, a moving document in the history of female endeavour, shows.

November 23, 24, 25 and 26 having been all spent fruitlessly in trying to get the motor to go, the November 30 entry reads triumphantly as follows: "Motor went with benzoline for the first time. Awfully pleased." However December 9 was not so good: "Drove to Lee at 10. Motor sparked at once and went well. After lunch started for home in motor car; came round by Fareham; had lovely drive; police spotted us; awful crowd followed us at Cosham; had to beat them off with umbrella." December 10: "Policeman called at 1.30; took our names re driving through Fareham without red flag ahead." December 16: "Took train to Fareham; met Hobbs (Hide and Hobbs solicitors) and Mr Heckett, and proceeded to Court House; filthy place; Hobbs spoke up well for motoring; silly old magistrate fined us one shilling and costs 15s 7d."

From now on it is one long catalogue of disasters, which might have daunted anyone less intrepid than Mrs Koosen. Finally Mrs Koosen takes her car to the Imperial Institute Exhibition and has a happy day driving people round the Institute in it, in spite of an explosion due to the blowing out of the asbestos joint of the exhaust box which "frightened Cumins into fits". Alas, the entry for July 18 reads: "By special permission all the cars were allowed to drive to Hurlingham, where we had an excellent lunch and drove round the grounds all the afternoon. On the way back something went wrong with the works, so we took a hansom; car was shoved back to Institute. Awful!" But Mrs Koosen was indomitable. On August 21 "Sold our car and ordered another of the same make."

One would like to know how the early women racers felt about their reinless steeds which literally hurled them abroad "Heavy curled stooping against the wind" in a way which Rossetti predicted, even if he did not foresee it. How did Madame Junek, the first woman to drive in the arduous Targa Florio race over the mountains of Sicily in 1927, feel about her famous Bugatti, which became a feature of European races between the wars? Did Mme de Gast, racing from Paris to Bordeaux in a 1903 de Dietrich and averaging 31 miles per hour to take seventy-seventh position in the Paris-Madrid race, feel any less tenderly towards her car than a successful rider towards the horse which has carried her to the end of a successful day's hunting?

However, exclusivity brings its own perils, and the special relationship of a woman and a car can in certain cases endanger her other relationships. In 1902 Lord St Helier optimistically prophesied that, among other benefits, motoring would "extend in a delightful manner the range of one's personal friendships, and promote pleasant social intercourse between the sexes". I do not feel that every man in 1965 would necessarily agree that motoring had fulfilled its early promise in this respect. I once had an ideal relationship in which it was My car but He drove it, but such happy combinations are hard to come by. On the whole I fear that cars, and the conducting of cars, have increased the heat in the sex war in a way which might please James Thurber, but bodes no good for the future of the race ...'

Jean Shrimpton and ten Minis
by Don Honeyman
Minis were 'British to the back wheels', reported *Vogue*. 'They've been snapped up in their thousands by Americans who are panting for more'
February 1962

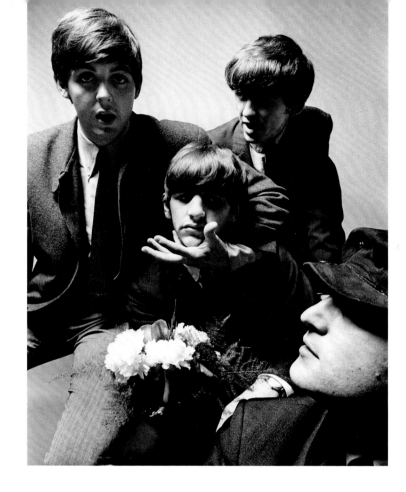

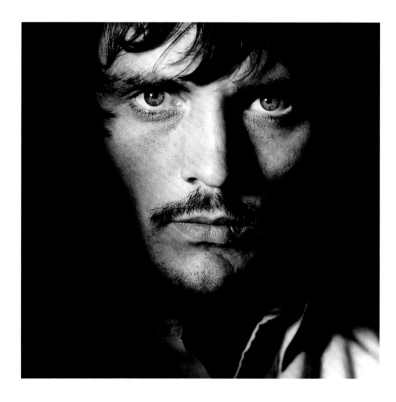

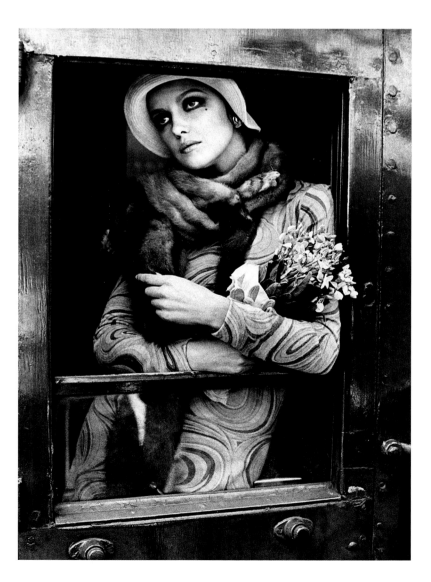

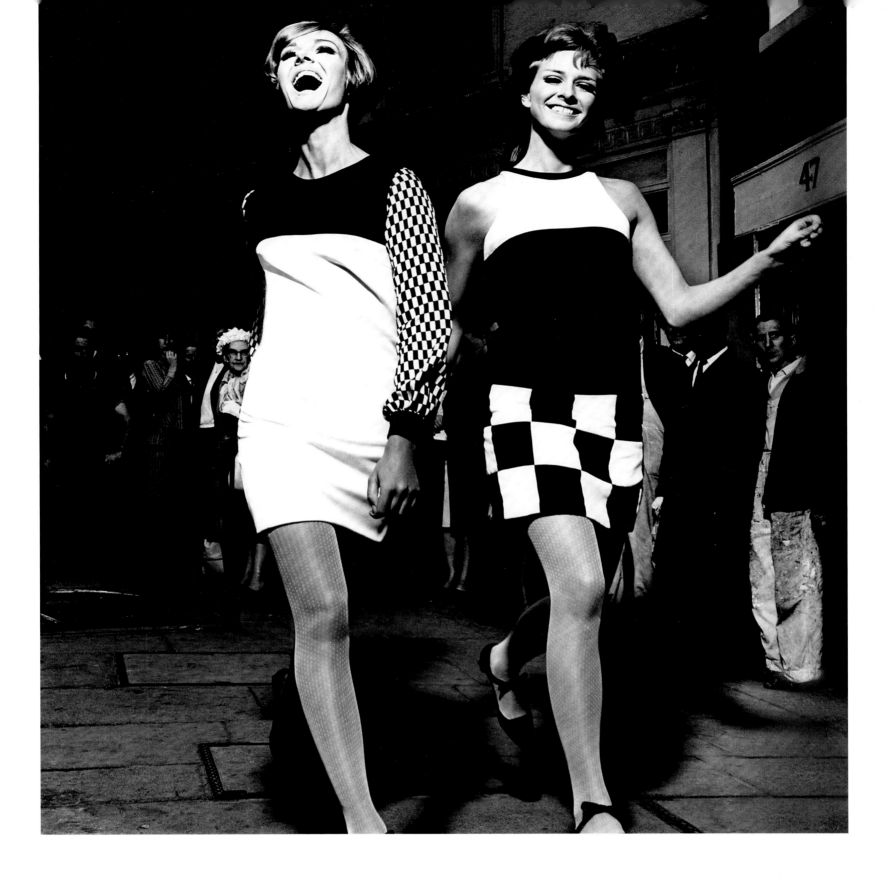

145

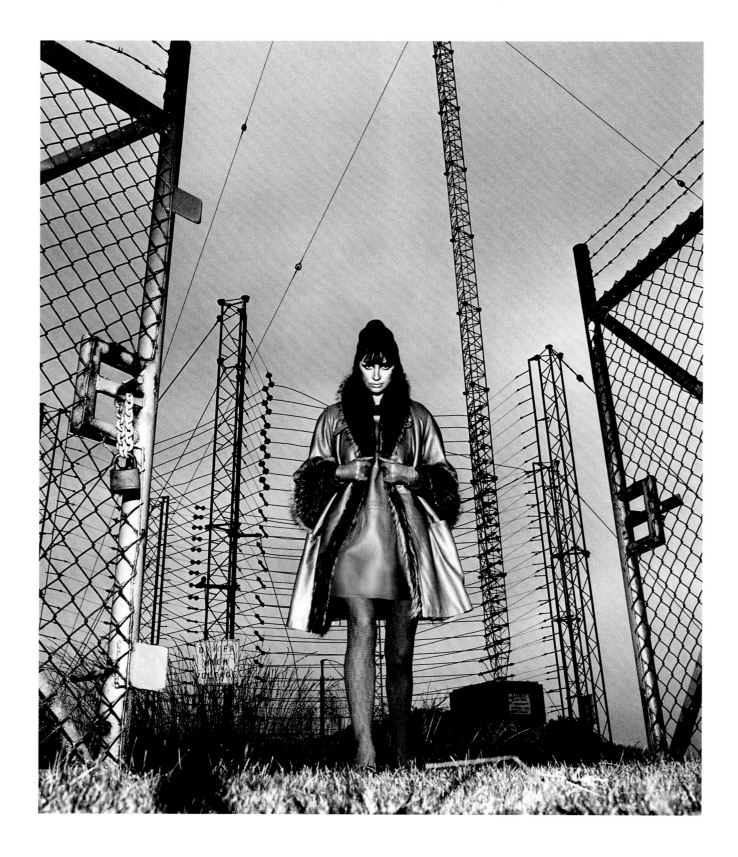

'High voltage': Katherine Pastrie
by Helmut Newton
Pastrie in a shocking red kidskin coat
with racoon ruffles over a minidress edged
in wool knit, both by Bonnie Cashin
November 1966

'Focus on the face': Jean Shrimpton
by Saul Leiter
The American photographer found fame with
his urban landscapes, pensive and oblique. Here
a similar sensitivity is brought to a beauty shot
August 1966

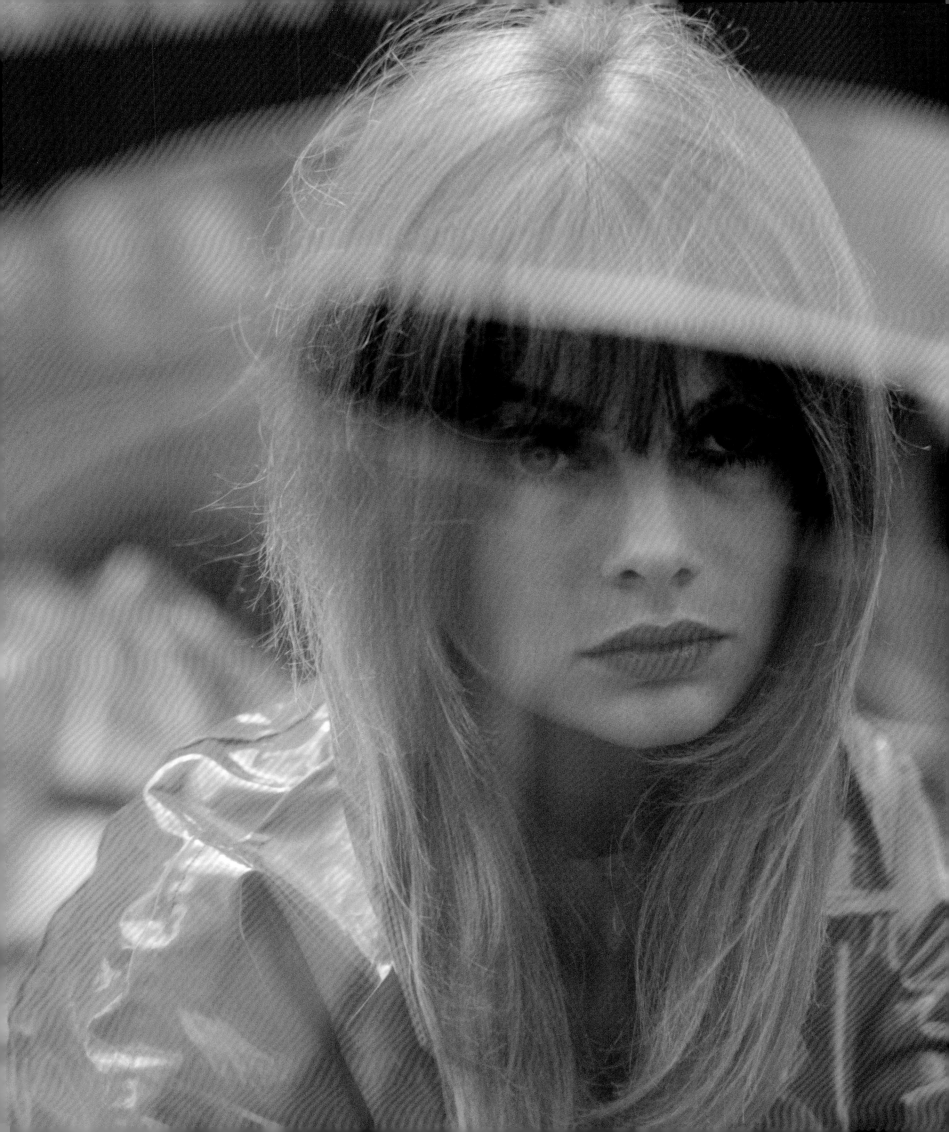

VOGUE

CONDÉ NAST PUBLICATIONS LTD

HANOVER SQUARE · LONDON W·1 GROSVENOR 9080

30th December, 1960.

, Esq.,

Clapham Road,
London, S.W.9.

Dear Mr. Bailey,

This is just to confirm the agreement we have entered into verbally,
that we make you a guarantee of £600 for work done for Conde Nast
magazines during the period of one year from November 1st, 1960, terminating
on October 31st, 1961. We shall pay you a page rate of £15 and prorata.
You will continue to receive payment for your Shophound photographs separately,
for which we will pay at the rates already established.

In return for this guarantee, it is understood you will do no editorial
work for either Harpers Bazaar or the Queen.

It is further agreed that you will channel all your advertising work
through Vogue Studio Ltd. who will provide the necessary film, processing
and prints at their expense, and that we will pay you a commission of 33-1/3%
on the net sum received for each advertising assignment that we may offer you
or you may bring to the Studio. Your commission will be credited to your
account monthly. It is further understood that all advertising work will be
placed through Vogue Studio Ltd. and that you will not undertake advertising
work other than through Vogue Studio Ltd. All prices for advertising sittings
must be arranged by the Manager or Assistant Manager of Vogue Studio, and their
decision as to the amount charged must be final.

I shall be very glad if you will be kind enough to sign the attached
copy of this letter signifying your acceptance of this arrangement, which will
then be considered binding on both parties for the length of the agreement.

I am very pleased to have you working for us, and I am sure you will
make a very handsome contribution to Vogue pages.

Yours sincerely,

John Parsons
Art Director.

DIRECTORS : H. W. YOXALL (CHAIRMAN), REGINALD A. F. WILLIAMS, AUDREY WITHERS, GERTRUDE PIDOUX, L. F. HARWOOD, J. PERRY, I. S. V. PATCÉVITCH (U.S.A.).

Letter to David Bailey
from John Parsons
Bailey's first *Vogue* photographs
appeared in 1960. Two years later,
he was its most prolific contributor
December 1960

Jean Shrimpton and Grace Coddington
by David Bailey
Two of *Vogue*'s fashion heroines model
the season's coats. Bailey's refusal to
conform made for a striking iconography
September 1966

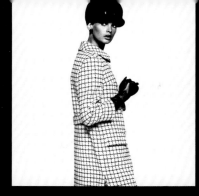

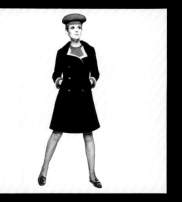
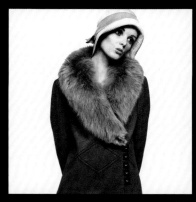
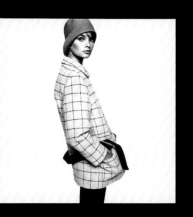
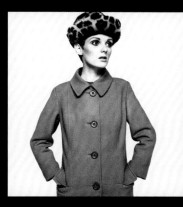
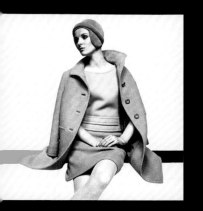
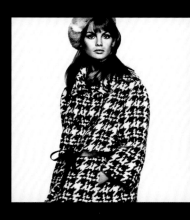
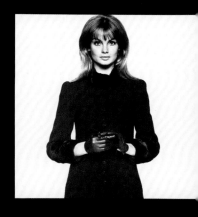
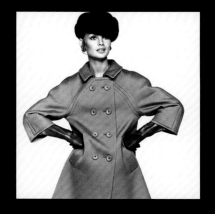
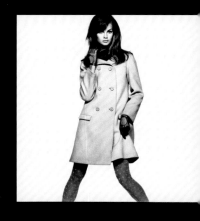
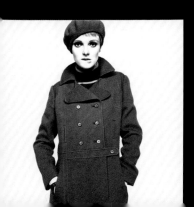
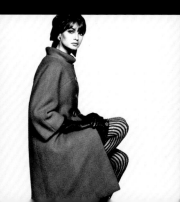
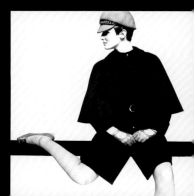

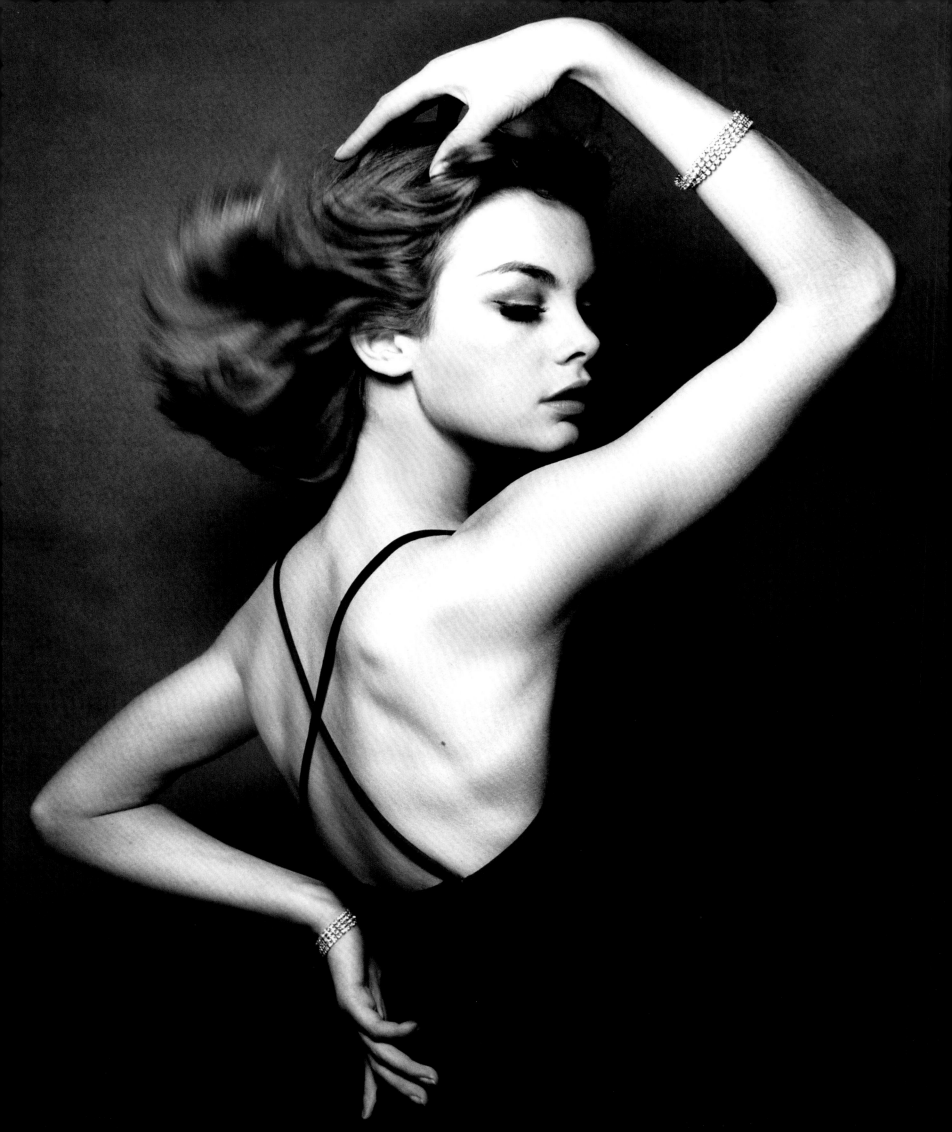

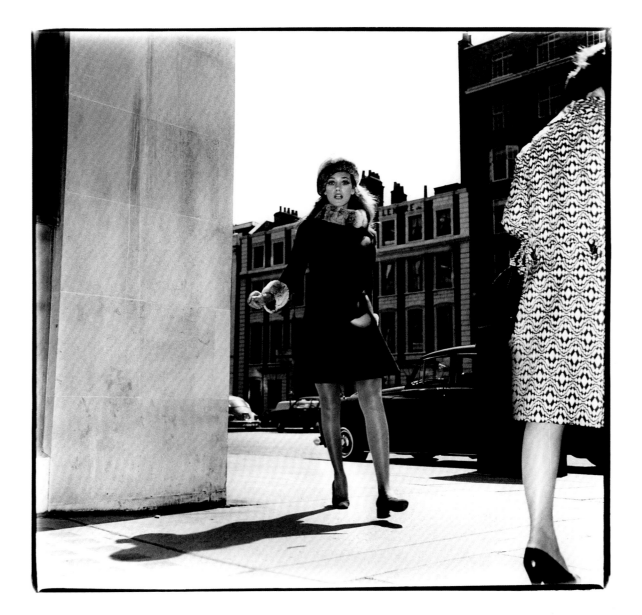

'Young idea': Jean Shrimpton
by David Bailey
For three years Bailey worked with
virtually no other model and the
collaboration of Bailey and Shrimpton
became a legendary one that lasted the
decade. It was, as one commentator put
it, 'a whirlwind romance via the camera'
February 1962

Marisa Berenson outside *Vogue*'s offices
by David Bailey
Marisa Berenson's *Vogue* pedigree was
an immaculate one. A favourite model
of Horst, Richard Avedon, Henry Clarke
and occasionally Bailey, her maternal
grandmother was the couturier
Elsa Schiaparelli
August 1968

Following pages
Donyale Luna on the set of
Qui êtes-vous, Polly Maggoo?
by William Klein
Luna became *Vogue*'s first black cover
model in the same year she appeared
with fellow models Peggy Moffitt and
Dorothea McGowan in Klein's art-house
film. It satirised the fashion world
October 1966

'It is a common fallacy to see the Plastic Age as dimly in the future, when these materials have already found their way into every aspect of our daily lives. Out of long habit we do not require of tin that it be rust-proof, of glass that it be unbreakable, of wood that it be fire-resistant, yet our ignorance of the new materials which will increasingly influence our lives allows us to ask miracles of them. At the beginning of this Plastic Age, we are standing in a place as charged with change as our ancestors were at the beginning of the Stone Age, the Bronze Age, the Steel Age.'

Freda Koblick, 'The New Frontiers', *Vogue*, October 1966

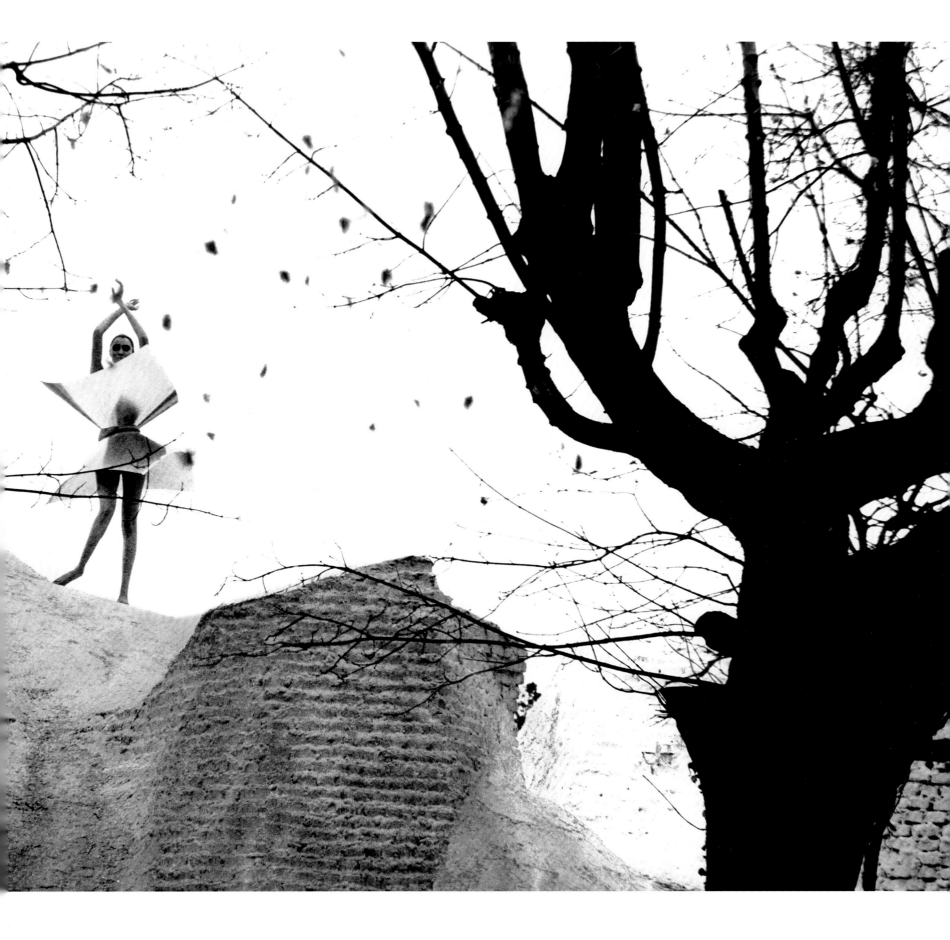

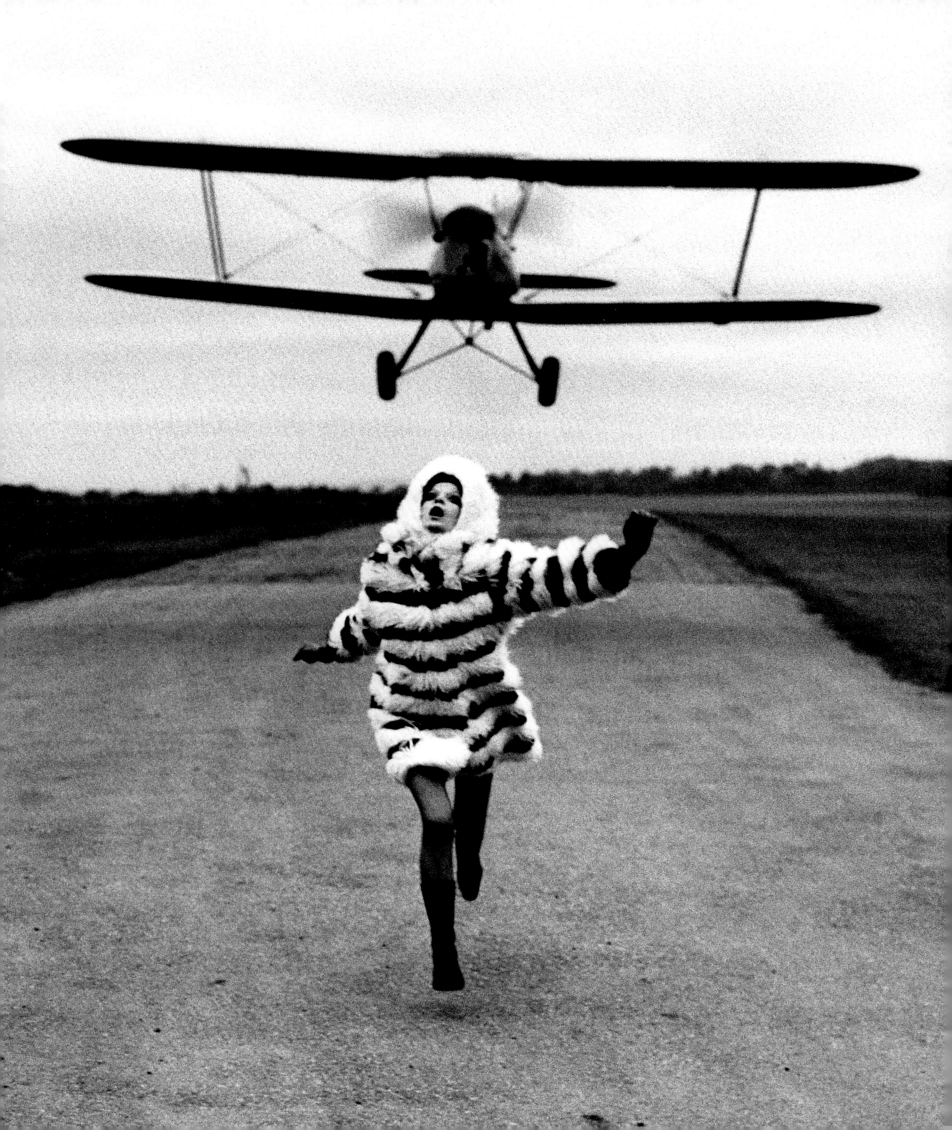

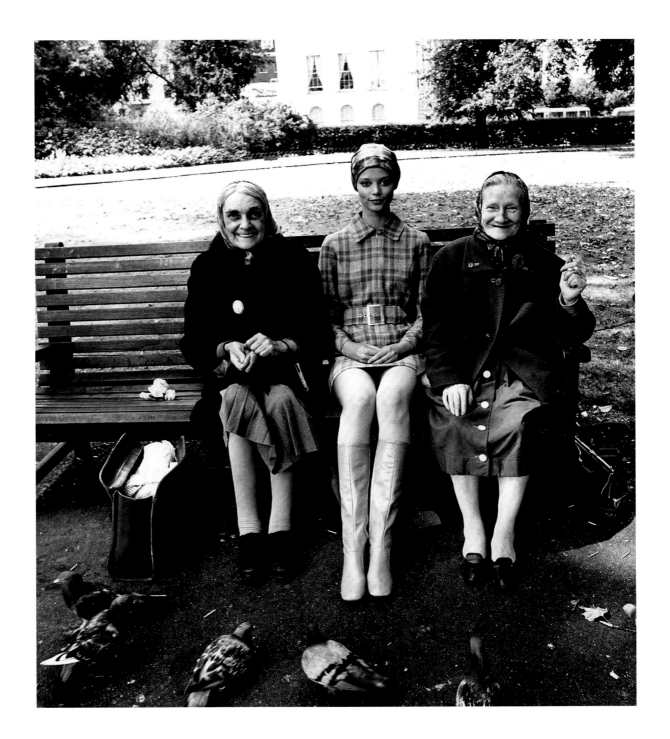

Willy van Rooy
by Helmut Newton
A Hitchcockian pastiche illustrated
the season's new furs. This coat, of
white Mongolian lamb and black kid,
was from Young Jaeger
December 1967

'Patterns in the Park': Mouche
by Barry Lategan
A gentle intrusion into daily life in
Regent's Park. French model Mouche
wears a woollen shirtdress by Sally
Grant for Emcar
September 1969

Following pages
David Hockney, Maudie James and
Peter Schlesinger
by Cecil Beaton
In Hockney's studio, James models lilac
sequins over chiffon culottes and matching
muffler, while the painter's muse looks on
December 1968

'It was in New York in 1961 that he first dyed his hair with "champagne ice", bought himself spectacles as large as bicycle wheels, and generally created for himself an astounding appearance. But soon you get over the shock of the pale canary silk hair, the pistachio suits, the retina-irritant Day-Glo colour of his ties, scarves and handkerchiefs. To see him, as he does a drawing, looking so intensely up and down at you through his super-Harold Lloyds, is to be reminded of the monkey house; but he will not mind this for he is far cleverer than the entire monkey house put together.'

Cecil Beaton, 'Eye to Eye', *Vogue*, December 1969

Pressure Drop

'SEVENTY-FIVE, the hinge of the decade, when we start to realise what we look like,' wrote novelist Angela Carter in *Vogue*. Her essay, which took in feminism and rejection of the bra, the 'fantasy milkmaid-ism' of Laura Ashley and the T-shirt as signifier of 'true classical modernism', disabused the notion of the division of history into decades, at least as far as changes in fashion were concerned. It was an unusual essay for *Vogue*, not just for Carter's postmodernist scrutiny of fashion and the mass market, but also for the fact that real life intruded in terms the magazine usually took pains to gloss over: 'economic instability', 'fiscal disaster', 'prophecies of ecological doom'. But this was the austere 1970s, and the harsh realities of the world outside were difficult to ignore.

When the economy was hit by escalating rates of inflation, a golden age of post-war prosperity in Britain came to a halt. Industrial unrest led to a three-day week to conserve energy. As prices soared, households panic-bought and hoarded. By August 1975 inflation had hit 26.9 per cent and politicians who were old enough to remember were comparing Britain to the hyper-inflationary Weimar Republic, as did *Vogue*. While life was not as harsh as during wartime, the sentiments were gloomily familiar: 'If you are making use of what you have, if you like to eat well without paying a lot of money for it. If you like to keep your family well, you will look like this. The clothes aren't smart but they obey the first rule of dress, which is that clothes must be appropriate.'

With no sign of short-term salvation, *Vogue* commissioned in 1977 J.G. Ballard's glimpse of the future: communities where residents simply hotwired themselves into the hardware. 'Without difficulty, we can visualise a future where people will never meet at all, except on the television screen.' The magazine's contributors may have included the dystopians Ballard, Samuel Beckett and Anthony Burgess, but the pull of popular culture was still strong. The hold that television acquired over the public during the 1970s led one observer to consider this the decade when Britain came closest to being 'one nation united by a common culture'. The comedians Morecambe and Wise were a double act with roots in variety, but their fame was cemented by television; in 1977 their TV Christmas show was said to have attracted over 28 million viewers. David Bailey photographed them for *Vogue* (pp.170–1). 'We deal in rubbish, high-class rubbish,' confided Morecambe in the accompanying interview.

Sanitised entertainment on the one hand and dystopia on the other – *Vogue*'s fashion pictures reflected these disjointed times in what it termed later 'a multiple aesthetic'. The colour photographs of Guy Bourdin were uncompromising, existential and occasionally misogynistic. More

Previous pages, left
Jerry Hall in the USSR
by Norman Parkinson
Standing heroically on top of the statue of Thamar on the banks of Lake Sevan in Armenia, Jerry Hall wears a jersey swimsuit by C&A
January 1976

Above Iman in Tobago by Norman Parkinson, 1976 *Below (left to right)* An illustration by Art Deco master Erté, 1973; *Vogue* covers starring Manolo Blahnik and Anjelica Huston by David Bailey, 1974; a close-up of red nails and green jelly by Willie Christie, 1977; Jerry Hall in Jamaica by Parkinson, 1975

Opposite top (left to right) Marie Helvin by David Bailey, 1976; Manolo Blahnik shoe by Lothar Schmid, 1977; fashion photograph by Sarah Moon, 1975 *Middle* Zandra Rhodes's punk-inspired designs by Schmid, 1977 *Below* Apollonia in Barbados by Parkinson, 1973 *Far right* Margaret Thatcher by Bailey, 1975

page, bandeau
...on. Gold-laced
...ngles. Emerald
...opposite. Take it
...d-calf, ready to
...ely comprom-
belt.

Zandra Rhodes

what a rip off

Mean streak of black
jersey, this page,
and another, opposite.
T-shirt shape
under ragged tunic.
All with blue cotton
stitching, chains,
ball bearings,
safety pins, random diamanté.
All from Zandra Rhodes.
Shop at Harrods.
Jersey by Racine.
Very high heel
gold sandals,
Manolo Blahnik for Zapata.
Hair by Fabian
at Jean Louis David

If you haven't a rag
to your name,
there is now
Zandra Rhodes' jersey,
ripped, slashed
and blue stitched
into her personal
view of punk.
She calls it
"conceptual chic".
In style she thinks
it is the first time
here shown
themselves.
It is no holds barred style.

peculiarly British were the labour-intensive beauty pictures of Barry Lategan and the off-kilter landscaped fashion images of Steve Hiett, set against a suburbia that Ballard might have recognised (pp.182–3).

Fashion plundered history. A high Victorian phase yielded to Pre-Raphaelite curls and high-necked, peacock-hued smocks. An Art Deco revival promoted by the London boutique Biba, with impressionistic photographs by Sarah Moon, took the reader back to a golden age of ocean-going liners and crêpe de Chine tea dresses. The punk explosion of the mid-to-late 1970s was built upon sloganeering, hand-drawn on T-shirts but also spray-painted on to inner-city walls. *Vogue* was not late to the party – socio-anthropologist Ted Polhemus dissected for the magazine the meaning behind the provocative, non-verbal communication of punk style.

Through it all there would always be Paris. Helmut Newton's confrontational eroticism found its *métier* at French *Vogue* (although British *Vogue* was allowed decent offcuts). Never did the 'continent' look more glamorous or more somnolent. Even Euro-stars who flickered only briefly found their way into *Vogue*: Helmut Berger, histrionic star of Visconti's films; Marisa Berenson, socialite granddaughter of Schiaparelli; and Dominique Sanda, muse to Yves Saint Laurent. Sylvia Kristel – star of the genre classic *Emmanuelle* (1974) – modelled the Chanel collection for *Vogue* in 1976. Bianca Jagger was the subject of a character sketch by the photographer Eric Boman, who had shot her for the March 1974 cover (p.168). Deadly in its accuracy, it was prescient, too, for the decades to come: 'When she says she's the only person who has become a star without having done a thing, you tend to agree …'

Meanwhile, in London, *Vogue* was introducing readers to the new Leader of the Opposition, whom it felt, if she lasted the course, might one day be prime minister. 'Mrs Thatcher crinkles her eyes when she addresses you with a determined desire to please,' wrote *Vogue*'s Marina Warner in 1975, 'but there is a granite edge to her graciousness and a chilliness at the core of her charm.'

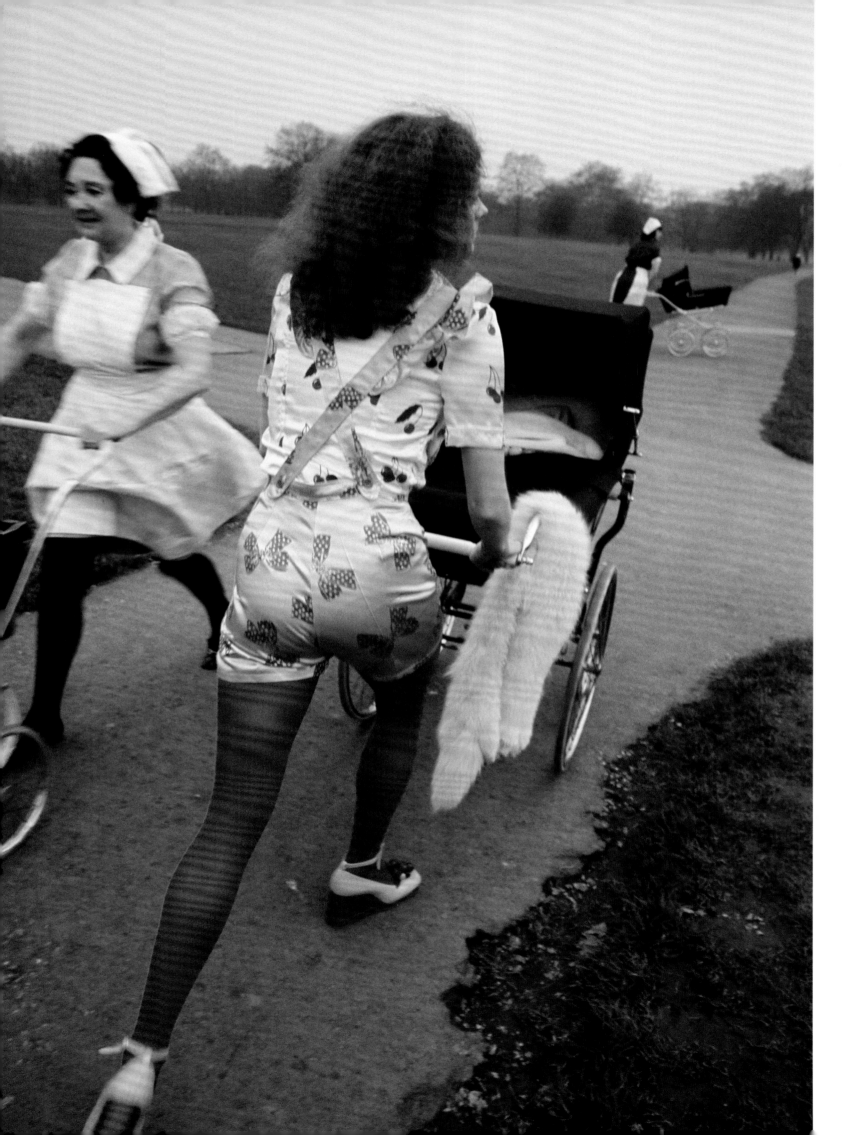

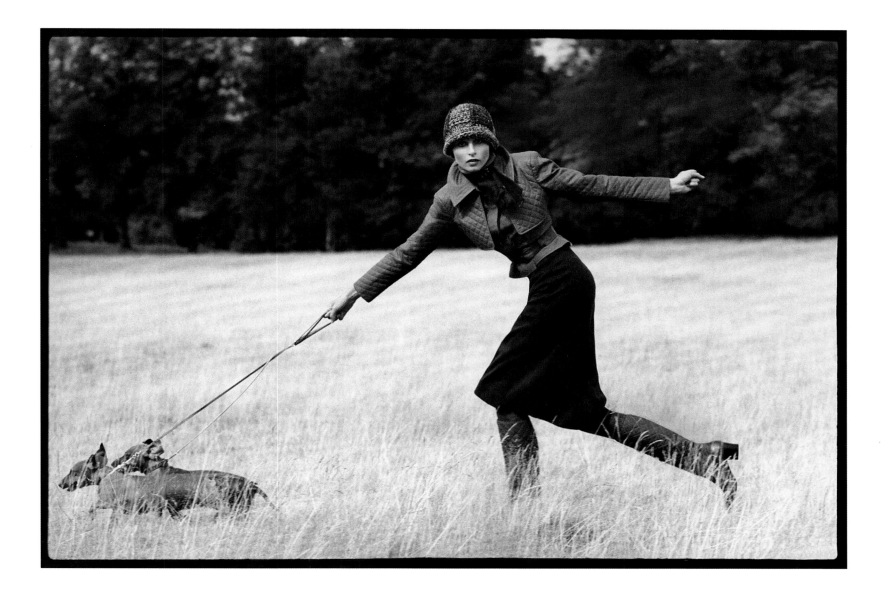

'What's in a diamond?'
by Guy Bourdin
Bourdin's work was characterised by an
obsessive sexuality. Models would contort
themselves to breaking point and fashion
editors were reduced to tears of frustration
October 1976

'Is bad taste a bad thing?': Gayla Mitchell
by Peter Knapp
Mitchell attempted an answer in hotpants
by Electric Fitting. 'Style,' said *Vogue*, 'can
be innocent or sophisticated, intuitive or
educated. To define is to dissect'
June 1971

Apollonia van Ravenstein
by Arthur Elgort
'Between you, against the elements,
are the right clothes.' *Vogue* offered a
fly-fronted quilted jacket with trench
yoke by Saint Laurent
October 1971

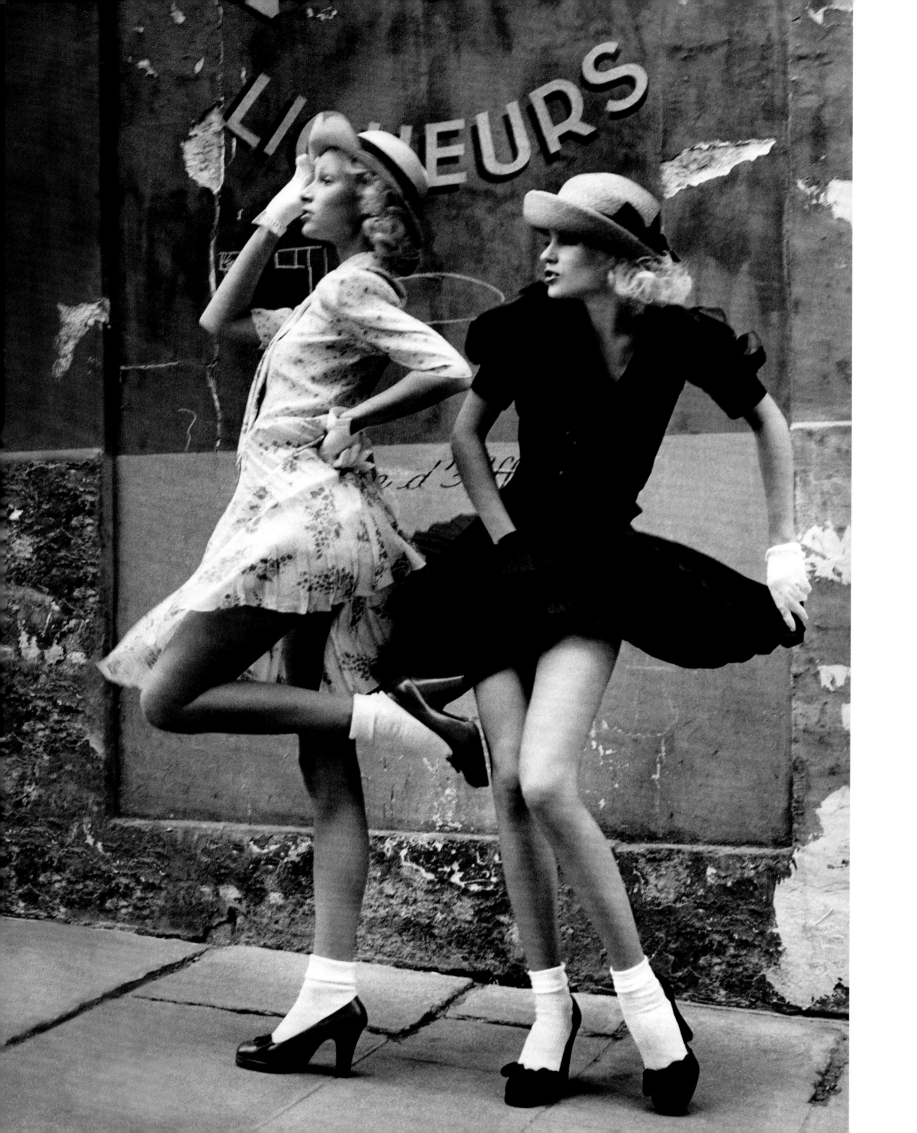

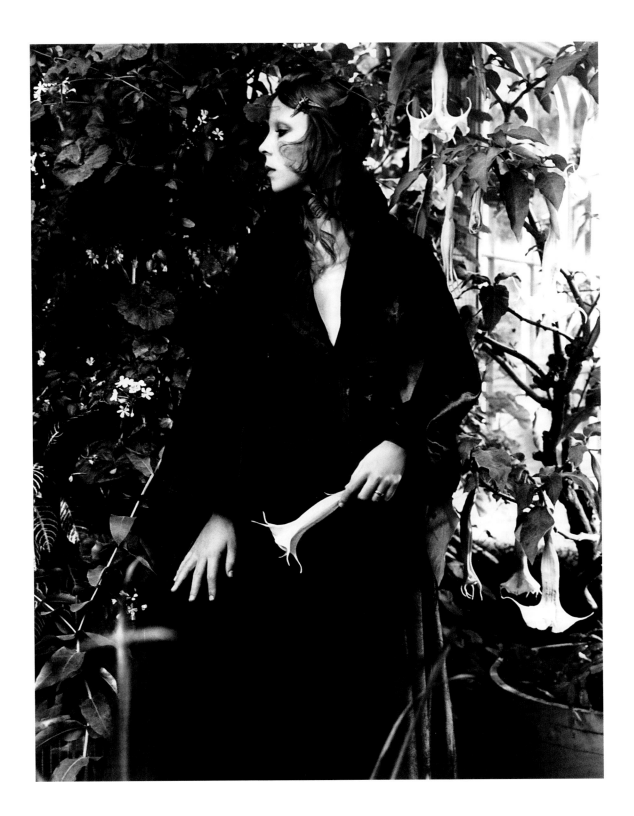

Louise Despointes and Donna Jordan
in Paris
by Sacha
Despointes and Jordan wear hats with
pleated skirts by Chloé and Mary Quant.
Jordan was muse to Antonio Lopez, then
fashion illustrator *du jour*
April 1972

Penelope Tree at Reddish House,
Wiltshire
by Cecil Beaton
Tree, then the girlfriend of David Bailey,
models a black panné-velvet suit by
Ossie Clark in the 'winter garden' of
Beaton's home
December 1970

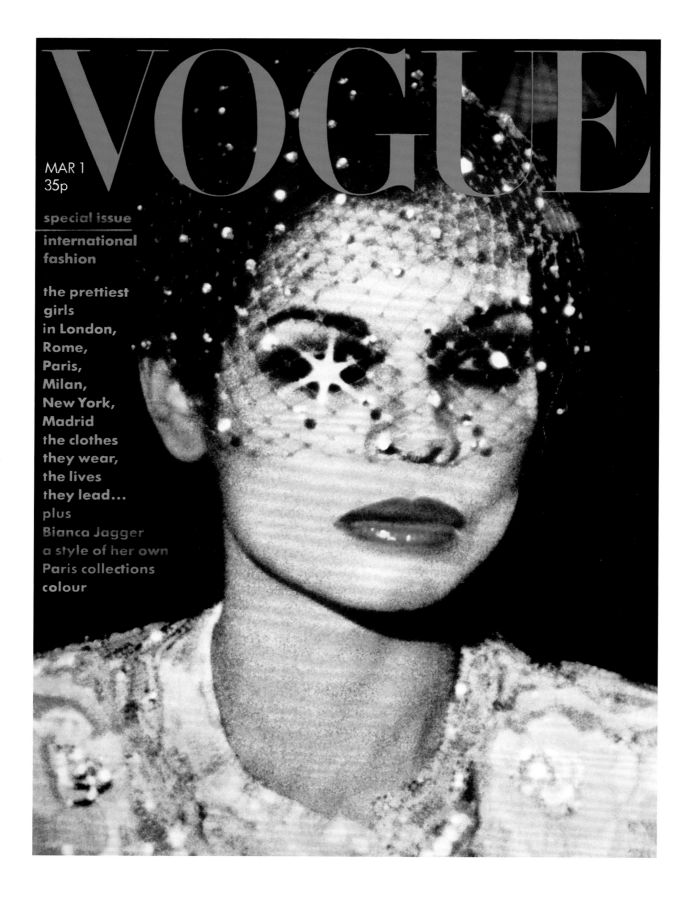

VOGUE

MAR 1
35p

special issue

international
fashion

the prettiest
girls
in London,
Rome,
Paris,
Milan,
New York,
Madrid
the clothes
they wear,
the lives
they lead...
plus
Bianca Jagger
a style of her own
Paris collections
colour

**Bianca Jagger at Maxim's, Paris
by Eric Boman**
Vogue revealed that its cover star loved
having her picture taken and that 'she'll
bring not only the clothes and hats but
everything in boxes and suitcases'
March 1974

**Kathy Quirk and Carrie Nygren
by Guy Bourdin**
Quirk and Nygren wear black rubberised,
kimono-shaped raincoats and shoes by
Saint Laurent. The background presence
is fashion editor Grace Coddington
September 1975

Following pages
**Morecambe and Wise
by David Bailey**
At their peak in the 1970s, Eric Morecambe
(right) and Ernie Wise (left) were the most
famous – and probably best-loved – comic
entertainers on television
July 1970

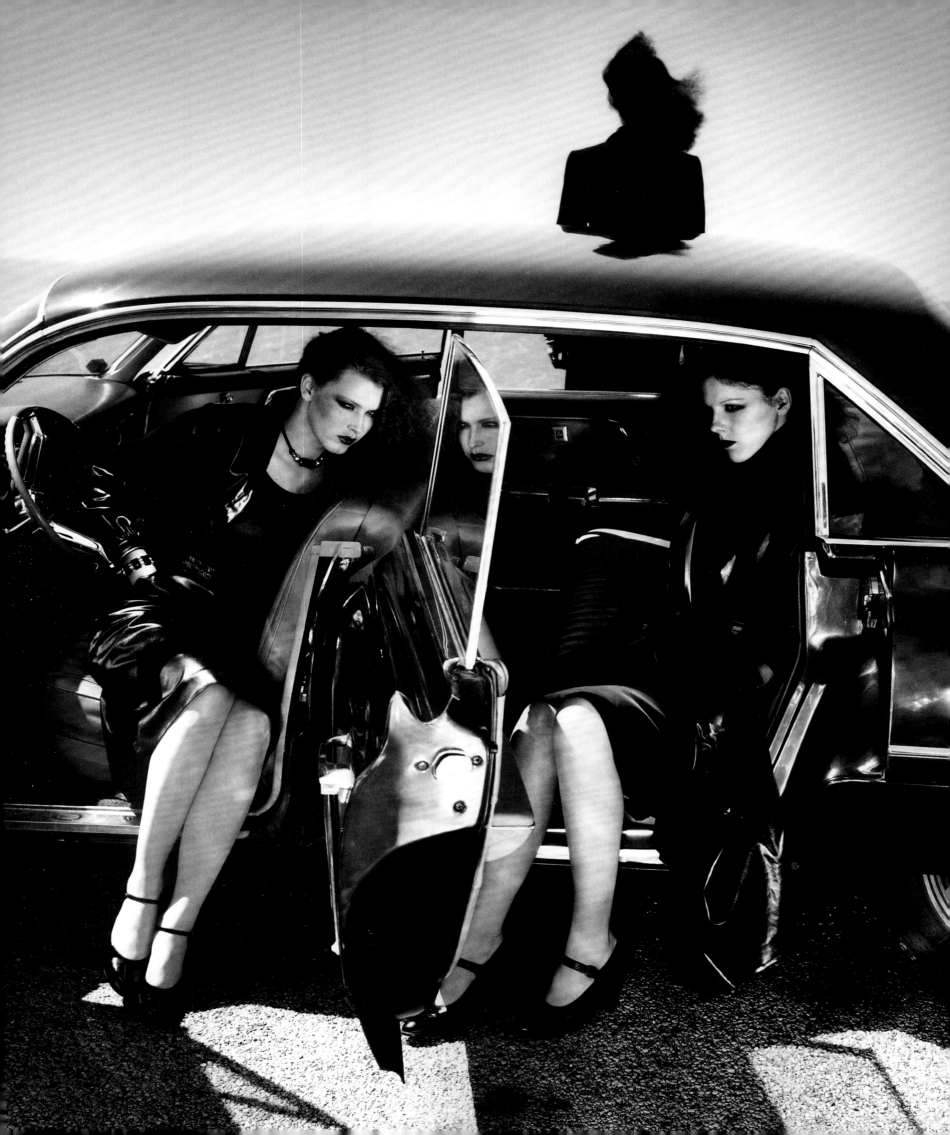

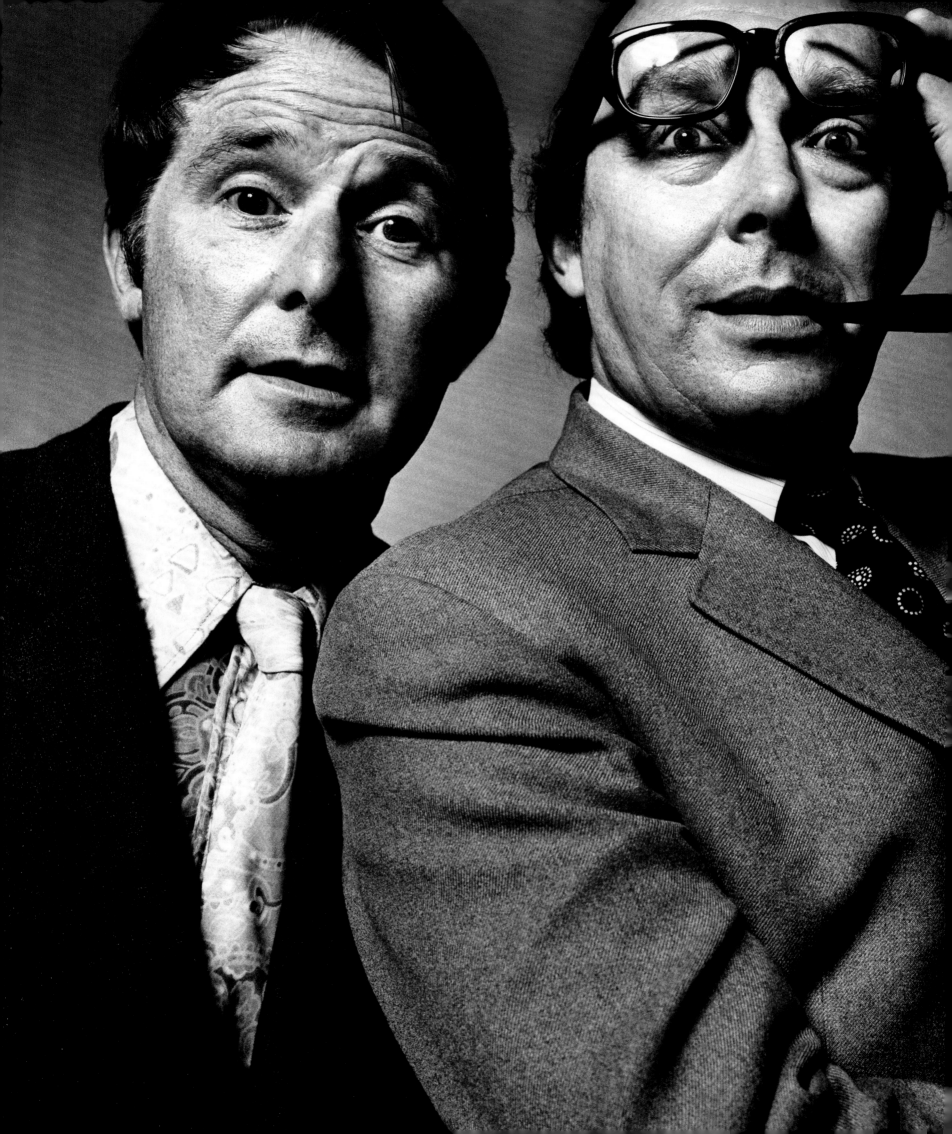

*'There are very few
public faces at all any
more. Perhaps the
demise of the movies as
a popular medium has
something to do with it;
television is a domestic
medium, it pipes its
heroes and heroines
directly into your home
so every face, even if
it is seen by 15 million
people, becomes a
private face. Personality
is repersonalised.'*

Angela Carter, 'The Public and
the Private Face', *Vogue*, May 1977

J.G. BALLARD
from 'The Future of the Future', *Vogue*, November 1977

'DURING the past fifteen years, the strongest currents in our lives have been flowing in the opposite direction altogether, carrying us ever deeper into the exploration not of outer but of inner space. This investigation of every conceivable byway of sensation and imagination has shown itself in a multitude of ways – mysticism and meditation, encounter groups and fringe religions, in the use of drugs and bio-feedback devices – all of which attempt to project the interior realm of the psyche on to the humdrum world of everyday reality, in short to externalise the limitless possibilities of the dream. So far, though, the techniques available have tended to be extremely dangerous (drugs such as LSD and heroin), physically uncomfortable (the contortions of classical yoga), or mentally exhausting (the psychological assault course of suburban encounter group, with its staged confrontations and tantrums, its general hyper-ventilation of emotions).

Already, though, far more sophisticated devices have begun to appear on the scene, above all, video projection systems and micro-computers adapted for domestic use. Together these will achieve what I take to be the apotheosis of all the fantasies of late twentieth-century man – transformation of a reality into a TV studio, in which we can instantaneously play out the roles of audience, producer and star.

In the dream house of the year 2000, Mrs Tomorrow will find herself living happily inside her own head. Walls, floors and ceilings will be huge, unbroken screens on which will be projected a continuous sound-and-visual display of her pulse and respiration, her brain-waves and blood pressure. The delicate quicksilver loom of her nervous system as she sits at her dressing table, the sudden flush of adrenaline as the telephone rings, the warm arterial tides of emotion as she arranges lunch with her lover, all these will surround her with a continuous lightshow. Every aspect of her home will literally reflect her character and personality, a visible image of her inner self to be overlaid and enhanced by those of her husband and children, relatives and friends. A marital tiff will resemble the percussive climax of *The Rite of Spring*, while a dinner party (with each of the guests wired into the circuitry) will be embellished by a series of frescoes as richly filled with character and incident as a gallery of Veroneses. By contrast, an off day will box her into a labyrinth of Francis Bacon's, a premonition of spring surround her with the landscapes of Constable, an amorous daydream transform the walls of her bathroom into a seraglio worthy of Ingres.

However fanciful all this may seem, this transformation of our private lives with the aid of video systems and domestic computers is already at hand. Micro-computers are now being installed in thousands of American homes, where they provide video games and do simple household accounts. Soon, though, they will take over other functions, acting as major-domo, keeper of finances, confidant and marriage counsellor. "Can you afford the Bahamas this year, dear? Yes ... if you divorce your husband." The more expensive and sophisticated computers will be bought precisely to fulfil this need, each an *éminence grise* utterly devoted to us, aware of our strengths and weaknesses, dedicated to exploring every possibility of our private lives, suggesting that this or that marital strategy, a tactical infidelity here, an emotional game-plan there, a realignment of affection, a radical change of wardrobe, lifestyle, sex itself, all costed down to the last penny and timed to the nearest second, its print-outs primed with air tickets, hotel reservations and divorce petitions.

Thus we may see ourselves at the turn of the century, each of us the star of a continuous television drama, soothed by the music of our own brain-waves, the centre of an infinite private universe. Will it occur to us, perhaps, that there is still one unnecessary intruder in this personal paradise – other people? Thanks to the videotape library, and the imminent wonders of holistic projection, their physical presence may soon no longer be essential to our lives. Without difficulty, we can visualise a future where people will never meet at all, except on the television screen. Childhood, marriage, parenthood, even the few jobs that still need to be done, will all be conducted within the home.

Conceived by AID, brought up within the paediatric viewing cubicle, we will conduct even our courtship on television, slyly exchanging footage of ourselves, and perhaps even slipping away on a clandestine weekend (that is, watching some travelogues together). Thanks to the split-screen technique, our marriage will be witnessed by hundreds of friends within their own homes, and pre-recorded film taken within our living rooms will show us moving down the aisle against a cathedral backdrop. Our wedding night will be a masterpiece of tastefully erotic cinema, the husband's increasingly bold zooms countered by his bride's blushing fades and wipes, climaxing in the ultimate close-up. Years of happy marriage will follow, unblemished by the hazards of physical contact, and we need never know whether our spouse is five miles away from us, or five hundred, or on the dark side of the sun. The spherical mirror forms the wall of our universe, enclosing us for ever at its heart.'

'New cover story'
by Barry Lategan
Against an equally austere urban backdrop,
a sharply cut black gabardine coat by Tiziani
September 1970

Above
**Germaine Greer in Portobello Road
by Snowdon**
Of the author of *The Female Eunuch*
(1970) Snowdon recalled: 'We went for
a walk; she was rather disconcerted
when a tramp came up and asked if
he could kiss her'
May 1971 (unpublished version)

Below
**Martin Amis
by Snowdon**
'Will *Success* spoil Martin Amis?' asked
Vogue. 'Martin Amis is now 28. At last,
perhaps, his age is no longer the most
extraordinary thing about him.' *Success*
(1978) was Amis's third novel
August 1978

Opposite
**Peter Sellers on the River Thames
by Snowdon**
In *The Optimists of Nine Elms* (1973) Sellers
played a song-and-dance man. He busked
around London unrecognised but for a
woman who said, 'It's Peter Sellers. You can
tell by the nose.' The nose was, in fact, false
April 1973

Above
**John Betjeman at home
by Snowdon**
Like Tennyson before him, the Poet
Laureate was an unavowed populist,
his poetry widely loved. In the early
1970s he recorded albums of his
verse set to music
April 1974 (unpublished version)

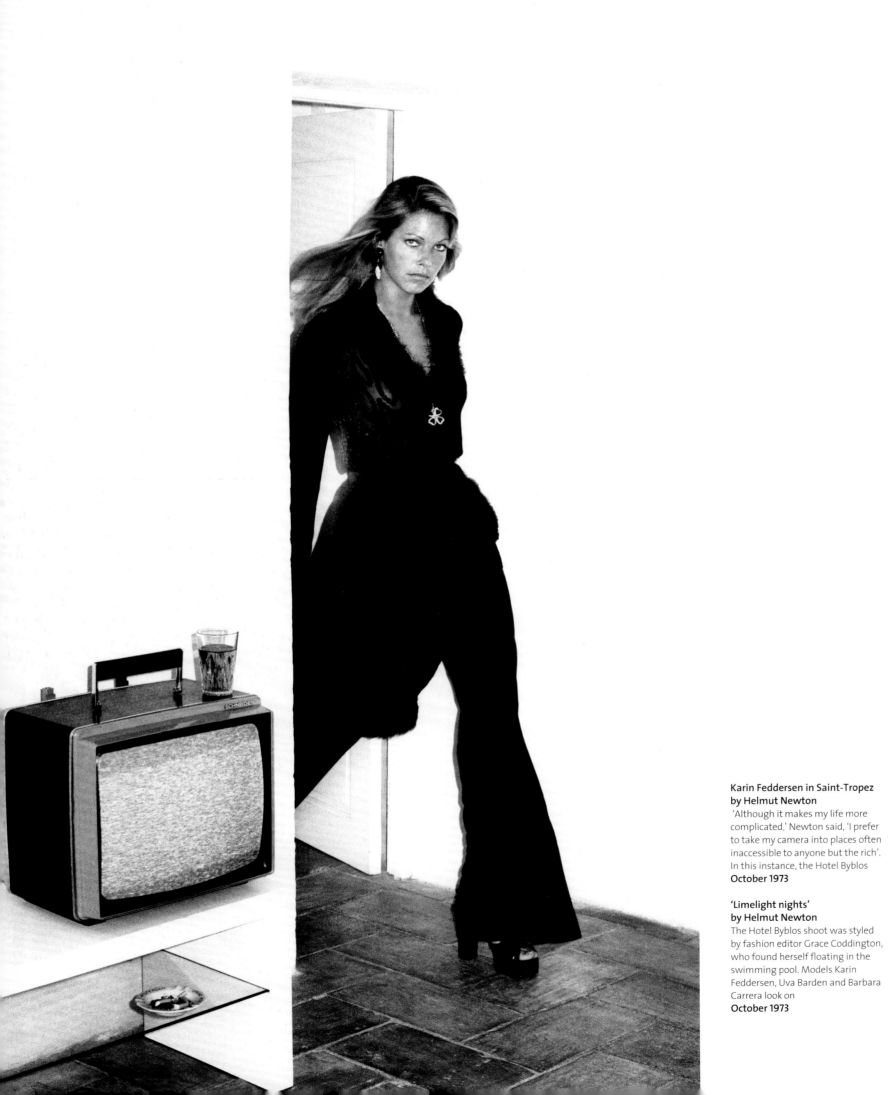

**Karin Feddersen in Saint-Tropez
by Helmut Newton**
'Although it makes my life more
complicated,' Newton said, 'I prefer
to take my camera into places often
inaccessible to anyone but the rich'.
In this instance, the Hotel Byblos
October 1973

**'Limelight nights'
by Helmut Newton**
The Hotel Byblos shoot was styled
by fashion editor Grace Coddington,
who found herself floating in the
swimming pool. Models Karin
Feddersen, Uva Barden and Barbara
Carrera look on
October 1973

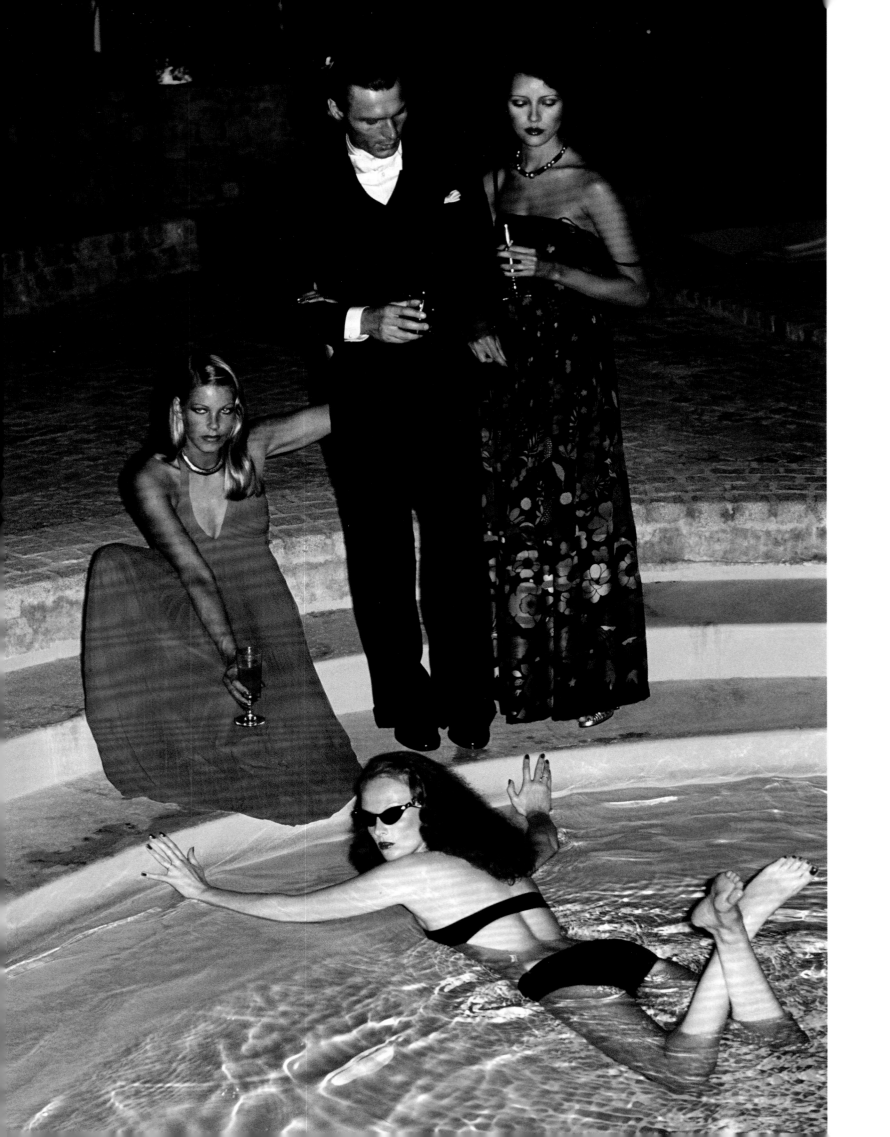

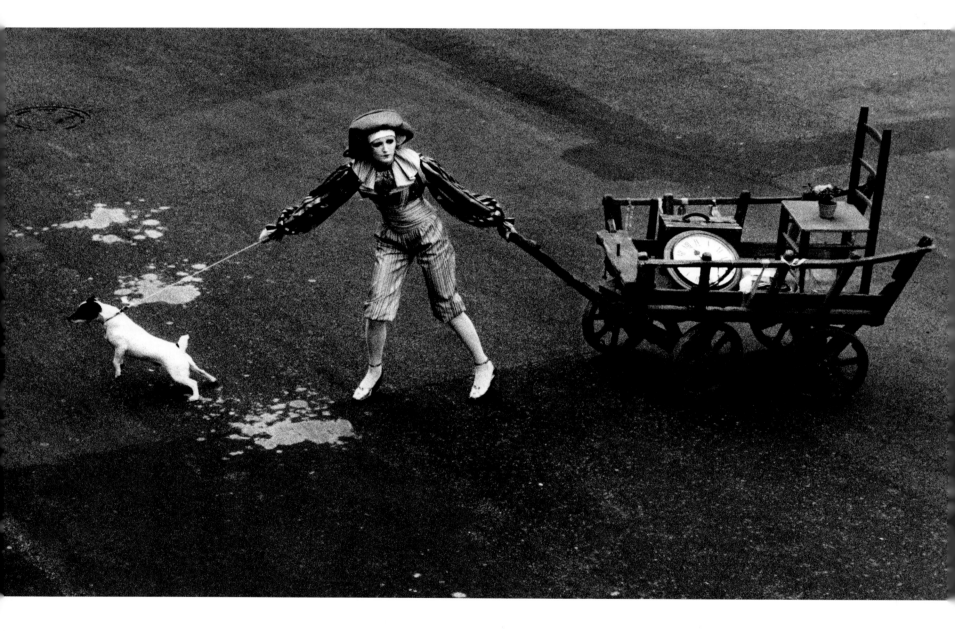

'A song of spring': Susan Moncur
by Sarah Moon
On the streets of Paris, *Vogue*'s
Pierrette wears 'a silk frill, a flounce,
a stripe, a pair of baggy pants, pointed
hat and feathered pom-pom'
April 1972

'Nights of Paris'
by Helmut Newton
Echoing the Paris of Brassaï, the Hotel
Crillon forms a setting for print dresses
in two layers with V-shaped backs by
Saint Laurent
January 1974

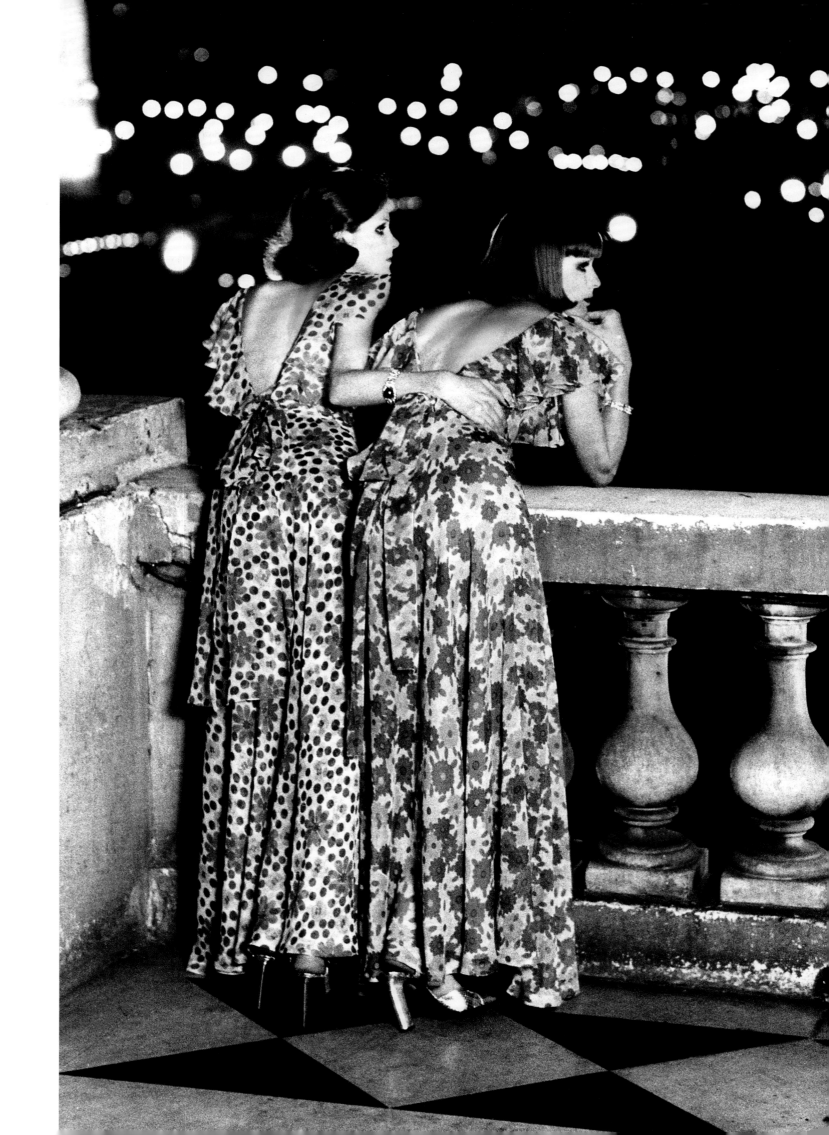

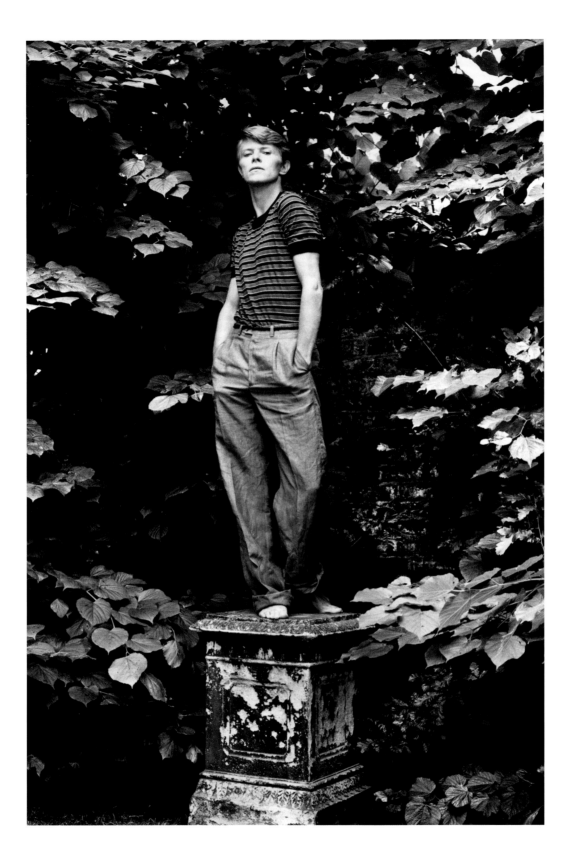

David Bowie in South Kensington by Snowdon
Bowie had completed his Berlin trilogy of albums (released 1977–9) and was divesting himself of his 'Thin White Duke' persona. Of the preceding few years and his struggle with addiction, he told *Vogue*, 'my insides must have been like perished rubber!'
September 1978 (unpublished version)

'Punk: danger, stranger' by Johnny Rozsa, Luciana Martínez and Derek Jarman
A collage of Jordan, Siouxsie and the Banshees and the cast of *Jubilee* (1978): 'The year hair stood on end with fluorescent dyes, the year of war paint. We add to the excess by looking at the origins of ferocious adornment'
December 1977

Following pages
In suburbia: Louise Despointes by Steve Hiett
Despointes wears a turquoise mohair skirt, and mohair and wool waistcoat. In 1976 Britain experienced the hottest summer temperatures for over 350 years. In Yorkshire and East Anglia the domestic water supply was replaced by communal standpipes
November 1976

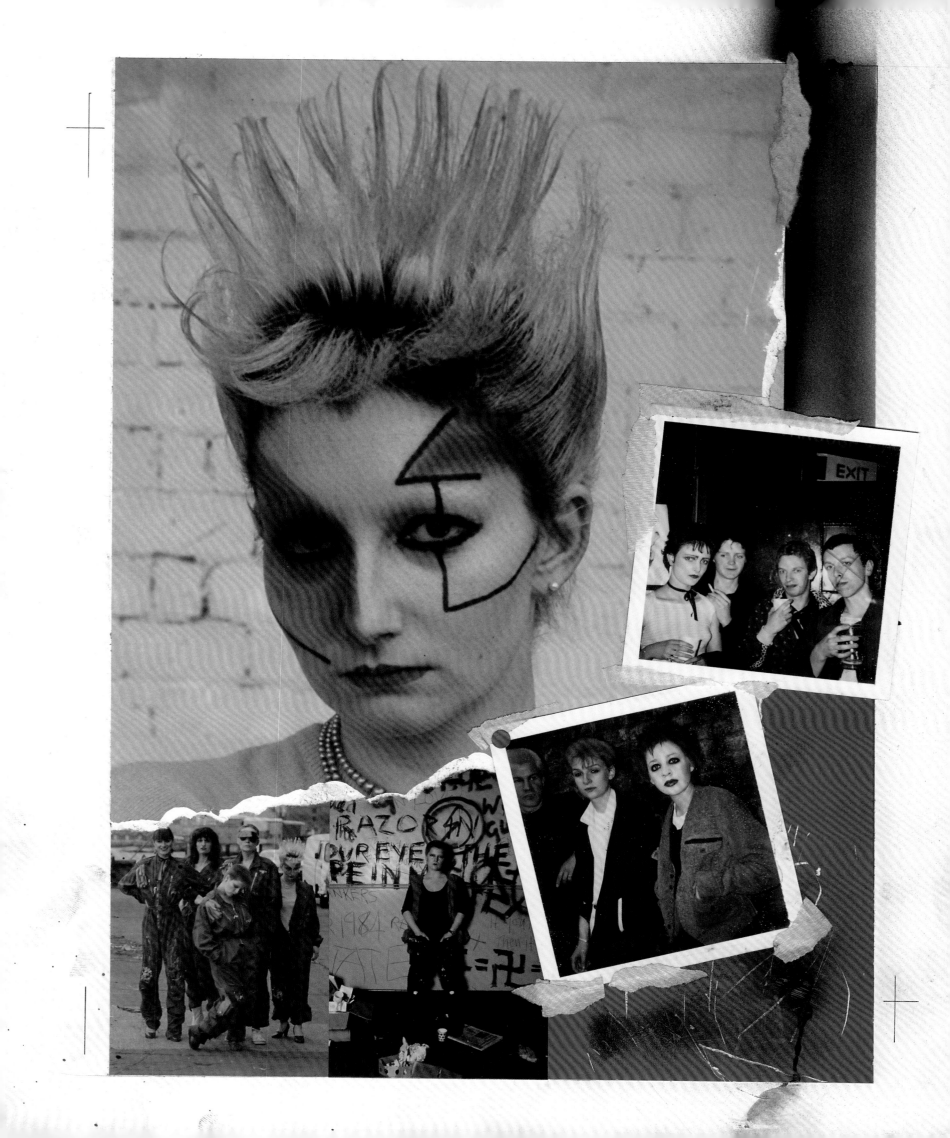

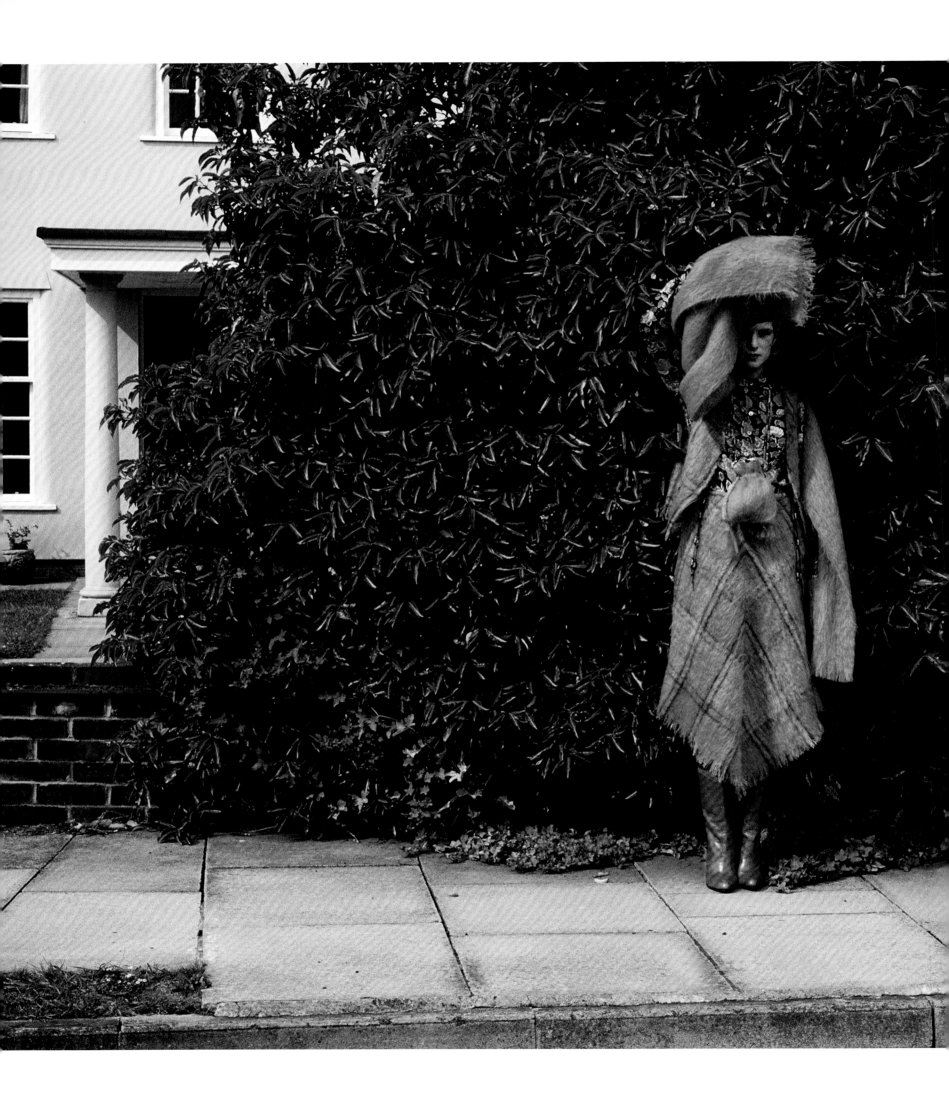

'It had been largely dry since the previous autumn and occasional days had reached 84 degrees as early as May. Temperatures continued to climb. At the Wimbledon Championships, in June, tennis balls had burst in the heat. By July 8, the temperature had not dipped below 90 degrees for fourteen days. On July 28, it passed 95 degrees in Southampton. By now it was not just the look of the country but a way of life that was changing.'

Elizabeth Speller, 'The Summer of 1976',
Vogue, July 2006

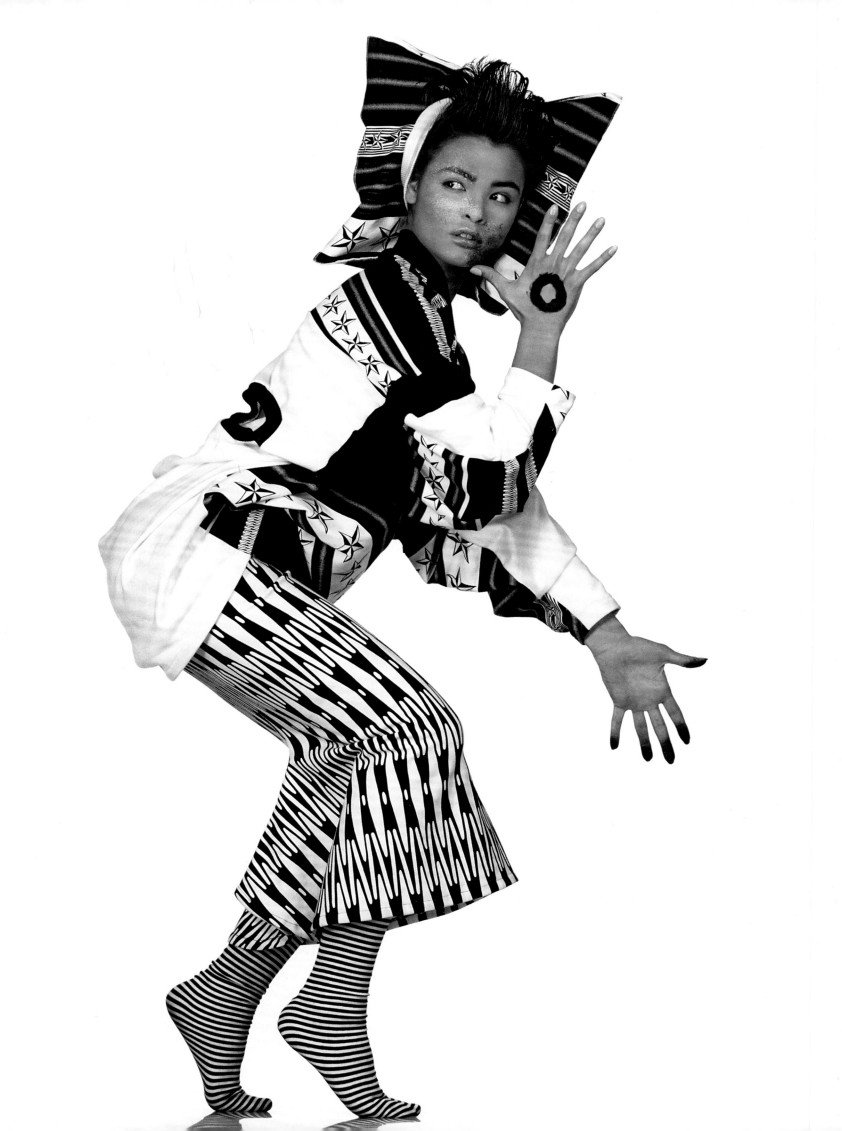

The Speed of Life

'I AM passionately interested in fashion. It brings both pleasure and it brings jobs.' At the midpoint of the decade, in October 1985, the Prime Minister addressed *Vogue*'s readers. The interview was intended to highlight Margaret Thatcher's personal style and more. How did she arrive at the image she now presented to the British public and to the wider world? How would she further promote her government's zeal for an industry that found itself booming in the 1980s? Finding it difficult to talk about herself in anything other than abstract terms, especially in the context of her own appearance, she concluded: 'I think, historically, "Thatcherism" will be seen to be a compliment. People say "inflexible". What they mean is firm. People want to know where they are with you.'

Dominant and domineering, Mrs Thatcher framed the 1980s. Britain under the three-term prime minister saw huge changes: economic, demographic and cultural. She stood for individualism, self-advancement and achievement, but the downside was equally distinct: a displaced underclass, rising urban poverty and an alarming level of homelessness. The first half of the decade saw the number of millionaires in Britain double, while unemployment climbed to levels not seen since the Depression.

As it began to unfold, one photographer – Norman Parkinson – summed up his hopes for the decade: 'It's been so depressing, hasn't it? People want style now, they need romance; they need beautiful women to be in beautiful and provocative surroundings.' His hopes were mostly fulfilled, as this decade, more perhaps than any other of the twentieth century, was devoted to image-consciousness.

Getting one's message across was key. Politically aware designer and activist Katharine Hamnett spelt out her message on her T-shirts: '58% Don't Want Pershing' was emblazoned on one she wore to meet Mrs Thatcher at 10 Downing Street. (The Prime Minister's response was quizzical. Surely, she pointed out, it was Cruise, not Pershing, missiles that were to be based in Britain?)

Vogue devoted pages of spectacular photography to 'power dressing' and aspirational lifestyles. Fashion veered from expensive to the barely credible. Parisian couturier Jean-Louis Scherrer covered one gown in 400,000 hand-sewn seed pearls. Karl Lagerfeld, appointed chief designer at Chanel in 1983, revisited the house's glorious past while modernising it and, in so doing, making almost a parody of its double-C insignia. The quasi-architectural designs of a new wave of Japanese designers, primarily Yohji Yamamoto and Rei Kawakubo of Comme des Garçons, advocated an uncompromising 'post-apocalyptic chic' of asexuality and shapelessness, as radical and anarchic as anything occidental. 'For me,' Yamamoto told *Vogue*, 'the body is nothing.' By contrast Azzedine Alaïa, who showed officially from 1981, 'carved' his creations to replicate, in every provocative detail, the line of the female form.

Previous pages, left
'The new rave': Talisa Soto
by Albert Watson
Model (later actress and Bond girl) Soto wears Bodymap's starfish-and-stripes printed Lycra top, form-fitting skirt with 'fin' panel and matching square hat
August 1984

Top Contact print of a Chanel suit with swatch attached by Arthur Elgort, 1988
Above Madonna by Herb Ritts, 1989
Right (left to right) Vogue covers featuring Elizabetta Ramella by Paolo Roversi, 1984; Talisa Soto by Albert Watson, 1984; Stephanie Seymour by Ritts, 1988

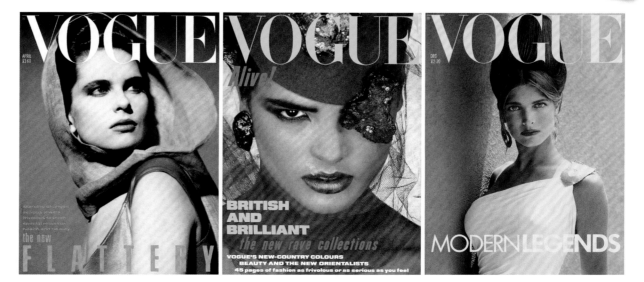

The image above shows a two-page magazine spread. The left spread reads:

rock & royalty

The exaggerated inventive glamour of pop stars and the increasing fashion consciousness of the young royals make them the potent media images of the decade. SARAH MOWER looks at...

DIVA

The right spread reads:

Modern Britain

indisputably, clothes for the life you lead from those British designers who best understand that modern dressing needs to be grown-up, chic and simple. New kinds of tweed suit, houndstooth check, black and white... New coats, the ideal loose pale top layer, the simplified coat-dress, modern brevity over crisp shirts and skirts, and the new refinements of bias cut and brilliant colour... The importance of the perfect detail.

how to dress the day with a softer shirt to contrast tweediness, a smooth pill-box or insouciant felt, sheer or matt black tights, the spring of a high vamped high heel...

New Day at the London collections!

Above (left to right) Rock meets royalty: Boy George by David Bailey, 1987, and Diana, Princess of Wales; a dynamic spread with Yasmin Le Bon by Peter Lindbergh, 1986 *Far left* 'Dancing Shoe' drawn by Manolo Blahnik, 1981 *Left* 'The New Rave' by Albert Watson, 1984 *Below* Contact sheet of Morrissey by Andrew MacPherson, 1986

The word 'designer' was pervasive, applied to jeans, underwear, mineral water, chocolates, restaurant food, hair, furniture and earrings. *Vogue* featured examples of 1980s excess: from Hermès, leather straps fashioned into a holder for carrying a bottle of mineral water; from Christian Lacroix, rainbow-hued couture, exotic and barely wearable, plundered from costume history and defiantly at odds with practicality.

If the Prime Minister was caricatured by her stridency, the other figure whose image dominated the decade – and more intensely for much of the next – was Diana, Princess of Wales. Silent and sphinx-like, her life was played out in photographs. As *Vogue* put it in its obituary of Diana in 1997: 'Millions rarely heard her speak. Clothes were her vocabulary.' She became a global fashion icon, a member of an international jet set whose values, codes of behaviour and notions of style removed her from her aristocratic roots. By 1987 hers was the most potent media image of the decade. 'British fashion means pop video on MTV and splashy Di and Fergie cover stories in weekly magazines,' wrote *Vogue*'s Sarah Mower. 'To the world at large our style is that which is worn by youth at its class extremes: British fashion in international markets is Rock 'n' Royalty.' Diana, Princess of Wales became, quite simply, the most recognisable English woman of her time and, perhaps, the most photographed woman in twentieth-century history – whether she liked it or not.

At the decade's start, *Vogue* tested the temperature of the young. Eton schoolboy Charles Villiers wrote in terms peculiar to the era: 'The concept of inherited wealth has been whittled down. Fantasies such as starting a wine-bar or holding the patent for a magnetic L-plate are merely attempts to sugar the reality that we must work for our bread.' As the decade closed, British *Vogue* offered a valediction on a world perceived as 'safe for the rich': the ten years had been 'marked by Wall Street businessmen being honoured for "go-getting" and then jailed when it was discovered how'.

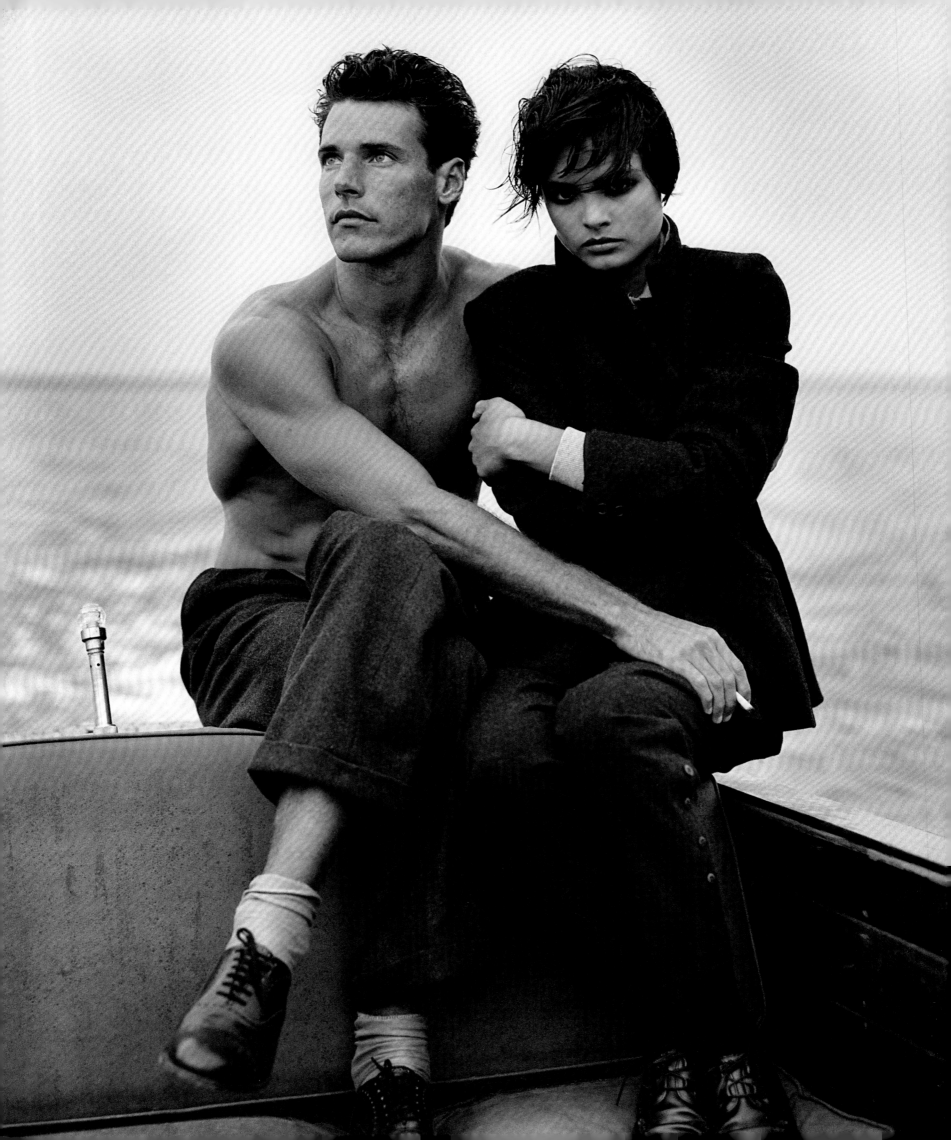

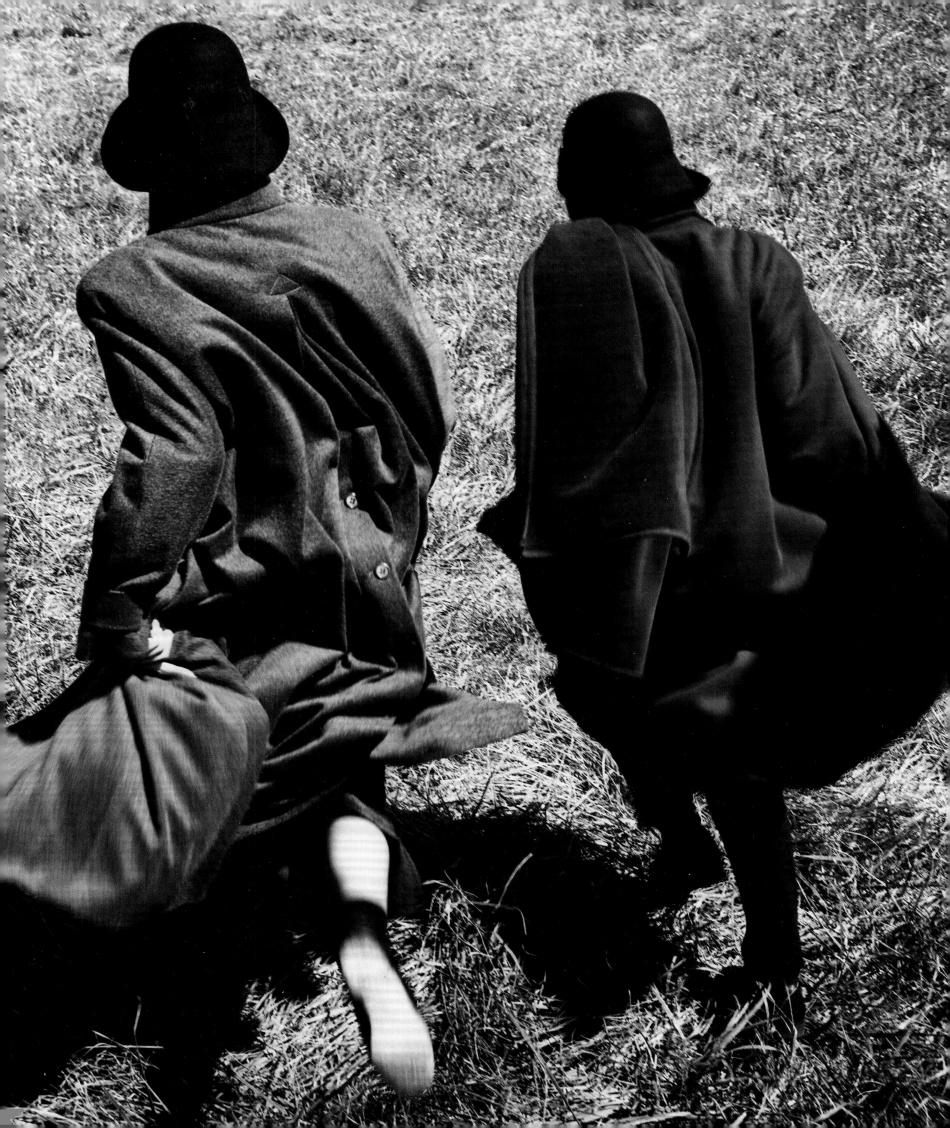

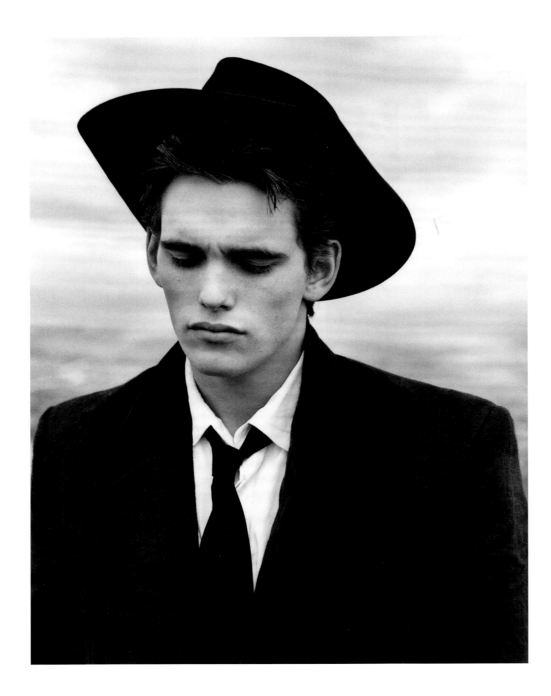

Matt Dillon in Hollywood
by Bruce Weber
Dillon was a leading teen idol, specialising in troubled characters with unstable emotions. He became the spokesman for teenage angst in film such as *Rumble Fish* and *The Outsiders*
June 1983

Previous pages, left and right
'Under Weston eyes'
by Bruce Weber
Weber's homage to the American photographer Edward Weston, his way of seeing and way of life, was shot in and around Weber's Long Island home
December 1982

'Filming after a fashion'
by Bruce Weber
On the back lot at Culver Studios in Los Angeles, with the hired help of costumed heroes, model Shana Zadrick wears sequinned gauze over a white T-shirt and skirt by Zoran
July 1983

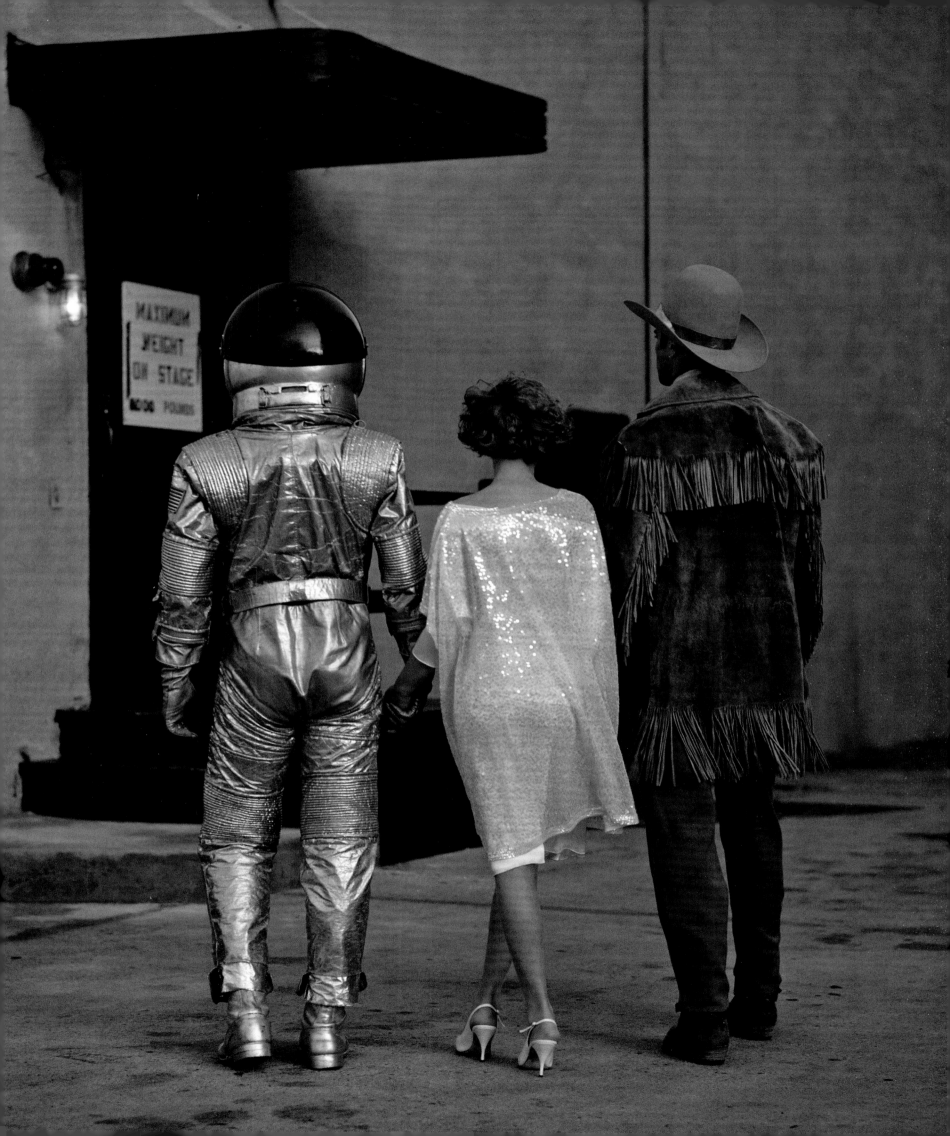

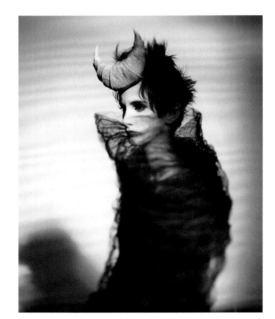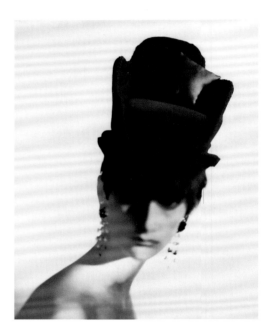
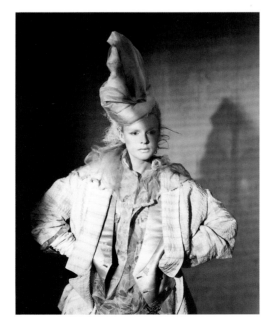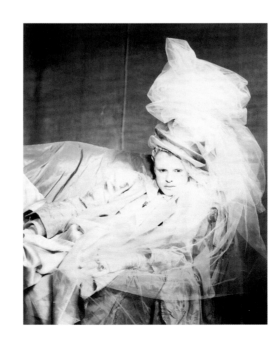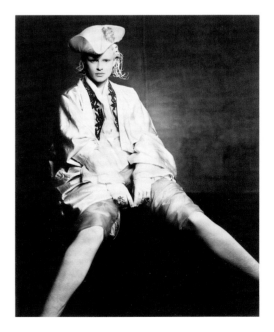

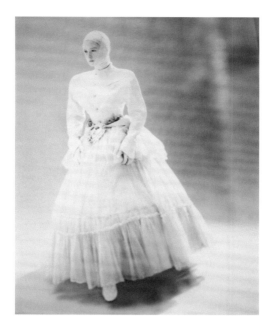

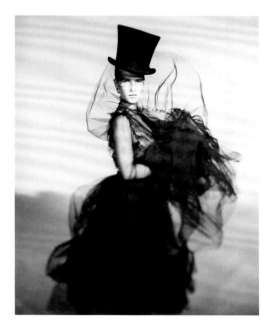

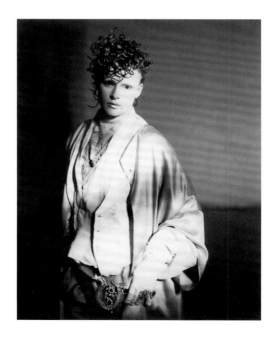

'So what is this elusive thing called good taste which creates a social enthronement through its very possession? "You are born with it, it's as simple as that," says Piers von Westenholz, the antiquaire with the golden eye. He believes in setting his own ground rules – dark green paint almost everywhere, only black shoes in the wardrobe, only black cars in the garage and definitely no jogging and within rules there is room for aesthetic manoeuvre, providing of course you have "it".'

Candida Lycett Green, 'A Question of Taste',
Vogue, December 1989

Previous pages
**Polaroid photographs
by Paolo Roversi**
Roversi's lighting and *Vogue*'s styling gave
his large-format Polaroid prints an almost
painterly quality
**February 1985, November 1985 and
April 1986**

**Beth Chatto's gardening boots, Essex
by Tessa Traeger**
The celebrated plantswoman's boots
and collecting basket pictured amid the
funnel-shaped blooms of *Colchicum*
'Rosy Dawn'
December 1984

**'In an English country garden':
Victoria Lockwood
by Bruce Weber**
'A style that could grow on you,' ventured
Vogue of model Lockwood in a sheath
dress by Victor Edelstein
December 1984 (unpublished version)

**Bruce Chatwin in Belgravia
by Snowdon**
Chatwin's jacket and walking boots
point to his renown as a travel writer.
He was an acclaimed novelist, art expert
and connoisseur, who had also studied
archaeology
October 1982

**Salman Rushdie at home in London
by Snowdon**
Rushdie was a little-known novelist before
Midnight's Children won the Booker Prize
(1981). Set in the early days of India's
independence, its hero is born at the stroke
of midnight on 14 August 1947
December 1982

**Rupert Everett in South Kensington
by Snowdon**
The actor had received acclaim for his role
in the stage play *Another Country* (1981),
opposite another rising star, Kenneth
Branagh. He later starred in the film version
opposite Colin Firth
April 1983 (unpublished version)

Steve Cram
by Paolo Roversi
In the summer of 1985, the 'Jarrow Arrow' had set three new world records within twenty days, becoming the fastest man over 1500m, 2000m and the mile
December 1985

John Galliano
by Peter Lindbergh
Three years out of college, Galliano had just been crowned British Designer of the Year for the first time, an accolade he would win on three further occasions
February 1988

Uma Thurman in the Friedman Gallery, New York by Sheila Metzner
Two years before her film debut, Thurman was a 15-year-old model, seen here wearing a dress by Emanuel
December 1985

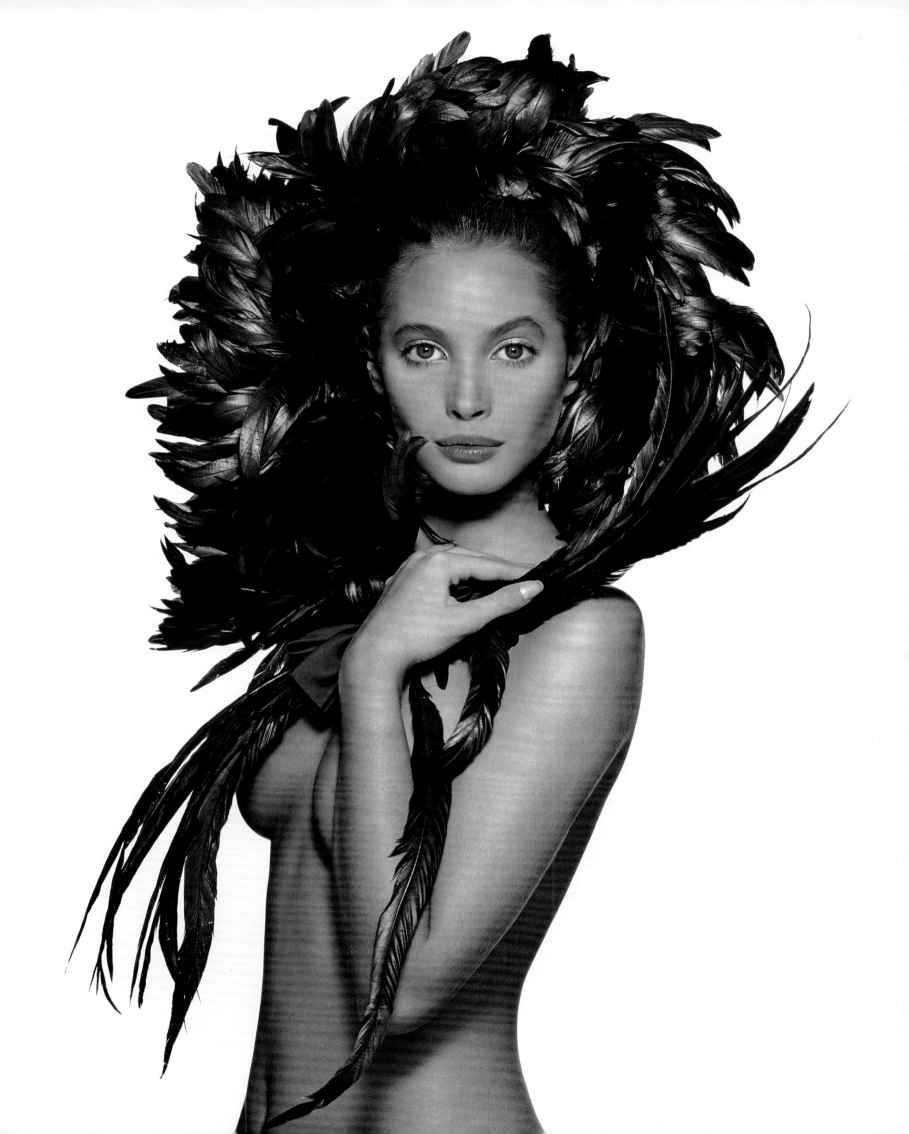

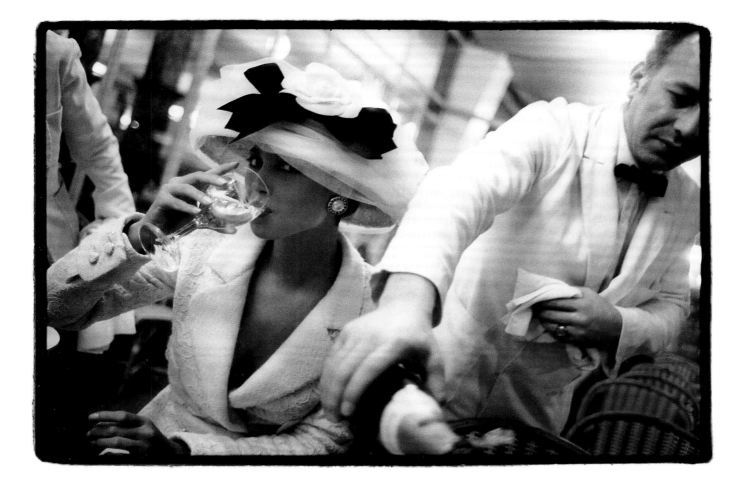

**Christy Turlington in feathers
by Patrick Demarchelier**
This arrangement of bristling quills on a silk
band, part of a suit designed by Antony Price, was
perfect, *Vogue* surmised, for any 'coqtail party'
December 1987

**Christy Turlington in La Coupole, Paris
by Arthur Elgort**
Pictured in the famous Parisian brasserie,
the supermodel-to-be wears a signature
Chanel tweed suit and lace 'meringue' hat
April 1988

JOAN JULIET BUCK
from 'The Seine Life', *Vogue*, October 1987

'IT COMES down to narrow streets versus wide streets, size of rooms, varieties of lettuce, the frequency and comfort of buses, and the fact that my bank is dangerously near Hermès. Living in Paris is the strangest and most comforting combination of economic simplicity and outrageous luxury. Of course I don't live here; my official address is still in New York, as are my books, my fifty-four Japanese lustre Depression-era cups and saucers, and my best sheets. I only came here to get away from New York for a few months and finish my book. I've been here two years. A friend of mine, whom I used to think wise, always says that great passions last exactly two and a half years; I think he's wrong, but in six months we shall see.

What Paris offers the casual dweller is not the same thing it offers the casual visitor. And it is: the Pont Alexandre III is as breathtaking whether you have to cross it every day or have flown 3,000 miles just to look at it. The Eiffel Tower never struck me as the profoundly silly monument that it is until, having had it squarely in my window for three months, I found that it had invaded my dreams, a giant inverted funnel. The main feature of the casual dweller is that you move every few months, from sublet to sublet, and the movement resembles that of a dog looking for the most comfortable place to settle for a nap. You end up with different points of view on the town, depending on what sort of shop is immediately next to your front door. You become an addict to homeopathic remedies if it's a pharmacy, an expert in prints if it's a print shop, a connoisseur of coffee if it's a *brûlerie*, where coffee is ground and roasted. I have been lucky enough to avoid living next door to any boutiques. But I have found out that life is different in the crowded streets of the *sixième* than on the wide boulevards of the *septième*, different on the Left and Right Banks. There are London analogies: the *sixième* is Chelsea, the *septième* Belgravia, with its tiring widths and reticent buildings inhabited by the rich with a past; but whereas in London the reference for theatre and shopping and eating is always the West End, in Paris each area has its cluster of movie houses and famous restaurants.

The various worlds do not mingle here; businessmen stay with their kind, the pushers and shovers push and shove each other but no one else, the careful people stay at home; groups stay closed, in case new blood should bring alarming change. In New York you are always sitting next to a total stranger at dinner, and hearing intimate details of his gory private life; in Paris you are always sitting next to someone you have known for fifteen or twenty years, and you talk about nothing in an erudite and entertaining way. Challenge here is reserved for encounters with other drivers, not evening conversation. No one asks how much you earn, what rent you pay, or what you want out of life. No one mentions the damn biological clock. You never get the feeling, endemic in New York, that life is passing you by, that you have to hurry to succeed; as a result you slow down enough to be able to do your work, and are in danger of slowing down even further so that life may indeed pass you by, at a comfortable pace. Paris teaches patience, the most difficult of all virtues because its reward is, alas, more patience.

I used to think that Paris was made up of confident men in green corduroy jackets who went to nightclubs; then of fashion photographers, noisy in small restaurants; later of shabby committed film-makers, art experts, neurotic novelists. It all depends whom you know and whom you see.

Because this is not a period of particular ferment, of polemic rage, the newspapers offer information one can ingest without being moved to action: the Klaus Barbie trial was conducted with unimpeachable dignity, the cohabitation of left and right in the government leads to debates of infinite hair-splitting boredom, and although the rise of the French National Front seems to be progressing in a disturbing way, it is difficult to take seriously M Le Pen, whose wife posed naked in the French *Playboy*, undressed as a maid, because he refused to pay her alimony and said she should clean houses for a living. Last year we felt history when bombs were going off in stores; history and danger. We felt prickly about the eyes and a little nauseated a week before the government announced that the Chernobyl cloud had passed over France; but the French, sublimely indifferent to anything they cannot see, touch, and analyse, kept right on eating lettuce from the contaminated south. Aids is as alarming in France as everywhere else; an exceptionally coherent minister of health, Madame Michèle Barzach, has put good measures into effect. The dreadful M Le Pen has called its victims *sidaïques*, and suggested that they be put in *sidatoriums*. The only other word that ends in "ique" is *judaïque*, Jewish, and the word *sidatorium* recalls crematorium; France is perhaps the only country where a politician has attempted to make a subtle link between Jews and Aids. It is so peculiar that you can't take it seriously; it is a good reason not to move all the books and teacups here.'

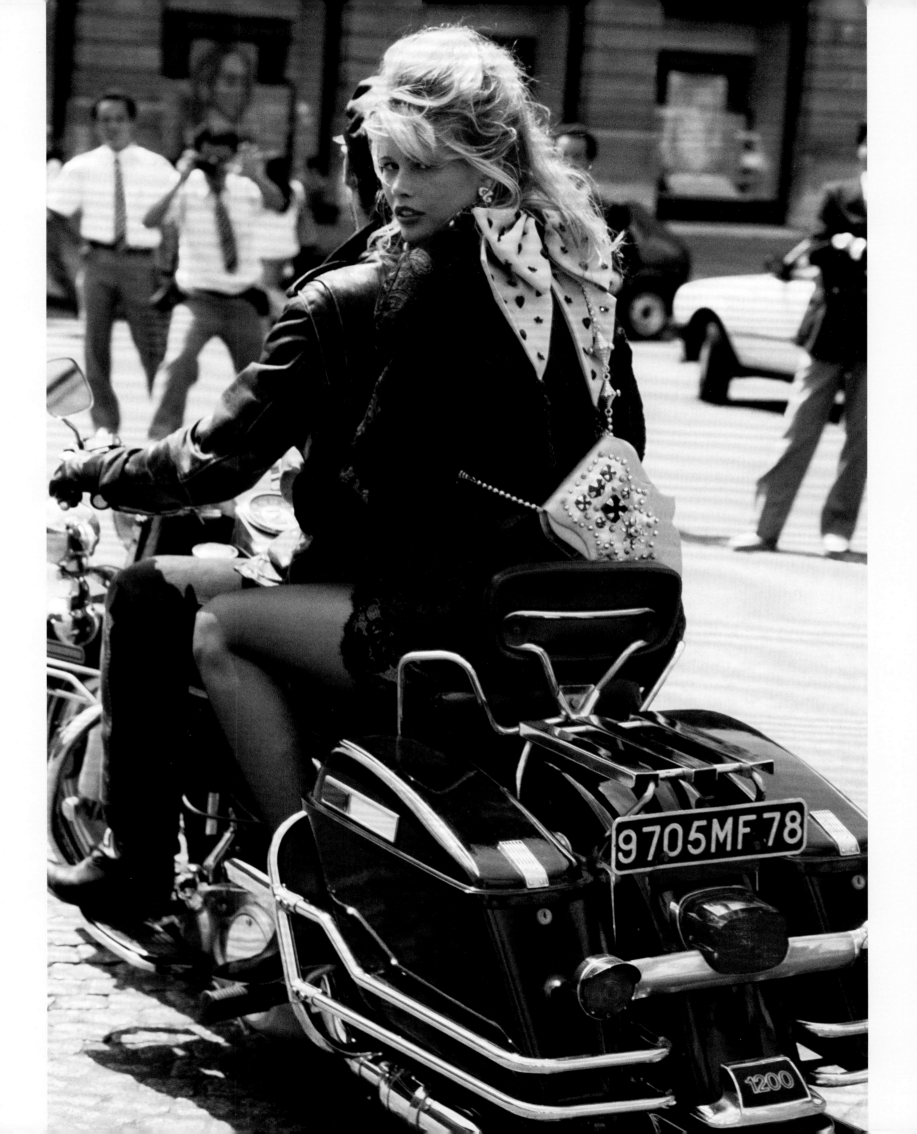

Bonnie Berman in Barbados
by Patrick Demarchelier
'We pursued a sort of acrobatic, healthy
look,' recalled the photographer of his shoot
with Berman. 'We made our own props
with rope and tape stored on the boat to
construct the swing'
May 1983

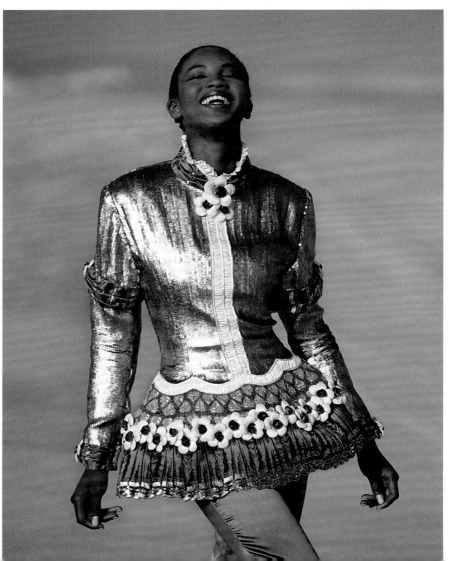

Naomi Campbell
by Patrick Demarchelier
The image for Naomi Campbell's debut
cover shows her wearing a shimmering dress
by Chanel. There would be many more in
her journey from bright-as-a-button south
London teenager to supermodel
December 1987

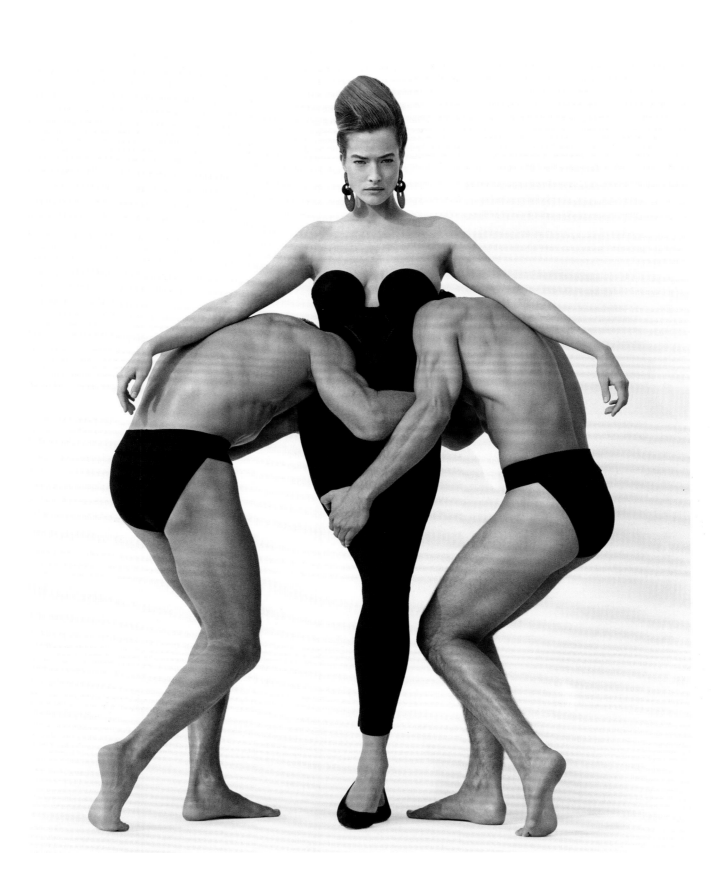

Tatjana Patitz
by Herb Ritts
'The mood is sultry,' observed *Vogue*, 'the diva
dressed in uncompromising fashion.' In the
California sunshine Ritts made full use of the
male form, Hellenic in feel and echoing the
work of Horst and Heune in the 1930s
July 1988

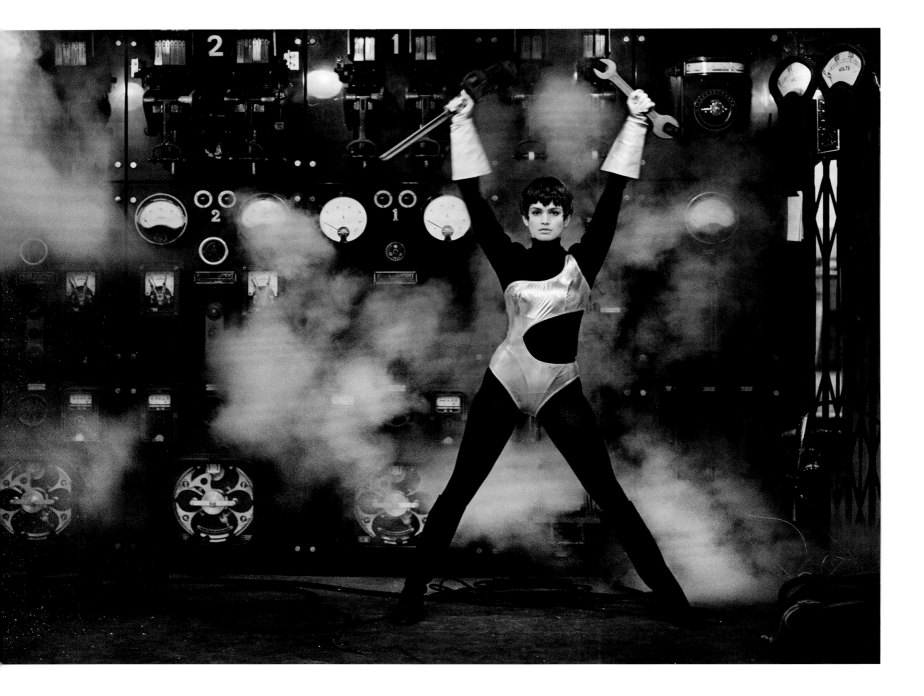

'Superheroine': Cindy Crawford
by Peter Lindbergh
Futuristic motifs and industrial landscape
marked out Lindbergh's early photographs.
'My heavy German expressionist side', as
he once remarked, is here played out in a
homage to Fritz Lang
February 1989 (unpublished version)

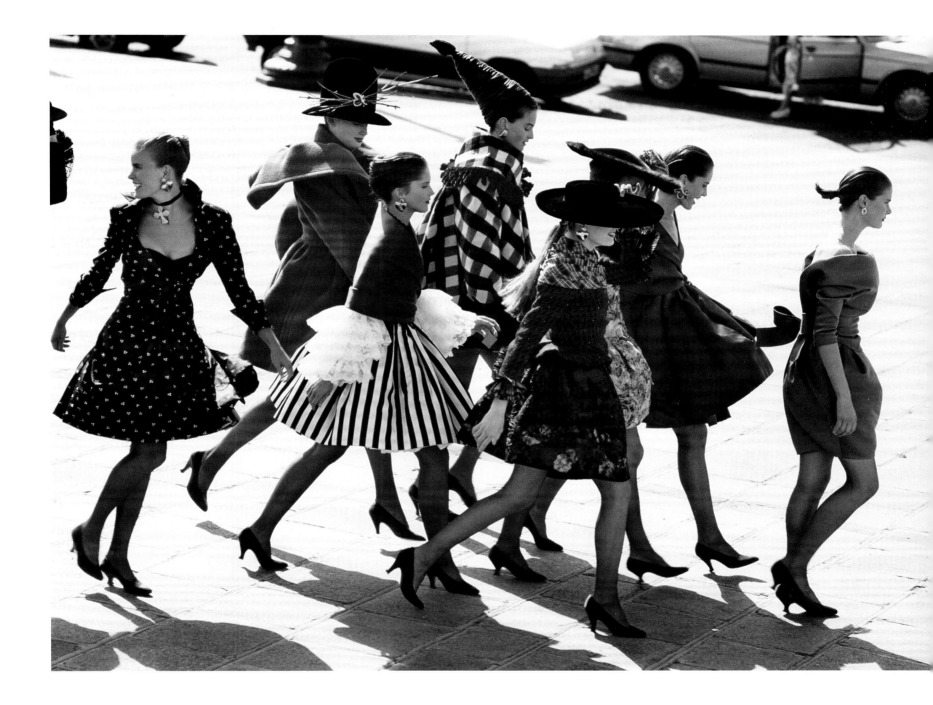

'The romance of Lacroix'
by Patrick Demarchelier
In its inaugural year, observed *Vogue* of
the house of Lacroix, its 'irreverent spirit
spurred everyone on to new heights of
lively, short and seductive'
October 1987

Following pages
Margaret Thatcher in 10 Downing Street
by David Bailey
After the general election of 1987,
Mrs Thatcher became the first prime
minister since the nineteenth century
to serve three consecutive terms
October 1985

'*I do read Vogue. When we look at fashions, ordinary people like me, we would love photographs which show you what the clothes are actually like – back and front, and what they look like in movement. When you're buying clothes, you mustn't just stand in front of the mirror, but see how you move in them. If you're buying a classic, they are expensive, and you've got to be very, very careful in buying.*'

Margaret Thatcher, 'A Certain Style', *Vogue*, October 1985

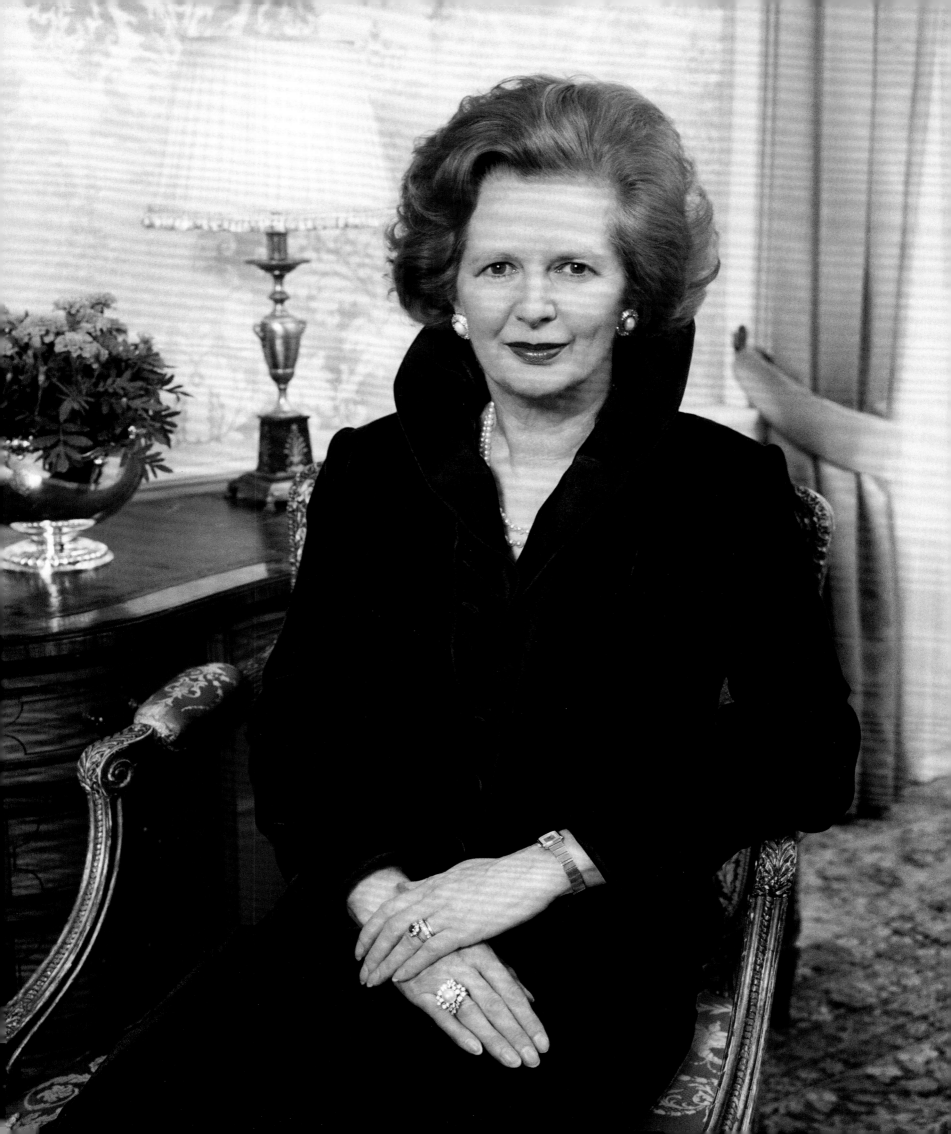

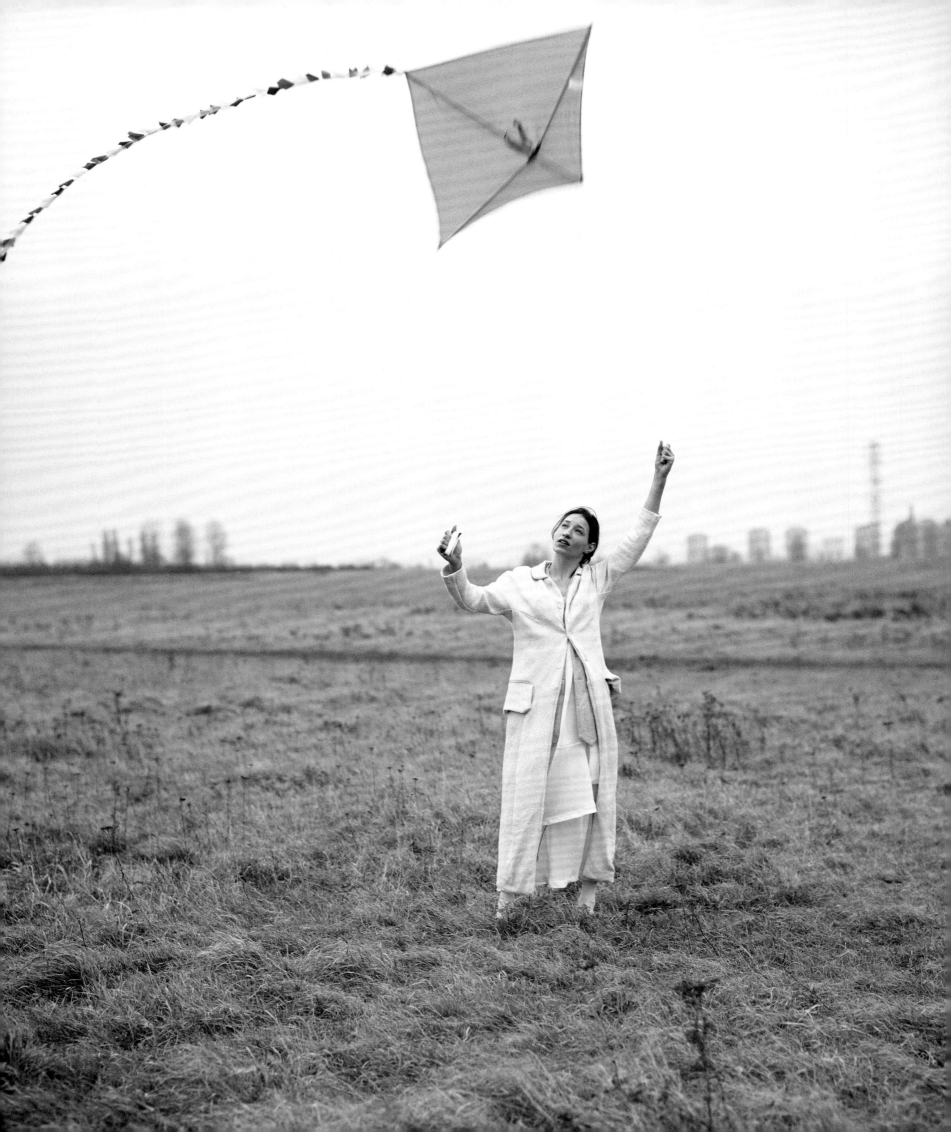

Broken Glamour

VOGUE celebrated its seventy-fifth anniversary in 1991 with a commemorative issue. The cover image, taken by Herb Ritts, featured Linda Evangelista, Christy Turlington and Cindy Crawford, vital components of a bigger, unstoppable engine: the supermodel movement. They seared themselves on the public consciousness as living exponents of the billion-dollar power of the fashion business, their otherworldly glamour a marketing tool for a ruthless industry of conglomerates, franchises and licensees. The pages of *Vogue* were never going to be big enough to contain their collective ambition. The minutiae of their social lives and off-duty uniforms were picked over, their occasional opinions given almost Delphic significance. They were among the highest-earning young women of their generation, marked out against a backdrop of conspicuous consumption. There were two further main players – Naomi Campbell and Tatjana Patitz – and a fluid supporting cast: Claudia Schiffer and Nadja Auermann from Germany; Americans Stephanie Seymour, Amber Valletta and Shalom Harlow; and the Danish expatriate Helena Christensen, among others. All, as *Vogue* put it, were 'aware of their absurd good fortune'. British *Vogue* had played its part in their ascension: the cover to the very first issue of the new decade (p.214), photographed by Peter Lindbergh, showed the five leading models grouped together for the first time above the appropriate words, 'The 1990s. What Next?'

Within three years the climate had changed perceptibly. A memorandum intended for the eyes of John Major, prime minister since the start of the decade, was leaked to the press (in itself marking a new phenomenon). He was warned that, although the government had promised a 'classless society of opportunity, the reality is now that the rich are getting richer on the backs of the rest who are getting poorer'. Britain was going into recession again.

Vogue began to change, too. Although in peacetime it rarely reported on domestic or foreign politics, in 1993 the journalist Marie Colvin revisited post-Gulf War Baghdad, providing a tone of reportage that had not sounded in *Vogue* since 1946. Coverage was given to issues such as homelessness, the environment and other topics in tune with the zeitgeist: political correctness (1993); the death of the career girl and women who choose not to have children (1994); women who kill and the end of feminism (hotly disputed) (1995); food faddism, exactly who is Cherie Blair and high-end prostitution (1996).

A similar sensitivity began to take hold on the fashion pages, reflecting shifts in fashion trends and the conscience of those who depicted

Previous pages, left
'New spirit': Rosemary Ferguson in south London
by Corinne Day
'Floaty layers in a field of dreams': a long coat and shift dress by Comme des Garçons
March 1993

Above Shalom Harlow by Mario Testino, 1995
Below (left to right) Two *Vogue* covers of Linda Evangelista by Patrick Demarchelier, 1991, and Nick Knight, 1993, and one of Diana, Princess of Wales by Demarchelier, 1994; hand-decorated photograph by Bruce Weber, 1991

out of this world

From Morocco to Mongolia, the East is exerting its magical influence on designers' imaginations. Minimalism might reign elsewhere, but here the exotic and the delicate, the rich and the rare make dressing an exercise in artistry

Above (left to right)
A fashion story by Paolo Roversi, 1994; Kate Moss's first *Vogue* cover by Corinne Day, 1993 *Right* A multiple Kate by Juergen Teller, 1994 *Left* Cabinet minister Peter Mandelson at home, by Snowdon, 1998 *Below right Vogue*'s star-studded *fin-de-siècle* party by Testino, 1999

them – and of those who commissioned them. The quasi-documentary photographs of Corinne Day and the naturalistic approach of Juergen Teller appeared unusual in the context of *Vogue*'s history. This new sensibility was linked to a flourishing movement with its roots first in music and then in fashion. The grunge aesthetic, which in visual terms for *Vogue* was short-lived, became a flag of convenience that lazily covered the collective outputs of younger photographers. Day and Teller, as well as Glen Luchford and David Sims, had made their mark in the youth-orientated style magazines of the early decade, but little else connected them.

Within a year there was a renaissance of high glamour, a reaction to the prevailing, more muted look. As the model Rosemary Ferguson recalled: 'Photographers didn't shoot you in a pile of sand in a reclamation yard any more.' This cultural shift was trumpeted as early as November 1993 with a cover that declared 'Glamour is back'. The photographs inside consolidated Nick Knight's position as the outstanding British fashion photographer of his generation, a tireless experimenter, confident in his use of the tools of new technology to hone off-kilter notions of fashion and beauty. Contemporaneously, the success of photographer Mario Testino, a traditionalist in the finest sense, balanced the magazine. His simply composed tableaux – often deceptively simple – recalled the vivacity of his *Vogue* predecessors Beaton and Parkinson, while defining beauty for *Vogue* at the start of a new century.

Through the decade one name gained currency month by month. Kate Moss's first cover had been published in March 1993, when she stood out as the personification of the 'London Girl'. At 5ft 6½in, she was demonstrably petite for a top model and slight in build. By the end of the decade that made her famous, she was the most celebrated beauty of her era and, after the Queen, the most recognisable living British woman.

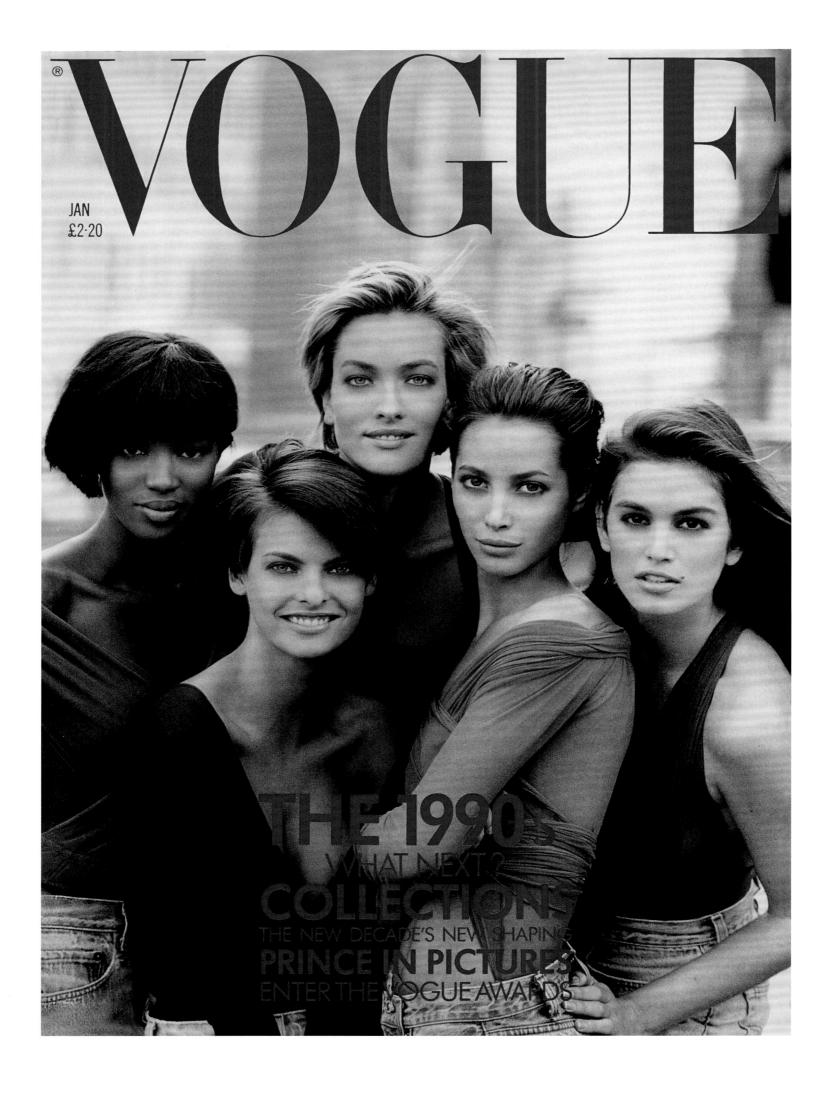

VOGUE

JAN
£2·20

THE 1990s
WHAT NEXT?
COLLECTIONS
THE NEW DECADE'S NEW SHAPING
PRINCE IN PICTURES
ENTER THE VOGUE AWARDS

'The supermodels': Naomi Campbell, Linda
Evangelista, Tatjana Patitz, Christy Turlington
and Cindy Crawford, New York
by Peter Lindbergh
'Every five years or so,' said *Vogue*, 'a handful
of young women at the peak of their profession
seem to encapsulate the look of the time'
January 1990

'Knight errant': Stephanie Seymour
in Los Angeles
by Herb Ritts
'Powerful weaponry for women at
arms': a Boucher-print gold Lurex corset
by Vivienne Westwood with diamanté-
encrusted shoes by Manolo Blahnik
September 1990

Naomi Campbell as a Dionysian
handmaiden
by Herb Ritts
Campbell wears a draped bikini bottom by
Norma Kamali and a crown of wreathed
autumn leaves
December 1990

Azzedine Alaïa in his Paris studio
by Snowdon
'The man who loves women dresses the
female form better,' wrote *Vogue* of Alaïa,
shown with his dog Patapouf and family
who clamber over some pattern books
October 1990

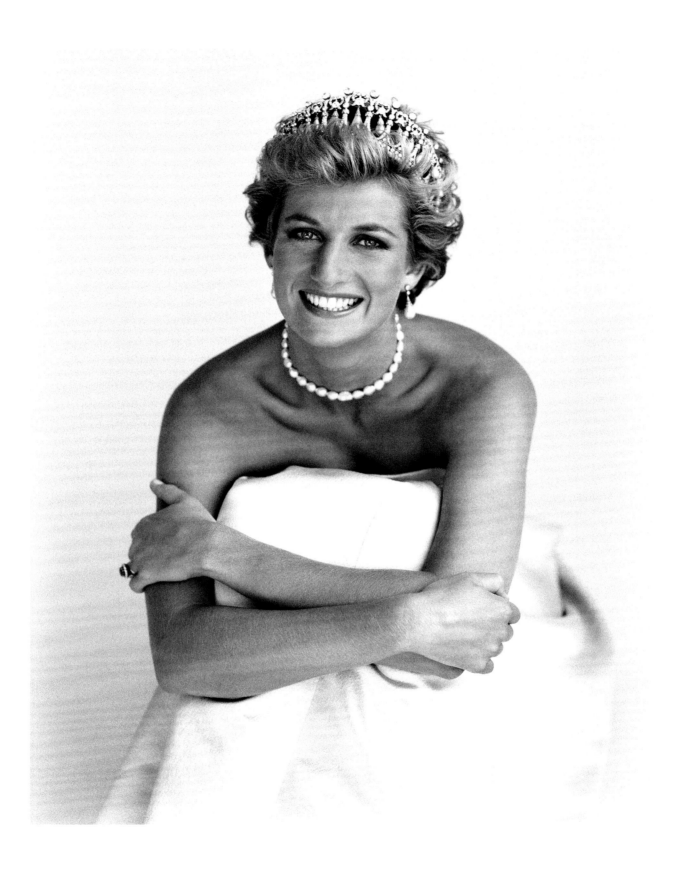

Diana, Princess of Wales
by Patrick Demarchelier
The most recognisable woman of her
time, Diana had travelled far to become
a modern, *soignée* princess
December 1990

Linda Evangelista
by Patrick Demarchelier
A rhinestone-encrusted silk crêpe dress with
lilac and peppermint silk taffeta opera coat,
modelled by Evangelista, designed by Versace
October 1991

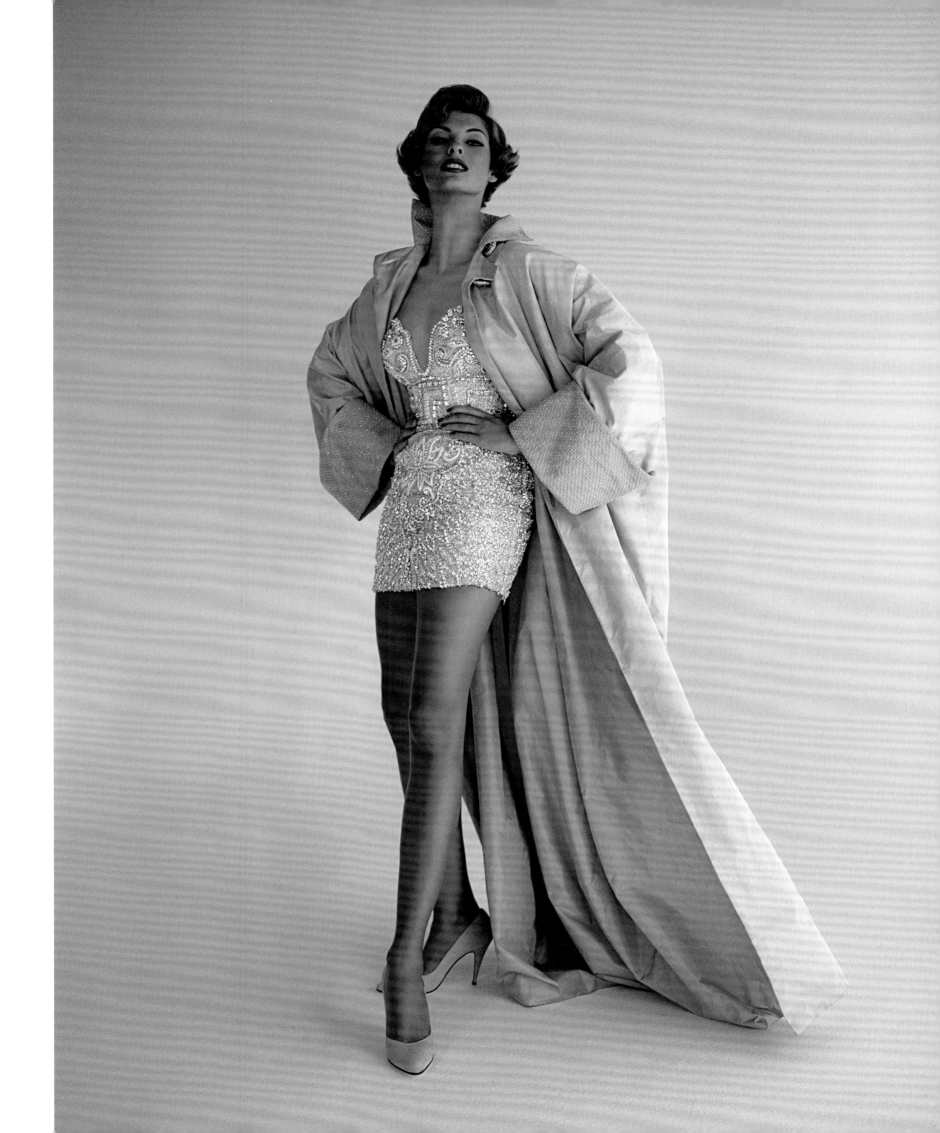

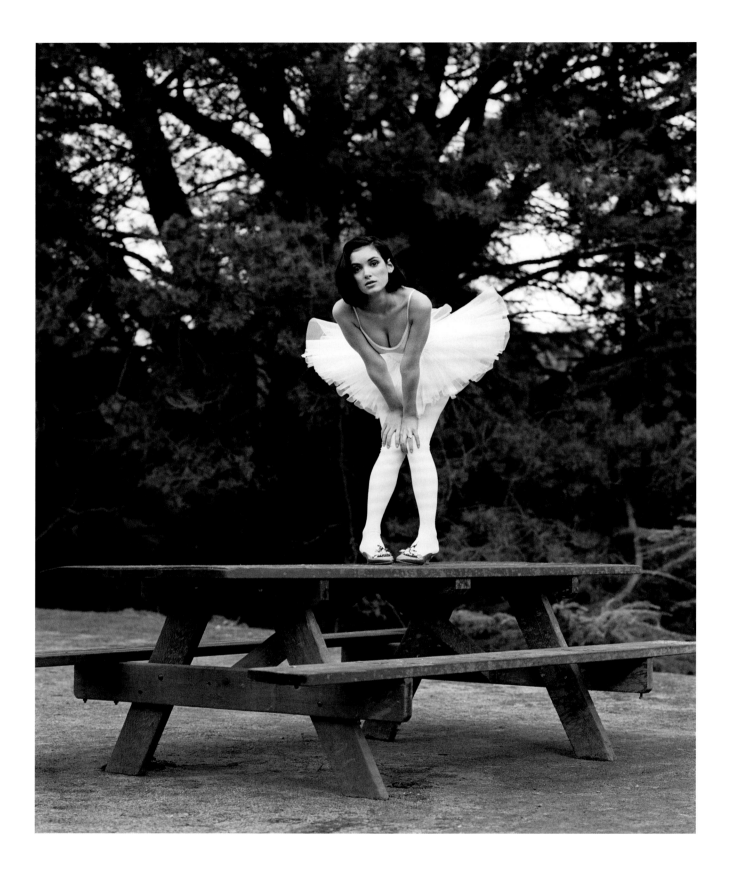

**Winona Ryder at home in Los Angeles
by Herb Ritts**
Wearing a ballet tutu by Gamba, the actress
dances in the garden of the home she then
shared with Johnny Depp
May 1991

**'Big country': Jamie-Jo Madeiras
by Bruce Weber**
Under Montana skies, stunt-rider Madeiras
defies gravity in showgirl diamanté by
Thierry Mugler
January 1991

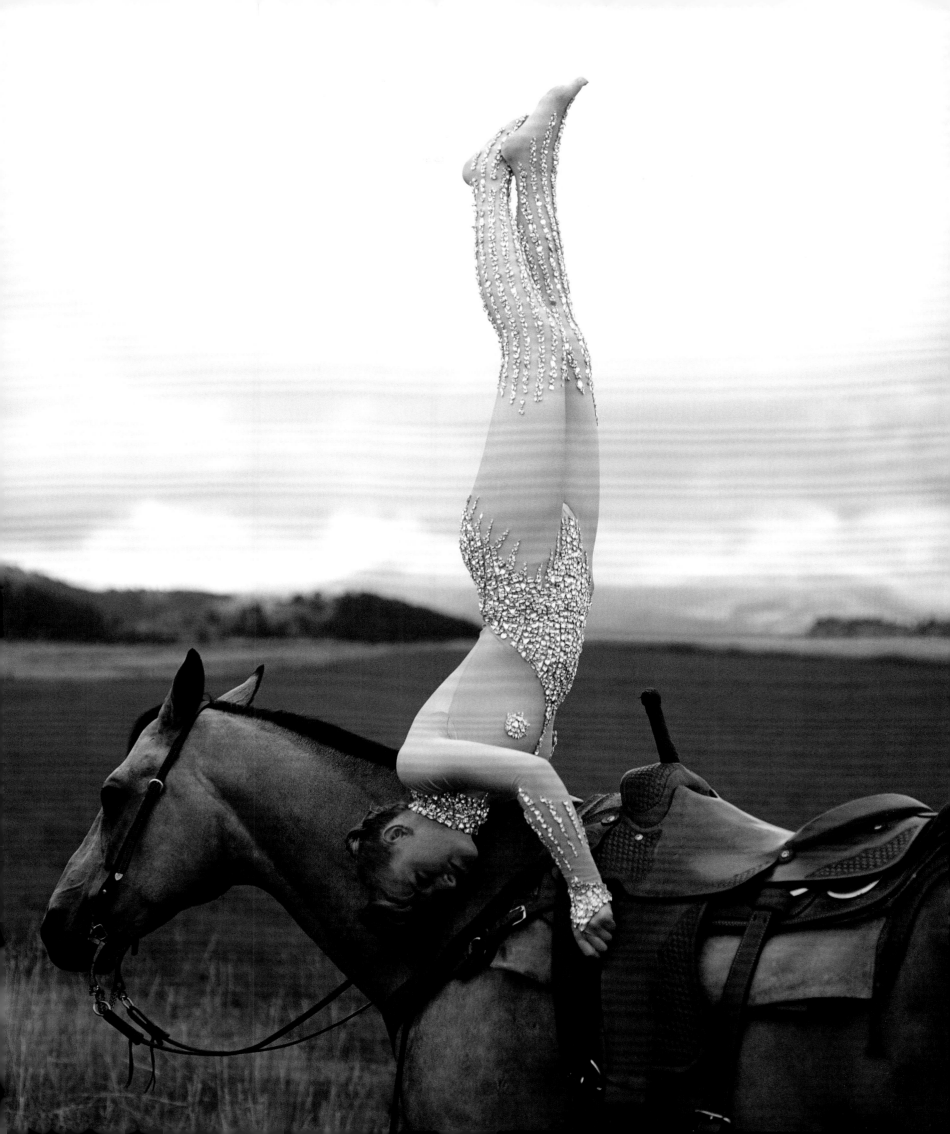

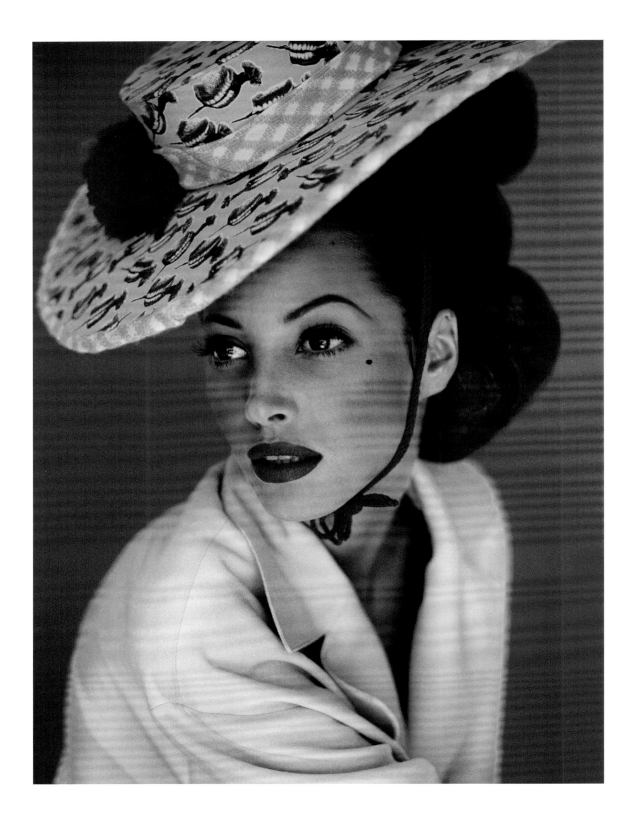

**'New beauty': Christy Turlington
by Javier Vallhonrat**
'Exquisite make-up and scent are
the essence of the new, bewitching
beauty,' said *Vogue* – and clearly, too,
an idiosyncratic sombrero
March 1992

**'La dame masquée': Nadja Auermann
by Ellen von Unwerth**
At first, model Auermann wanted to be a
tightrope walker or Chancellor of Germany.
In this homage to the provocative images of
Helmut Newton, her mask is by Philip Treacy
October 1991

'London girl': Kate Moss
by Corinne Day
'She was just this cocky kid from Croydon,'
recalled Day, adding, 'she wasn't like a model,
but I knew she was going to be famous'
June 1993

LISA ARMSTRONG
from 'Fashion's New Spirit', *Vogue*, March 1993

'IF London Girls have seemed a little chirpier of late, or slightly springier of step, it is with some reason. Suddenly their native style has made them *personae gratae* again. At the recent collections, their wardrobes seemed to have provided the blueprint for some of the most important shows. Ralph Lauren showed gauzy floral dresses with clumpy shoes, ruffled shirts and shawls. Chloé had layers and layers of pretty clothes that had a dusted-down-from-the-attic feel. Perry Ellis did a take on London eclecticism, mix-matching crochet and leather and sticking funny little woollen hats and National Health granny glasses on his models. In Milan, Complice paid a tongue-in-cheek tribute to Carnaby Street, shovelling Union Jacks and tiaras on to the kind of slightly-too-short jackets and stovepipe trousers that always go down well with a certain kind of British girl.

After years of having the international beauty standard set by glowing superwomen, of trying to match the tans, the curves and – most self-deludingly of all – the hairdos of Cindy Crawford and Claudia Schiffer, London Girl has come into her own.

This means that it's now OK to look a bit ragged round the edges. It's even fashionable to wear slightly fraying cardigans from the menswear department at Marks & Spencer and to mix poor-boy sweaters with Spandex trousers. Unfathomable as it may seem to women who have learnt how to dress like executives and worship at the shrine of the capsule wardrobe, it is the London look – the one photographer Andrew MacPherson describes as "elegantly wasted"; the look you and I would probably define as the appearance of having a slightly haphazard approach to organisation and an, *ahem*, novel take on grooming – that is considered madly desirable just now.

Not since the days of Marianne and Mick, the Shrimp and Bailey, has the world been so keen to discover what London Girls are really like.

Cecilia Chancellor, London Girl *par excellence*, has seen her ten-year modelling career miraculously revived in the past few months. Japanese film crews have jammed the flight paths to Heathrow, eager to ask Kate Moss, a tiny waif from Croydon with limp hair, wide eyes and a million-dollar contract with Calvin Klein, the questions they put to Linda Evangelista two years ago. Meanwhile, Corinne Day, another scrap of a girl with a whispery south London accent, and a great mate of Moss, has had to sign off the dole since she became the photographer on the hugely prestigious advertising campaign for Barney's, America's hippest department store. Day's subjects include Tesco checkout-girl-turned-model Rosemary Ferguson, and Sarah Murray, whose CV covers stints in a chip shop and at a Go-Kart track. And there are hundreds, probably thousands more girls like them in this country: pale, laconic creatures with fine bones, hair the colour of tea, faces that look lived-in

at fourteen and an almost maddeningly cavalier attitude to their own good looks. But this is a style that is not confined to those born within the sound of Bow bells, although eventually those who possess it drift towards the capital. It can be found, in pockets, the length and breadth of the country and sometimes out of it – since she chopped her bob into a wispy balaclava style and sported mohair skinnyribs, Lucie de la Falaise, who lives in Paris, has emerged as an honorary London Girl. Nor is London Girl a recent phenomenon. Lady Caroline Lamb, the eccentric, beautiful tomboy mistress of Byron, was an early prototype. Later incarnations included Lady Diana Cooper, a legendary beauty and unconventional dresser who only once bought "normal" clothes, before she accompanied her husband to the Embassy in Paris, on the pretext that "I must try not to swell the list of mad English ambassadresses". Another London Girl was Lucie de la Falaise's great-grandmother, Lady Birley, a noted lovely who wore odd clothes and fed lobster thermidor to her roses.

What began as a sort of wild-child attitude was later cloned into a style. By the Sixties these blithely beautiful girls with an inimitable stance on self-presentation had become a definable set whose membership included Jane Birkin, Lady Jacquetta Eliot, the successful model Vicky Hodge – whose vast collection of clothes was covered in hairs from an even vaster collection of dogs – Talitha Pol, who became Mrs Paul Getty II, and Lord Harlech's daughter Jane Ormsby-Gore, who wore second-hand Twenties and Thirties dresses with bell-bottoms, married a trendy boutique owner and called her son Saffron. Upper-class girls all of them: they would be – after all, Britain is famous for the down-at-heel appearance of its aristocracy. But in keeping with the egalitarian spirit of the day, there were scores more girls across the class spectrum who began to grasp the essentially aristocratic taste for the old and the tatty – two qualities that are integral to London Girl's style.

By the mid-Eighties, apart from a select, high-profile few – among them Amanda Grieve, now Lady Harlech, who worked successfully with John Galliano as his stylist-cum-muse – London Girl's star was on the wane because everyone wanted to look obviously successful and London Girl doesn't like to look obvious about anything. But what with the recession and "grunge" (which as any social chronicler will tell you is a way of dressing that has been second nature to London Girl for aeons), she is in danger of becoming our biggest fashion export.

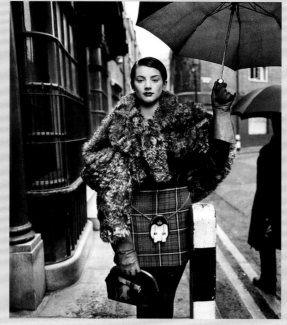

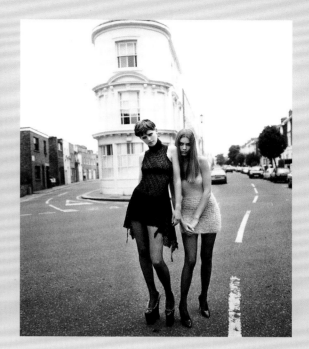

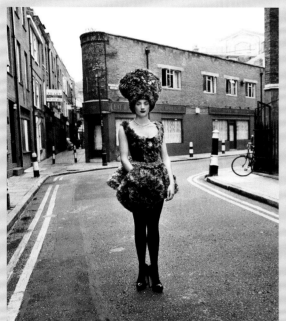

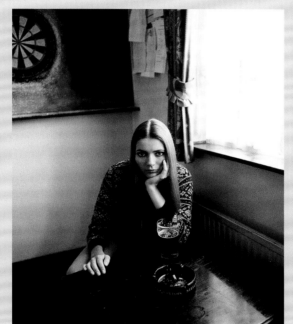

Hugh Grant on the set of *Four Weddings and a Funeral*
by Julian Broad
At the time the highest-grossing British film, Mike Newell's production launched the career of its floppy-haired leading man of impeccable comic timing
June 1994

'Young cinema': Jude Law
by Albert Watson
'You can't help staring at Jude Law. Like some kind of radiant, emerald-eyed pixie, his Puck-meets-punk demeanour is utterly compelling,' enthused *Vogue* of the new young star of British cinema
March 1996

Kate Moss
by Nick Knight
As London swung again, *Vogue* celebrated
'Cool Britannia', the 1990s boom in
British arts, which for *Vogue* meant a
special issue marking British creativity
June 1998

Nadja Auermann
by Nick Knight
Vogue's 'platinum-blonde powerhouse',
5ft 11 ½in with legs measuring 45in
long, Auermann wears a minidress by
Yohji Yamamoto
March 1994

Sara Morrison
by Nick Knight
A bias-cut dress that follows form by Hussein
Chalayan, twice British Designer of the Year
June 1997

Rebekka Botzem
by Nick Knight
Beauty with bite: an unmounted black pearl
from Mikimoto, balanced by Rebekka Botzem
July 1996

Opposite
**Carmen Hawk
by Craig McDean**
An artful, backless construction in satin
by Christian Lacroix
October 1996

Above
**Guinevere van Seenus
by David Sims**
An understated, strapless black evening
dress by Yohji Yamamoto
March 1996

Left
**Stella Tennant
by David Sims**
The new-look leather is given an original
treatment as a minidress by Anna Sui
September 1995 (unpublished version)

'Girl overboard': Kate Winslet
by Regan Cameron
The actress had just appeared in James
Cameron's film *Titanic*, for which she
would receive the second of her six Oscar
nominations
January 1998

'In Bonnard's bathroom'
by Sarah Moon
On the eve of a Tate retrospective of painter
Pierre Bonnard's evocative work, Moon paid
photographic tribute
February 1998

Following pages
**David and Victoria Beckham in Manchester
by Juergen Teller**
Then one of the Spice Girls and arguably the
country's best-known footballer, the Beckhams
are photographed in the Midland Hotel
March 1999

'It's difficult not to feel a wave of affection at the thought of them carefully laying out all the tabloids every morning to see which one their pictures are in and discussing who is more famous: "He gets more respect because he is considered more talented," Victoria concludes.'

Christa D'Souza, 'Life is Sweet', *Vogue*, March 1999

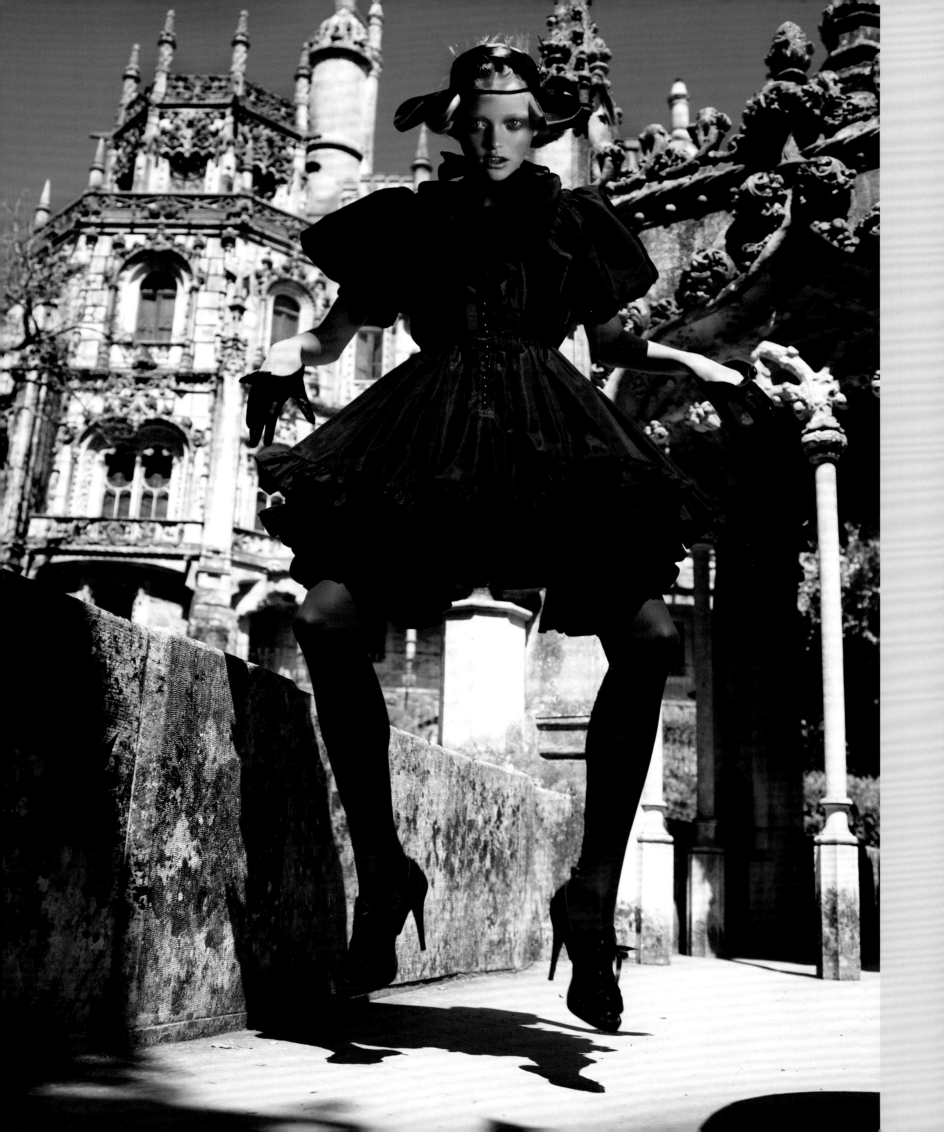

Darkness Falls

'IT'S 9.30 am. I have no clue as to what has happened, sure that, if nothing else, there is a huge fire somewhere downtown. At Balthazar, the news starts trickling in ... A girl who has been talking quietly on her mobile phone starts crying and runs from the restaurant. The waitresses are teary and cling to the restaurant phone ... The maître d' is allowing his staff, one at a time, to walk a couple of blocks and look at the by now burning towers.' Vogue's deputy editor, Susie Forbes, was on the spot in Lower Manhattan for the immolation of the World Trade Center in 2001, an event that shifted perceptibly the 'tectonic plates' of the decade and, as likely, those of the years that followed. The decade had barely got into its stride. War in Afghanistan and Iraq further redefined the geopolitical map. A collective heightened tension had led, in the United States, to both higher church attendance and an increase in mysticism and alternative beliefs, as well as displays and expressions of patriotism at every given opportunity – or so it seemed.

For Vogue, then, an apposite time for a special cover. Taken by Mario Testino shortly after the Twin Towers atrocity and ready for the January 2002 issue, a pull-out cover showed eighteen of Britain's leading models, posed in union flags customised by the fashion designers of the moment. As a public display of patriotism, it was hard to beat; as a symbol for the nation's mood, it was unerringly precise.

Spiritual values had earlier been espoused by Vogue's supporters in its special millennium issue. 'A new direction will come from people's dreams and hopes,' pronounced designer Issey Miyake. 'I think,' added the milliner Philip Treacy, 'that the future could be friendlier, bringing with it a "new spiritualism".' In an unprecedented move, Vogue ran its horoscope over three consecutive pages – understandable, perhaps, from the perspective of the millennial edge. Gratifyingly, the future looked 'dazzling'. As the decade took hold, it seemed that the new spiritualism had firmed its grip, too. In 2004 novelist Jeanette Winterson zealously shared the inner workings of her 'zodiac wheel'. 'Astrology,' she claimed, 'is a working model of the individual, a model that shows what is, what has been and what might be. Its purpose is not predictive; rather it is a multiple of possibilities.' Life in the Age of Aquarius, she concluded, was more than just the facts, rather 'a strange web of energy and interconnections', which again tapped into a collective sensibility.

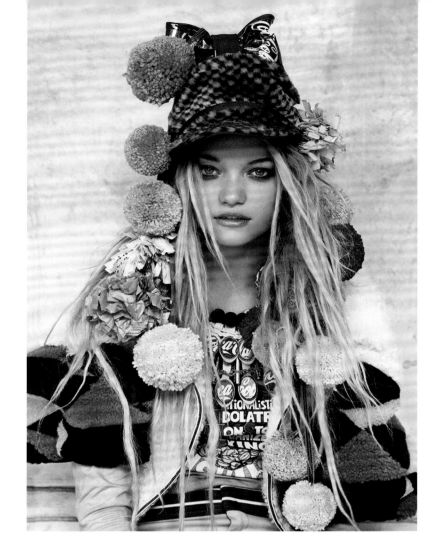

Previous pages, left
Gemma Ward at the Palácio de Regaleira in Sintra, Portugal by Mario Testino
The Australian model wears a Saint Laurent silk-taffeta dress and vertiginous heels by Christian Louboutin
August 2005

Above Gemma Ward, suitably colourful for an Indian summer, by Patrick Demarchelier, 2007 *Below left* Fashion pantomime starring Erin O'Connor by Tim Walker, 2004 *Below right* Patriotic cover by Mario Testino, 2002

On the ground, in 2005, Jane Wells reported for Vogue on the civil war in western Sudan. Her words seared the page: 'One woman named Aisha described witnessing the murder of her parents, brother, husband and youngest child. They were beheaded and their heads thrown into the flames of their burning home. She and her other son were tending animals and survived by hiding behind a well when the Janjaweed attacked. When she talked, she wept and so did I. I held her hand and she begged me to take her home with me.'

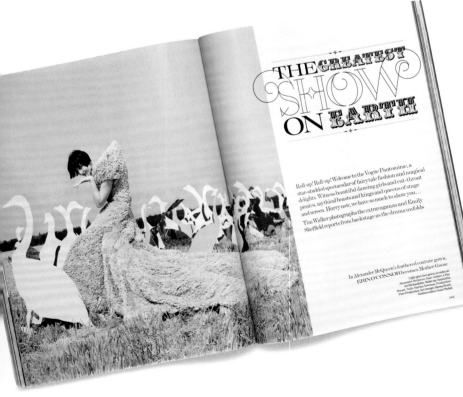

Above A Gareth Pugh ensemble by Lachlan Bailey, 2006 *Above (left to right)* Three *Vogue* covers by Nick Knight: star wattage from Sienna Miller, 2007; a 'day-g o' arrangement, 2003; the reigning queen of *Vogue*, 2001 *Right* A graphic frontispiece, 2008 *Far right* Sixties-inspired fashion by Knight, 2006 *Below right* A barely disguised Robbie Williams by Testino, 2000

Globalisation intensified and was propelled by faster communications: the internet, selling and buying online, social networking. Guilt and consumerism might often be combined, but not inextricably. *Vogue* reported in 2003 on the allure and the economics of coffee ('Globally speaking it's the second most popular drink after water, and the second biggest market after oil') and in 2004 historian Simon Schama abandoned academia to pay tribute to his lower-brow passion for ice cream.

The magazine also noted, in 2003, that the universal greeting 'How are you?' was now 'Where are you?' Our words, it continued, were 'dependent on the little plastic packets of components and circuitry we carry in our handbags. Of course you're carrying one …' A year later, for a feature on the new phenomenon of internet dating, *Vogue*'s correspondent was able to say: 'It's been an odd fortnight. After being more or less single, I've had offers of dates from over 400 men.'

Casting a long shadow over *Vogue*'s rapidly moving, technologically advancing decade was the darkly brilliant mind of Alexander McQueen. A designer of immense talent, his work, flamboyant and disturbing, was, according to one observer, 'a form of confessional poetry' entirely in tune with the times. 'When I'm dead and gone,' he pronounced, 'people will know that the twenty-first century was started by Alexander McQueen.' He committed suicide as the decade closed. 'I just think I've sussed out what it all means. From the old narrative of life and death I have to start thinking on a wider scope. I mean I've done religion, done sex, done politics and death in a big way. Maybe I should start doing life – but then life is all of those …'

Sofia Coppola in London
by Corinne Day
Born into Hollywood royalty, the young director
had just completed filming *The Virgin Suicides*
March 2000

Prince Charles at Highgrove
by Mario Testino
The Prince of Wales feeds his Welsummers
and Marans in a wool coat from Pakistan
February 2002

'What lies beneath'
by Cindy Sherman
An unnerving self-portrait of the American
photographer, despite the cheerful use of
a clown's make-up and wig
June 2003

Damien Hirst in his Gloucestershire studio
by Norbert Schoerner
'I don't believe in genius, I believe in freedom,'
the artist told *Vogue* as he prepared for a new
London show
September 2003

**Kate Moss and white stallion
by Nan Goldin**
Moss, photographed in Goldin's celebrated
snapshot aesthetic, styled by Stella McCartney
October 2001

**Gisele Bündchen
by Corinne Day**
The Brazilian supermodel spills a mug of tea
over her trainers and dress by Roberto Cavalli
June 2002

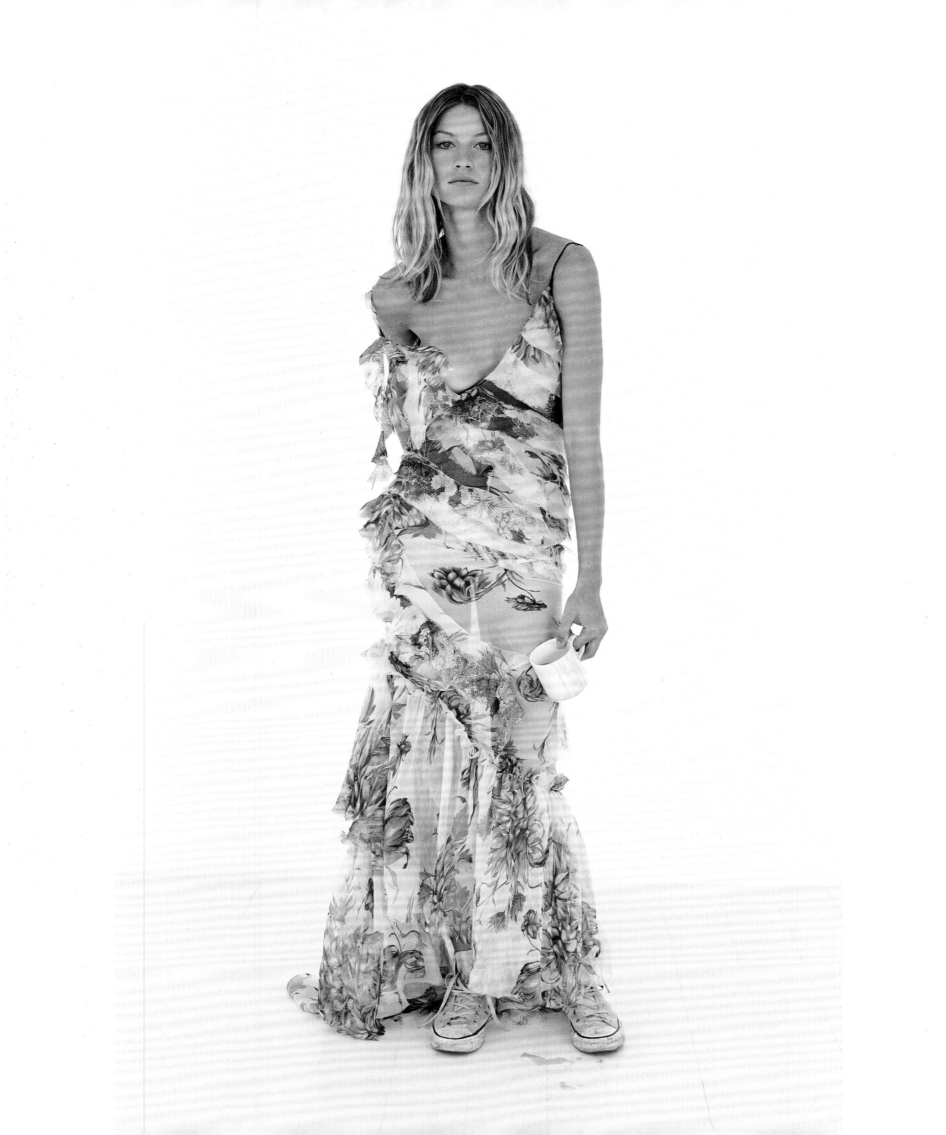

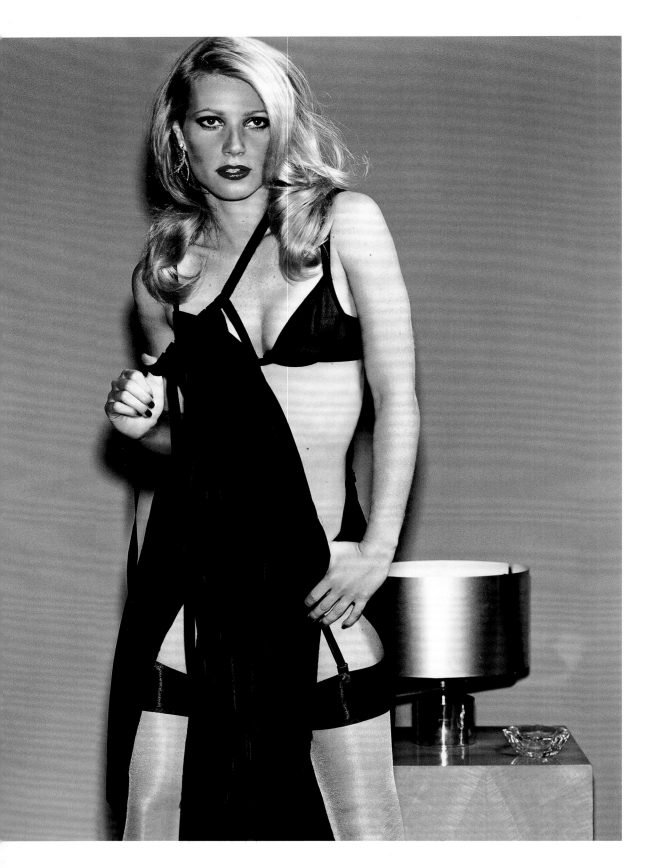

'Belle de jour': Gwyneth Paltrow
by Mario Testino
The American actress, in Paris for the couture
shows, wears a silk-satin dress by Lanvin
October 2002

Rie Rasmussen at Novosibirsk station
by Norbert Schoerner
Schoerner's photographs for *Vogue* followed
the Trans-Siberian Express from Moscow
to Beijing
January 2005

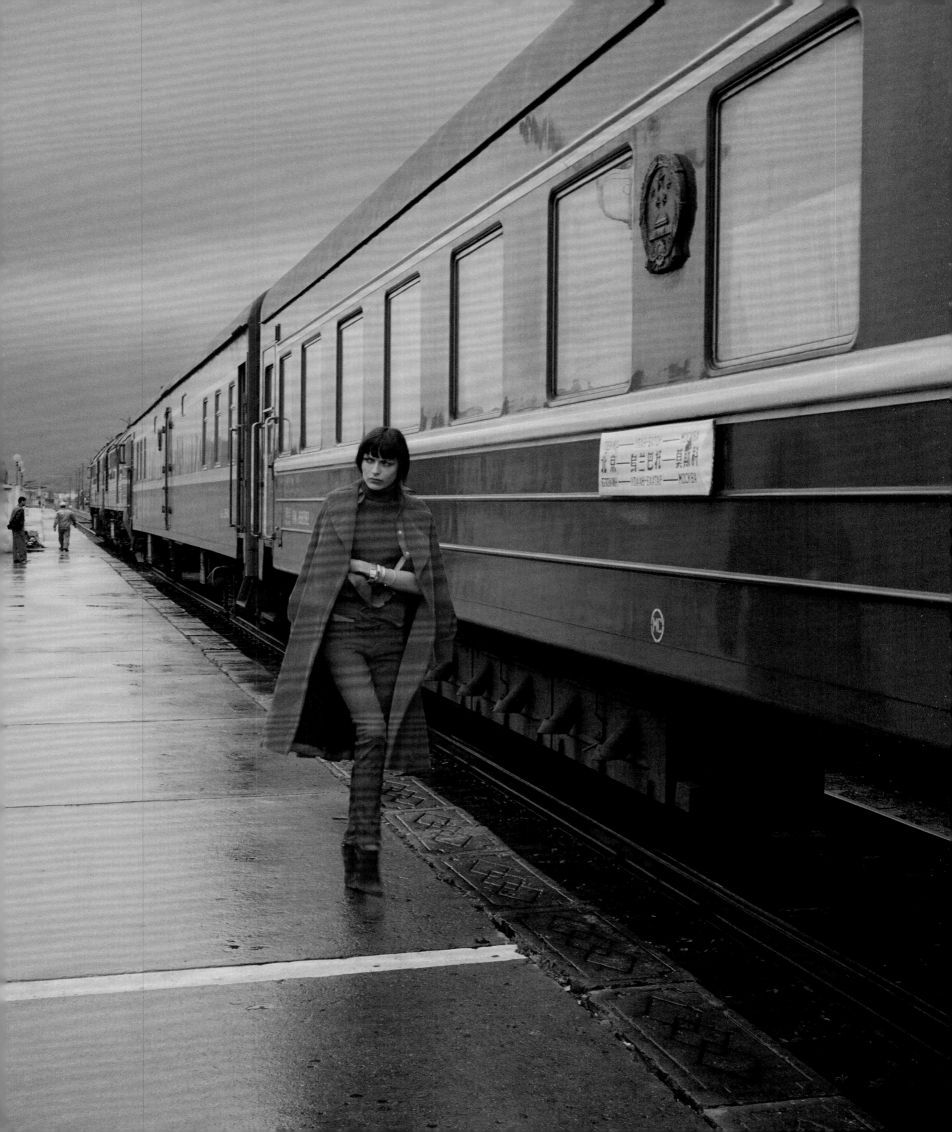

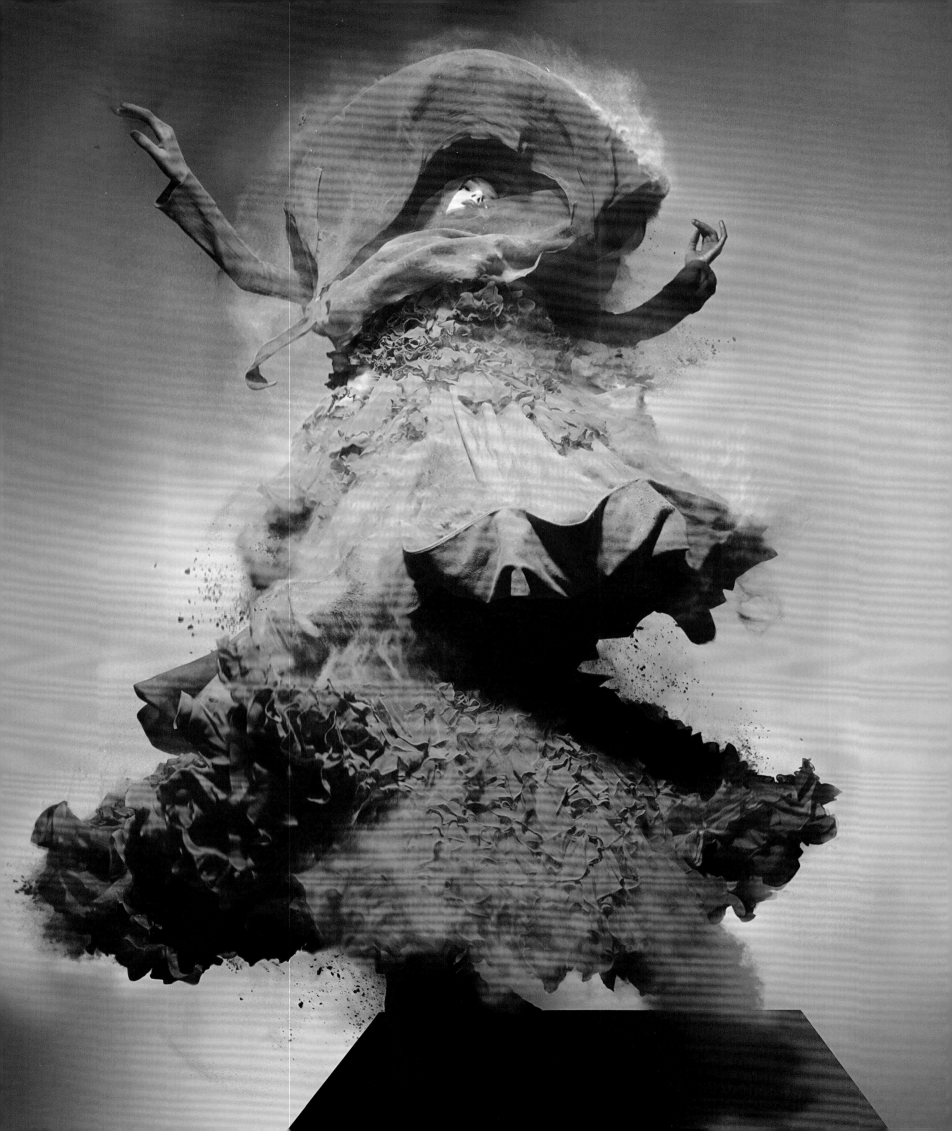

Lily Donaldson
by Nick Knight
In 2003 John Galliano bestrew Diwali powder
paints over his models, the moment recreated
here for a survey of 'Unbelievable Fashion'
December 2008

Gold Kate Moss
by Nick Knight
For a special issue, British designers were
invited to create gold outfits. The swan-
necked profile was instantly recognisable
December 2000

GEOFF DYER
from 'Encore!', *Vogue*, October 2003

'OUR Eurostar train was still creeping through the Kent countryside when my minder from *Vogue* expressed her first doubts concerning my mission. "Do you actually know what couture is?"

"Yes, I do," I replied. "In the sense of … No, not really." Detecting an "I thought as much" look flicker across her face, I reassured her that this was no cause for concern. Since the readers of *Vogue* obviously knew what couture was, it made no difference that the reporter didn't. I thought this was pretty clever, especially since I rounded off my defence with a well-chosen pun. "We're about to enter the Chanel tunnel," I said. It was my way of letting her know that I knew more than I was letting on.

The first show – Christian Dior – was at the Hippodrome on the outskirts of Paris. We drove there in an unmarked car. Security was tight, but I hadn't lost my invitation so it was OK. I have a vague memory of entering a tent or marquee but the interior had been transformed so totally that, by the time I took my seat, all sense of the world outside – *le monde sans couture* – had evaporated. At one end of the runway was a football terrace of photographers; at the other, a vast wall of light boxes, illuminated by the letters "CD" in blazing red. For a moment, I thought that we had actually travelled back in time to witness the launch of a technological breakthrough that would render the LP obsolete. Certainly, there was a major sense of expectation. The lights dimmed. Music roared and pumped. The wall of lights came alive in luminous rectangles of colour. Show time…

Thin as legend claims, the models began streaming into view. A Spanish flamenco element was unmistakable. The thing about flamenco is that you have to do it with a serious expression on your face and the Dior models brought to their task a sternness of expression befitting the judges at Nuremberg. Whether "face" is an adequate term to describe the site of this seriousness is a different matter entirely. "Face" is suggestive of something human, but make-up and paint had here been applied to make this seem a quaint, possibly unfounded assumption. It quickly became apparent that flamenco was just one bee in a swarming bonnet. There was a bit of everything going on. The models appeared, variously, as flappers, can-can dancers, sprites, zombies – you name it. A seasoned fashion writer said to me later that this show had actually been comparatively tame: "There were things in it that you might even wear," he said. Nothing brought home my ignorance of couture to me more clearly than this crestfallen lament. To my untutored eye what was on offer here had nothing to do with clothing as traditionally understood. Looking at the coats – which seemed capable of anything except keeping you warm or dry – I was reminded of Frank Lloyd Wright's response to clients who grumbled about the roof leaking: "That's how you can tell it's a roof." And so it was here: it was primarily by their extravagant refusal of the function for which they had been nominally intended that these could be defined as clothes. This was a form of pure and vibrant display that took the job of covering the human body only as a launchpad.

And how lovely it was, this celebration of our capacity to produce excess. What progress we have made from the cave-dwelling days when arguments would break out over whose turn it was to wear the hide.

The music surged and changed. The models kept exploding into view. It was like a firework display in that you wished it would never end – though even as you wished this you knew that you would be bored rigid if the pyrotechnics lasted a moment longer than they did. At the end of it all, Galliano came stomping along the runway, looking like a cross between a toreador and Conan the multi-cultural Barbarian. I say "Galliano" but I only learned that it was he after I turned to my minder and asked if it was Christian Dior. "No, it is not," she replied. The reason for this, apparently, is that Dior has been dead for about a thousand years. Well, as Philip Larkin conceded, "useful to get that learnt". It was obvious that only a response of the utmost gravity would redeem me in the eyes of my minder. "Ah yes," I said. "But his spirit lives on in Galliano."

This impression was confirmed – or, for all I knew, refuted – when Galliano appeared on telly later that evening. I was right about one thing: there really was a bit of everything going on. Fluent in French and English, Galliano had been inspired by Spain, by his travels in India and by African ceremonies. He ended by saying that it had all been done for his father. Just as couture has floated free from any anchoring in function, so no-one feels under any compulsion to anchor what is said about it in something as humdrum as sense. No-one would have batted an eyelid if Galliano had said that he'd intended the whole show as an offering to the gods of the Incas.

After the Dior show I went to have a look round the Ungaro atelier, where this kind of high-end clobber is actually constructed. It was, to say the least, a far cry from the sweatshops of Bangkok. Everyone wore white medical jackets, creating the impression that they were engaged in work that was vital to the health of the human race. And who is to say that they were not? For it would be a dreary old planet if there weren't the chance to create stuff so far in excess of what anyone could ever need. "Nothing needs to be this lavish," the poet Mark Doty exclaims in rhetorical astonishment. To which the only riposte – as the poet himself was surely aware – is King Lear's: "Oh, reason not the need!" I was reminded, watching *les petits mains* at work, of the painstaking labour and inventiveness that goes into the preparation of exquisite food: that same devotion to transcending the body's base requirements.

Several of the people here had worked for Ungaro for a decade or more. They seemed a contented and fulfilled workforce, proud of their skills and glad of the chance to deploy them to such extravagant ends. I thought of my mum who, for years, mended my clothes when they were torn and took them in if they were too large. Having completed one of these tasks, she always said that she would love to have been a seamstress. Not a seamstress for a designer; just someone whose skills would be sufficient to earn a modest living. Maybe this is the greatest excess and waste in the world: the huge reservoir of abilities that never gets a chance to be used.'

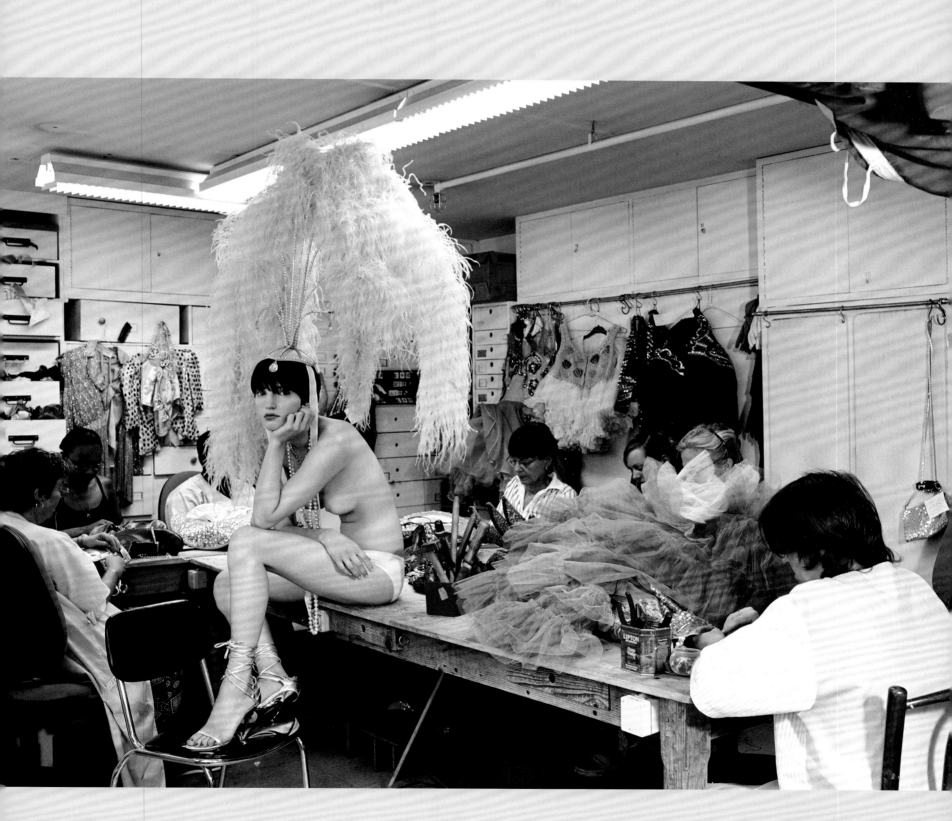

**Ben Grimes-Viort backstage at the
Lido in Paris
by Corinne Day**
At the venue for the Dior Haute Couture
collection, model Grimes-Viort wears an
ostrich feather and rhinestone headdress
October 2003

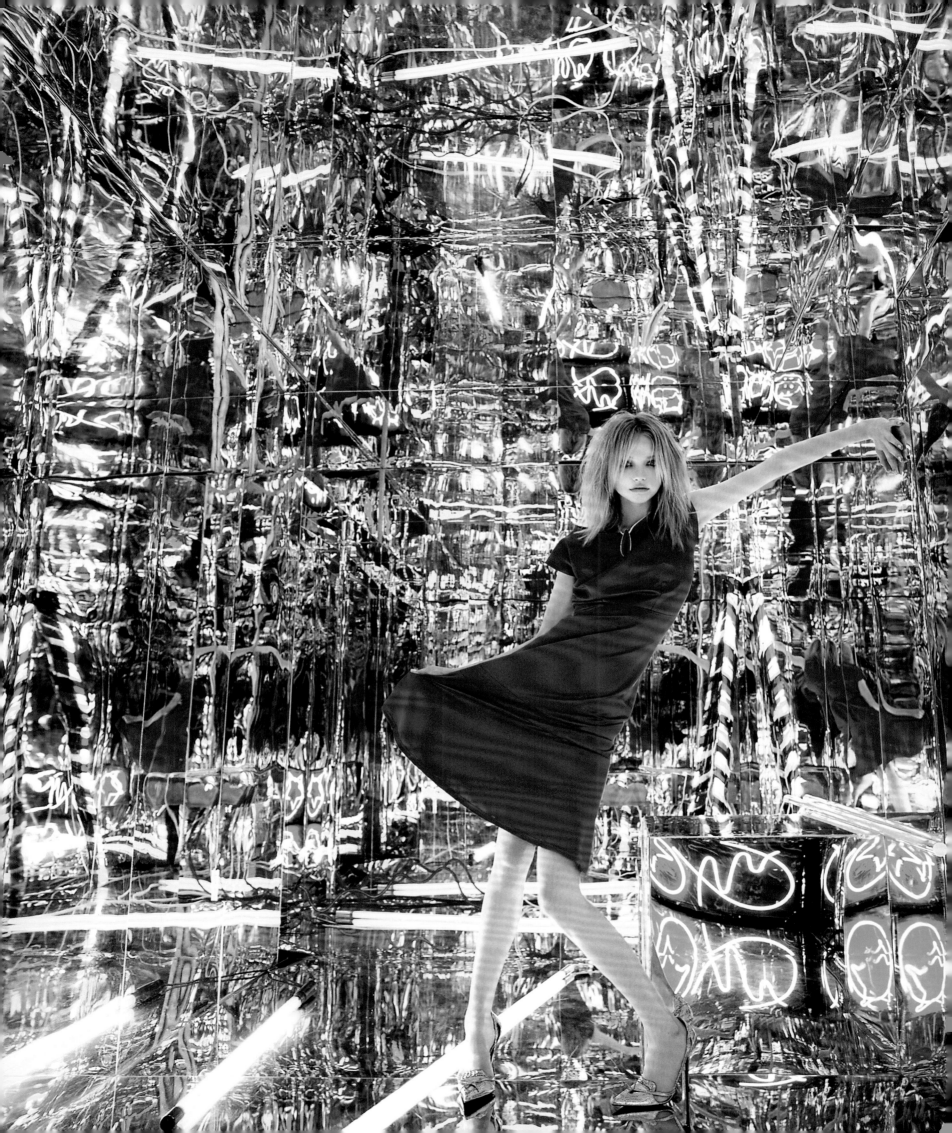

'I loathe that hideous, synthetic, commercial pink that is marketed to eleven-year-old girls. I consider coral and salmon very mother-of-the-bride. Over the years, I've realised that I only really like two pinks: dusty, bonbon pink or the Elsa Schiaparelli pink that lent its name to her perfume, Shocking. Both are truly chic to wear or decorate with.'

Plum Sykes, 'Ma Vie en Rose', *Vogue*, July 2009

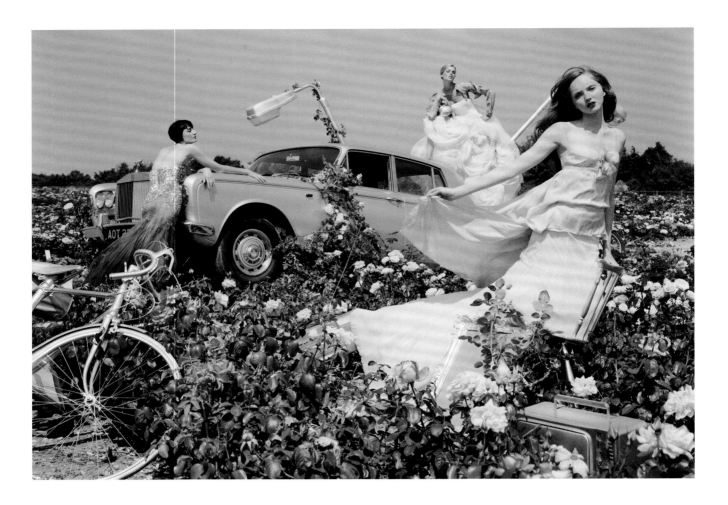

Previous pages
Gemma Ward
by Nick Knight
'Play to the crowd in bright slinky jerseys,
metallic fabrics and stunning digital prints.'
Vivid fuchsia dress by Jil Sander
September 2004

'Fashion pantomime'
by Tim Walker
With models Erin O'Connor, Jacquetta Wheeler
and Lily Cole, it was cheaper to buy a vintage
Rolls-Royce rather than risk damaging a hired one
December 2004

Suvi Koponen in the Maldives
by Javier Vallhonrat
Light fantastic. Sea-blue camisole top with
sequinned bandeau and vinyl miniskirt,
all by Emporio Armani
February 2008

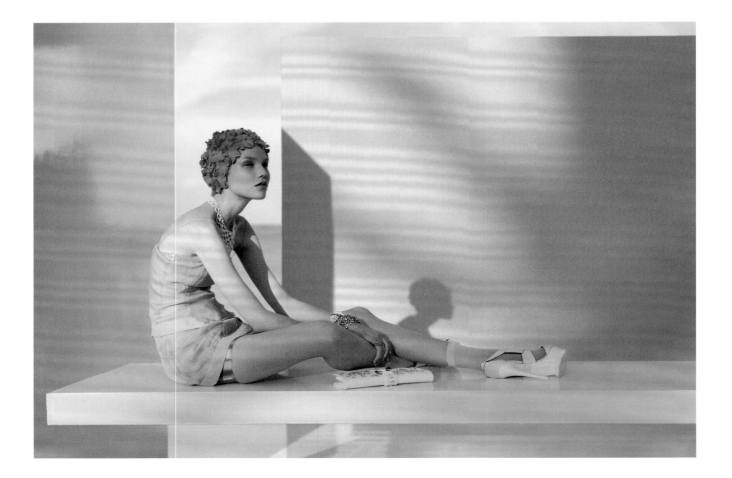

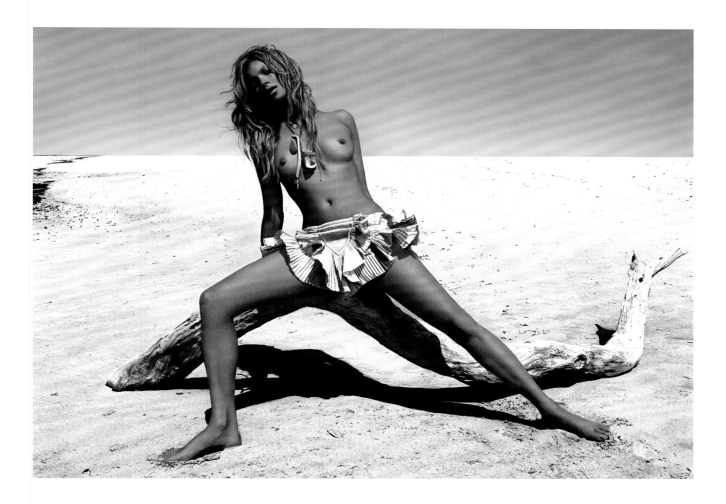

**Kate Moss on Manda Island
by Mert Alas and Marcus Piggott**
Off the coast of Kenya, Moss is pictured
in faded and salvaged materials and a
pleated-ruffle silk skirt by Valentino
June 2002

**Daria Werbowy in the foothills of the Andes
by Mario Testino**
Standing out frcm the herd, Werbowy
strides forth in tulle skirts and a cotton dress
by Nicole Farhi
March 2008

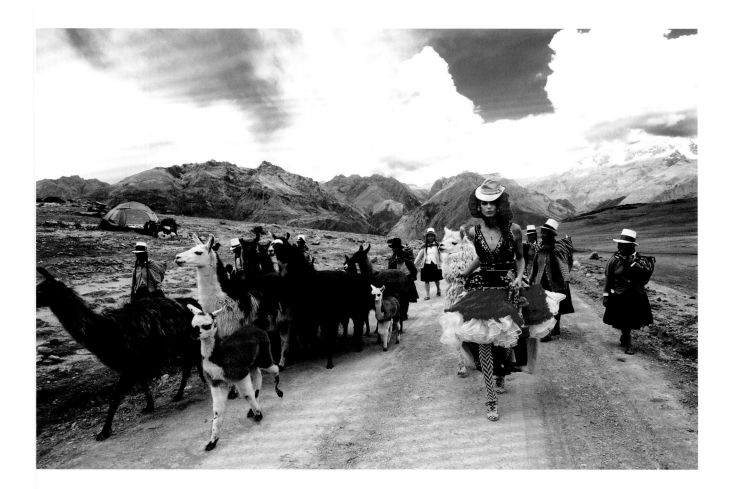

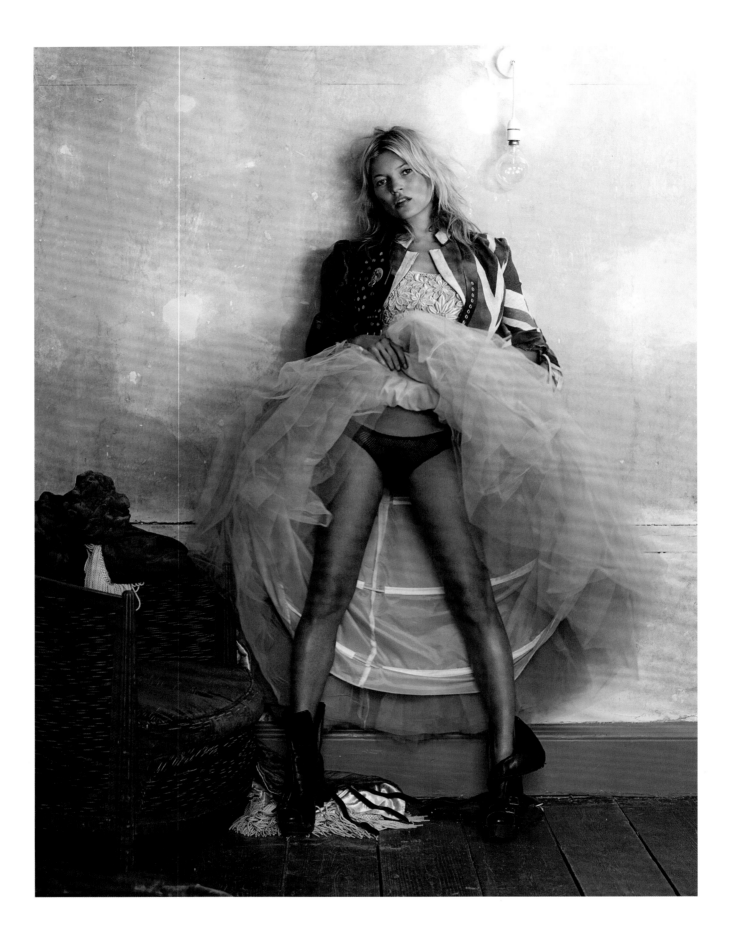

Kate Moss at the Master Shipwright's
House, Deptford
by Mario Testino
Tulle Britannia. Dress by Elie Saab Couture and
vintage union-flag jacket by Russell Sage
October 2008

Karen Elson and crocodile
by Tim Walker
'Never smile at a crocodile,' warned *Vogue*,
'unless you are wearing Giles's blood-curdling
red silk dress'
December 2008

Following pages
Lily Donaldson and fighter pilot
by Tim Walker
A characteristically inventive scenario by
the master of the fantasy fashion photograph
for the season's military-inspired style
March 2009

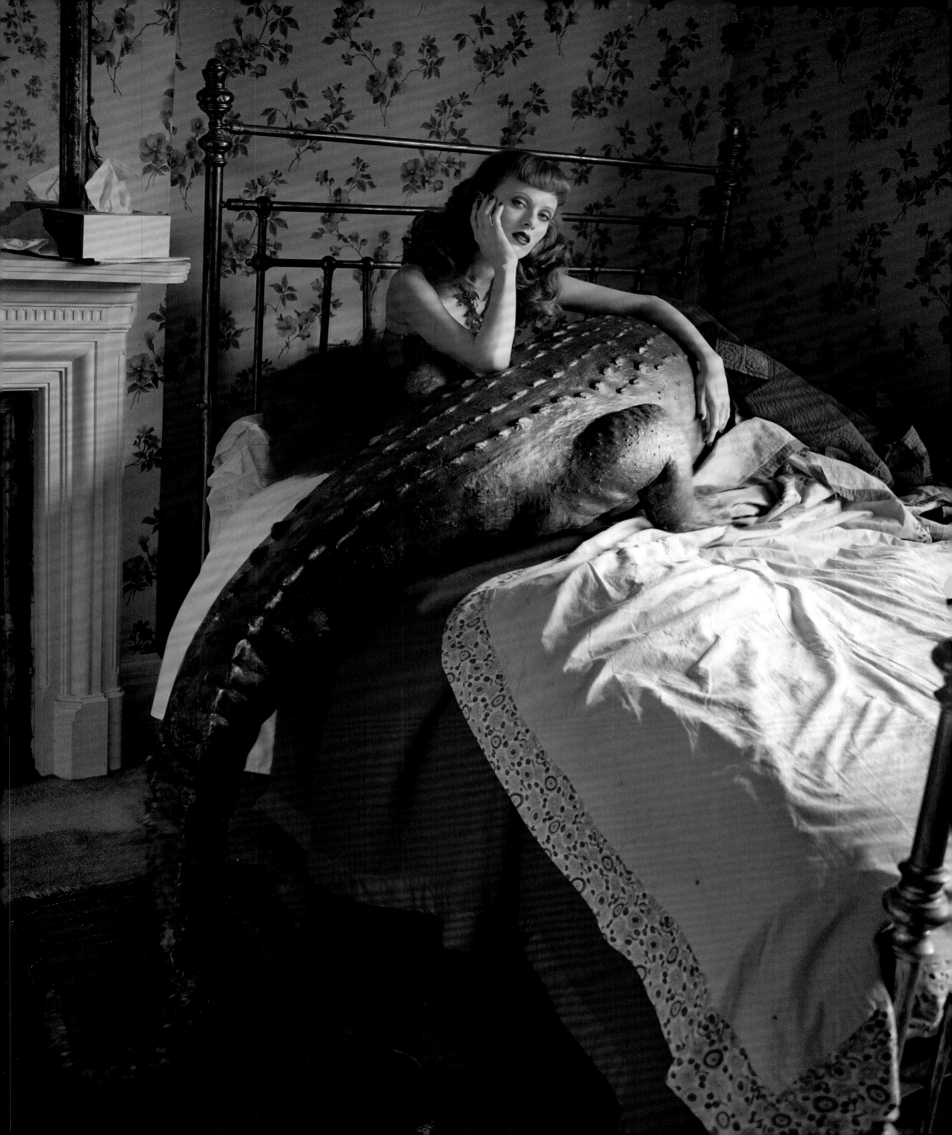

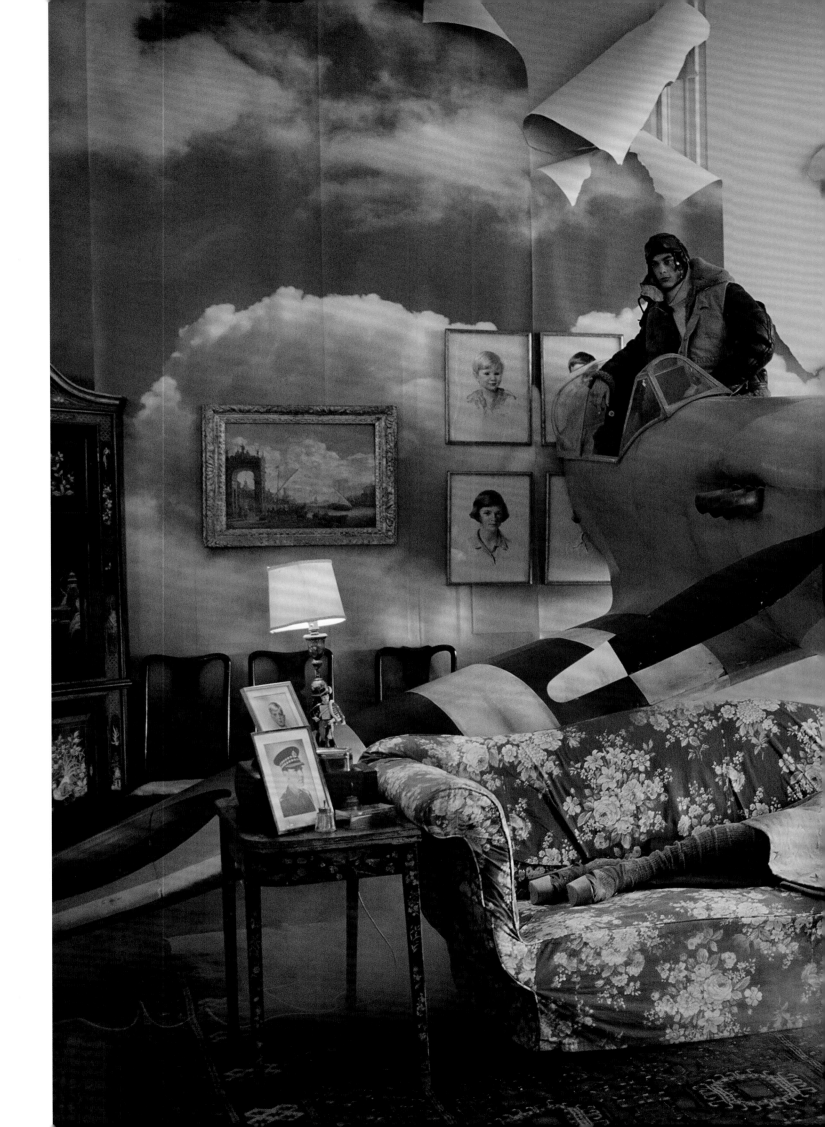

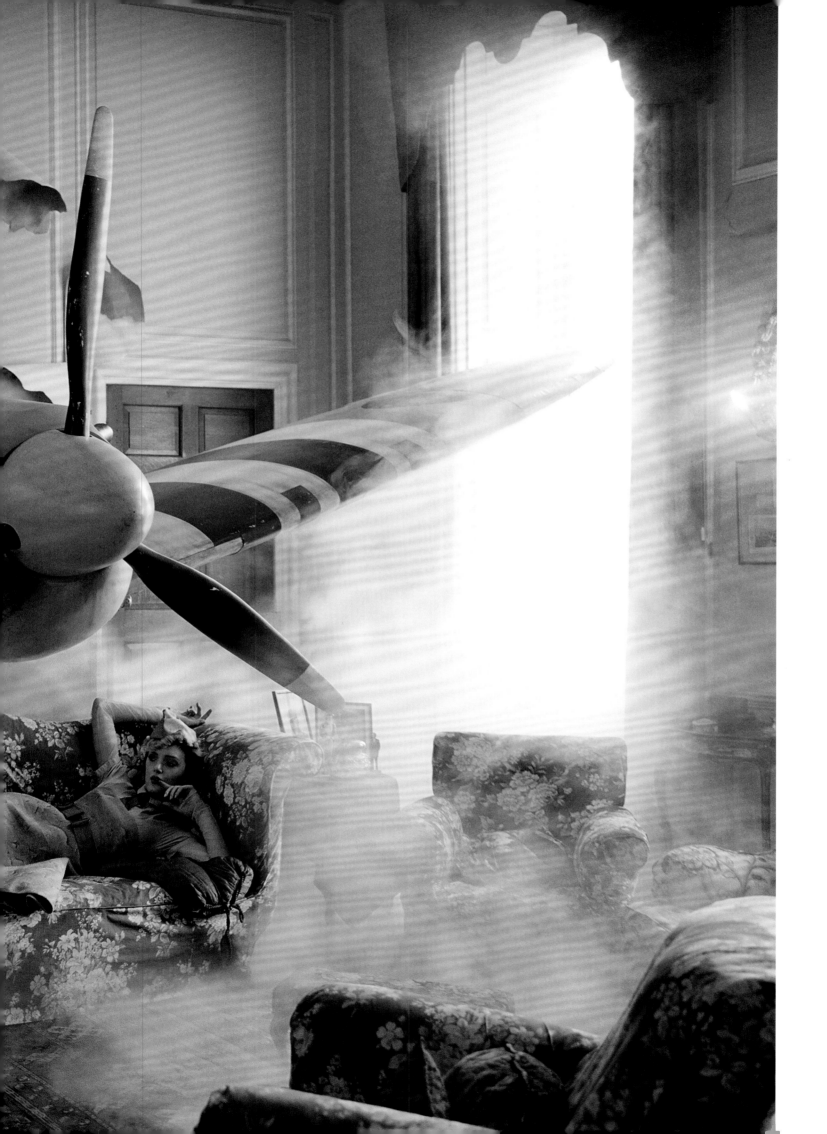

Lily Donaldson
by Nick Knight
Head rush. Silk dress with suede fringing
and feather embroidery by Alessandro
Dell' Acqua
March 2009

Natalia Vodianova with rabbit ears
by Mario Testino
When the Russian model was discovered by
talent scouts in 1999, she was selling fruit on
her family's market stall in Nizhny Novgorod
May 2008

Rosemary Ferguson in bearskin
by Corinne Day
Military precision with embroidered
silk trousers by Alexander McQueen
January 2002

Cate Blanchett
by Patrick Demarchelier
'We all want people to have opinions
about us, good or bad,' the self-aware
actress told *Vogue*. 'We all want to be
heroes of our own narrative'
January 2009

Following pages, left and right
Alexander McQueen
by Tim Walker
'McQueen,' observed *Vogue*, 'is obsessed
with sex, death and religion' and 'respects
no limits to what a fashion show can be'
October 2009

Vivienne Westwood
by Tim Walker
'Anyone can just take any blanket, pair of
curtains or a lump of fabric and hurl it around
them,' said the thrice-named Designer of the
Year of her DIY fashion aesthetic
October 2009

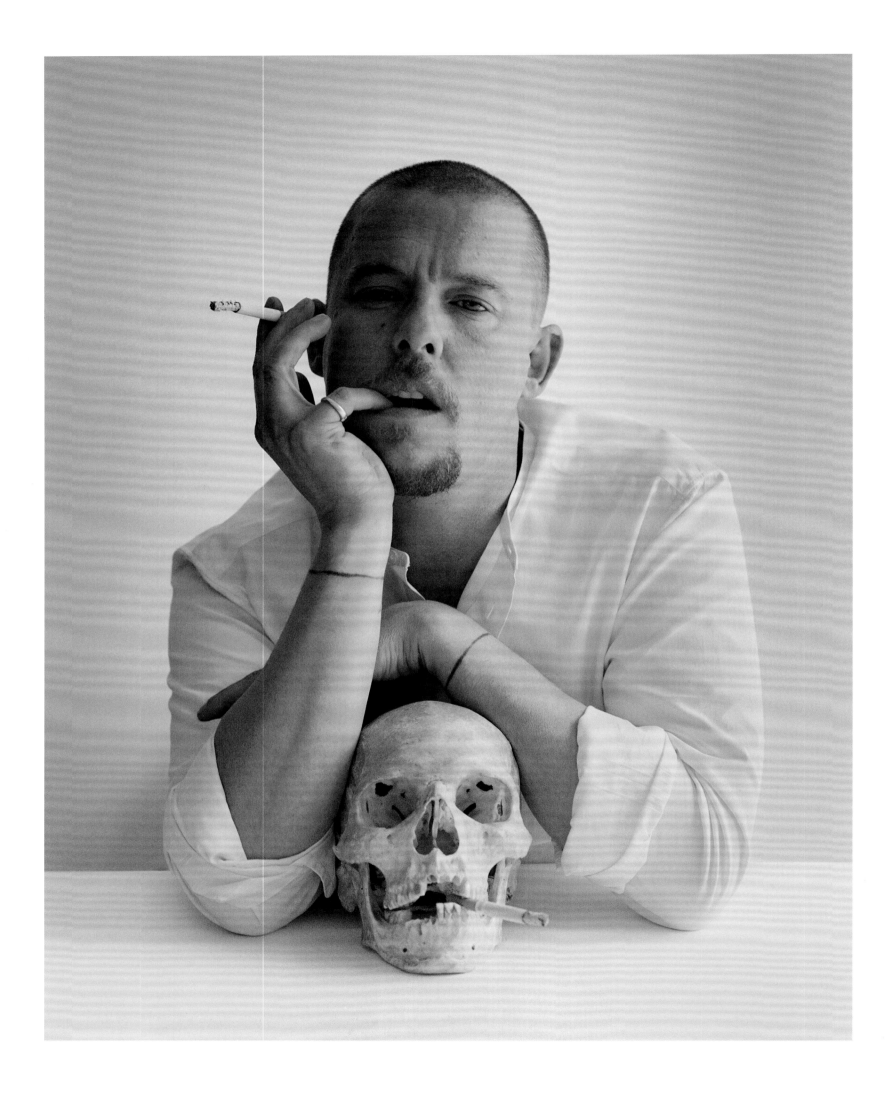

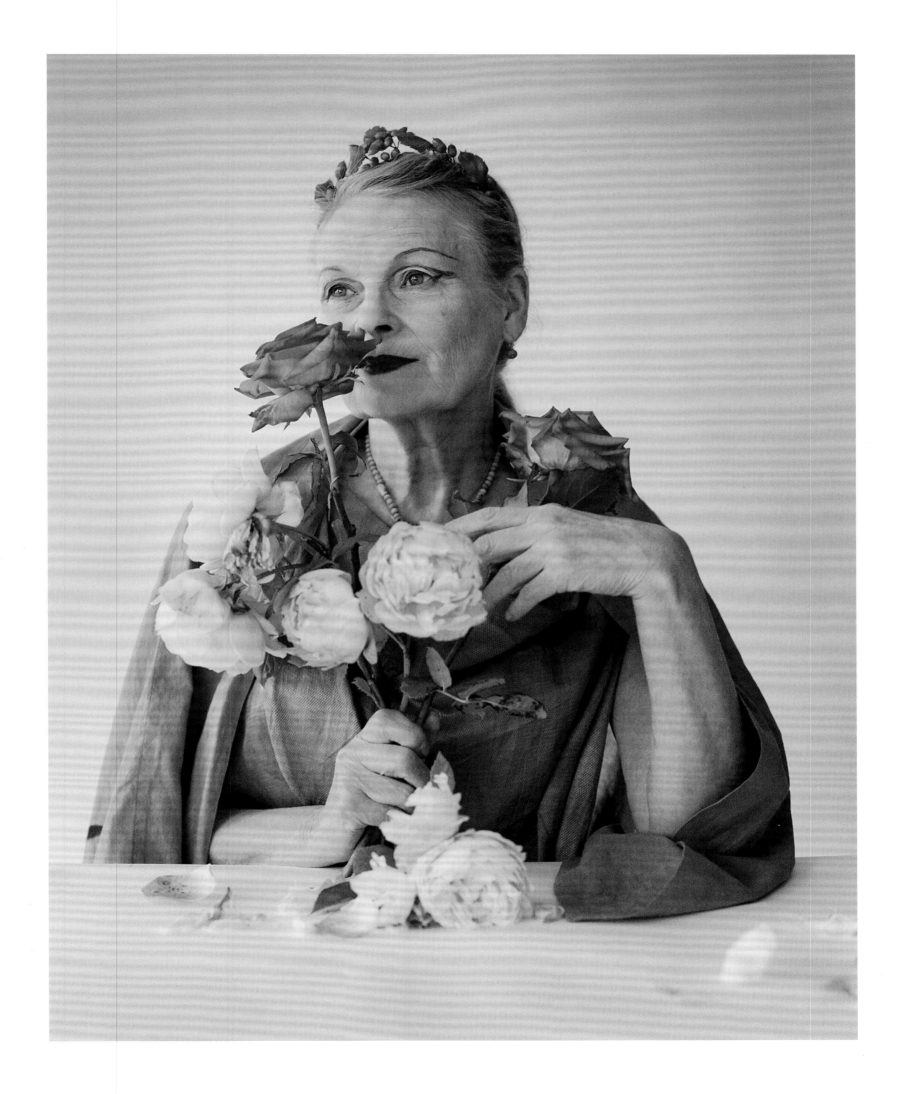

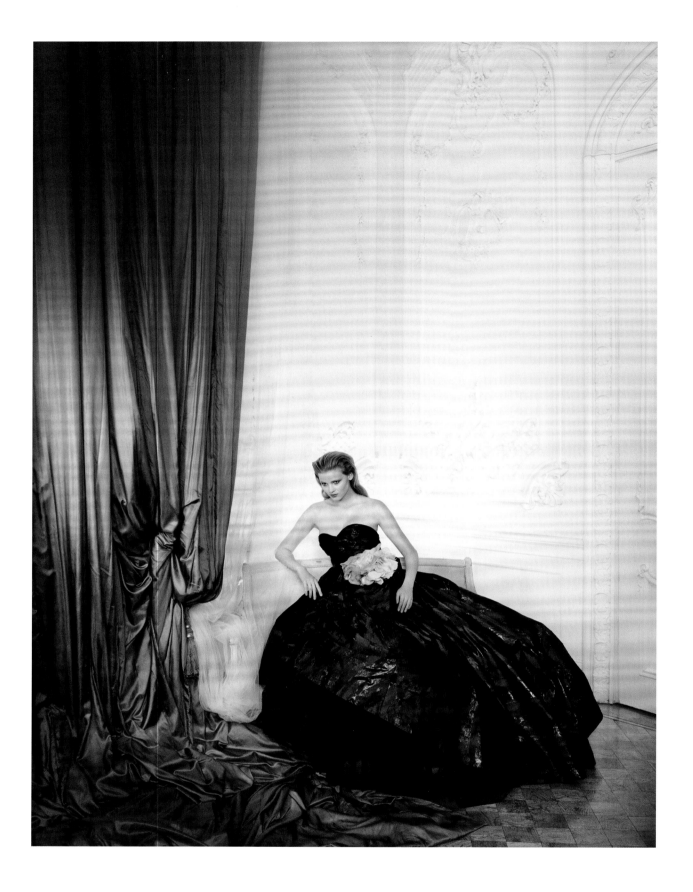

**Lara Stone in Carlton House Terrace
by Mario Testino**
'She is the embodiment of beauty today',
opined Testino of model Stone, who wears
a crinoline gown by Oscar de la Renta
December 2009

**Helena Bonham Carter in glass elevator
by Tim Walker**
For a Christmas tableau, inspired by Roald
Dahl's stories, the actress wears a sapphire-
blue dance dress by Alexander McQueen
December 2008

Following pages
**Jourdan Dunn
by Nick Knight**
A tour de force of intricate silk-gazar origami
by John Galliano for Dior Haute Couture
with a neon headpiece by Piers Atkinson
December 2008

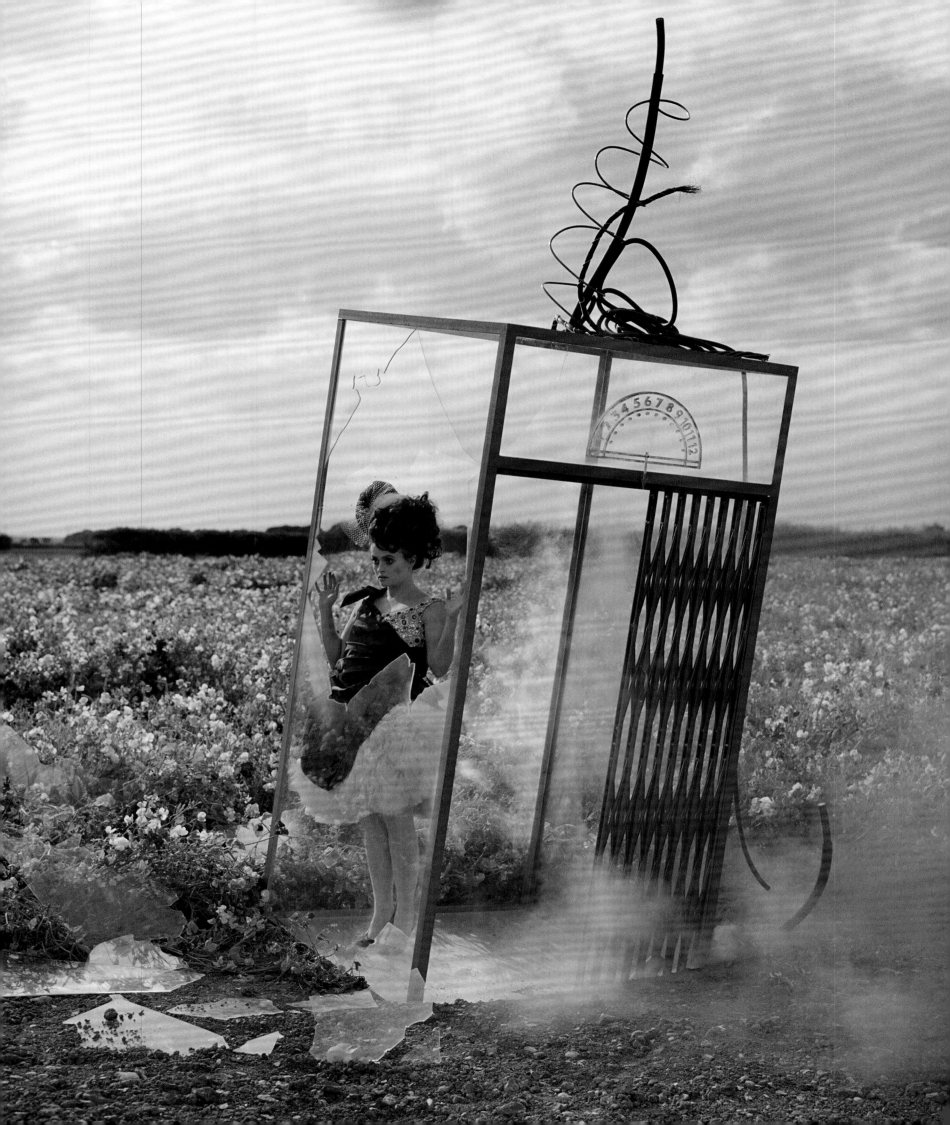

'How can the planets possibly influence us? Well, if the moon can affect the tide, I'm sure she can affect me. Most women will recognise moon patterns in their lives. I'm full of energy at the full moon – in fact, I go a bit bonkers – while the new moon seems to make me reflective and rather quiet.'

Jeanette Winterson, 'Star Struck',
Vogue, July 2004

Where Are We Now?

RECURRING, cyclical, the new decade began against a backdrop of global recession and an escalating eurozone debt crisis. (Three out of the five countries with the least hope of refinancing their government debt – Greece, Portugal and Spain – published their own editions of *Vogue*, which continued against the odds to flourish.) Where Europe's increasingly fluid borders ran out, the 'Arab Spring' began, leading to revolution in Tunisia, a coup d'état in Egypt and a popular uprising in Syria that evolved into full-blown civil war. In 2011 *Vogue* commissioned from the Syrian journalist Rana Kabbani an essay as unbearably impassioned as it was urgent: 'Fear is an ugly, humiliating emotion. It distorts features and the nerves. State-of-the-art scans can now track its minute ravages on the human brain, which apparently never quite recovers from its first brush with it. It leads to lives of cowardice, compromise and corruption. It denatures society utterly and totally, debasing all that is fine about the human spirit. As an Arab of a certain generation, I have lived in fear all my life ...'

There were other revolutions less immediately costly to human life. *Vogue* kept pace with the advance of technology, though not without quizzicality on behalf of its readership. 'This is the era of augmented humanity, of life lived through the tiny, shiny black screen. Those dim and distant years before smartphones existed (2007) feel not only preposterous but also impossible. How did people get anything done?' The magazine could add more to its list of addictions compiled over 100 years (the compulsion to talk unnecessarily by telephone during the Second World War, if anti-social and unpatriotic, was further decried by *Vogue* as 'a mania'). The social-networking service Twitter burst into life in 2006. Five years later it had nearly half a billion users. Facebook had arrived two years previously and its users numbered a billion. For *Vogue*, in 2013, Kathleen Baird-Murray revealed that we were in danger of a collective short-circuit: 'Our attention spans have reached crisis point ...'

When the London Olympics fell neatly into step with Queen Elizabeth II's Diamond Jubilee year, the occasion gave rise to a special celebratory issue in June 2012. The gap between Her Majesty's birth and that of *Vogue* was just under ten years. Her first picture in *Vogue* was at her mother's knee in 1926 and in the intervening eighty or so years she was, as the magazine put it, 'a constant. She has been around for as long as most of us can remember: a quiet safe-feeling presence, endlessly "turning up", perfectly punctually and impeccably turned out.' Her private motto, *Vogue* confided, had always been and remains: 'I have to be seen to be believed.'

The cover was given over to Kate Moss, nineteen years after her first

Previous pages, left
'Mighty Aphrodite': Kate Moss
by Mert Alas and Marcus Piggott
Versace's body-sculpting superwoman suit 'demands an epic pose and a spotlight'
June 2012

Above Cara Delevingne, pretty in pink, by Walter Pfeiffer, 2013 *Below (left to right)* *Vogue* covers of Edie Campbell by David Sims, 2013; Kate Moss by Mert Alas and Marcus Piggott, 2012; and Jourdan Dunn by Patrick Demarchelier, 2015; and a dynamic colour-fest by Mario Testino, 2012

cover shot. She continued to advance through the years as though she might, like the Queen, be a part of it all forever: 'In our secular age,' pronounced *Vogue*, 'Kate Moss is our icon: a beautiful, untouchable thoroughly twenty-first-century woman who remains as inscrutable as an early Renaissance heroine'.

Preparing for the Olympics involved the greatest mobilisation of the largest workforce since the Second World War: a million pieces of sports equipment, a thousand picnic benches ... It was an occasion on which

Left 'China white' Sasha Pivovarova by Tim Walker, 2010
Above Two fashion images by Craig McDean, both 2014
Below Eye-mask by Nick Knight, 2010 *Bottom* A Mongolian adventure with Kirsi Pyrhönen by Walker, 2011

Vogue could celebrate a nation of fashion heroines, sporting gods, a resilient Royal Family and, of course, 'National Treasures' – defined as 'one part intelligence, maybe two parts wisdom and integrity and no small amount of brilliance' – whose number included Patrick Moore, David Attenborough, Damon Albarn and the most indefatigably English of Hollywood actresses, Helena Bonham Carter.

A royal wedding has always excited *Vogue* as much as the rest of the nation and when, in 2011, Catherine Middleton married the heir but one to the throne, the magazine's viewpoint was as pragmatic as the new Duchess herself. She was 'a Princess for our time' and *Vogue*'s 'Katepedia' meticulously analysed her every outfit, as a taxonomer might the petals of a rare orchid.

As the decade progressed towards its halfway point, the fashion industry became increasingly concerned with environmental and ethical problems. Buzzwords for the middle of the decade now included 'eco-friendly branding', 'greenwashing' and 'fast fashion', the lead taken by activist Livia Firth and the fashion tycoon François-Henri Pinault, who is taking giant strides into the sustainable future: 'It's not a question of consumption, but rather of consuming differently. We will get to a future when consumption will be clean …'.

In 1916, on its very first page, *Vogue* had promised this: 'Really and truly, such amazing things are going to happen to you that you would never believe them, unless you saw them in *Vogue*.' As the magazine moves into its second century, the promise and the expectation remain emphatically undimmed.

Spots and stripes and bursts of hyper-colour collide head-on. Cover girl Natalia Vodianova sets them in motion and watches how they fly. Photographs by Mario Testino

**Keira Knightley
by Mario Testino**
The British leading lady was already a
showbusiness veteran, having asked her
parents for an agent at the age of three
January 2011

**Guinevere van Seenus as Vargas pin-up
by Javier Vallhonrat**
The Jazz Age poster girls of illustrator
Alberto Vargas inspired the season's
seductive dresses, corsets and lingerie
April 2010

'Rave new world': Karmen Pedaru
by Alasdair McLellan
With string-knits, tie-dye and
skateboarder T-shirts revitalised for a
new era, *Vogue* revisited the second
summer of love
May 2012

Sam Rollinson and Max Minghella in
Yorkshire
by Alasdair McLellan
The star model and the young actor wear
designs from the British collections, pictured
in and around Rollinson's home town
August 2013

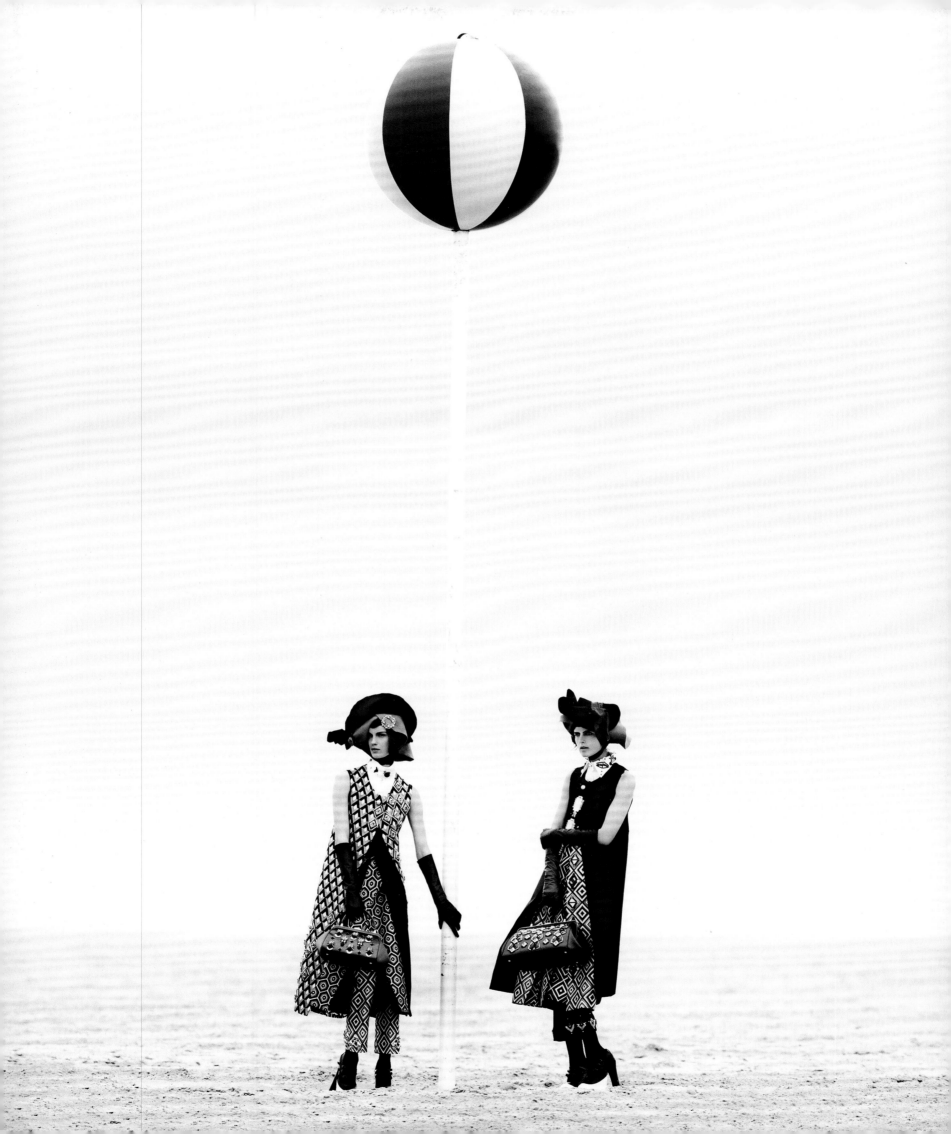

Previous pages, left and right
**'Neo-geisha': Guinevere van Seenus
by Paolo Roversi**
A twenty-first-century take on the serene
beauty of the traditional geisha
June 2011

**'Deauville rendezvous': Marte van Haaster
and Stella Tennant
by Mario Testino**
Set against the coastal landscape of northern
France, the *belle époque* is revisited in silk
ensembles and embellished Gladstone bags
by Prada
September 2012

**Lara Stone
by Ryan McGinley**
In her leafy bower, *Vogue*'s modern-day
Ophelia wears a floral needlepoint bustier
by Dolce & Gabbana
September 2012

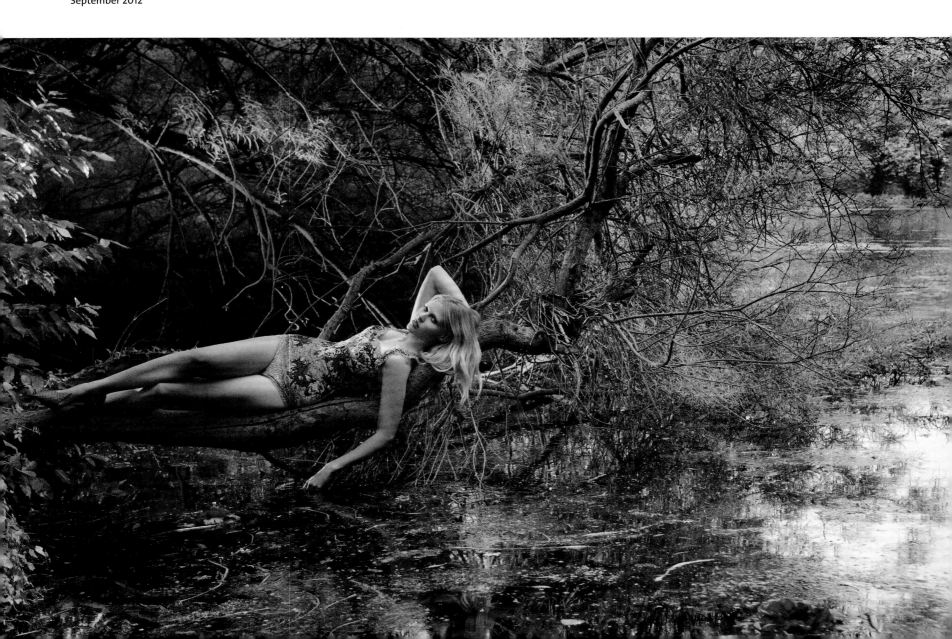

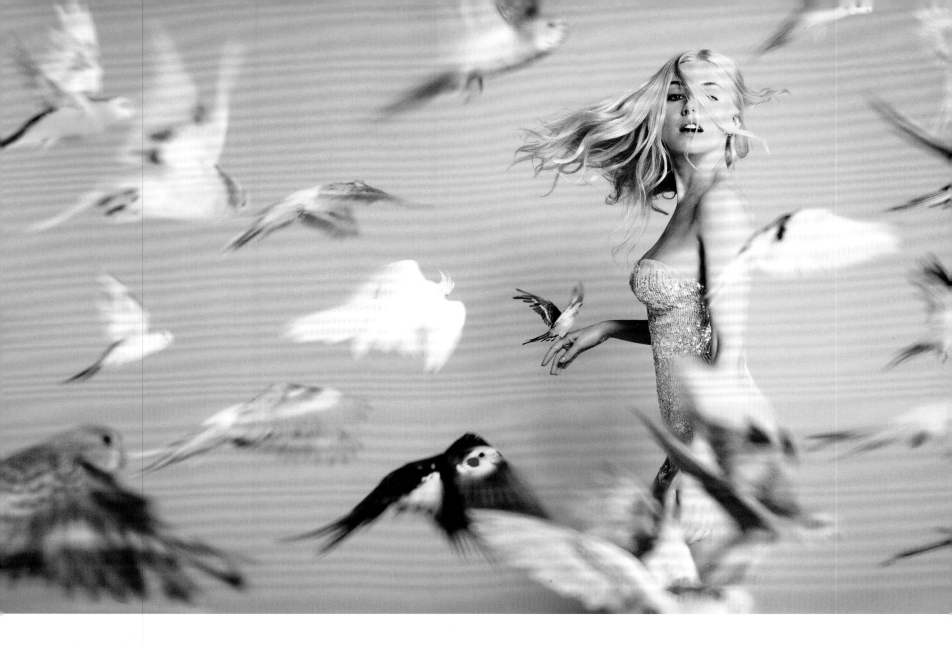

Sienna Miller
by Ryan McGinley
The British actress and model was about to
appear in *The Girl*, a film about Alfred Hitchcock
and his obsession with the American actress
and model Tippi Hedren, whom he had cast in
The Birds. Hence the supporting cast
April 2012

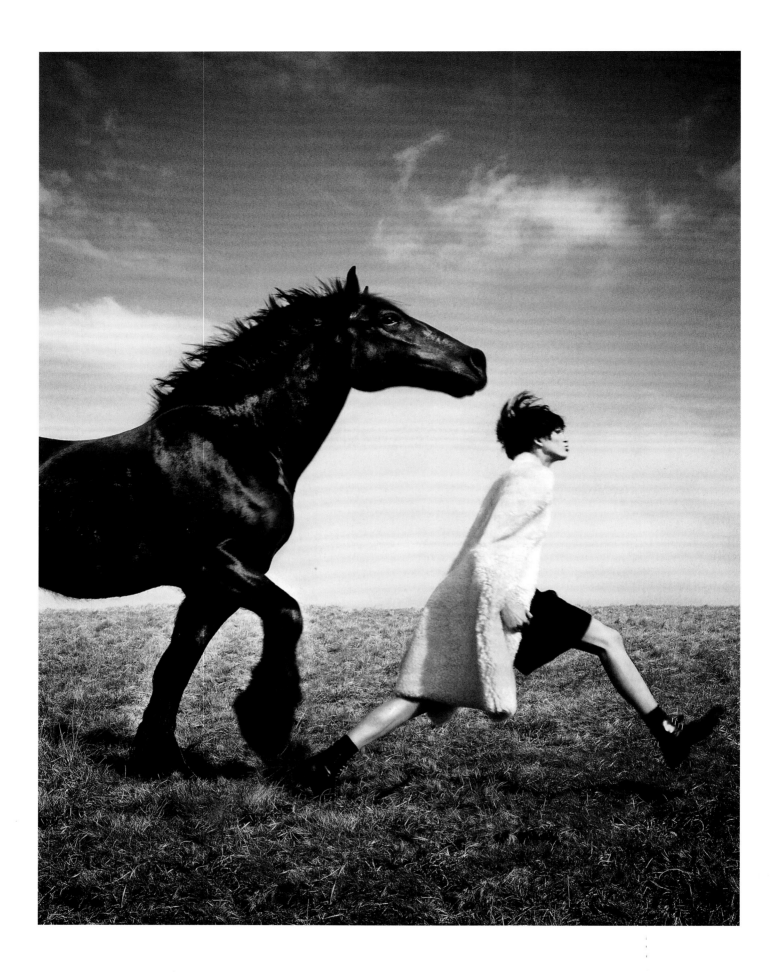

**Iselin Steiro in Cornwall
by David Sims**
Against the rugged moorland landscape,
a sheepskin cape by Céline
October 2010

**Kirsi Pyrhönen in Mongolia
by Tim Walker**
Finding common ground, a goat-hair jacket
by Giles and a wild marshland yak
December 2011

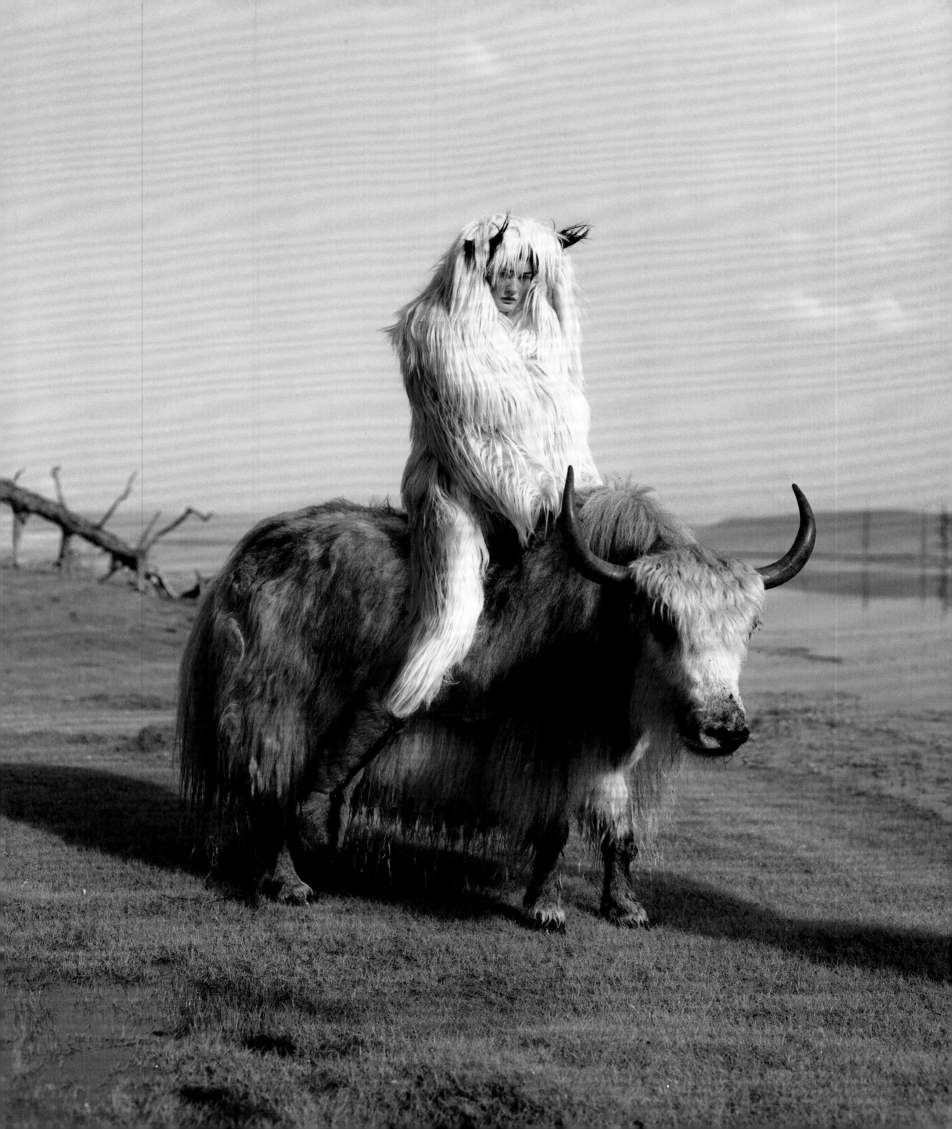

CHARLOTTE SINCLAIR
from 'Are You What You Eat?', *Vogue*, June 2012

'THE history of diets is a history of women eating badly. Just look at the fads we've surrendered to over the years: the Hay diet, the South Beach diet, Atkins, Dukan, the Master Cleanse, the Mediterranean diet, the Zone diet, the Beverly Hills diet, the grapefruit diet, cabbage soup, low GI, low GL, low-fat, no fat, dairy-free, wheat-free, gluten-free, diet pills, laxatives, macrobiotic diets, Paleolithic diets, fruitarianism, biblical eating, caveman eating, mindful eating, even – dear God – the ingesting of tapeworms. Almost none of this would qualify as healthy eating, let alone healthy thinking. We allow our food to blame and shame us, or, equally suspect, to redeem and reward us. Aside pounds lost or gained, dieting has a major biological impact. It affects our brain chemistry, hormone levels, digestion and metabolic systems.

Most diets don't work. But an entire, million-pound industry is built on the basis that, just out of reach, is the perfect combination of food to make us healthy and slim forever. Control over our appetites is highly prized. But consider this: a 2010 study found that the stress of going on a diet created compulsive, "maladaptive" behaviour in mice; the poor creatures tolerated *electric shocks* just to eat chocolate again. To clarify, we are the mice in this scenario.

Healthy eating borrows much of its urgency and incentive from the pervasive notion that thin is good and fat is bad. (Just think how little sympathy we accord the obese, while anorexia is depicted as a terrible psychological disease.) What constitutes our current thinking on physical perfection can be found a quick flick from this article. Models are paid to look a certain way, and by extension eat a certain way, too. "You've got to be a particular shape to fit sample clothes," says Stella Tennant. "You can't expect to work if you don't really fit the clothes. But some designers cut clothes much smaller than others. Do you want to fight against your natural body shape in order to fit them? As a model you have to make a choice, but you have to make sure you're sane and healthy."

"Since I have been modelling less, I feel I have an increasingly healthy attitude to my body and weight," says Lily Cole, perhaps the first *Vogue* model to get a double first from Cambridge, for which she put her fashion career on hold. "I have seen many examples of the long-term physical damage that can be caused to bodies by not eating healthily, though I would be lying if I said that being self-employed in an industry which demands almost unrealistic body sizes did not distort my perception of myself. At my first ever casting, when I was 14, the casting director commented on my weight."

Often the more successful the model, the more conscious they are of eating healthily. Natalia Vodianova runs marathons; Daria Werbowy sails; Gisele does martial arts. By all accounts, Doutzen Kroes out-skips half of Manhattan at her gym's jump-rope classes. The rise of the Victoria's Secret Angels, with their lean muscle tone, bright eyes and bouncing bosoms, has brought about a corollary interest in fitness, good eating and the athletic form. Positive it may be, but this Glamazonian aesthetic is no easier to attain and maintain than the Eastern Bloc waifs who dominate the catwalks.

There will always be waifs and there will always be supermodels; but when it comes to healthy eating in the modelling world, it's all in the balance.

But what are real women – and by that, I mean my friends – eating? One, a diet lifer, emails from a detox retreat in New York:

"Yesterday I had a juice of olive oil, lemon and kale for breakfast, followed by a nut and seed shake, julienned courgettes with smoked tofu, basil and garlic pesto for lunch, and asparagus soup for dinner." Another friend, a very lean size eight, says she "never thinks of food in terms of fat, only of deliciousness". In one day she ate: "A bowl of chocolate cereal with skimmed milk, then when I got to work, two slices of toast with butter and peanut butter. For lunch, I had a packet of ready-salted crisps and a Brie and tomato baguette. When I got home, I had a buttered hot-cross bun, another packet of crisps and two chocolate Hobnobs. (My God, this is kind of gross, isn't it?) We had dinner at a friend's house: steak and chips with a creamy sauce and meringue for pudding." She adds an afterthought: "I know I don't eat enough vegetables."

Contrast this with another friend's daily intake: "Breakfast is a shake made from almond milk, coconut water, frozen pineapple, frozen blueberries, half a courgette, half an avocado, a handful of chopped frozen kale, a scoop of rice protein powder, a scoop of coconut oil, almond butter, green powder and acai powder. I took a bag of cut-up veggies to eat at my desk, and seeds and raw almonds as snacks. For lunch, I had seaweed salad and grilled salmon. More veggies and hummus when I got home, and some crackers. Then, for dinner, roasted broccoli and celeriac with brown rice. I try to eat 30 per cent raw food every day."

Which of the three is the best example of healthy eating? The first seems too calorie restrictive. The second involves an unseemly smorgasbord of salt, sugar, unrefined carbohydrate and processed food. The third seems like a nutritionist's dream, right? Yes, but that's just the problem, according to author Michael Pollen. What he calls the ideology of

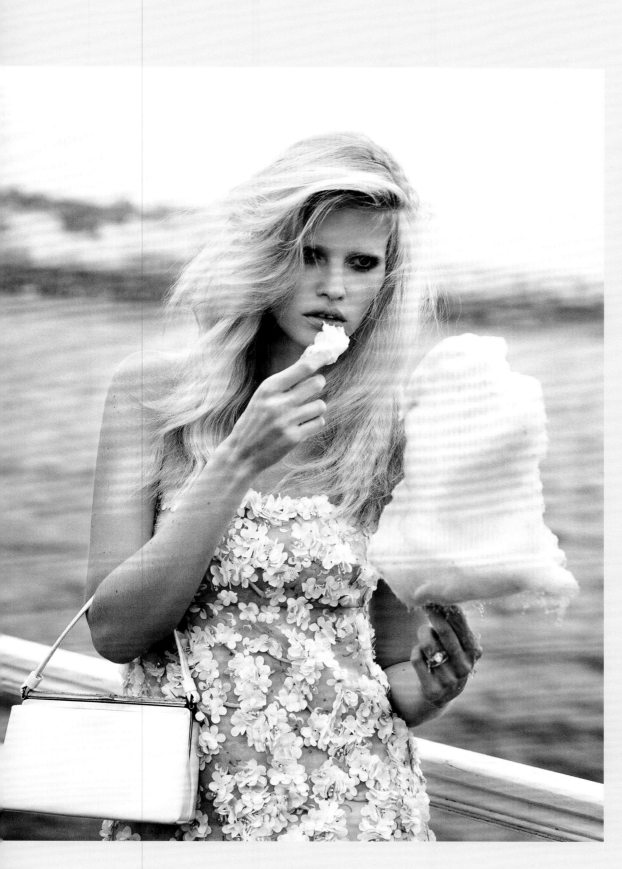

"nutritionism" – eating for antioxidants, for vitamin content and minerals – isn't eating properly at all. "It encourages us to take a mechanistic view of that transaction: put in this nutrient, get out that physiological result. People don't eat nutrients, they eat foods, and foods can behave very differently than the nutrients they contain." In other words, we shouldn't view food in such isolated terms. And we should avoid any food (or "food substance") that comes with a health claim slapped on the label. "They're apt to be processed."

Can there ever be a consensus on healthy eating? Not as long as there are industries making money from our confusion. Michael Pollen's prescription seems almost naively simple: "Eat food. Not too much. Mostly plants." Specifics, please. "A little meat isn't going to kill you, though it might be better approached as a side dish than a main. And you're better off eating whole fresh foods rather than processed food products." If something has more than five ingredients, it's probably suspect. Don't restrict food groups. Take enjoyment into account. These are all things we know. So we need to forget what we *think* we know about eating, and eat what our instinct tells us is right. (And those instincts are never going to tell you it's OK to consume a whole tub of Ben & Jerry's.)

Easier said than done. If you want to see the complexities of our relationship to food, the sub-conscious impulses, the synaptic shifts and alignments, just watch a group of women eat together. Who chooses what, who finishes first, who leaves half, who orders pudding … Even when we don't care, we still notice these things; they're still occupying space in our brains that should be reserved for sonnets or really great jokes. Until scientists learn how to manipulate our DNA to reduce weight gain (it's happening), we're going to have to learn to say no to the Dairy Milk.

'Brighton rock': Lara Stone
by Alasdair McLellan
'I went to Brighton recently with my husband
[comedian David Walliams],' Stone told *Vogue*.
'I love that tiny train that runs along the seafront'
November 2010

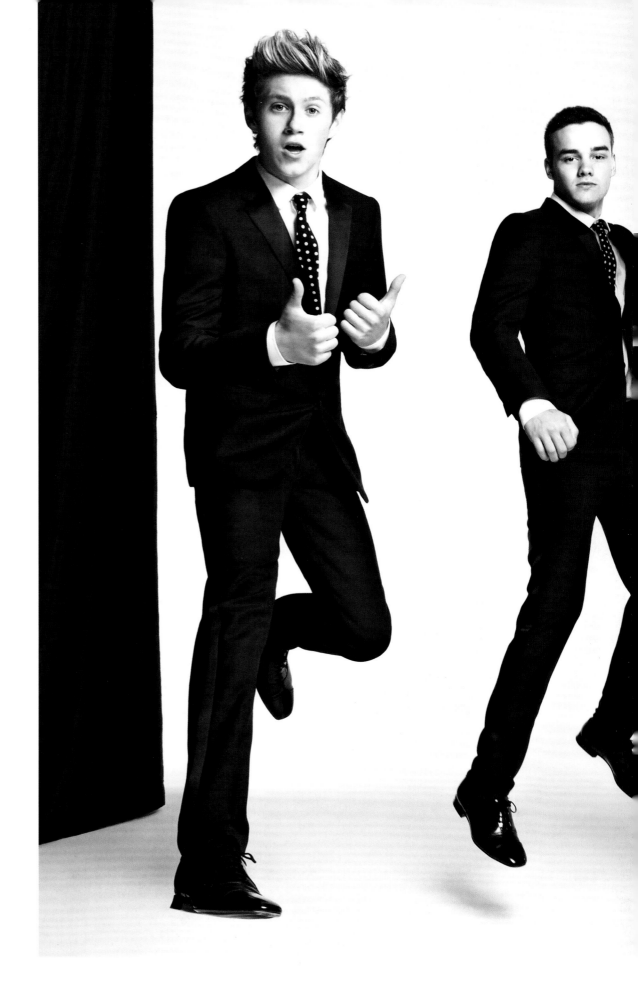

'Harry Styles, whose delightful scowl of petulant confusion, like a teddy bear trying to do trigonometry, has skewered millions of fluttering hearts and has wooed scores of women if the papers are to be believed (and wouldn't you, if you were he and had that kind of opportunity?)'

Jo Ellison, 'The Fab Five',
Vogue, December 2012

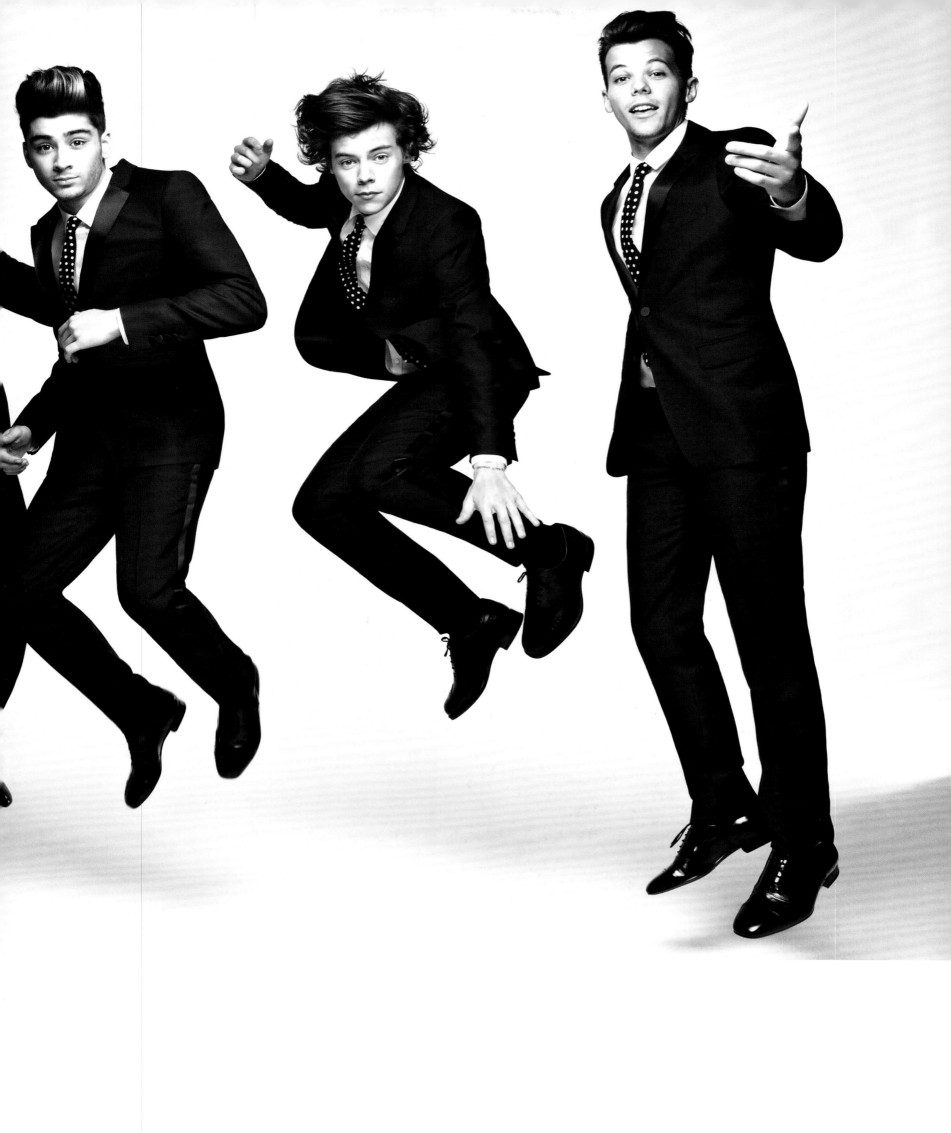

Previous pages
One Direction
by Patrick Demarchelier
Within barely two years, One Direction had
charged their way to global fame. Their debut
album was the first by a British act to go
straight to Number One in America
December 2012

Above
Alex Turner at Camden Lock
by Alasdair McLellan
The musical architect of the Arctic Monkeys
would shortly play with his band at the opening
ceremony of the London Olympic Games
June 2012

Opposite
Cara Delevingne
by Glen Luchford
Where better to play out the multiplicity of
the season, asked *Vogue*, than 'amid the varied
world of the car-boot sale'
November 2012

Following pages
Boris Johnson at the Olympic Park
by Henry Bourne
'That rare beast – a politician known as much
for his ready wit as for his policies,' considered
Vogue. Behind Johnson looms Anish Kapoor's
114.5m-high Arcelor Mittal Orbit
April 2012

'With the site still waterlogged and unfinished, the mayor of London looks remarkably relaxed as he wanders through the park, past the scaffold poles, flapping polythene and muddy holes. "It's all absolutely fine and will be ready on time," he says with great confidence. Workmen greet him like a long-lost friend, and he stops to shake every hand.'

Hannah Rothschild, 'Blond Ambition',
Vogue, April 2012

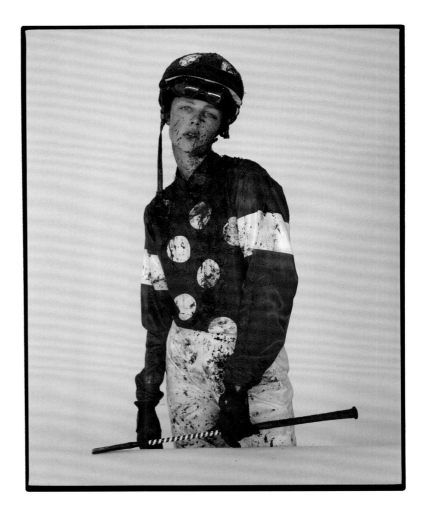

Edie Campbell
by Tim Walker
The horse-mad model in a copy of her racing silks by Bella Freud. 'These are the clothes I am most comfortable in,' she told *Vogue*
December 2013

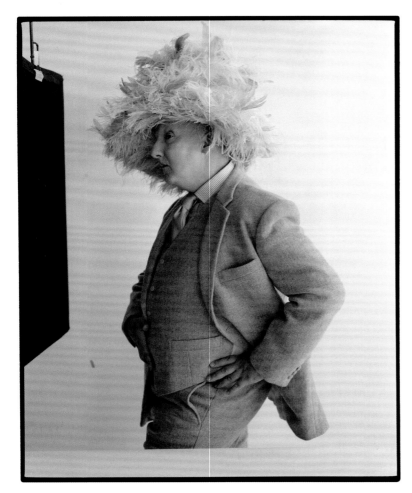

Stephen Jones
by Tim Walker
The celebrated milliner in a design of his own creation. 'I feel like Barbara Cartland on acid,' he commented
December 2013

Opposite
'Sporting gods': Luke Campbell
by Peter Lindbergh
The bantamweight boxer and his black eye: 'I had a flu jab on Tuesday, it took over my body and on Wednesday I sparred and got this.' Two months later he won a Gold Medal at the London Olympics
June 2012

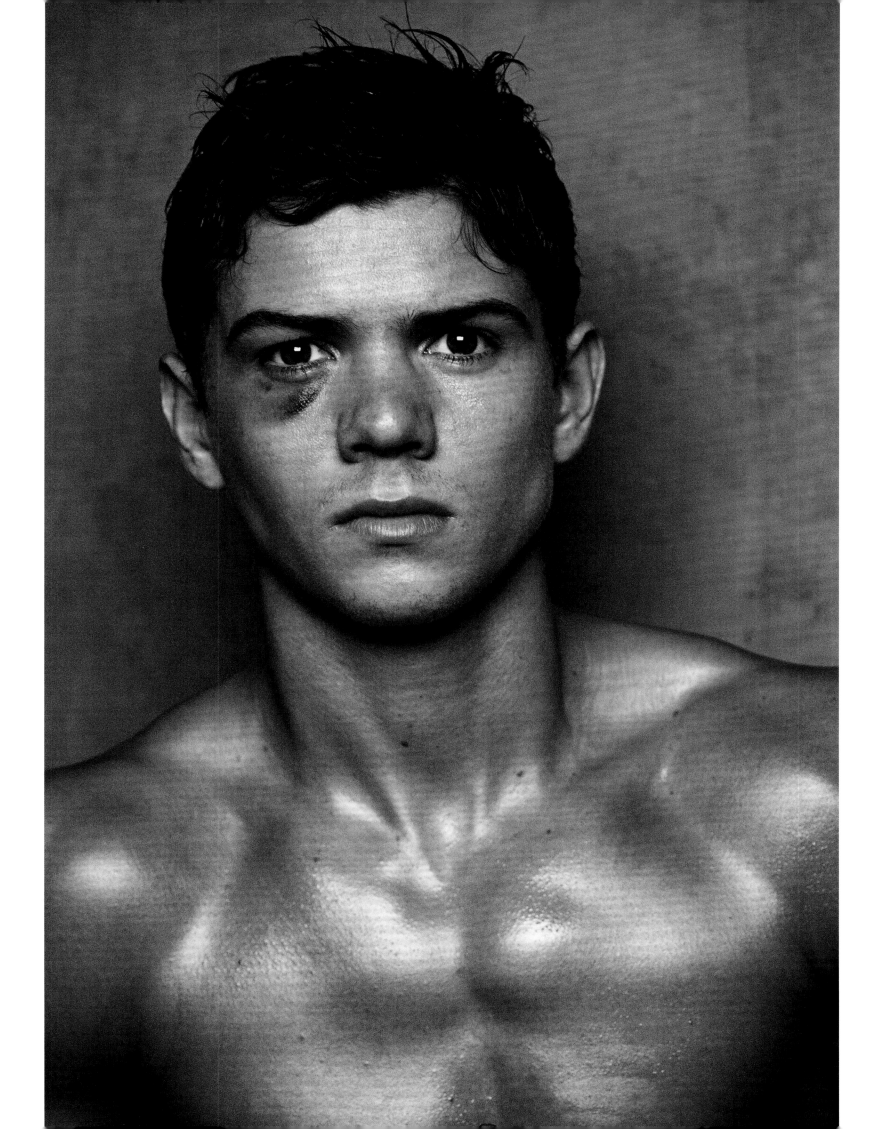

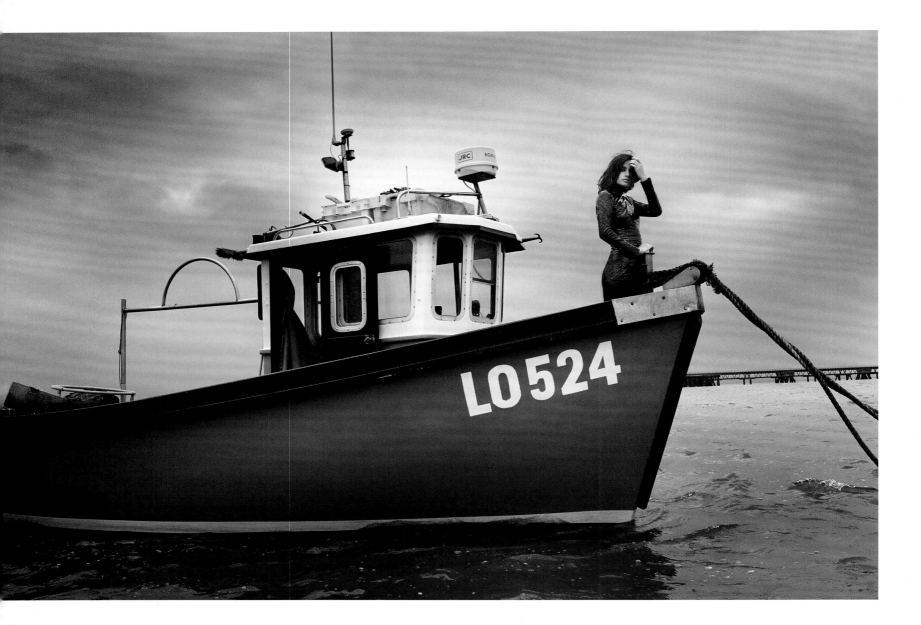

'Somewhere girl': Andreea Diaconu by Glen Luchford
A tugboat moored at Canvey Island, Essex. 'Tugboats are famed for their simplicity and steeliness,' said *Vogue*. 'Gucci's cracked patent-leather day dress carries the same bounty'
November 2013

'Life through a lens': Suvi Koponen by Glen Luchford
A homage to the freewheeling 1970s style of Linda McCartney: a glittering T-shirt and denim skirt from the late photographer's own collection
April 2014

Following pages
'Fade to black': Estella Boersma by Jamie Hawksfield
State of the (wearable) art. In Jacquemus's far-from-classic black wool coat, the future looks graphic, sculptural and, evidently, bright
September 2015

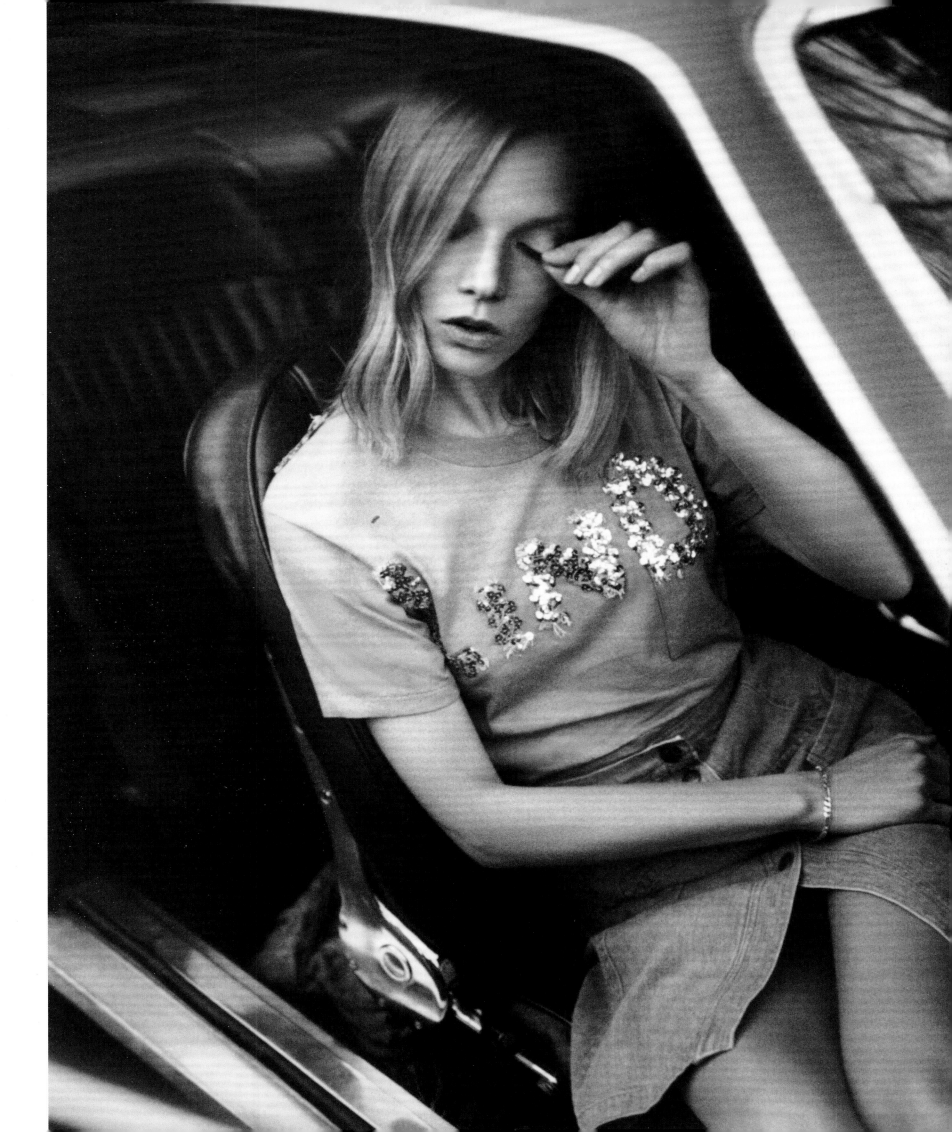

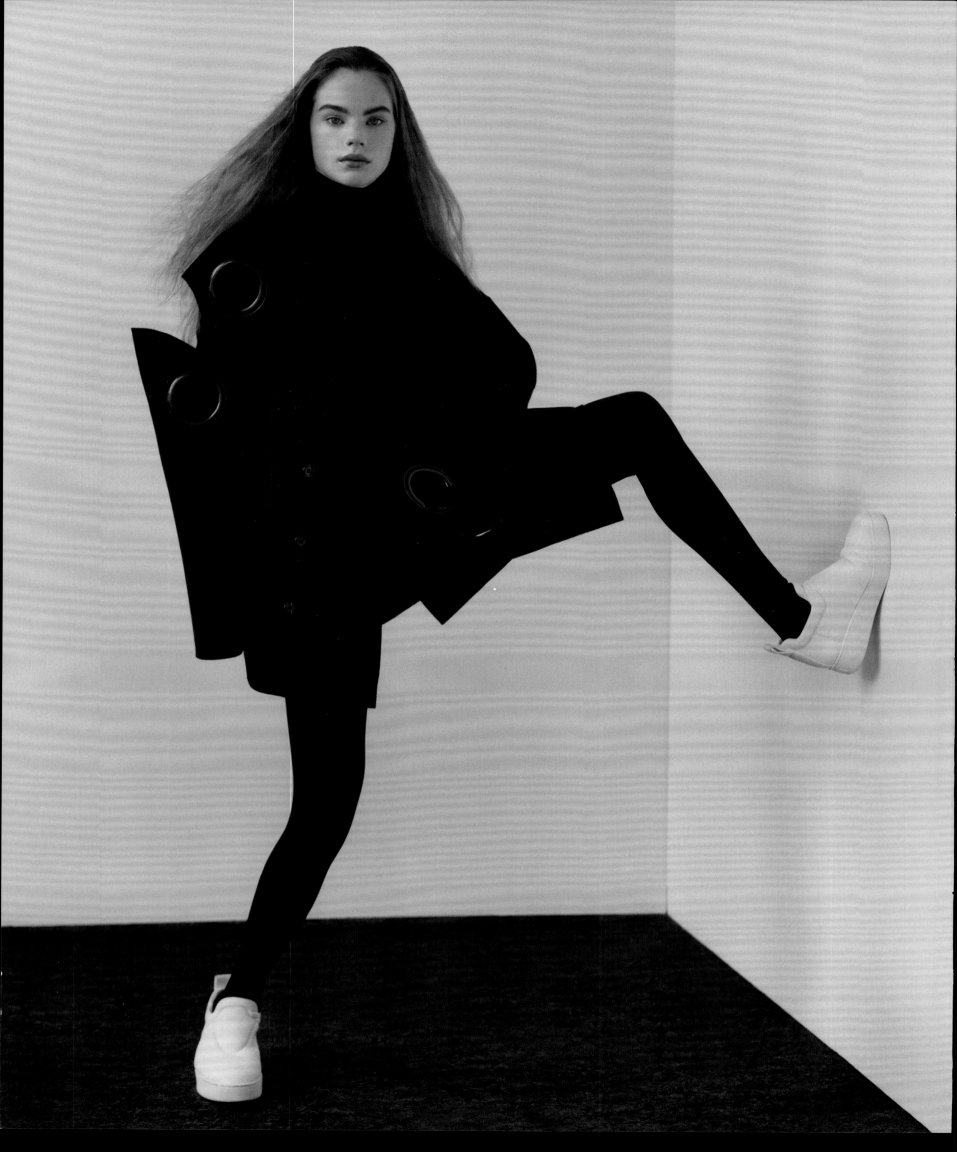

ACKNOWLEDGEMENTS

DOCUMENTING *Vogue*'s first 100 years has been a collaborative process and on a grand scale. Neither this book nor its accompanying exhibition could have been achieved without the collective efforts of the magazine's current photographers and their representatives. This demonstrates better than anything else, I think, their admiration for *Vogue*, for its remarkable history and for its present editor, Alexandra Shulman. The National Portrait Gallery is the ideal context in which to showcase this remarkable story and body of work.

Vogue's milestone apart, in 2016 Alexandra will be the magazine's longest-serving editor, having surpassed the tenure of Beatrix Miller (1964–86) by two years. My first debt of gratitude is to her for entrusting me with this significant project. I would also like to pay tribute to her predecessors, from Dorothy Todd onwards, and their art directors, who shaped the magazine's visual style and for many of us our view of the century.

Next, at the Condé Nast Archive, New York, my thanks go to Gretchen Fenston (Registrar), Lindsay Foster (Imaging Lab Manager), Marianne Brown, Sarah Glaser, Pamela Griffiths, Paul Quitoriano and Samantha Vuignier; at the Condé Nast Archive, Paris: Amélie Airault De Andréis and Vanessa Bernard; and at the Condé Nast Archive, London, Ulrika Becker, Frith Carlisle, Poppy Roy and Ben Evans.

I am especially grateful to the following private lenders of prints, artworks and other material: Vince Aletti, Andrew Cowan, Glen and Amanda Fuhrman, Paul Lyon-Maris, Terence Pepper, Filippo Tattoni-Marcozzi; Sir John Smiley, Bt.; Mark Szaszy and Lukas Gimpel (Corinne Day); Tessa Traeger (Ronald Traeger); and those who prefer to remain anonymous.

It has been a great pleasure to work again with the National Portrait Gallery. I would particularly like to thank the former director, Sandy Nairne, who commissioned me to curate the exhibition and whose encouragement from the outset was key, and Dr Nicholas Cullinan, his successor, for his enthusiasm and support, as well as Sarah Tinsley, Pim Baxter and Rosie Wilson.

For the production of this book, I am hugely grateful to Christopher Tinker (Managing Editor) for his expert guidance and insight into so many aspects of twentieth-century culture. Thanks also to his colleagues Nicola Saunders, Ruth Müller-Wirth and Kathleen Bloomfield, and to Denny Hemming.

I am grateful too for the help of Perry Bushell, Robert Carr-Archer, Andrea Easey, Naomi Conway, Joanna Down, Neil Evans, Phillip Prodger, Sylvia Ross and Denise Vogelsang.

I would particularly like to acknowledge and thank Eloise Stewart (Exhibitions Manager) and Michael Barrett (Exhibitions Assistant), who have co-ordinated with meticulous care the myriad elements of this large-scale exhibition.

The following curators, directors, owners and institutions are also due grateful thanks for agreeing loans: Clayton Flynn (Affirmation Arts); James Moores, Hatty Buchanan and Paul Rousseau (Bruce Bernard Collection and John Deakin Archive); Danielle Berger Fortier (Mona Bismarck American Center, Paris, France); Gabriel Jones (National Gallery of Canada); Diana Donovan and Alex Anthony (Terence Donovan Archive); Judy Keller and Jennifer Garpner (The J. Paul Getty Museum); Franziska Mecklenburg and Jasmin Seck (F.C. Gundlach Collection); Hilary Roberts (Imperial War Museum); Antony Penrose and Carole Callow (Lee Miller Archive); Michael Hoppen and Clemency Cook (Michael Hoppen Gallery); Beatrice Behlen (Museum of London); Kimberly Jones (Pace McGill); Elizabeth Smith and Alex Anthony (Norman Parkinson Archive); Dee Vitale-Henle and Matthew Krejcarek (Irving Penn Foundation); Her Excellency Sheikha Al Mayassa bint Hamad bin Khalifa Al Thani and Toshike Abe (Qatar Museum Authority); Mark MacKenna (Herb Ritts Foundation); Kim Sajet and Beth Isaacson (National Portrait Gallery/Smithsonian Institution); Etheleen Staley (Staley/Wise Gallery); Matt Moneypenny, Leslie Simitch and Billy Vong (Trunk Archive); Dries

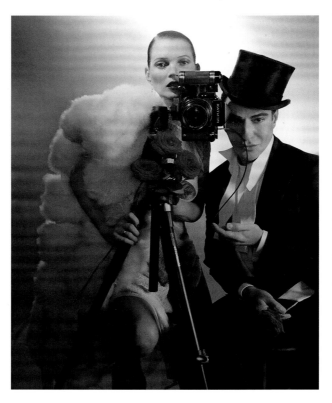

Van Noten, Patrick Vangheluwe and Jan Van Hoof (Dries Van Noten); Susanna Brown and Bronwen Colquhoun (Department of Photographs, Victoria and Albert Museum); Michael Wilson and Hope Kingsley (Wilson Centre for Photography).

Grateful thanks are due to the following photographers and their representatives, agents and studios: Henry Bourne; Julian Broad; Sheila Metzner; Gregory Spencer (Art Partner for Mario Testino, Alasdair McLellan, Mert Alas and Marcus Piggot, and Glen Luchford); Mark Pattenden (Camera Eye Ltd for David Bailey); Heloise Goodman (Regan Cameron); Hugo Grimwood (Tom Craig); Oneta Jackson (Patrick Demarchelier); Jeffrey Peabody (Matthew Marks Gallery for Nan Goldin); Julie Brown (MAP for Jamie Hawksworth); Carrie Scott, Jessica Salzer and Charlotte Knight (Nick Knight/SHOWstudio); Thierry-Maxime Loriot (Peter Lindbergh); José Freire (Team Gallery Inc for Ryan McGinley); Michael Van Horne (Art + Commerce for Craig McDean and Steven Meisel); Anna Hägglund (Paolo Roversi); Olivia Gideon Thompson, Rhianna Petrie and Hidé Shimamura (We Folk for Norbert Schoerner); Tom Heman (Metro Pictures for Cindy Sherman); Carrie Scott, Francisco Soiero and Sarah Dawes (David Sims); Frances von Hofmannstahl and Sarah Brown (Snowdon Archive); Camilla Lowther, Georg Rulffes, Rozi Rexhepi and Sally Waterman (Juergen Teller); Michele Filomeno and Nigel Boekee (Javier Vallhonrat); Anne-Marei Heinrich (Ellen von Unwerth); Graeme Bulcraig, Alex Paysley-Taylor and Emma Dalzell (Tim Walker); Aaron Watson (Albert Watson); Nathaniel Kilcer (Little Bear Inc for Bruce Weber).

Special thanks are due to Professor Steve MacLeod, Tony Window, Jason Tasker and John Cleur at Metro Imaging, who have meticulously undertaken specialist printing from *Vogue*'s negatives and on behalf of many contemporary photographers.

At the Condé Nast Publications Ltd I would like to thank the following: Anna Harvey, Nicholas Coleridge, Jonathan Newhouse and Stephen Quinn; at *Vogue*: Diana Duah, Rachel Lucas-Craig, Louisa McGillicuddy, Bridget Moloney, Jaime Perlman, Kate Phelan and Venetia van Hoorn Alkema. I owe much to Stephen Patience for his judicious editing, to Aimée Farrell for research and to Julian Alexander of Lucas, Alexander, Whiteley.

This project would not have been realised but for several exceptional people. Shawn Waldron (Senior Director, Archive and Records) readily allowed *Vogue*'s earliest masterworks to be flown to London from the New York archive. Without his support there would be little to show from *Vogue*'s pre-war era. Over many years the enthusiasm of Terence Pepper (formerly Head of Photographs at the National Portrait Gallery) for early fashion and portrait photography has significantly shaped my understanding of it. Harriet Wilson (Director of Editorial Administration and Rights) has balanced with skill and tact the interests of the Condé Nast Publications and those of its photographers to achieve equilibrium. Brett Croft (Library and Archive Manager) has turned the archives of *Vogue* in London into what must be the finest private repository of fashion photography in Europe. One of the greatest pleasures was to work closely with Patrick Kinmonth, who has creatively directed the exhibition with all the flair and attention to detail for which he is world-renowned; thanks also to his assistants Cara Newman and Jennifer Lee. At the Gallery, Jude Simmons and Lauryn Amara have given Patrick vital help.

Similarly it was a joy to work again with Ray Watkins of Price Watkins. She has designed the book with elegance and sympathy for its subject, and with the highest regard for its images. The magazine apart, her vision of the *Vogue* century on these pages will, I am sure, be the benchmark by which it is judged in years to come.

Finally, grateful thanks to Adam Boon, who has worked tirelessly and with good grace on the project for three years and has contributed more than anyone. His title of curatorial assistant belies his influence and his involvement in every single aspect.

Robin Muir

INDEX

PICTURE CREDITS

The National Portrait Gallery would like to thank those individuals and institutions that have lent works for the *Vogue 100: A Century of Style* exhibition, and the copyright holders for granting permission to reproduce works illustrated in this book. Every effort has been made to contact the holders of copyright material, and any omissions will be corrected in future editions if the publisher is notified in writing.

p.1 Josephine Baker by George Hoyningen-Huene. Courtesy Staley-Wise Gallery/© Condé Nast Inc. • pp.2–3 Kate Moss by Nick Knight. © Nick Knight. • p.4 Marion Morehouse by Edward Steichen. Condé Nast Archive New York/© Condé Nast Inc. • p.6 Christy Turlington by Nick Knight. Nick Knight/© Nick Knight • p.10 First *Vogue* cover by Helen Thurlow. Terence Pepper Collection • p.12 Wartime cover by Porter Woodruff. © The Condé Nast Publications Ltd; Pola Negri by Edward Steichen. © Condé Nast Inc. • p.13 Lee Miller by George Hoyningen-Huene. Courtesy The Lee Miller Archives Collection, Lee Miller Archives, England. www.leemiller.com/© Condé Nast Inc. • p.14 'Summer Life' by Tony Armstrong Jones. © The Condé Nast Publications Ltd • p.15 Pages at the Coronation by Norman Parkinson. © Norman Parkinson Ltd/Courtesy Norman Parkinson Archive; 'Britannica' cover © The Condé Nast Publications Ltd • p.16 'Young Ideas' cover by Norman Parkinson. © The Condé Nast Publications Ltd; Charles James dress by Bruce Weber. © The Condé Nast Publications Ltd • p.17 Cyrus and Joe Jr by Bruce Weber. © The Condé Nast Publications Ltd • p.18 Christy Turlington by Patrick Demarchelier. Patrick Demarchelier/© The Condé Nast Publications Ltd • p.19 75th anniversary cover by Tyen. © The Condé Nast Publications Ltd; Kate Moss by Corinne Day. Condé Nast Archive London/© The Condé Nast Publications Ltd • p.20 cover featuring Naomi Campbell by Mario Testino. © The Condé Nast Publications Ltd; Kirsty Hume by Tim Walker. © The Condé Nast Publications Ltd • p.21 Karen Elson in Texas by Tom Craig. Tom Craig/© Tom Craig • p.22 Helen Lyons by Baron Adolph de Meyer. Condé Nast Archive New York/© Condé Nast Inc. • p.24 Viscountess Maidstone by E.O. Hoppé. Terence Pepper Collection/© by permission of the E.O. Hoppé Estate Collection/Curatorial Assistance Inc., Pasadena, California; cover by Pierre Mourgue. © The Condé Nast Publications Ltd; cover by Eduardo Benito. © The Condé Nast Publications Ltd; cover by Guillermo Bolin © The Condé Nast Publications Ltd; 'Shining at a Private View', by 'Fish'. © The Condé Nast Publications Ltd • p.25 Colour plates by Eduardo Benito. © Condé Nast Inc.; 'Age of Jazz' by Edward Steichen. © Condé Nast Inc.; Rudolph Valentino by Maurice Beck and Helen Macgregor. © The Condé Nast Publications Ltd; cover by Georges Lepape. © The Condé Nast Publications Ltd; Cecil Beaton by Curtis Moffat and Olivia Wyndham (two images). © estate of Curtis Moffat. • p.26 Maxine Elliott by Arnold Genthe. Wilson Centre for Photography/© The Condé Nast Publications Ltd • p.27 Sybil Thorndike by Howard Instead. National Portrait Gallery, London • p.28 'Dolores and the crystal ball' by Baron Adolph de Meyer. Qatar National Collection/© Condé Nast Inc. • p.29 'Summer brings the hat' by Baron Adolph de Meyer. One Hundred Photographs: A Collection By Bruce Bernard/© Condé Nast Inc. • p.30 Nancy Cunard by Man Ray. Private Collection/© Man Ray Trust/ADAGP, Paris and DACS, London; Lady Diana Cooper by Hugh Cecil. Condé Nast Archive New York/© The Condé Nast Publications Ltd • p.31 Oliver Messel by George Hoyningen-Huene. Condé Nast Archive New York/© Condé Nast Inc.; Fay Compton by Maurice Beck and Helen Macgregor. Condé Nast Archive New York/© Condé Nast Inc. • p.33 'Motley magnificence' by Helen Dryden. Condé Nast Archive New York/© Condé Nast Inc. • p.34 Aldous Huxley by Charles Sheeler. Condé Nast Archive New York/© Condé Nast Inc. • p.35 Virginia Woolf by Maurice Beck and Helen Macgregor. © The Condé Nast Publications Ltd • p.36–7 'Navy blue and white are good sailors' by Edward Steichen. Condé Nast Archive New York/© Condé Nast Inc. • p.38 Helen Wills Moody by Dorothy Wilding. National Portrait Gallery, London. Given by the photographer's sister, Susan Morton, 1976/© William Hustler and Georgina Hustler/National Portrait Gallery, London • p.39 'Bare facts about fashion' by George Hoyningen-Huene. Condé Nast Archive New York/© Condé Nast Inc. • p.40 *Vogue* constellation' by Eduardo Benito. Condé Nast Archive New York/© Condé Nast Inc. • p.41 The Marquise de la Torre and Madame Martinez de Hoz by Frères Séeberger. Condé Nast Archive New York/© Condé Nast Inc. • p.42 Tallulah Bankhead by Cecil Beaton. Condé Nast Archive London/© The Condé Nast Publications Ltd • p.43 Edith Sitwell by Cecil Beaton. National Portrait Gallery, London/© The Condé Nast Publications Ltd • p.44 *Vogue* Deco' by Eduardo Benito. Condé Nast Archive New York/© Condé Nast Inc. • p.45 Charlie Chaplin by Edward Steichen. National Portrait Gallery, Smithsonian Institution; acquired in memory of Agnes and Eugene Meyer through the generosity of Katharine Graham and the New York Community Trust, The Island Fund/© The Estate of Edward Steichen/Joanna T. Steichen/ARS, NY and DACS, London • p.47 'Soap Suds' by Cecil Beaton. Condé Nast Archive New York/© Condé Nast Inc. • p.48 Lady Elizabeth Paget by Cecil Beaton. Condé Nast Archive London/© The Condé Nast Publications Ltd • p.50 Cover featuring Miriam Hopkins by George Hoyningen-Huene. © The Condé Nast Publications Ltd; cover by Eduardo Benito. © The Condé Nast Publications Ltd; cover by Pierre Mourgue. © The Condé Nast Publications Ltd; cover by Edward Steichen. © The Condé Nast Publications Ltd; cover marking the death of King George V. © The Condé Nast Publications Ltd; 'Spirit of Nacktkultur' by Dr Paul Wolff. © Condé Nast Inc. • p.51 George Balanchine's choreography for *I Married an Angel* by Anton Bruehl. Condé Nast Archive New York/© Condé Nast Inc.; Swimming costume by Brigance by Toni Frissell. © Condé Nast Inc.; drawing by Christian Bérard. © Condé Nast Inc.; 'The Noël Coward Paper Doll' by Constantin Alajálov. © The Condé Nast Publications Ltd • p.52 Marlene Dietrich by Cecil Beaton. Condé Nast Archive London/© The Condé Nast Publications Ltd • p.53 Vivien Leigh by Cecil Beaton. Condé Nast Archive London/© The Condé Nast Publications Ltd • p.54 'Fashion flashes' by Edward Steichen. Condé Nast Archive New York/© Condé Nast Inc. • p.55 Toto Koopman by George Hoyningen-Huene. National Gallery of Canada, Ottawa. Gift of Rodney and Cozette de Charmoy Grey, Geneva, 1979/© Condé Nast Inc. • p.56 'Modern torso' by Arnold Genthe. Andrew Cowan/© Condé Nast Inc. • p.57 'Modern mariners' by George Hoyningen-Huene. Collection of William T. Hillman, New York; Promised gift to the Carnegie Museum of Art, Pittsburgh/© Condé Nast Inc. • p.58 Tilly Losch by Cecil Beaton. Condé Nast Archive New York/© Condé Nast Inc. • p.59 Mr and Mrs Harrison Williams by Cecil Beaton. Courtesy of the Mona Bismarck American Center, Paris, France/© National Portrait Gallery, London • p.61 Margaret Whigham by Dorothy Wilding. Filippo Tattoni-Marcozzi/© The Condé Nast Publications Ltd • p.62 Advertisement for Victor Stiebel by Peter Rose Pulham. Courtesy of Paul Lyon-Maris • p.63 Louise Sheldon by Cecil Beaton. Condé Nast Archive New York/© Condé Nast Inc. • p.64 Queen Elizabeth by Cecil Beaton. Condé Nast Archive London/© Victoria and Albert Museum, London • p.65 Mrs Wallis Simpson by Cecil Beaton. Private Collection/Condé Nast Inc. • p.66 and back cover Fred Astaire by André de Dienes. Condé Nast Archive New York/© Condé Nast Inc. • p.67 Baron Adolph de Meyer by George Hoyningen-Huene. Condé Nast Archive London/© The Condé Nast Publications Ltd • pp.68–9 'April comes to Paris: spring in town' by Roger Schall. Condé Nast Archive New York/© Condé Nast Inc. • p.70 Lisa Fonssagrives by Horst. Condé Nast Archive, Paris/© Condé Nast Inc. • p.71 'Where there's a will, there's a waist' by Horst. Andrew Cowan/© The Horst Estate/Condé Nast Inc. • p.72 Joan Crawford by Edward Steichen. Condé Nast Archive New York/© Condé Nast Inc. • p.73 'Harlequin games' by Erwin Blumenfeld. Condé Nast Archive New York/© Condé Nast Inc. • p.74 'A midsummer night's dream' by André Durst. Condé Nast Archive New York/© Condé Nast Inc. • p.76 Walter and Thérèse Sickert by Cecil Beaton. Condé Nast Archive London/© The Condé Nast Publications Ltd • p.78 'British *Vogue* Carries On' brochure. © Condé Nast Inc.; *'Vogue* Can Save You Pounds'. © The Condé Nast Publications Ltd; cover by Horst. © The Condé Nast Publications Ltd; cover by Eduardo Benito. © The Condé Nast Publications Ltd; 'Pulling in Your Belt'. © The Condé Nast Publications Ltd; cover by James de Holden-Stone. © The Condé Nast Publications Ltd • p.79 Annotated Christmas cover based on photograph by Irving Penn. © Condé Nast Inc.; Guipure corset by Clifford Coffin. © The Condé Nast Publications Ltd; Spread showing drawing by René Bouché and photograph of Barbara Goalen by Horst. © The Condé Nast Publications Ltd • p.80 'Fashion is indestructible' by Cecil Beaton. Victoria and Albert Museum, London/© The Condé Nast Publications Ltd • p.81 Home defence in Hampstead by Lee Miller. The Lee Miller Archives/© Lee Miller Archives, England. All rights reserved. www.leemiller.co.uk • p.82 'Raising the vegetables' by Lee Miller. Condé Nast Archive London/© Lee Miller Archives, England. All rights reserved. www.leemiller.co.uk • p.83 'Bright fashion for dark days' (two images) by 'Eric'. Condé Nast Archive New York/© Condé Nast Inc. • p.84 'Winged squadrons' by Cecil Beaton. Condé Nast Archive London/© The Condé Nast Publications Ltd; 'Enemy skeletons' by Cecil Beaton. National Portrait Gallery, London/© The Condé Nast Publications Ltd • p.85 In the aircraft recognition room by Cecil Beaton. Imperial War Museums/© Imperial War Museums (HU 112285) • p.86–7 'Götterdämmerung of the Third Reich' by Lee Miller. The Lee Miller Archives/© Lee Miller Archives, England. All rights reserved. www.leemiller.co.uk • p.88 Letter to Edna Woolman Chase from Harry Yoxall. © Condé Nast Inc. • p.89 The daughter of the Bürgermeister of Leipzig by Lee Miller. The Lee Miller Archives, England. All rights reserved. www.leemiller.co.uk • p.90 'Rococo rubble' by the US Signal Corps. Condé Nast Archive London/© The Condé Nast Publications Ltd • p.91 Chinese commandos by Cecil Beaton. Condé Nast Archive London/© The Condé Nast Publications Ltd • p.92 'The second age of beauty is glamour' by Cecil Beaton. Condé Nast Archive London/© The Condé Nast Publications Ltd • p.93 Princess Troubetskoy by Clifford Coffin. Condé Nast Archive London/© The Condé Nast Publications Ltd • p.94 Jane Bowles and Truman Capote by Cecil Beaton. Condé Nast Archive London/© The Condé Nast Publications Ltd • p.95 Alfred Hitchcock by Irving Penn. National Portrait Gallery, London/© Condé Nast Inc. • pp.96–7 The New Look by Clifford Coffin. Condé Nast Archive London/© The Condé Nast Publications Ltd • p.97 Christian Dior by Clifford Coffin. Condé Nast Archive New York/© Condé Nast Inc. • p.98 Gore Vidal by Clifford Coffin. Condé Nast Archive London/© The Condé Nast Publications Ltd; Christopher Isherwood by George Platt Lynes. Condé Nast Archive London/© The Condé Nast Publications Ltd; Lucian Freud by Clifford Coffin. Condé Nast Archive London/© The Condé Nast Publications Ltd • p.99 Henri Matisse by Clifford Coffin. Condé Nast Archive New York/© Condé Nast Inc. • p.100 Barbara Goalen by Cecil Beaton. Condé Nast Archive London/© The Condé Nast Publications Ltd • p.101 A Conversation Piece by Cecil Beaton. Condé Nast Archive London/© The Condé Nast Publications Ltd • p.102–3 Wenda Rogerson by Clifford Coffin. Condé Nast Archive London/© The Condé Nast Publications Ltd • p.104 Jean Patchett by Clifford Coffin. Condé Nast Archive New York/© Condé Nast Inc. • p.106 cover by Norman Parkinson. © The Condé Nast Publications Ltd; cover by Irving Penn. © The Condé Nast Publications Ltd; cover by Clifford Coffin. © The Condé Nast Publications Ltd; cover by Norman Parkinson. © The Condé Nast Publications Ltd; spread by Tony Armstrong Jones. © The Condé Nast Publications Ltd; Audrey Hepburn by Norman Parkinson. © Norman Parkinson Ltd/Courtesy Norman Parkinson Archive • p.107 Jean Patchett by Norman Parkinson. © Norman Parkinson Ltd/Courtesy Norman Parkinson Archive; spread featuring Nena von Schlebrügge by Claude Virgin. © The Condé Nast Publications Ltd; cover by René Bouché. © The Condé Nast Publications Ltd; spread featuring photograph by Donald Silverstein and illustration by Eric Stemp. © The Condé Nast Publications Ltd; spread featuring illustration by René Bouché and photograph by William Klein. © Condé Nast Inc. • p.108 Dylan Thomas by John Deakin. John Deakin Archive/© The Condé Nast Publications Ltd • p.109 Wenda Parkinson by Norman Parkinson. National Portrait Gallery, London/© Norman Parkinson Ltd/Courtesy Norman Parkinson Archive • p.110 Anne Saint Marie by Henry Clarke. Condé Nast Archive London/© The Condé Nast Publications Ltd • p.111 Adèle Collins by Norman Parkinson. © Norman Parkinson Ltd/Courtesy Norman Parkinson Archive • p.112 Francis Bacon by John Deakin. Victoria and Albert Museum, London/© The Condé Nast Publications Ltd • p.113 David Lean by John Deakin. Condé Nast Archive London/© The Condé Nast Publications Ltd • p.115 Queen Elizabeth II by Cecil Beaton. Condé Nast Archive London/© The Condé Nast Publications Ltd; • p.116 Evelyn Waugh by Irving Penn. National Portrait Gallery, London/© Condé Nast Inc. • p.117 Covent Garden market porter by Irving Penn. The J. Paul Getty Museum, Los Angeles (2008.1.22). Partial gift of Irving Penn. The Irving Penn Foundation • p.118 Memoranda (two) between Peter Coats and Audrey Withers. © The Condé Nast Publications Ltd • p.119 'Mishap at Victoria' by Tony Armstrong Jones. © The Condé Nast Publications Ltd • p.120 John Osborne by Tony Armstrong Jones. Snowdon/© The Condé Nast Publications Ltd • p.121 Alec Guinness by Tony Armstrong Jones. Condé Nast Archive London/© The Condé Nast Publications Ltd • p.122 Anne Saint Marie by Henry Clarke. Condé Nast Archive London/© The Condé Nast Publications Ltd • p.124 Anne Gunning by Norman Parkinson. © Norman Parkinson Ltd/Courtesy Norman Parkinson Archive • p.125 'Luminous brilliance' by Herbert Matter. Condé Nast Archive New York/© Condé Nast Inc. • pp.126–7 Yves Saint Laurent by Irving Penn. The Irving Penn Foundation/© The Irving Penn Foundation • pp.128–9 Mr and Mrs John Taylor by Tony Armstrong Jones. Snowdon/© The Condé Nast Publications Ltd • p.130 Twiggy by Ronald Traeger. Condé Nast Archive London/© The Condé Nast Publications Ltd • p.132 Peggy Moffitt by David Bailey. © The Condé Nast Publications Ltd; spread featuring Vidal Sassoon bob by Terence Donovan. © The Condé Nast Publications Ltd; 'Young Idea' spread featuring Kenneth Tynan and Jean Shrimpton by David Bailey. © The Condé Nast Publications Ltd; graphic cover from 1961. © The Condé Nast Publications Ltd; cover featuring Sandra Paul by Peter Rand. © The Condé Nast Publications Ltd • p.133 Catherine Deneuve by David Bailey. © The Condé Nast Publications Ltd; cover featuring Celia Hammond by David Bailey. © The Condé Nast Publications Ltd; space-age tableau by Helmut Newton. © The Condé Nast Publications Ltd; 'Travel in *Vogue*' guide. © The Condé Nast Publications Ltd; Robert Carrier cookery page. © The Condé Nast Publications Ltd; Jill Kennington by Bob Richardson. © The Condé Nast Publications Ltd • p.134 Maggi Eckardt by Don Honeyman. Condé Nast Archive London/© The Condé Nast Publications Ltd • p.135 Maggi Eckardt by William Klein. Condé Nast Archive London/© The Condé Nast Publications Ltd • p.136 Judy Dent by Brian Duffy. Condé Nast Archive London/© The Condé Nast Publications Ltd • p.137 Ros Watkins by Frank Horvat. Condé Nast Archive London/© The Condé Nast Publications Ltd • p.138 Crawley new town by Terence Donovan. Terence Donovan Archive/© Terence Donovan Archive • p.139 'People who are just people' by Peter Laurie. Condé Nast Archive London/© The Condé Nast Publications Ltd • pp.140–1 Tamara Nyman by Ronald Traeger. Tessa Traeger/© The Condé Nast Publications Ltd • p.143 Jean Shrimpton by Don Honeyman. Condé Nast Archive London/© The Condé Nast Publications Ltd • p.144 Mary Quant and Alexander Plunket Greene by Terence Donovan. Condé Nast Archive London/© The Condé Nast Publications Ltd; The Beatles by Peter Laurie. Condé Nast Archive London/© The Condé Nast Publications Ltd; Terence Stamp by Terence Donovan. Condé Nast Archive London/© The Condé Nast Publications Ltd • p.145 Nicole de Lamargé and Agnetta Darren by Ronald Traeger. Condé Nast Archive London/© The Condé Nast Publications Ltd • p.146 Katherine Pastrie by Helmut Newton. Condé Nast Archive London/© The Condé Nast Publications Ltd • p.147 Jean Shrimpton, by Saul Leiter. Condé Nast Archive London/© The Condé Nast Publications Ltd • p.148 Letter to David Bailey from John Parsons. © The Condé Nast Publications Ltd • p.149 Jean Shrimpton and Grace Coddington (fifteen images) by David Bailey. Condé Nast Archive London/© The Condé Nast Publications Ltd • p.150 Jean Shrimpton, by David Bailey. © The Condé Nast Publications Ltd • p.151 Marisa Berenson by David Bailey. Condé Nast Archive London/© The Condé Nast Publications Ltd • pp.152–3 Donyale Luna by William Klein. Condé Nast Archive London/© The Condé Nast Publications Ltd • p.154 Willy van Rooy by Helmut Newton. Condé Nast Archive London/© The Condé Nast Publications Ltd • p.155 Mouche by Barry Lategan. Condé Nast Archive London/© The Condé Nast Publications Ltd • pp.156–7 David Hockney, Maudie James and Peter Schlesinger by Cecil Beaton. Condé Nast Archive London/© The Condé Nast Publications Ltd • p.158 Jerry Hall by Norman Parkinson. Norman Parkinson Ltd/Courtesy Norman Parkinson Archive • p.160 Iman by Norman Parkinson. © Norman Parkinson Ltd/Courtesy Norman Parkinson Archive; illustration by Erté. © The Condé Nast Publications Ltd; cover featuring Manolo Blahnik and Anjelica Huston by David Bailey. © The Condé Nast Publications Ltd; cover featuring red nails and green jelly by Willie Christie. © The Condé Nast Publications Ltd; cover featuring Jerry Hall by Norman Parkinson. © The Condé Nast Publications Ltd • p.161 Spread featuring Marie Helvin by David Bailey. © The Condé Nast Publications Ltd; Manolo Blahnik shoe by Lothar Schmid. © The Condé Nast Publications Ltd; Fashion photograph by Sarah Moon. © The Condé Nast Publications Ltd; spread featuring Zandra Rhodes's designs by Lothar Schmid. © The Condé Nast Publications Ltd; Apollonia van Ravenstein by Norman Parkinson. © Norman Parkinson Ltd/Courtesy Norman Parkinson Archive; spread featuring Margaret Thatcher by Bailey. © The Condé Nast Publications Ltd • pp.162–3 'What's in a diamond?' by Guy Bourdin. Condé Nast Archive London/© The Condé Nast Publications Ltd • p.164 Gayla Mitchell by Peter Knapp. Condé Nast Archive London/© The Condé Nast Publications Ltd • p.165 Apollonia van Ravenstein by Arthur Elgort. Condé Nast Archive London/© The Condé Nast Publications Ltd • p.166 Louise Despointes and Donna Jordan by Sacha. Condé Nast Archive London/© The Condé Nast Publications Ltd • p.167 Penelope Tree by Cecil Beaton. Condé Nast Archive London/© The Condé Nast Publications Ltd • p.168 cover featuring Bianca Jagger by Eric Boman. © The Condé Nast Publications Ltd • p.169 Kathy Quirk and Carrie Nygren by Guy Bourdin. Condé Nast Archive London/© The Condé Nast Publications Ltd • p.170–1 Morecambe and Wise by David Bailey. Condé Nast Archive London/© The Condé Nast Publications Ltd • p.173 'New cover story' by Barry Lategan. Condé Nast Archive London/© The Condé Nast Publications Ltd • p.174 Peter Sellers by Snowdon. Condé Nast Archive London/© The Condé Nast Publications Ltd • p.175 John Betjeman by Snowdon. Snowdon/©Armstrong Jones; Germaine Greer by Snowdon. Snowdon/© Armstrong Jones; Martin Amis by Snowdon. Snowdon/© Armstrong Jones • p.176 Karin Feddersen by Helmut Newton. Condé Nast Archive London/© The Condé Nast Publications Ltd • p.177 'Limelight nights' by Helmut Newton. Condé Nast Archive London/© The Condé Nast Publications Ltd • p.178 Susan Moncur by Sarah Moon. Condé Nast Archive London/© The Condé Nast Publications Ltd • p.179 'Nights of Paris' by Helmut Newton. Condé Nast Archive London/© The Condé Nast Publications Ltd • p.180 David Bowie by Snowdon. Condé Nast Archive London/© Armstrong Jones • p.181 'Punk: danger, stranger' by Johnny Rozsa, Luciana Martínez and Derek Jarman. Condé Nast Archive London/© The Condé Nast Publications Ltd • pp.182–3 Louise Despointes by Steve Hiett. Condé Nast Archive London/© The Condé Nast Publications Ltd • p.184 Talisa Soto by Albert Watson. Albert

Published in Great Britain by National Portrait Gallery Publications, St Martin's Place, London WC2H 0HE

Published to accompany the exhibition *Vogue 100: A Century of Style* at the National Portrait Gallery, London, from 11 February to 23 May 2016 and at Manchester Art Gallery, from 24 June to 30 October 2016.

Vogue 100: A Century of Style has been organised by the National Portrait Gallery, London, in collaboration with British *Vogue* as part of the magazine's centenary celebrations.

This exhibition has been made possible by the provision of insurance through the Government Indemnity Scheme. The National Portrait Gallery, London, would like to thank HM Government for providing Government Indemnity and the Department for Culture, Media and Sport and Arts Council England for arranging the indemnity.

ISBN 978 1 85514 561 0

A catalogue record for this book is available from the British Library.

10 9 8 7 6 5 4 3 2 1

For the National Portrait Gallery
Managing Editor: Christopher Tinker
Copy-editor: Denny Hemming
Design: Raymonde Watkins
Production Manager: Ruth Müller-Wirth
Editorial and Production Assistant: Kathleen Bloomfield

For *Vogue*
Director of Editorial Business & Rights:
Harriet Wilson
Library and Archive Manager: Brett Croft
Curatorial assistance and research:
Adam Boon

LEON MAX

MAXSTUDIO●COM

Sponsored by Leon Max

The National Portrait Gallery's Spring Season 2016 sponsored by Herbert Smith Freehills

Sold to support the National Portrait Gallery, London.
For a complete catalogue of current publications, please write to the National Portrait Gallery at the address above, or visit our website at www.npg.org.uk/publications

Printed and bound in Italy by Conti Tipocolor S.p.A.
Origination by Altaimage Ltd, London
Typeset in Didot and Miller

p.300 Kate Moss and John Galliano by Tim Walker, 2013
p.304 *Vogue's* merry-go-round by Vic Volk, 1946

NOTE: References to *Vogue* denote the British edition unless otherwise indicated. Dates in captions refer to the month and year of original publication unless stated otherwise. Several photographs taken for *Vogue* were not published until later, sometimes years later, while others intended for publication never appeared at all. Occasionally, alternate versions of published images are shown. Archive features have been edited for inclusion in this publication.